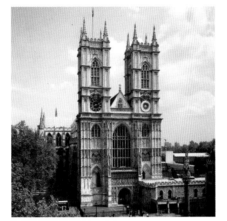

TREASURES OF
WESTMINSTER
ABBEY

Tony Trowles

© Scala Arts & Heritage Publishers Ltd, 2008

Text © Westminster Abbey Enterprises Ltd, 2008
Photography © The Dean and Chapter of Westminster, 2008,
except for the following pages:
133 (bottom) © Angelo Hornak Photograph Library
129 (top) © Collection of the Earl of Pembroke, Wilton House,
Wilts./The Bridgeman Art Library
143 © Mary Evans Picture Library
57 © National Gallery, London, UK/The Bridgeman Art Library
144 © National Maritime Museum, Greenwich, London
37 and 137 © National Portrait Gallery, London
68 © National Portrait Gallery, London, UK/The Bridgeman Art Library
8 and 94 (top and bottom) © Picture Partnership
146 © Royal Society, London, UK/The Bridgeman Art Library
145 © Victoria & Albert Museum, London, UK/The Bridgeman Art Library
19, 29, 46, 48, 49, 54 (top), 55, 64 (bottom), 65, 66, 68 (top), 70, 74, 75, 77,
78, 79, 119, 129 (bottom), 130, 135 (top and bottom) and back cover ©
Westminster Abbey Enterprises Ltd

Published by Scala Arts & Heritage Publishers Ltd
10 Lion Yard
Tremadoc Road
London SW4 7NQ
Telephone: +44 (0) 20 7808 1550
www.scalapublishers.com

First published in paperback in 2008
This edition published in 2016
ISBN (paperback): 978 1 85759 660 1
10 9 8 7 6

First published in hardback in 2010
ISBN (hardback): 978 1 85759 649 6
10 9 8 7 6 5 4 3

Editor: Esme West
Design: Nigel Soper
Printed and bound in Singapore

British Library Cataloguing in Publication Data. A catalogue record for
this book is available from the British Library.

FRONT COVER:
The high altar and its Victorian screen.

BACK COVER:
Fan vaulting in Henry VII's Lady Chapel.

INSIDE COVER:
A detail from the Westminster retable.

CONTENTS

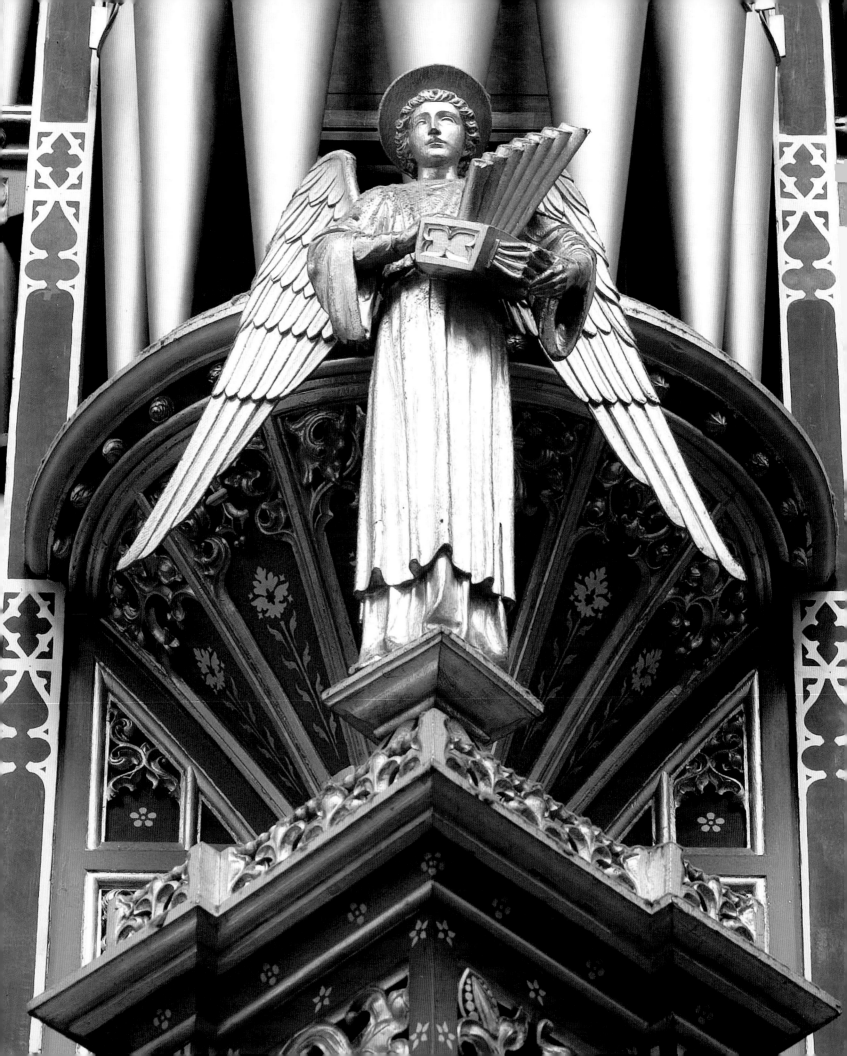

NOTE TO READERS

THE SECTIONS OF *Treasures of Westminster Abbey* are arranged to correspond as far as possible with the order in which the present church was built, beginning with St Edward the Confessor's Chapel and moving west through the sacrarium, lantern and quire (with its quire aisles). The text then describes the north transept, the north and south ambulatories with their associated chapels, the south transept and St Faith's Chapel. Next comes a description of the nave and the west front, followed by the Lady Chapel, the cloisters and the Abbey's precincts. A series of plans, numbered to correspond with the sections of the text, show the location of monuments and other items of interest.

The book describes almost all the tombs, memorials and gravestones that can now be seen at Westminster Abbey, but it certainly does not claim to mention every burial within the church and its precincts; for of this there is no complete record. Medieval tombs provide obvious physical evidence of some early burials, and others are reliably documented in the Abbey's archives, but the formal burial register only begins in 1607. Taken together these sources suggest that more than 3,000 people are buried in Westminster Abbey. In many cases it is impossible to say precisely where a person's grave is, and over the centuries stones have been replaced or removed and inscriptions have been worn away. Burials are now rare in the Abbey, apart from the occasional burial of ashes of former Abbey clergy or lay staff, but the tradition of memorialisation continues, and new commemorations are made from time to time. Today, as for the last four and half centuries, the right to decide who will be buried or commemorated here rests entirely with the dean of Westminster.

Each section of the book describes a particular area of the Abbey and gives an account of the monuments and floorstones found there. These are discussed in chronological order, arranged by the date of death of the person or (in the case of memorials) the date of installation of the monument, if known. In this way it is possible for the reader to gain some impression of the way in which specific parts of the abbey church have developed in the course of the centuries. It has not, however, been possible to provide an individual account of every one of the Abbey's funerary monuments in this way. Small memorial tablets and the gravestones of many lesser-known individuals are not described individually but merely listed (again in chronological order) at the end of each section, though all can be located by reference to the various plans. Gravestones without inscriptions have been omitted.

Except where the text states otherwise, all those whose monuments are described are buried in Westminster Abbey. In cases where a person has both a monument and an identifiable gravestone in the same part of the Abbey, the text describes only the former (unless the gravestone also records the names of others or is of particular artistic significance). Both can be found by referring to the appropriate plan. However, if a person has a monument in one part of the church and a gravestone in another, the latter is mentioned in the description of the monument and both will again be found on the appropriate plans.

Within each section the account of the monuments and memorials is followed by a description of stained-glass windows and other items of historic or artistic interest. Most of these are also marked on the relevant plan, with the exception of moveable objects which may not always be displayed in the same position.

The varying sizes of the gravestones and monuments makes it difficult to plot their locations exactly in relation to one another, but it should be noted that where reference numbers on the plans appear above one another on vertical stems, the numerical order of the references corresponds to the position of the monuments on the walls, the highest number referring to the highest monument.

OPPOSITE:
An angel playing a medieval organ adorns one of the elaborate organ cases over the quire screen.

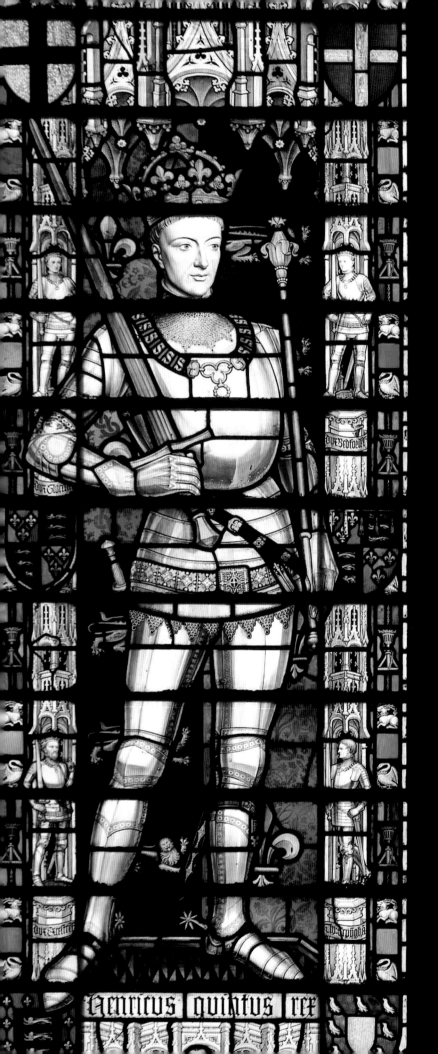
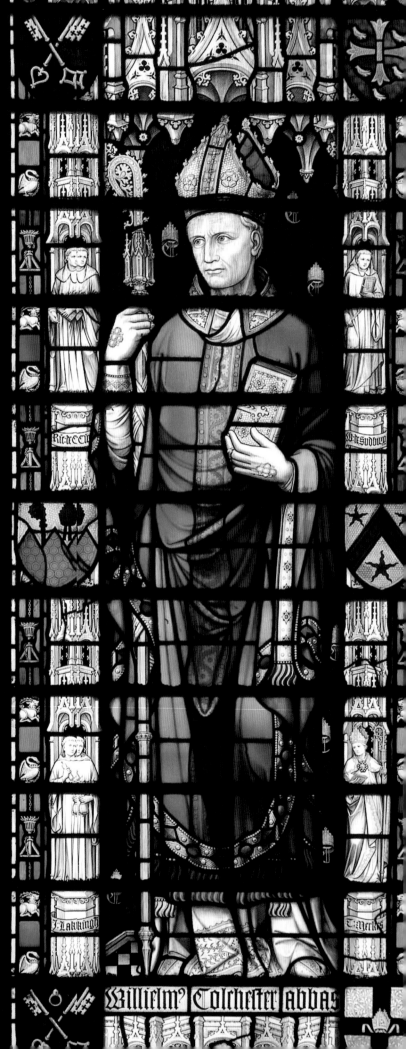

henricus quintus rex willielm' colchester abbas

INTRODUCTION

WESTMINSTER ABBEY is one of the world's great churches, with a history stretching back over a thousand years. A royal church from its first beginnings, it still has the shrine of its principal founder, the Anglo-Saxon king and saint Edward the Confessor, at the heart of the building. Since Edward's death in 1066 his successors have come to this church to be crowned, and sixteen of them lie buried within its walls. More than a million people now visit Westminster Abbey each year, and millions more across the globe know it through the televising of such events as the wedding of the Duke and Duchess of Cambridge in 2011.

Treasures of Westminster Abbey celebrates this remarkable building, one of the finest medieval churches in England but also a place where the art and architecture of subsequent centuries have left their mark. It describes the stained glass, furniture, textiles, wall paintings and many other beautiful and historic artefacts found within the abbey church and its precincts. Above all, it provides a unique and comprehensive survey of the Abbey's tombs, gravestones and monuments, including biographical information on some of the most significant individuals in the nation's history: royalty and aristocracy, clergy and politicians, writers, scientists and musicians. Several thousand people are buried in Westminster Abbey, and the many tombs and memorials (around 600 in all) form an extraordinary collection of monumental sculpture. No other church in the land has a history so inextricably bound up with that of the people of the British Isles and the lives they have lived, both at home and overseas.

Above all, Westminster Abbey has been for more than a millennium a Christian church, and in this fact can be seen most clearly the continuity of its life. Whether in the complex liturgy of the medieval monastery, in the austere preaching services of Oliver Cromwell's Commonwealth or in the rich blend of traditions that constitute the Church of England as it exists today, the honouring of God in worship and prayer has always been the Abbey's priority. The building has changed and adapted to the needs and priorities of the passing centuries, but the primary purpose for which it was built has never ceased to be honoured. Though it is now well over 400 years since it ceased to be a monastery, Benedictine influences are strong at Westminster, not just in the continued tradition of daily prayer but also in the commitment to hospitality and to the hope that those who arrive at the Abbey as tourists and visitors may leave it, in some small way, as pilgrims.

No one can say with absolute certainty when Westminster Abbey was founded. Its medieval monks, wishing to emphasise the antiquity of their monastery, promoted several stories about its origins, suggesting that it was founded by a rich citizen of London or by Sebert, king of the East Saxons, in the seventh century. It was said too that St Peter the Apostle had consecrated the first church, later rewarding the fishermen who ferried him across the Thames with a miraculous catch of salmon.

These legends aside, a church dedicated to St Peter may have stood here by the eighth century. We know more certainly that around 960 Dunstan, bishop of London, sent a group of Benedictine monks to establish a monastery on the north bank of the Thames, in a marshy and inhospitable place that was effectively an island, owing to the fact that the River Tyburn and one of its tributaries flowed into the Thames on either side of the site. Early documents describe the place as 'Thorney Island'. King Edgar (reigned 959–75) supported Dunstan's monks with a gift of land covering most of what is today London's West End, and a century later King Edward (reigned 1043–66) established his palace on Thorney Island and became an even more enthusiastic patron of the monastery. He increased the number of monks, gave them money and land and finally built an entirely new monastic church, which also became his own burial place.

Our knowledge of this building comes from early medieval descriptions, from a depiction in the Bayeux Tapestry and from some foundations surviving under the Abbey. It was only a little smaller

OPPOSITE:
The memorial window to Lord Kelvin, in the nave, depicts Henry V and Abbot William Colchester.

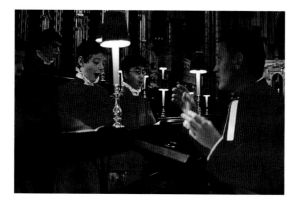

ABOVE:
A rehearsal of the Abbey's choristers.

BELOW:
A service in progress at the high altar.

8

than the present church, with an apsidal east end, transepts, a central tower and a lead-covered roof. It is said that the cathedral at Jumièges in Normandy was a strong influence on the design. By the time of its dedication on 28 December 1065 (the feast day of the Holy Innocents), the king was already gravely ill. He died a few days later, on 5 January 1066, and was buried in front of the new high altar. The construction of a cloister and other monastic buildings quickly followed, and the buildings that survive from this time in the east cloister (notably the undercroft) are now the oldest parts of the Abbey.

During his life King Edward acquired a

reputation for holiness, and after his death stories of miracles he had worked began to circulate. The monks promoted his cult, writing accounts of his life that emphasised his saintly character until, in 1161, Edward was canonised as 'St Edward the Confessor'. Two years later his body was moved or 'translated' to a shrine in front of the high altar.

No English king had a greater devotion to St Edward than Henry III, who came to the throne in 1216, shortly after his ninth birthday. His long reign had a profound effect on the Abbey, and his influence was quickly felt. In 1220 Abbot Humez started to build a Lady Chapel in which a daily mass in honour of the Virgin Mary might be held. The young king became interested in this project and eventually assumed responsibility for it, providing his own masons and other craftsmen to work on it. A further sign of the Abbey's importance came in 1222, with the confirmation by papal judges that the monastery was exempt from the jurisdiction of the bishop of London and the archbishop of Canterbury, and was subject directly to the pope.

Subsequently Henry III conceived the idea of building an entirely new Gothic church at Westminster, which would have a magnificent shrine for Edward the Confessor's remains at its heart. Work began in 1245 under the master mason Henry 'de Reyns'. It is not known whether he was English or French, but it is possible that he came from Reims, in France, for Henry III's abbey church is arguably the most French of any of the great medieval churches of England. The influences of the Sainte-Chapelle in Paris and of the cathedrals of Reims (the French coronation church), Amiens and Beauvais are all strongly felt.

The church is cruciform in shape, with a raised sacrarium containing the high altar at its east end and a chapel for the shrine of St Edward the Confessor beyond it. Around this chapel runs an ambulatory with radiating apsidal chapels opening off it, a plan derived from Amiens. The liturgical quire is placed to the west of the crossing, a feature copied directly from Reims Cathedral with the intention of making the crossing a suitable 'theatre' for coronation ceremonies. Other French features are the flying buttresses, the iron tie-bars linking the columns, the rose windows in the transepts and the superbly sculpted censing angels beneath them. There are also distinctively English characteristics, however, such as the long nave, the widely projecting transepts (though the recessed portals echo those at Amiens) and the single, rather than double, aisles. The Englishness of the Abbey is apparent too in the

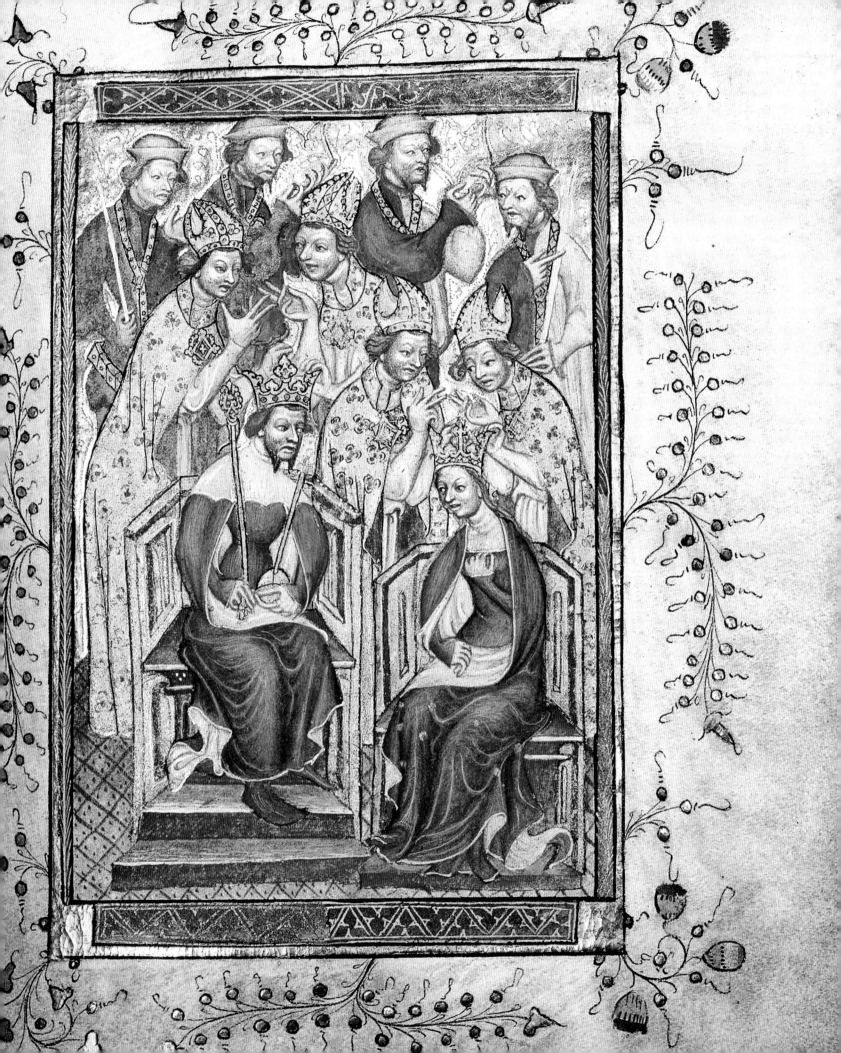

elaborate mouldings of the main arches, the use of polished Purbeck marble for the principal pillars, the method of filling the stone vaults and the overall sculptured decoration.

The first phase of building began in 1245, with the demolition of the eastern part of Edward the Confessor's church. Space was restricted: to the east by the very new Lady Chapel, to the west by the eleventh-century nave, and to the south by the cloisters and other buildings. Nevertheless, by 1259 the eastern arm of the new church, including the ambulatory and its chapels, the transepts and the chapter house, was complete. Henry de Reyns was succeeded first by Master John of Gloucester in 1253, and then by Master Robert of Beverley in 1260. As the masons erected the main fabric of the church, numerous craftsmen worked to decorate its interior with stained glass, paintings and sculpture of the finest quality. On 13 October 1269 the body of St Edward was transferred to its shrine, and the high altar of the new church was consecrated. When Henry III died three years later, the work had extended to one bay west of the quire, but it now ceased for over a century.

It resumed under Abbot Nicholas Litlyngton in March 1376, thanks to the generosity of Simon Langham (Litlyngton's predecessor) who had given generously to the Abbey during his lifetime and in death bequeathed the residue of his estate to support the building work. The Norman nave was demolished, and new exterior walls were begun. Langham had suggested that less expensive stone might be used for the columns, but Litlyngton apparently insisted not only on the continued use of Purbeck marble but also on following the original design of Henry III's masons. As a result the Abbey has a remarkable architectural unity despite the long period of its construction. Work continued under Litlyngton's successor, Abbot Colchester, and by 1403 all the columns were in place and the walls had been completed to triforium level. By then the master mason was Henry de Yevele (also responsible for much of the building of Canterbury Cathedral).

Richard II took a keen interest in the building and contributed money to it, but work stalled again in Henry IV's reign. It resumed between 1413 and 1422, assisted by grants from Henry V, and two 'Surveyors of the New Work' were appointed at this time, one of whom (drawn from outside the

ABOVE:
The north side of the Abbey engraved by Wenceslaus Hollar (1654).

BELOW:
The west front of the Abbey engraved by Wenceslaus Hollar (1654).

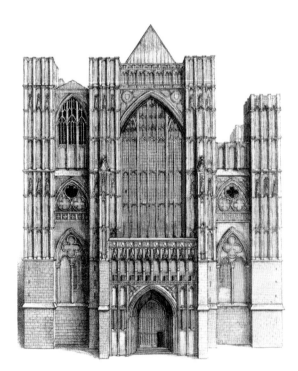

monastery) was Richard ('Dick') Whityngton. After the king's death the master mason John Thirske constructed Henry V's chantry chapel and probably also the high altar screen, which closed in the Confessor's chapel so that the shrine could no longer be seen from the quire.

Work on the nave proceeded slowly in the later fifteenth century, partly funded with gifts of money from Edward IV, but by 1495 the west window was complete. Meanwhile Edward's consort, Elizabeth Woodville, who had been granted sanctuary at the Abbey by Abbot Millyng in 1470, had funded the building of a small chapel of St Erasmus adjoining the Lady Chapel.

The election of Abbot John Islip in 1500 heralded the final phase of medieval building work. In 1503, at the instigation of Henry VII, work began at the east end on constructing a new Lady Chapel in place of the one built by Henry III in 1220. The main structure was complete by 1509, but work on the interior of this remarkable late Perpendicular structure with its magnificent fan vaulting and sculptural decoration continued for several more years. Meanwhile in the nave the vaulting above the west window had been finished by 1502, and the window itself was glazed. With the completion of the final vaulting in 1506, the great building project came to an end, two and half centuries after work began, leaving only the west towers unfinished.

The great Gothic church at Westminster had been a royal project, instigated by Henry III and carried forward in the centuries after his death through the continuing interest and financial support of several of his successors. Within a few decades of its completion, however, Henry VIII had resolved to close all the monasteries in the land, and Westminster was no exception, though it was among the last wave of houses to be dissolved. The commissioners who oversaw the process arrived in the early days of 1540, and Abbot Boston, with twenty-four monks, signed the deed of surrender in the chapter house on 16 January 1540. Every penny of the monastery's wealth passed to the king, and most of the liturgical furnishings were removed, but the Abbey's role as the coronation church and a royal mausoleum probably protected it from more severe vandalism. Soon after its dissolution Henry VIII established the Abbey as a cathedral church for a new diocese of Westminster, with a bishop, dean and twelve prebendaries, and after March 1550 it served instead as a second cathedral within the diocese of London. In 1556, under Mary I, the Benedictine monastery was restored, but following her death in 1558 the monastic community was dissolved for a second time, and Elizabeth I established the Abbey by royal charter as 'the Collegiate Church of St Peter'.

Like its monastic predecessor, this collegiate foundation was exempt from episcopal jurisdiction, but it was now a 'Royal Peculiar', with the sovereign as its Visitor. The new foundation, consisting of a

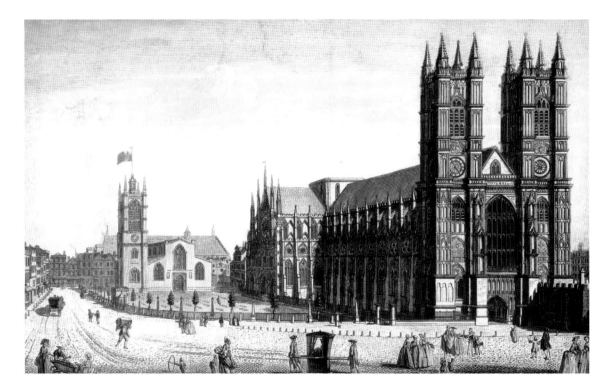

RIGHT:
The Abbey and St Margaret's Church in the mid-eighteenth century.

dean and prebendaries (later known as canons) with assistant clergy and lay officers, had two main duties: to continue daily worship (for which an organist, choristers and singing men were provided) and to educate forty scholars. Both activities continue today, though Westminster School is now greatly enlarged and independently governed.

During the Commonwealth period in the mid-seventeenth century the collegiate foundation was abolished, and the Abbey and school were governed instead by a committee. The church continued to be used for preaching, but the choir was disbanded and the Anglican liturgy was abandoned until the Restoration of the monarchy, when the Elizabethan foundation was reinstated. Attention now turned to the fabric of the building, which in places needed repair. In 1698 Sir Christopher Wren was appointed surveyor of the fabric, and repair work began, especially on the north front. Wren also resolved to provide the two towers at the west end, which the medieval masons had certainly intended but had not been able to complete. Wren's original designs were modified by his successor as surveyor, Nicholas Hawksmoor, and the towers were finally completed by John James in 1745. The celebrated painting by Canaletto depicting a procession of knights of the Order of the Bath leaving the Abbey is among the earliest depictions of the newly completed towers.

The eighteenth and early nineteenth centuries were periods of relative stability and prosperity for the Abbey, but the reform movements of the mid-nineteenth century affected it in two significant ways. In 1868 Westminster School became independent of the Dean and Chapter, though the two institutions remain closely connected (for example, the school uses the Abbey as its chapel). At about the same time legislation required the Dean and Chapter to hand over its lands and other property to the newly formed ecclesiastical commissioners. This had significant financial consequences for the Abbey, which has never received regular funding from the church, the state or the crown. The dean of Westminster during this period was Arthur Penrhyn Stanley, who brought new vigour to the Abbey's life and wrote extensively about its history. He gave permission for the burial of figures such as Dickens and Livingstone, and did much to establish a unique place for the Abbey in the minds and affections of the British people.

Much of this book is concerned with that remarkable collection of monuments and memorials, an assemblage that Dean Stanley felt helped both to create and to underpin the Abbey's

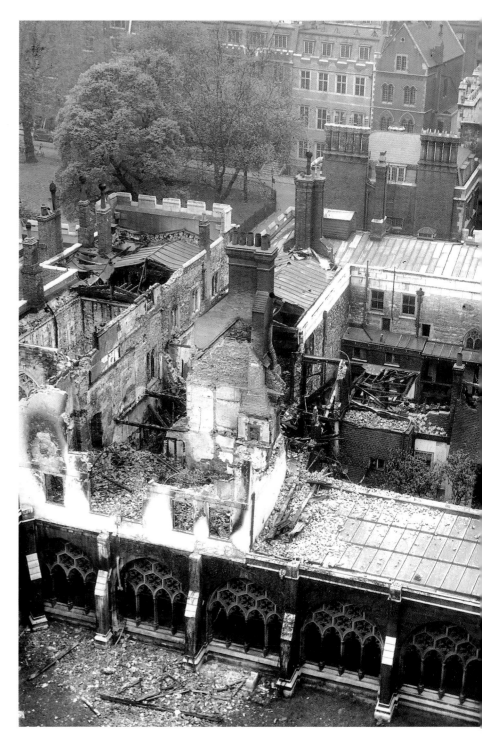

unique place in British history. Though monuments now seem to fill every available space, in monastic times burials in the church had been limited almost exclusively to kings and their immediate families, a few highly favoured nobles and the abbots of Westminster. In the later sixteenth century the apsidal chapels, which had been stripped of their medieval altars and furnishings at the Reformation, began to be filled instead with tombs. Edmund

LEFT:
The deanery destroyed by bombing, 1941.

Spenser's burial close to Geoffrey Chaucer's tomb in the south transept initiated Poets' Corner. Over time large numbers of monuments were erected in the transepts and the nave too, and a tradition developed of placing memorials to people who were actually buried elsewhere. There is no obvious or deliberate pattern in all this, and the presence of a certain monument or the decision to bury or memorialise a person in the Abbey, taken at a particular moment, is more a comment on the social, political and cultural history of that time. It is a mistake to suppose that for an individual to have a monument here he or she must have been greatly distinguished; nor has the Abbey ever been a regulated national pantheon where a memorial to every person of recognised distinction will be found. This very diversity contributes to the Abbey's remarkable character.

The Abbey's national role, which Dean Stanley had encouraged, acquired a new impetus in the aftermath of the First World War. Many memorial services were held for those who had died, and the burial of the Unknown Warrior in 1920 particularly focused the nation's attention on the Abbey, so that in subsequent decades it was increasingly chosen as a venue in which to observe occasions of national celebration or sorrow. The four coronations of the twentieth century, with their pomp and pageantry, emphasised continuity with the past, but there were many other events that had no historical precedents, such as the services held in the 1950s and 1960s to mark the independence of countries that had previously been British colonies. These strengthened the Abbey's links with the Commonwealth so that the annual Commonwealth Observance, almost invariably attended by The Queen, is now a fixed event in the Abbey's calendar, alongside a busy and varied series of special services that commemorate significant anniversaries or respond to specific events. Heads of state, church leaders and other distinguished visitors from around the world are regularly welcomed, the visit of Pope Benedict XVI in 2010 being an especially significant and historic occasion. This rich and varied mission, rooted in a long history but always responding to changing and current needs, continues to place Westminster Abbey at the centre of the nation's life.

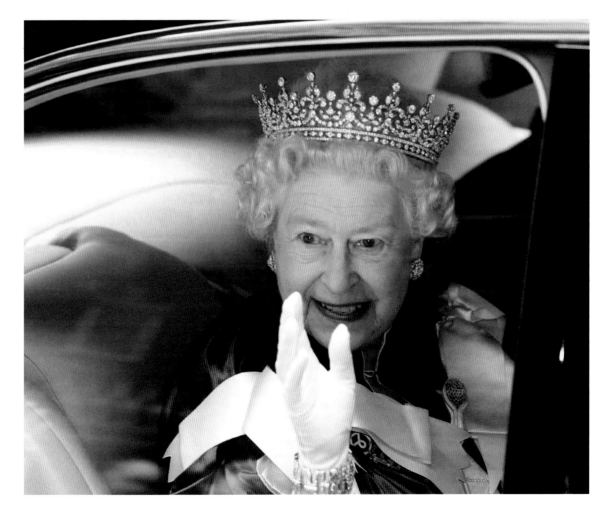

RIGHT:
HM The Queen leaving the Abbey after the installation service for the Order of the Bath in 2006.

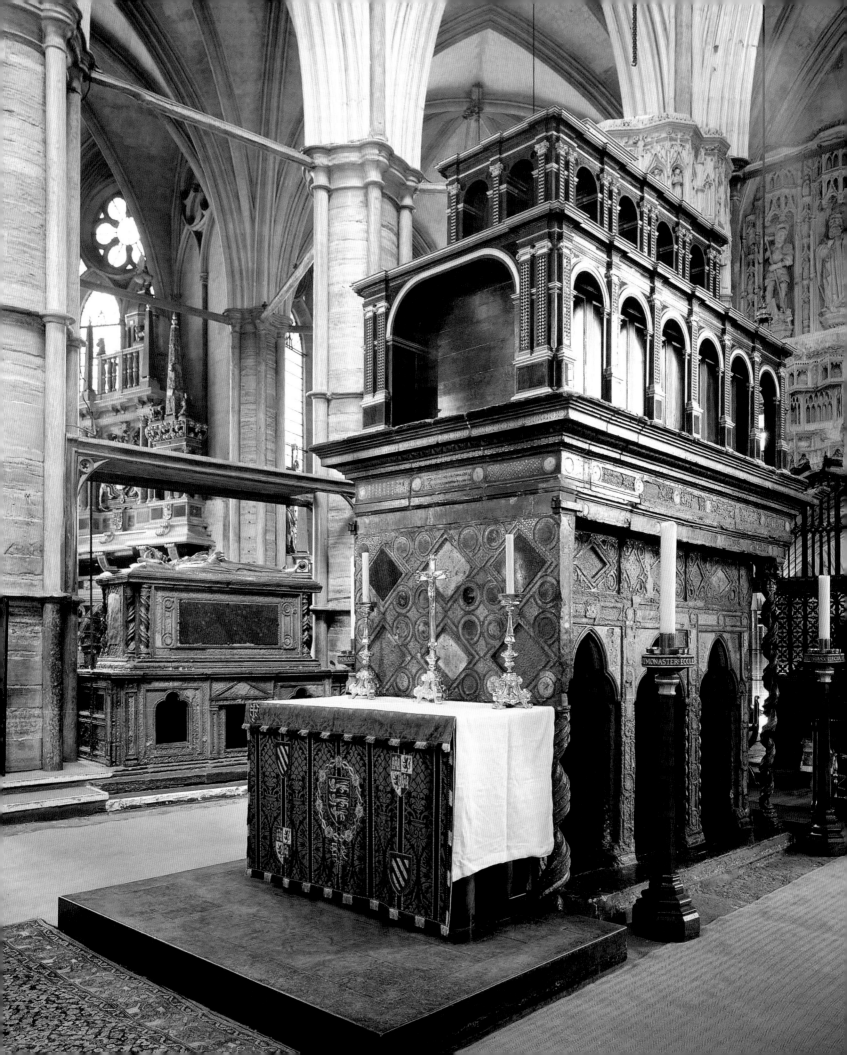

OI | EDWARD THE CONFESSOR'S CHAPEL

A T THE HEART OF HENRY III's rebuilding of Westminster Abbey was the magnificent shrine of St Edward the Confessor, whose patronage of the monastery was largely responsible for its wealth and importance. The shrine stands in its own chapel behind the high altar and occupies the lofty, apsidal east end of the Gothic church. Its importance is emphasised architecturally by the processional ambulatory surrounding it and by the radiating chapels beyond. The original lavish decoration included a Cosmati-work pavement, laid at the same time as the great pavement in the sacrarium, though in a different style. Originally the shrine could be seen from the crossing and quire, and only when the altar screen was built in the mid-fifteenth century did St Edward's Chapel become the enclosed space it is today.

Saints' shrines were found in many medieval churches, but in Britain most were destroyed at the Reformation, and Edward is the only major English saint whose body still rests in its medieval shrine.

Henry III's devotion to the Confessor led him to choose burial close to the shrine. Several of his successors followed his example, and five kings and three queens now lie here in some of the most important medieval tombs in the country.

OPPOSITE:
The shrine of St Edward the Confessor.

BELOW:
Bronze tomb effigy of Henry III.

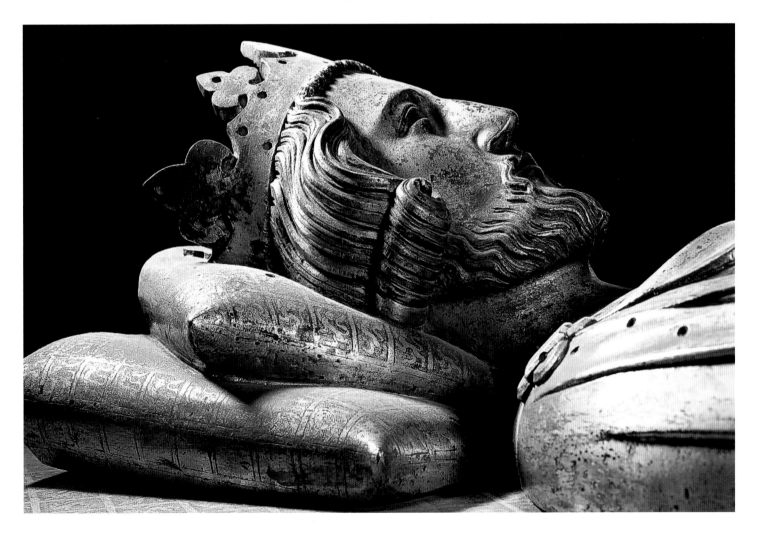

MONUMENTS AND FLOORSTONES

◆ SHRINE OF ST EDWARD THE CONFESSOR (*c*.1005–66)

Edward, the son of Ethelred (known as 'the Unready'), was driven from England by the Danes and spent his youth and early adulthood in Normandy before returning to England at the age of thirty-six and being crowned king at Winchester on Easter Day 1043. Soon afterwards he established his palace on Thorney Island and began to build a new church for the monastic community there. When he died, on 5 January 1066, shortly after the dedication of that new church, he was buried before its high altar, which stood a little to the east of the present high altar. The original burial vault lies below the present Confessor's Chapel.

After Edward's death many miracles were said to have been worked at his grave, and when the tomb was opened in 1102, in the presence of Henry I, the body was found to be uncorrupted. The monks of Westminster began to press for Edward's canonisation, which was finally conferred by Pope Alexander III in February 1161. On 13 October 1163 the body of St Edward the Confessor was transferred or 'translated' to a shrine prepared for it by Henry II, in the presence of the king and of Archbishop Thomas Becket. The robes in which the body was wrapped on that occasion were later made into three copes. Abbot Laurence took from the king's finger the ring supposed to have been given to him by St John and deposited it among the Abbey's relics.

On the day of the consecration of Henry III's new church, 13 October 1269, the saint's coffin was brought in solemn procession (on the shoulders of the king himself, two of his sons and his brother Richard) to a new shrine designed by Peter the Roman (*alias* Pietro di Oderisio). In monastic times the anniversary of these two translations was observed annually at Westminster with great ceremony, and 13 October remains a major festival in the Abbey's calendar.

The Purbeck marble shrine base was richly decorated with mosaic. Some of this remains (notably on the west side and on some of the twisted pillars), but much has been picked off over the centuries. In the lower part are arched recesses for the sick and pilgrims to kneel in prayer. The Confessor's golden coffin or 'feretory' rested on the base and was decorated with jewels and small golden images of kings and saints. A wooden canopy covering it could be raised or lowered by ropes from the vaulting above. At the sides of the shrine were pillars surmounted by golden statues of St Edward and St John the Evangelist.

At the dissolution of the monastery in 1540 the shrine was dismantled, the gold images and jewels disappeared and the body of the saint was buried in some obscure place. In the reign of Mary I the body was returned to the chapel, and in the early months of 1557

◆ *St Edward's body within its shrine, as depicted in the Litlyngton Missal (1383–4).*

◆ *Cosmati work on St Edward's shrine.*

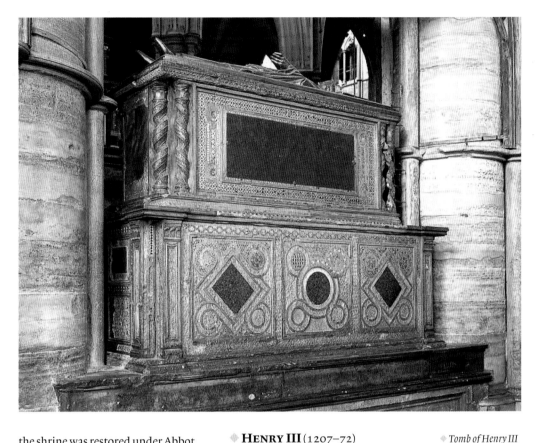

the shrine was restored under Abbot Feckenham. This was apparently done in haste, for the shrine was not set up in exactly the same position and certain parts were incorrectly reassembled. The wooden canopy is usually said to date from this time, but it may in fact be pre-Reformation and an early example of the use of classical form and design in England.

Originally this chapel had two altars. One stood at the west end of the shrine until the Reformation (the present altar dates from 1902). It has been suggested that the small tomb decorated with Cosmati work that now stands in the south ambulatory, and which is said to contain the remains of royal children, may have been the original shrine altar, but scholars are not agreed on this point. East of the shrine was an altar of the Holy Trinity, around which the Abbey's relics were displayed. This altar was dismantled when Henry V's tomb and chantry were constructed in the fifteenth century. The Abbey's relics all disappeared at the Reformation. 01

◈ **HENRY III** (1207–72)

After a magnificent funeral Henry III's body was temporarily laid in the burial chamber that had originally been the Confessor's. Much later, in 1291, it was placed in a splendid tomb commissioned by Edward I. In the same year, and in accordance with his own wish, Henry III's heart was taken to the abbey of Fontevrault, in France, where lay many of his Angevin forebears.

The king's Purbeck marble tomb is in two stages. Slabs of porphyry are set into the sides, and originally the whole tomb was inlaid with brightly coloured porphyry, marble and glass, in a style similar to the two Cosmati pavements. Much of this decoration has been picked off, especially in the more accessible places, but from the north ambulatory it is still possible to form an impression of the tomb's original splendour. On the south side are recesses which probably contained relics.

The superb effigy of gilt-bronze was cast by the London goldsmith

◈ *Tomb of Henry III viewed from the north ambulatory.*

William Torel. The king's head rests on pillows decorated with the lions of England, which also cover the tomb top. There was probably once a gablet similar to that surviving on Eleanor's tomb, but this has been lost. An iron grille by Henry of Lewes formerly protected the tomb, and the plain wooden canopy was once gilt and painted. An inscription in Norman French, cast in Lombardic letters, runs round the tomb's chamfered edge. 04

MARGARET DE VALENCE
(D. 1276) AND HER BROTHER
JOHN (D. 1277)

Stones with fragmentary brasses mark the graves of two infant children of William de Valence. One, probably Margaret's, is inlaid with Cosmati work. 07

◈ **ELEANOR** (*c*.1244–90), CONSORT OF EDWARD I

Queen Eleanor, daughter of Ferdinand III, king of Castile and Leon, was married to Edward I for thirty-six years. She died at Harby in Nottinghamshire, and Edward brought her embalmed body in state to Westminster, erecting memorial crosses at the places where the procession rested (the last was at Charing Cross).

The tomb has a Purbeck marble chest, probably made by Richard of Crundale and a gilt-bronze effigy cast by William Torel in 1291 (gold florins were brought from Lucca for the gilding). On the sides of the chest are sculpted heraldic shields hung on branches of trees. The effigy is an idealised likeness of the queen, who holds her left hand over the string of her cloak. Her right hand, now empty, originally held a sceptre. The gilt-bronze tomb top and the pillows beneath Eleanor's head are decorated with the castle of Castile and the lion of Leon, and around the queen's head is a gilt-bronze gablet. The Norman French inscription is partly obscured by Henry V's chantry. A wooden

17

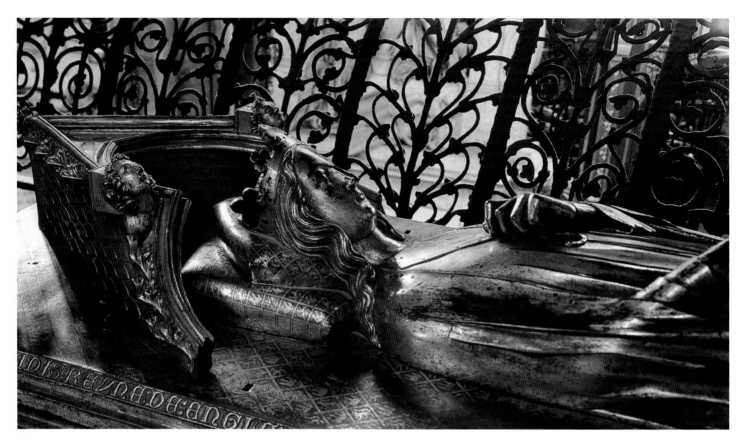

canopy made for the tomb by Thomas de Hokyntone and painted by Master Walter of Durham did not long survive, and the present canopy is a late medieval replacement. Curving outwards above the tomb on the ambulatory side is a finely worked iron grille by Thomas of Leighton Buzzard. It consists of panels of scrolled foliage adorned with small beast-heads and rosettes.

On the masonry below the tomb base are the remains of a painting by Master Walter. It is thought to depict Sir Otes de Grandison (who accompanied Edward I to the Holy Land) kneeling in front of the Virgin and Child, alongside four pilgrims praying before the Holy Sepulchre. 06

EDWARD I (1239–1307)

Edward I succeeded his father in 1272 and was the first king crowned in the Gothic abbey church. He commissioned the splendid tombs of his father and of Queen Eleanor, and

◆ Gold coins brought from Italy were melted down to gild the bronze tomb effigy of Eleanor of Castile.

ordered the manufacture of the Coronation Chair, but prolonged military campaigns exhausted Edward's wealth and his own tomb is a plain marble chest with no effigy. On the north side are the words *Edwardus Primus Scotorum Malleus* ('Edward the First, hammer of the Scots') and *Pactum Serva* ('keep troth'), both probably painted in Abbot Feckenham's time. The original wooden tomb canopy was broken down during disorder at the funeral of the earl of Bath in 1764, and an iron grille that once protected the tomb on the ambulatory side has also been lost.

In 1774 this tomb was opened to reveal a Purbeck marble coffin. The king's body within was wrapped in waxed linen, the head covered with a crimson facecloth. Beneath this were the royal robes: a tunic of red silk damask with gold tissue and a mantle of crimson velvet, with a piece of rich cloth of gold laid loosely over them. In the right hand was a sceptre, in the left a rod surmounted by a dove and oak

leaves, and on the king's head was a gilt crown. The length of the corpse was 6 feet 2 inches, confirming the aptness of Edward's nickname, 'Longshanks'. 03

PHILIPPA OF HAINAULT

(1314–69), CONSORT OF EDWARD III

Edward III was devoted to his consort, whom he married in 1328. Her lavish tomb of black marble was begun some years before her death and completed in 1376. It cost the king £3,000 and is by Jean (Hennequin) de Liège, a Netherlandish sculptor who pioneered a style of tomb in which the sarcophagus is surrounded by small mourning figures or 'weepers'. Philippa's tomb was originally encased in alabaster tabernacle work, which provided niches for thirty-two such figures of her ancestors and her immediate family, but almost all this decoration had disappeared by the mid-seventeenth century. In the 1850s George Gilbert Scott cut away some of the encroaching masonry of Henry V's

chantry chapel to reveal three of the original weepers. One was subsequently lost, but a figure of Blanche, duchess of Lancaster, holding her pet monkey is intact. Scott also found and restored to the tomb some of the original tabernacle work. The queen's alabaster effigy, enriched with paint and gilding, is undoubtedly a portrait but is badly damaged: the sceptre has gone, and the hands are broken. Railings from a tomb in St Paul's Cathedral were transferred to the queen's monument, which was further adorned with 'diverse images in the likeness of angels', cast by the bronzeworker John Orchard. 08

EDWARD III (1312–77)

The tomb of Edward III, who reigned from 1327, lies beside that of his beloved queen, after whose death the king declined and became increasingly debilitated. He died at Sheen Palace but was brought to Westminster for burial, carried to a temporary resting place by four of his sons. Work on the tomb, erected by his grandson Richard II, did not start until several years later, but it was completed by 1395, when it became the model for Richard's own monument. The gilt-bronze effigy (surrounded by a Latin rhyming inscription) is perhaps by John Orchard, who had earlier worked on Queen Philippa's tomb. The face is thought to be modelled on a cast taken after death, though the hair and beard have been conventionalised. Around the Purbeck marble chest are niches in which were once little bronze images of twelve of Edward's fourteen children. The six remaining (on the south side) are from left to right: Edward, 'the Black Prince'; Joan of the Tower; Lionel, duke of Clarence; Edmund, duke of York; Mary of Britanny; and William of Hatfield. Only four of the little enamelled shields originally below each figure survive, but on the ambulatory side are four large shields with the arms of England and St

George. The wooden tomb canopy is by Hugh Herland. 10

RICHARD II (1367–1400)
AND HIS FIRST WIFE,
ANNE OF BOHEMIA (1366–94)

Richard II (reigned 1377–99) was devoted to Westminster Abbey, and his coronation there was more splendid than any seen before. He had a special

Bronze tomb effigy of Edward III. The face is thought to be modelled on a cast taken after the king's death.

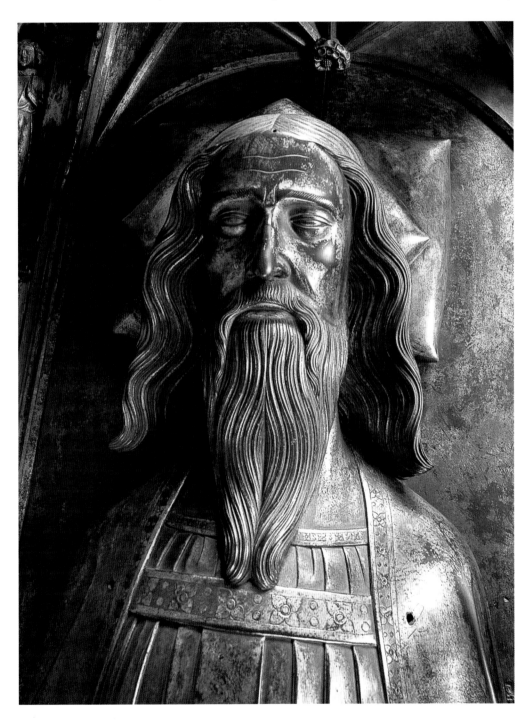

veneration for the Confessor and supported the continued building of the Abbey's nave. Richard's personal emblem of a white hart was painted in the Muniment Room, and traces of it can be seen on the roof of the Chapel of Our Lady of the Pew. Though in many ways an accomplished and enlightened prince, Richard was an unsuccessful ruler and was eventually

19

deposed by his cousin Henry, duke of Lancaster, and subsequently murdered or starved to death at Pontefract Castle. He was first buried at Langley in Hertfordshire, but in 1413 the body was disinterred on Henry V's orders and brought to Westminster, the king and his nobles following. There Richard was buried in the tomb that he had himself commissioned for his beloved first wife, Anne (daughter of the emperor Charles IV), whom he had married in the Abbey in 1382.

The tomb, designed from the start as a joint monument, was modelled on that of Edward III and commissioned in 1395. Henry Yevele and Stephen Lote made the marble base, and the gilt-bronze effigies are by the London coppersmiths Nicholas Broker and Godfrey Prest, who also made figures of saints (for the niches of the tomb chest), angels and enamelled coats of arms, all of which have been lost. The effigies are undoubtedly portraits, and by the king's own wish he is shown holding the queen's hand. He wears coronation robes and is depicted with curling hair and a pointed beard. The cape of his mantle is bordered with seed pods of the broom plant, the Latin name for which – *planta genista* – gave the Plantagenet dynasty its name. Both effigies are stamped all over with other badges and emblems such as the white hart and the sunburst, as well as the two-headed imperial eagle and the lion of Bohemia. The queen's bodice was originally set with precious stones. The tomb chest lid is similarly decorated and has a Latin epitaph in bronze. Above the tomb is a wooden canopy, which has its own inscription and is painted inside with depictions of Christ in Majesty and the coronation of the Virgin, and with the king and queen's arms. The artist was John Haxey (or Hardy). **12**

JOHN DE WALTHAM

(D. 1395), BISHOP OF SALISBURY

Gravestone with an incomplete brass of the bishop in vestments. Within the crook of his pastoral staff and on his chasuble are representations of the Virgin and Child. Waltham was highly regarded by Richard II, who ordered his burial here, to the indignation of the monks, who resented this intrusion into an otherwise exclusively royal chapel. The Abbey was compensated, however, by the gift of two copes and a large sum of money from the king and the bishop's executors. **02**

THOMAS 'OF WOODSTOCK', DUKE OF GLOUCESTER (1355–97)

Thomas was the youngest son of Edward III and Philippa of Hainault to attain manhood. In the reign of his nephew Richard II, Thomas was arrested for conspiring against the crown, taken to Calais and murdered.

◆ *Bronze tomb effigies of Richard II and Anne of Bohemia.*

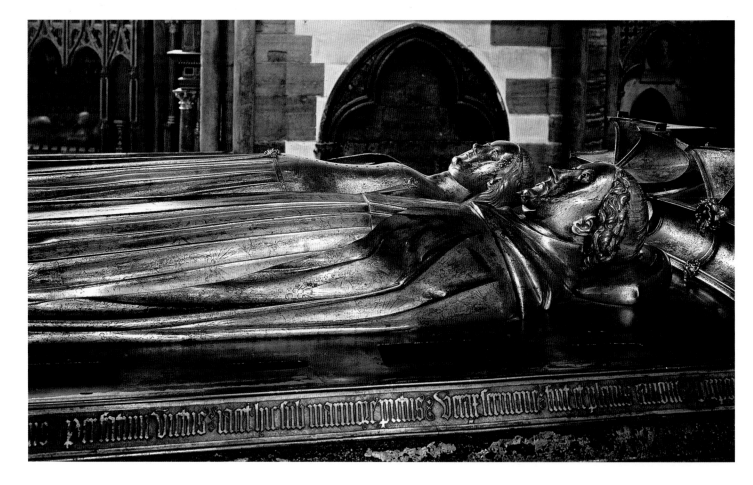

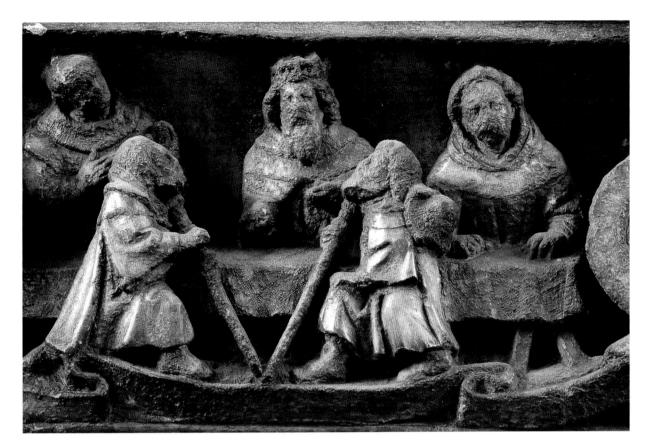

A scene from the life of St Edward on the fifteenth-century screen in his chapel.

He had married Eleanor de Bohun and was originally buried in St Edmund's Chapel, where his wife's tomb remains. His body was moved on the orders of Henry IV and placed beneath a fine brass, which has not survived. 09

Here also lie: Edith (d. 1075), Edward the Confessor's queen, and Matilda (d. 1118), first queen of Henry I. Both were buried in the eleventh-century church but were subsequently reburied close to the shrine. Neither of their graves, nor that of Richard Courtenay, bishop of Norwich (d. 1415), is marked. Also in this chapel are the small Purbeck marble tomb chests of Princess Margaret (d. 1472, aged nine months), daughter of Edward IV, and of Princess Elizabeth (1492–5), infant daughter of Henry VII.

OTHER FEATURES

◈ STONE SCREEN

The screen closing the west side of the chapel is mid-fifteenth-century. Its carved frieze depicts the principal events, real and legendary, of Edward the Confessor's life. From left to right the subjects are: nobles swear fealty to Edward's mother (Queen Emma) in the name of her unborn son; Edward's birth; Edward's coronation; Edward sees the Devil (the figure is now broken off) dancing on casks containing the Danegeld, the tax imposed on the people to induce the Danes to leave the country; Edward (in bed) warns a servant who is stealing his treasure to escape before the king's chamberlain returns; Christ appears to Edward during Mass; Edward has a vision of the shipwreck of the king of Denmark, who was drowned on his way to invade England and is shown in the carving as an armed figure falling into the sea (the falling towers are thought to represent the failure of the expedition); the

quarrel between Harold and Tostig, Earl Godwin's sons, from which the king prophesies their future feuds and unhappy fate (the sons are in the foreground, and Edward, Edith and Godwin sit at a table behind); Edward sees a vision of the Seven Sleepers of Ephesus, who had taken refuge in a cave from their heathen persecutors about AD 250 and who turn from their right sides to their left as a portent of misfortune (messengers are shown verifying the vision); St John the Evangelist in the guise of a pilgrim asks alms of the king and is given a valuable ring; blind men are restored to sight by washing in water used by Edward (in the foreground the king washes his hands, and at the side an attendant presents the water to the men); St John the Evangelist restores Edward's ring to two pilgrims in Palestine, bidding them warn the king of his approaching death; the pilgrims give the ring and St John's message to the king; a depiction of the dedication of the Abbey church in 1065.

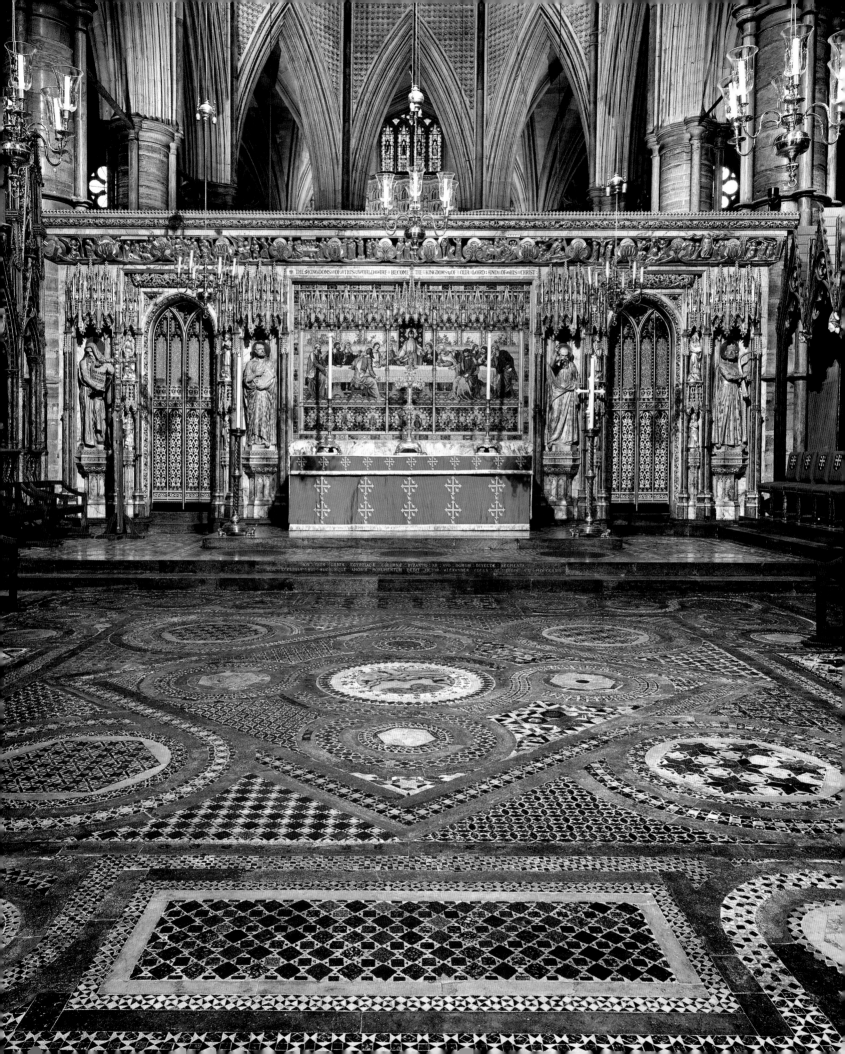

THE KINGDOMS OF THIS WORLD ARE BECOME THE KINGDOMS OF OUR LORD AND OF HIS CHRIST

THE SANCTUARY OR PRESBYTERY – called the 'sacrarium' at Westminster – is bordered on the north by three fine medieval tombs, and on the south by the sedilia and the tomb of Anne of Cleves. Nothing survives of the high altar of Henry III's church, but the Westminster Retable, displayed in the Abbey's museum, is thought to have been its altarpiece. This remarkable panel painting, adorned with gesso and coloured glass, has suffered much damage over the years and was only rediscovered in 1827. It has now been carefully conserved, allowing the artistry of those portions that survive (notably a painting of St Peter with his keys and a central figure of Christ in Glory, holding a small globe painted with minute details) to be properly appreciated.

In the Middle Ages the sacrarium was hung with cloth of arras, adorned with legends of the Confessor. In Queen Anne's reign wooden wainscoting, which concealed the fine medieval tombs, and in 1706 an altarpiece originally designed by Christopher Wren for the Chapel Royal at Whitehall Palace were erected. Both the wainscoting and the altarpiece remained in place until 1820. The present altar and screen were erected between 1867 and 1873 after George Gilbert Scott's design. The sculpted figures on the screen (Moses, St Peter, St Paul and King David) are by H. H. Armistead. Behind the altar itself is a mosaic of the Last Supper designed by J. R. Clayton and carried out by Antonio Salviati.

The ceremony of coronation takes place before the high altar and is performed by the archbishop of Canterbury, who on that occasion alone claims a place in the Abbey by right. Harold, last of the Saxon kings, was probably crowned in the Abbey in January 1066, but the first documented coronation at Westminster was of William the Conqueror on

23

OPPOSITE:
The high altar and Cosmati pavement.

RIGHT:
Decoration on the high altar screen.

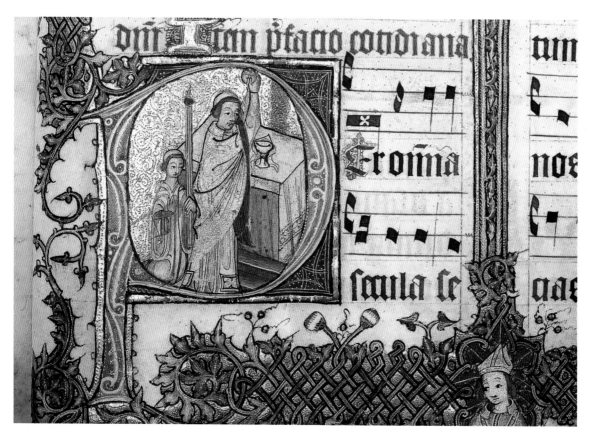

24

Christmas Day the same year. Thirty-two kings and six queens regnant have been crowned here since – every monarch except Edward V and Edward VIII, neither of whom was ever crowned.

The actual crowning takes place in the sacrarium, the Coronation Chair being placed in front of the high altar. Here the sovereign is anointed with holy oil (the most solemn part of the service), invested with coronation robes and regalia, and finally crowned with St Edward's Crown. The newly crowned monarch is then enthroned on a raised dais in the crossing to receive the people's homage. The placing of the quire of the Abbey to the west of the crossing (as in Reims Cathedral) created a 'theatre' where these ceremonies could be performed before the largest possible number of witnesses.

Coronations have always been a mixture of continuity and change. In the late fourteenth century a new copy of the order of the service was made. Called the *Liber Regalis*, it was kept by successive abbots of Westminster and continues in the custody of the Dean and Chapter to this day. For the coronation of James I the service was wholly in English for the first time, and other changes have been introduced over time to accommodate varying religious and political sensibilities. Nevertheless, the basic form of the coronation service as laid down in

the *Liber Regalis* has been the pattern for all subsequent coronations. The scriptural words sung during the anointing ('Zadok the Priest and Nathan the Prophet anointed Solomon king') are particularly venerable, having been used since at least the coronation of King Edgar in the tenth century.

Coronations are state occasions, and the Abbey church is handed over to the earl marshal to be prepared. In the past not all coronations have gone smoothly. At William the Conqueror's in 1066 the congregation's acclamation of the new king was mistaken for rioting by soldiers outside, who began to set fire to houses near by. The celebrated anthems written by the composer Handel for George II's coronation in 1727 were performed in the wrong order, apparently owing to a mistake by the Abbey's choir. At the lavish coronation of George IV in 1821 the king's estranged wife, Caroline of Brunswick, was denied admission and jeered by the crowds. The coronations of the twentieth century were more decorous and meticulously rehearsed. For the coronation of Queen Elizabeth II in 1953 more than 8,000 guests were accommodated by building additional galleries in the transepts and the nave. The televising of that coronation made it possible for the general public in Britain and abroad to witness the ceremony in its entirety for the first time.

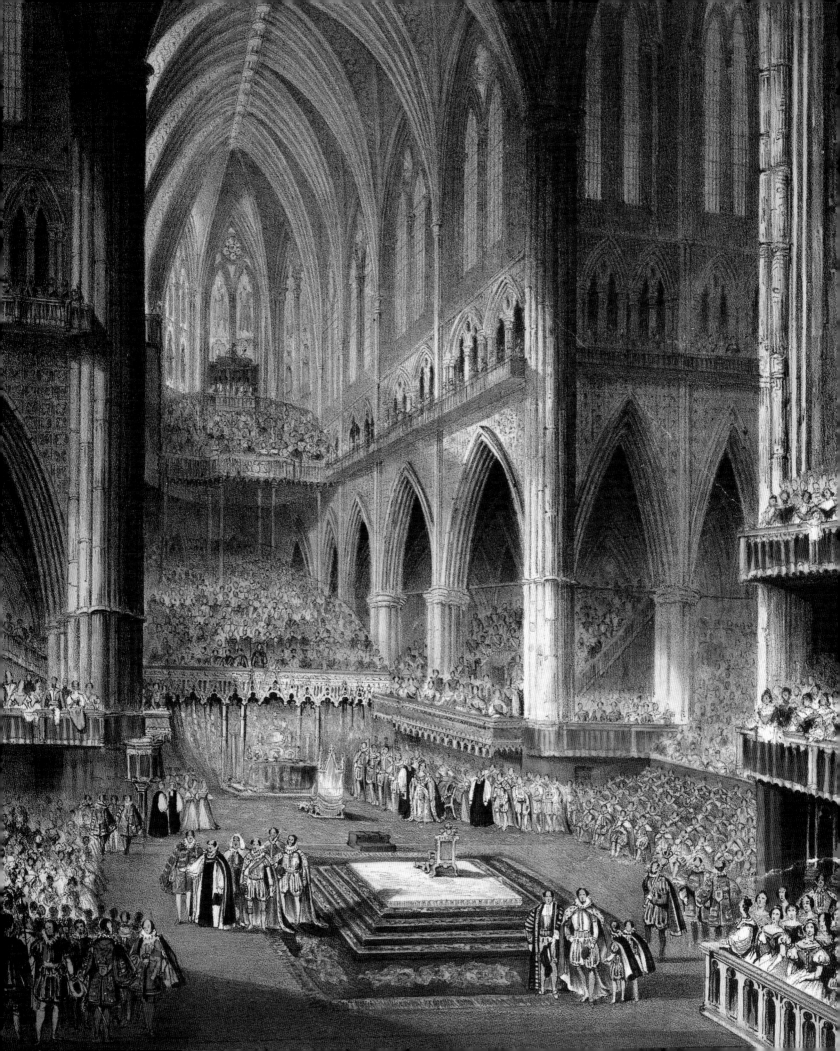

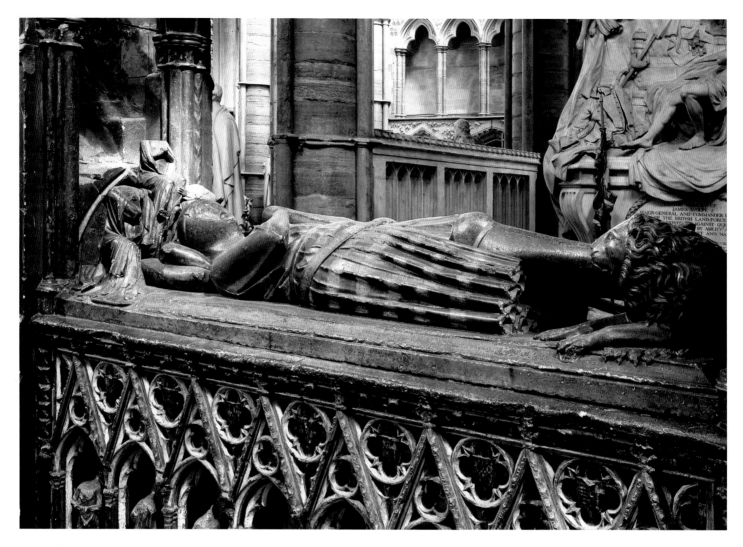

MONUMENTS

AVELINE, COUNTESS OF LANCASTER (D. 1274)

Aveline's marriage in 1269 to Edmund 'Crouchback', younger son of Henry III, was the first royal wedding in the new abbey church. Her stone tomb, which is probably by either Alexander of Abingdon or Michael of Canterbury, is closed in on the north side, but on the south side the tomb chest has six figures (now headless or defaced) in niches. The effigy depicts the countess in a long mantle with a coif and wimple, her head resting on pillows and supported by two angels. The stone canopy has suffered much damage, but traces of painted vine leaves survive in the vaulting of the arch. **01**

◆ AYMER DE VALENCE, EARL OF PEMBROKE (c.1270–1324)

Aymer was the son of William de Valence (whose tomb is in St Edmund's Chapel) and cousin of Edward I. He fought in the king's Scottish campaigns and died in France on a diplomatic mission. His tomb, finished by 1330, was commissioned by his second wife, Mary de St Pol (whose own modern memorial is near by), and is perhaps by Richard of Reading. The sculpture is of fine quality, though the weepers around the stone chest are now mutilated. The effigy is also very fine, though the shield has disappeared. Aymer is also depicted on horseback (in the way great lords were often depicted on their seals), at the top of the richly carved canopy. **02**

◆ Tomb of Aymer de Valence, one of the finest medieval tombs in the Abbey, though some of its sculpture has been badly damaged.

EDMUND, EARL OF LANCASTER (1245–96)

Edmund 'Crouchback' was Edward I's younger brother and died in France. He was not buried here until March 1301, by which time his elaborate tomb, the most important funerary monument of its time, was probably complete. It has been attributed to either Michael of Canterbury or Alexander of Abingdon. The stone tomb chest has ten niches on each side containing alternating male and female weepers. Above each are two shields (originally coloured), though the arms do not appear to relate to the individual figures. The fine effigy depicts the earl with crossed legs and wearing mail-armour (the links modelled in putty). The decorated triple canopy is much damaged but has an elaborate leaf pattern painted under the vault (like Aveline's) and shows the earl on horseback in a trefoil-shaped recess at the top. On the ambulatory side the tomb base has a frieze depicting ten figures in mail holding banners. They are perhaps the earl's household knights. **03**

ANNE OF CLEVES (1516–57), FOURTH QUEEN OF HENRY VIII

After her divorce from the king, Anne lived quietly in England for sixteen years. She died a Roman Catholic and was buried here during the monastic revival under Mary Tudor. The stone tomb is attributed to Theodore Haveus of Cleves and may have been intended as the base of a larger monument that was never completed. The central chest, decorated with skulls and crossed bones, is flanked by smaller detached pedestals adorned with lions' heads. The marble slab dates from 1606. **07**

Beneath the sacrarium are buried two important medieval abbots of Westminster: Richard de Ware (d. 1283), abbot 1258–83, during whose abbacy the Cosmati pavement was laid; and his successor Walter de Wenlock (d. 1307), abbot 1283–1307.

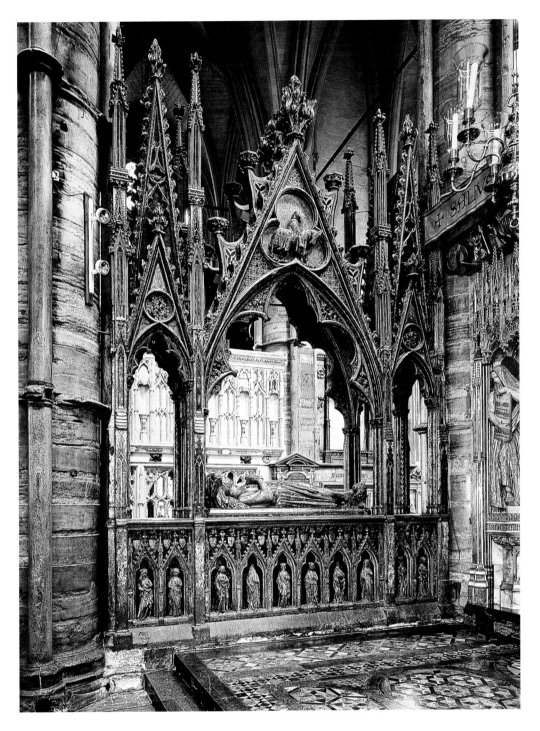

The tomb of Edmund, earl of Lancaster, younger brother of Edward I, has an elaborate triple canopy.

OTHER FEATURES

COSMATI PAVEMENT

Much of the sacrarium floor is filled by a remarkable pavement, nearly 25 feet square, composed of more than 30,000 pieces of porphyry, onyx and glass, cut to different sizes and shapes and set in geometric designs. The technique is known as *opus sectile*, or 'cut work', to distinguish it from traditional mosaic, in which the pieces are generally of a uniform size. The materials were brought from Rome and assembled here in 1268 as part of the decoration of Henry III's church. The name 'Cosmati' refers to the Italian family who specialised in this technique, and the idea of laying such a pavement in the Abbey probably came from Abbot

27

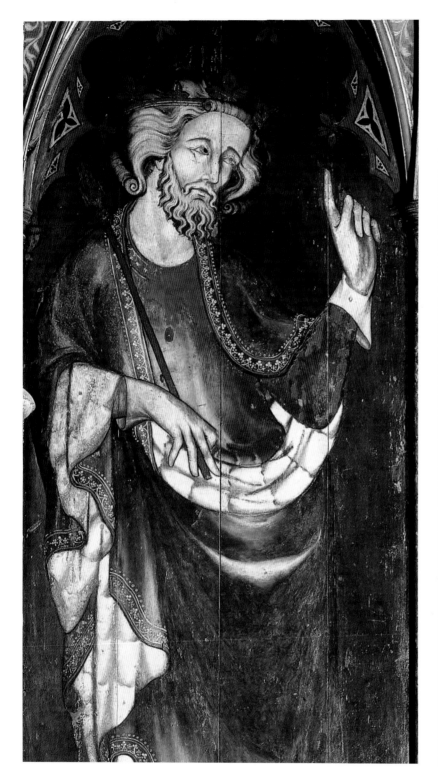
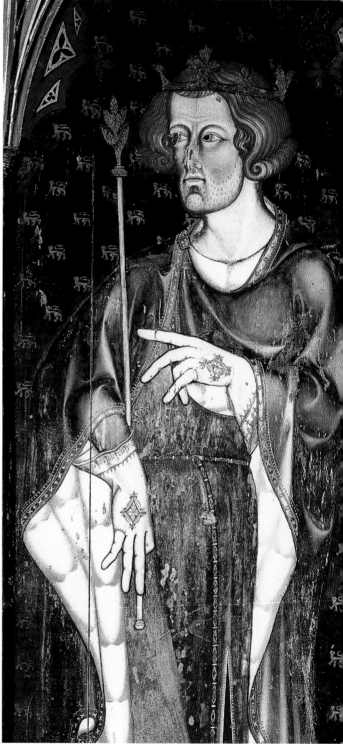

Richard Ware, who went to Rome in 1258 to have his election confirmed by the pope and would have seen similar pavements in the churches there. Unusually, the Abbey's pavement had Latin inscriptions, though these have been lost apart from a few letters. One inscription recorded the pavement's installation; the other two referred to the interpretation of its design. This remains a matter for speculation but appears to relate to the duration of the universe, which the original inscription suggested would end 19,863 years after the Creation. The pavement was hidden beneath carpet for more than a century and only rarely seen, but following extensive conservation (completed in 2010) it is now permanently uncovered. 09

◈ *Paintings of kings in the medieval sedilia.*

02

28

SEDILIA

The sedilia (seats used by the sacred ministers at Mass) were erected in the time of Abbot Wenlock. On the sacrarium side are painted two full-length figures of kings flanking a religious figure (possibly St Peter), who is almost entirely defaced. A fourth figure has completely disappeared. Above are two carved heads, the one in a mitre possibly representing Wenlock. On the ambulatory side restoration has uncovered the figure of the Confessor holding the ring out to the pilgrim (of whom no trace remains) and also a portion of a fourteenth-century Annunciation. 06

Fifteenth-century altarpiece by Bicci di Lorenzo.

FIFTEENTH-CENTURY ALTARPIECE

The altarpiece above the tomb of Anne of Cleves is by the Florentine painter Bicci di Lorenzo (1375–1452) and originally hung in the chapel of the Campagni family in the church of Santa Trinità in Florence. In the centre are the Virgin and Child enthroned, flanked on the right by St John the Baptist and St Catherine of Alexandria, and on the left by St Antony Abbot and (closest to Our Lady) St Giovanni Gualberto, to whom the Campagni Chapel was dedicated. Above these pairs of saints are small roundels containing images of Sts Peter and

Paul. Further saints are depicted in the outer pillars: Matthew, Nicholas and Francis on the left, and Luke, James the Less and Peter Martyr on the right. The painting was bequeathed to the Abbey by Arthur, Viscount Lee of Fareham (d. 1947). 08

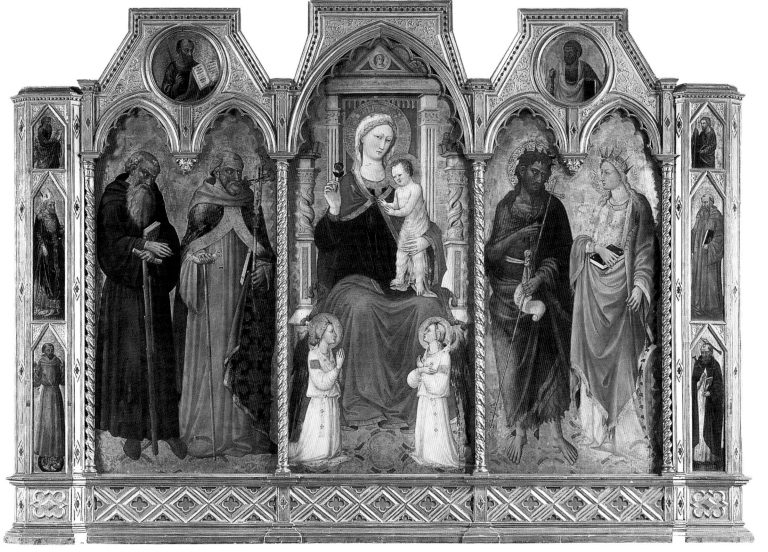

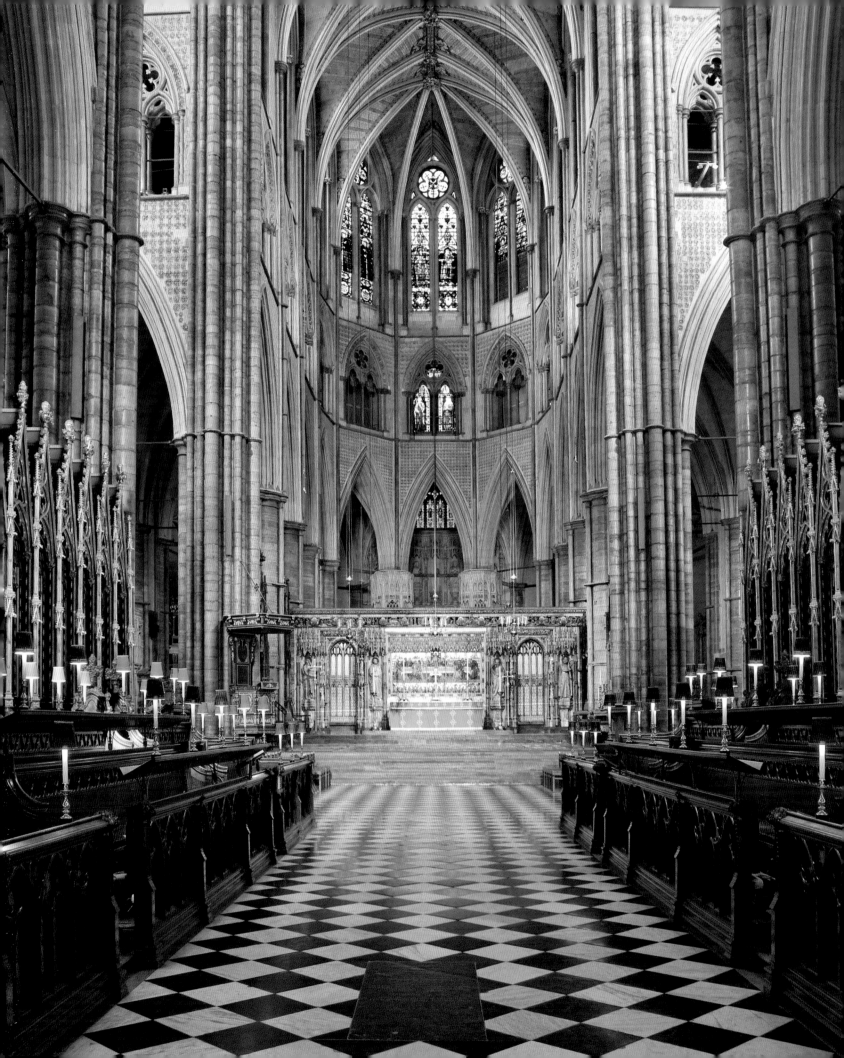

03 | QUIRE AND CROSSING

WEST OF THE SACRARIUM is the crossing or 'lantern', where the transepts intersect with the eastern bays of the nave that form the quire. Here a bomb fell in 1941, destroying the roof, which was restored and painted to a design by Stephen Dykes Bower in 1958. The lantern windows are filled with fragments of glass from the various war-damaged windows.

High up at the east end of the church are two further stained-glass windows. In the triforium, glass (1951) by Sir Ninian Comper depicts Eleanor of Castile and Lady Margaret Beaufort. In the apse is glass depicting Christ and Our Lady, St Edward the Confessor and St John the Evangelist (disguised as a beggar), St Augustine and St Mellitus. This window is mainly made up of fragments of glass, some of it medieval, assembled in the early eighteenth century.

The wooden partitions that separated the quire from the transepts in monastic times were later replaced by iron gates, which were finally removed in the nineteenth century. The medieval quire stalls were replaced by Henry Keene in the eighteenth century, and his stalls were themselves replaced by the present ones in 1848. They were designed by Edward Blore, then surveyor of the fabric. Above the dean's stall at the west end of the quire is the shield of arms of the collegiate church. Other stalls are allotted to the Abbey's clergy and lay officers and to the high commissioners for the Commonwealth countries.

In the quire aisles the most ancient features are the carved and painted shields in the spandrels of the wall arcade, which are thought to be of men or families who were benefactors to Henry III's rebuilding of the Abbey. Originally there were eight shields on each side, arranged as far as the point

OPPOSITE:
The quire looking east to the sacrarium and high altar.

RIGHT:
An early nineteenth-century engraving showing one of the wooden screens which formerly separated the transepts from the quire.

FAR RIGHT:
The quire c.1811 showing the choir stalls and the high altar beyond.

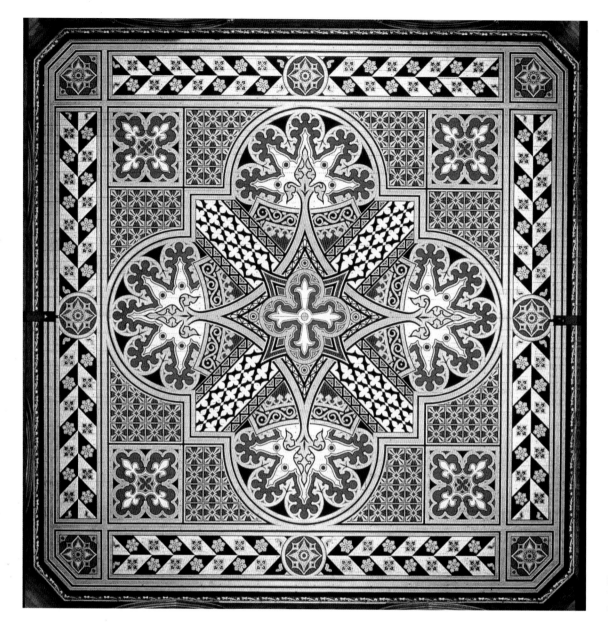

where Henry III's building work ended. The series was continued when work resumed in the fourteenth century, but the shields were then simply painted on the walls. These later shields also display the arms of families or individuals who were prominent in the thirteenth century, so it seems that a definite scheme was drawn up in Henry III's time, perhaps in the decade 1245–55. This may even be when the sculpted shields were set up.

From east to west the carved shields are in descending order of rank. In the south quire aisle the shields of Edward the Confessor and the king of England are followed by: the count of Provence; Roger de Quincy, earl of Winchester; Henry de Lacy, earl of Lincoln; Richard, earl of Cornwall; an earl of Ross. A shield of the king of Scots is missing. In the

north quire aisle the arms of the Holy Roman emperor and the king of France are followed by: Richard de Clare, earl of Gloucester; Roger Bigod, earl of Norfolk; Simon de Montfort, earl of Leicester; John de Warenne, earl of Surrey; William de Forz, count of Aumale. A shield of the Bohuns, earls of Hereford, has been lost.

Both aisles contain many monuments. Since the burial of Henry Purcell in the north aisle a number of musicians have been buried or commemorated in that area, giving rise to the name 'Musicians' Aisle'. In the late nineteenth and early twentieth centuries the quire screen wall at the west end of the aisle was particularly favoured for memorials to scientists, probably owing to its proximity to Newton's monument.

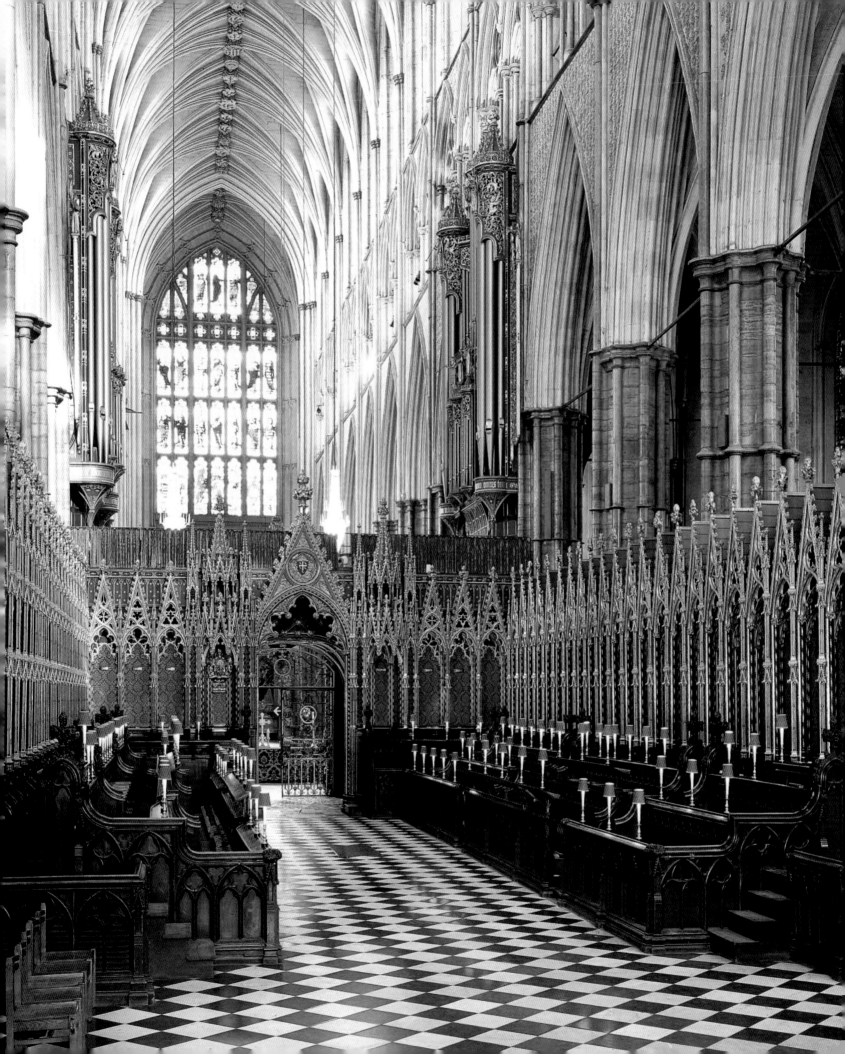

FLOORSTONES
IN THE QUIRE

ROBINSON DUCKWORTH

(1834–1911), CANON OF
WESTMINSTER 1875–1911

As a young Oxford don Duckworth
rowed the boat in which the original
story of *Alice's Adventures in Wonderland*
was told by 'Lewis Carroll' to Alice
Liddell, the inspiration for the story's
eponymous heroine. She was born at
19 Dean's Yard in 1852, her father
being then head master of
Westminster School. 01

ROBERT HOOKE (1635–1703),

NATURAL PHILOSOPHER

Memorial stone lettered by P. Surey,
2005. Hooke was college surveyor at
Westminster, 1691–3. Buried at
St Helen's, Bishopsgate, City of
London. 03

Also in the quire is the grave of
Anne Carey (d. 1660).

OTHER FEATURES
IN THE QUIRE

PULPIT

The pulpit was first erected in the
seventeenth century at the north-east
end of the quire and was removed in
1775 along with the thirteenth-
century quire stalls. It was placed in
the nave in the early twentieth century
but was moved to its present position
in 1935 and later repainted and gilded.

LECTERN

Designed by Sir Albert Richardson
and carved of English walnut, the
lectern was presented by the Baptist
Missionary Society in 1949 as a
memorial to William Carey (1761–
1834), missionary and translator
of the Bible.

◆ ORGAN

An organ built by Christopher
Schrider for use at the coronation of
George II and Queen Caroline in 1727
was placed over the quire screen in
1730. It was subsequently much
rebuilt and enlarged, notably in 1848,
1884 and 1909, by William Hill and
Sons. The present organ, built by
Harrison and Harrison, was first heard
at the coronation of King George VI in
1937. With four manuals and eighty-
four speaking stops, it incorporated
some of the pipework from the earlier
instrument. Further restoration work
and enlargement have followed, most
recently a complete overhaul of the
console in 2006 with the introduction
of modern technology to assist in the
performance of a wide repertoire. The
tradition that some of the old 8' and 4'
choir flute pipes date from the
seventeenth century (and so may even
have been played by Purcell) cannot be
verified by physical or documentary
evidence. The hanging cases
incorporating angels blowing
trumpets, were originally designed for
the Hill organ by John Loughborough
Pearson in 1899. They were reinstated
and ornately coloured in 1959.

A tablet in the south quire aisle

◆ *The richly
decorated organ
cases, designed by
J. L. Pearson.*

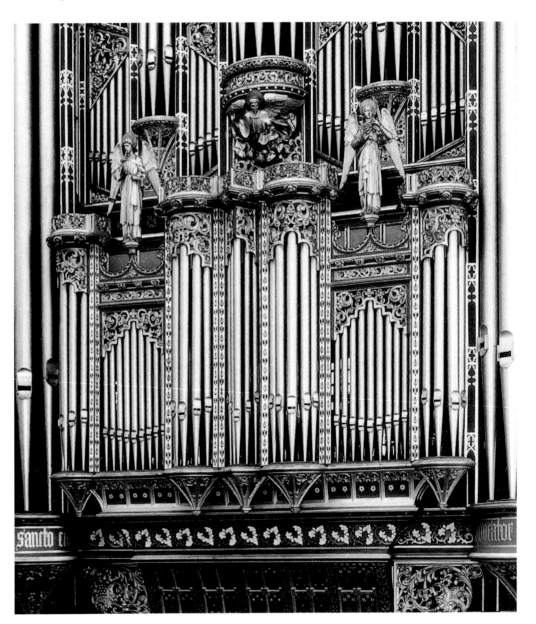

03

34

records that the organ case there was given in 1898 by F.A. Beare in memory of her brother-in-law, Arthur D. Clarke. He had given the 'celestial organ' in the triforium in 1898. 07

MONUMENTS IN THE SOUTH QUIRE AISLE

WILLIAM THYNNE (D. 1585)

Marble and alabaster chest tomb by one of the Southwark school of tomb-makers. It is decorated with heraldry and supports an effigy of Thynne in armour. 20

◆ **THOMAS OWEN** (D. 1598), JUDGE

Marble chest tomb by the Southwark school of tomb-makers. It may be from the same workshop as Sir Thomas Hesketh's monument, which it resembles. The effigy depicts Owen in legal robes, reclining on his side. Emblems decorating the background include an inverted torch and clusters of pomegranates. 11

SIR RICHARD BINGHAM

(1528–99), SOLDIER

Alabaster tablet with a shield of arms painted above. 42

SIR THOMAS RICHARDSON

(1569–1635), JUDGE AND SPEAKER OF THE HOUSE OF COMMONS

Marble and bronze monument by Hubert Le Sueur, 1635. The base supports a small sarcophagus above which an architectural surround encloses a bronze bust. 19

THOMAS THYNNE (1648–82),

SQUIRE OF LONGLEAT

Monument by Arnold Quellin. Thynne was shot dead in London on the orders of a Swedish adventurer, Count Karl von Konigsmarck, who hoped then to marry Thynne's wealthy widow. An effigy of Thynne reclines below an architectural surround swathed in drapery, and at the base of the monument is a carved depiction of his assassination. 08

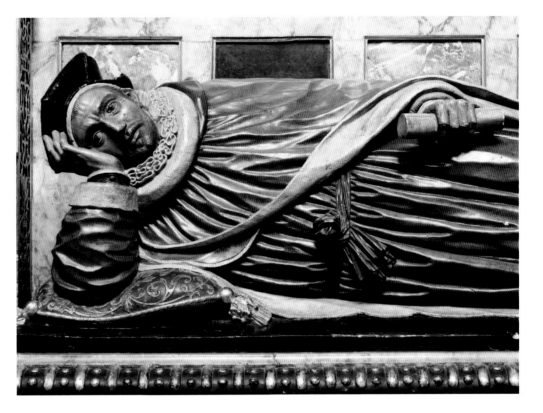

◆ *Tomb effigy of Thomas Owen dressed in his judge's robes.*

GRACE GETHIN (D. 1697)

Marble and alabaster monument depicting a kneeling woman holding a book, flanked by angels. Two female figures recline on a pediment above, flanking a shield of arms. The inscription also commemorates two children of Sir George and Lady Norton (Gethin's aunt and uncle). Buried at Hollingbourne church, Kent, where there is a similar memorial. 14

ANNE WEMYSS (*c*.1633–98)

AND HER MOTHER, **JANE** (D. 1698)

Marble tablet decorated with swags and heraldry, commemorating the daughter and wife respectively of Ludovick Wemyss, prebendary of Westminster. Buried in the east cloister. 25

MAJOR RICHARD CREED

(D. 1704), SOLDIER

Marble tablet adorned with military trophies and heraldry. Creed died in a cavalry charge at the battle of Blenheim (Blindheim) and is buried there. 41

◆ **ADMIRAL SIR CLOWDISLEY SHOVELL** (1650–1707)

Marble monument by Grinling Gibbons. The base displays naval trophies and a carved depiction of Shovell's shipwreck off the Scilly Isles. Pillars (supporting entablatures and seated cherubs) flank a bewigged effigy of Shovell in Roman armour and Classical drapery. He was washed ashore in Porthellick Cove still alive, but a woman seeing his emerald ring killed him for it. His body was later recovered and buried here. 27

GEORGE STEPNEY

(1663–1707), DIPLOMAT

Marble monument attributed to Grinling Gibbons, consisting of a sarcophagus and a bust flanked by cherubs and obelisks. 36

ELIZABETH FREKE

(*c*.1650–1714) AND HER SISTER

JUDITH AUSTIN (D. 1716)

Marble monument with portraits of both women on the base. Columns on either side of the inscription support a pediment with a cartouche of arms.

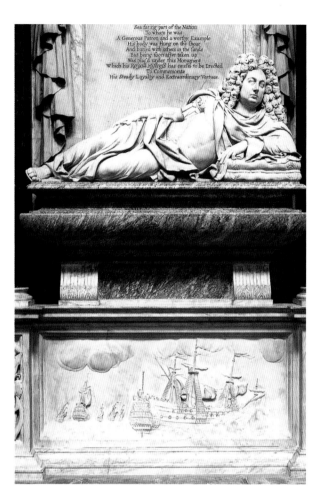

A third sister, Frances Norton (d. 1731), mother of Grace Gethin, erected the monument. All three are buried in the nave. 16

◆ *Monument of Admiral Sir Clowdisley Shovell.*

ADMIRAL GEORGE CHURCHILL
(1654–1710)

Marble monument by Grinling Gibbons, *c.*1715. It has an inscribed base supporting a sarcophagus with flanking obelisks and cherubs. Above this rises an architectural surround enclosing a black urn. Buried in the nave. 44

THOMAS KNIPE (*c.*1639–1711), PREBENDARY OF WESTMINSTER 1707–11

Marble monument, *c.*1715, consisting of an inscribed tablet within an architectural surround, surmounted by an urn. Knipe spent most of his life at Westminster School as pupil, usher, under master and finally head master

(1695–1711). The monument also commemorates his wives, Anne (d. 1685) and Alice (d. 1723). All three are buried in the north cloister. 32

SOPHIA JOHNSTONE, MARCHIONESS OF ANNANDALE
(1667–1716)

Marble monument designed by James Gibbs, 1723, consisting of a sarcophagus with a wall-piece behind. It also commemorates the marchioness's sons Lord William (d. 1721), buried with her in the south transept, and James, 2nd marquess of Annandale (d. 1730), buried in the north transept. 22

◆ SIR GODFREY KNELLER
(*c.*1648–1723), PORTRAIT PAINTER

Marble monument by Michael Rysbrack. Kneller's bust is flanked by cherubs, one of which holds a portrait of the artist's wife. The verse inscription is by Alexander Pope, who confessed it was 'the worst thing he ever wrote'. Kneller left money towards the erection of a monument but rejected the notion of burial in the Abbey, telling Pope 'They do bury fools there'. Buried at Twickenham, Middlesex. 28

JOHN METHUEN (*c.*1650–1706) AND HIS SON SIR PAUL METHUEN (1672–1757), DIPLOMATS

Marble monument by Michael Rysbrack, *c.*1758. Cherubs flank an inscribed tablet with a winged hour-glass and cornucopias of fruit at its base. John Methuen died at Lisbon but is buried here. Sir Paul was among the first knights installed at the foundation of the Order of the Bath in 1725. 37

LIEUTENANT-GENERAL WILLIAM STRODE
(*c.*1697–1776), SOLDIER

Marble tablet by Richard Hayward with a carved relief of a mourning woman surrounded by military trophies. Buried in the nave. 46

ISAAC WATTS
(1674–1748), HYMN WRITER

Marble monument by Thomas Banks, 1779. It consists of a bust flanked by cherubs with inverted torches (symbolic of death) and a carved relief of Watts seated at a desk with an angel guiding his pen. Among his best-known hymns are 'When I survey the wond'rous Cross' and 'O God, our help in ages past'. Buried at Bunhill Fields, London. 40

WILLIAM WRAGG (D. 1777)

Marble monument by Richard Hayward, 1779. A mourning woman leans over a depiction of the shipwreck in which the loyalist Wragg died while returning to Britain following the revolt of the American colonies. His son and a slave who helped him – both of whom survived – are shown clinging to wreckage. 29

MIDSHIPMAN WILLIAM DALRYMPLE (D. 1782)

Marble memorial by Robert Adam, *c.*1784. Dalrymple died at sea, aged eighteen, during the capture of a French ship off Virginia. 24

MARTIN FOLKES
(1690–1754), NUMISMATIST

Marble monument designed by William Tyler and executed by Robert Ashton; installed after 1788. A figure of Folkes leans on two books: one a treatise on medals, the other the *Philosophical Transactions* of the Royal Society (of which Folkes was president). Two cherubs hold a globe and a microscope, and a third veils an urn. Buried at Hillington, Norfolk. 45

PASQUALE DE PAOLI
(1725–1807), CHAMPION OF CORSICAN INDEPENDENCE

Marble bust and tablet by John Flaxman, installed *c.*1807 but sculpted in Paoli's lifetime (it was exhibited at the Royal Academy in 1798). Paoli took refuge in England and died here but is buried in Corsica. 12

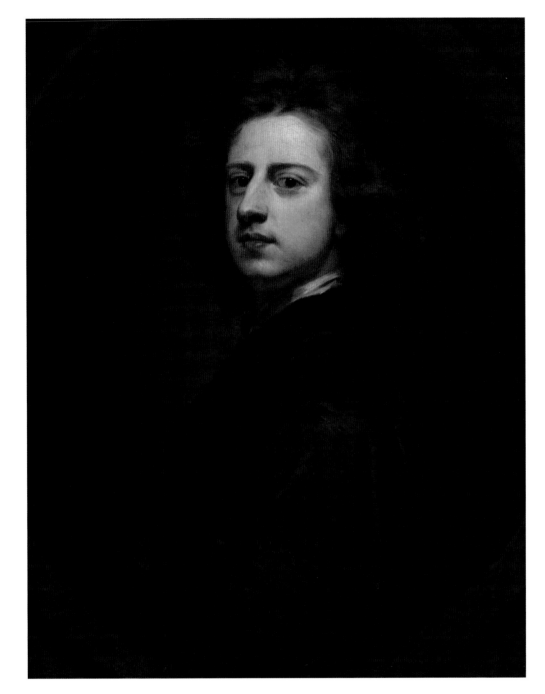

‘Madras’ or monitorial system of education, which Bell pioneered in India. 21

LIEUTENANT RICHARD CREED (D. 1841)
Marble tablet by John Thomas, c.1842, adorned with military emblems. Buried in India. 43

JOHN WESLEY (1703–91), FOUNDER OF WESLEYAN METHODISM, AND HIS BROTHER **CHARLES WESLEY** (1707–88), METHODIST AND HYMN WRITER
Marble tablet by John Adams-Acton, 1876, consisting of profile portraits of the brothers and a relief carving of a preacher addressing a crowd. Charles was associated with his brother in the foundation of Methodism, but his many well-known hymns are sung today by Christians of many denominations. Charles's birth date is incorrectly given as 1708; he is buried at Old Marylebone churchyard, London. John Wesley is buried at City Road Chapel, London. 35

COLONEL JOSEPH CHESTER (1821–82), AMERICAN GENEALOGIST
Marble tablet, 1883, erected by the Dean and Chapter in recognition of Chester's labours in editing for publication the Abbey's registers of baptism, marriage and burial. Buried at Nunhead cemetery, south London. 39

SAMUEL BARNETT (1844–1913), CANON OF WESTMINSTER 1906–13, AND HIS WIFE, **DAME HENRIETTA** (1851–1936), SOCIAL REFORMER
Marble tablet by Sir George Frampton, 1916, featuring a carved figure of a sower and the words 'Fear not to sow because of the birds'. Samuel founded Toynbee Hall, a university settlement in Whitechapel, east London; his wife campaigned to improve education for London's children and instigated the building of Hampstead Garden Suburb. Both buried at Hove, Sussex. 06

GENERAL SIR THOMAS TRIGGE (D. 1814), ARMY OFFICER
Marble tablet by John Bacon the Younger, c.1815, consisting of a draped urn and carvings of military emblems. 10

CHARLES BURNEY (1757–1817), BOOK COLLECTOR AND LEXICOGRAPHER
Marble tablet and bust (after Joseph Nollekens) by Sebastian Gahagan.

Burney's vast collection of books and newspapers is in the British Library. His father (Charles) and sister (Fanny) are also memorialised in the Abbey. Buried at Deptford, Kent. 33

ANDREW BELL (1753–1832), EDUCATIONALIST, PREBENDARY OF WESTMINSTER 1819–32
Marble monument by William Behnes. It shows a seated man beside a group of schoolboys, an allusion to the

◆ *Self-portrait (1685) by Sir Godfrey Kneller (National Portrait Gallery).*

ROBERT, 1ST BARON CLIVE OF PLASSEY (1725–74),
TWICE GOVERNOR OF BENGAL

Marble tablet by John Tweed, 1919, consisting of a profile portrait and carved heraldry. Clive ensured the dominance of the East India Company in southern India and Bengal and was a key figure in the establishment of British rule. During his second period as governor his conduct was severely criticised. Subsequently his mind became unbalanced and he committed suicide. Buried at Moreton Say, Shropshire. 30

WILLIAM TYNDALE (1494–1536),
BIBLE TRANSLATOR

Marble and alabaster tablet, 1938. Tyndale's English translation of the New Testament was published in Germany in 1525. Made directly from Greek and Hebrew sources, it has been hugely influential on the English language, for much of it passed unchanged into the King James version of the Bible (1611). Tyndale was burned at the stake in Vilvorde, near Brussels. 09

ADMIRAL ROBERT BLAKE (1599–1657)

Stone tablet by Gilbert Ledward, 1945, consisting of an achievement of arms above a ship carved within a laurel wreath. Blake, arguably the greatest naval commander of his age, was buried in the Lady Chapel, but his body was exhumed (with those of other regicides) in 1661. A memorial brass and window are in St Margaret's Church. 26

HENRY FRANCIS LYTE (1793–1847), PRIEST AND HYMN WRITER

Alabaster tablet, 1947, inscribed with the first line of Lyte's best-known hymn, 'Abide with me'. Buried in Nice, France. 38

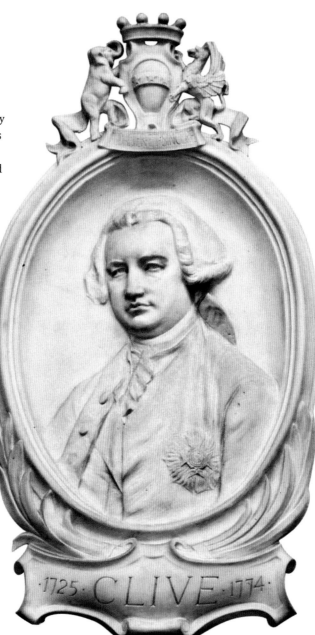

◆ *Memorial to Robert Clive, a key figure in the history of the British in India.*

DAME SYBIL THORNDIKE (1882–1976), ACTRESS

Black marble gravestone by Arthur Ayres, 1976, with a verse inscription by J.B. Priestley. 17

SIR NOEL COWARD (1899–1973), ACTOR AND PLAYWRIGHT

Black marble memorial stone designed by Peter Foster and lettered by Ralph Beyer, 1984. In addition to his plays Coward is remembered for his witty songs and for his screenplay for the film *Brief Encounter*, now regarded as a classic of the British cinema. Buried in Jamaica. 18

RICHARD DIMBLEBY (1913–65), JOURNALIST AND BROADCASTER

Bronze memorial designed by Donald Buttress and lettered by Dick Reid, with a portrait by Nicholas Dimbleby, 1990. Dimbleby provided a memorable television commentary for the 1953 coronation. Buried at Lynchmere, Sussex. 15

SEBASTIAN CHARLES (1932–89), CANON OF WESTMINSTER 1978–89

Memorial of limestone and marble, designed by Donald Buttresss and carved by Tim Metcalfe, 1992. It includes a sculpted and painted device of three entwined fishes. 34

Here are also monuments to: Captain William Julius RN (*c.*1645–98); James Kendall (*c.*1646–1708); Rear-Admiral John Harrison (*c.*1722–91); Captains John Knipe (d. 1798) and Robert Knipe (d. 1811).

OTHER FEATURES IN THE SOUTH QUIRE AISLE

CANDELABRA

Two bronze candelabra designed by Benno Elkan and featuring subjects from the Old and New Testaments are kept in this aisle. They were presented by Viscount Lee of Fareham, in 1939 and 1942 respectively.

MONUMENTS AND FLOORSTONES IN THE NORTH QUIRE AISLE

◆ SIR THOMAS HESKETH (D. 1605), LAWYER

Alabaster and marble tomb by the Southwark school of tomb-makers, consisting of a tomb and a reclining effigy. The inscription is flanked by niches containing figures of naked boys, one of whom blows bubbles.

The empty recess once contained a figure of Hesketh's wife. **99**

PETER HEYLYN (1600–62), PREBENDARY OF WESTMINSTER 1631–62

Marble and alabaster tablet commemorating the biographer of Archbishop William Laud. After the imprisonment of Laud's enemy Dean John Williams, Heylyn became the supreme authority in the Abbey. Forced into hiding during the Commonwealth, Heylyn resumed his duties at the Restoration and is buried in the quire. **50**

CAPTAIN RICHARD LE NEVE RN (c.1646–73)

Marble tablet, attributed to Abraham Storey, adorned with heraldry, canons and a post-horn. **54**

◆ *Tomb of Sir Thomas Hesketh, made at Southwark in the early seventeenth century.*

SIR THOMAS DUPPA (d. 1694)

Marble tablet by William Stanton surmounted by a wreathed and festooned urn. **86**

HENRY PURCELL (c.1659–95), ORGANIST OF WESTMINSTER ABBEY 1679–95

Marble cartouche with a flaming urn and a grotesque mask at the top, and a heraldic shield at the base. Purcell composed music for many ceremonies, including the coronations of James II and of William III and Mary II. Music he wrote for Queen Mary's funeral in 1695 was used at his own burial later the same year. The inscription on the monument begins: *Here lyes Henry Purcell Esq. Who left this life and is gone to that blessed place where only his harmony can be exceeded*. Purcell's nearby grave is shared with his widow, Frances (d. 1706). **66 & 93**

JOHN BLOW (1649–1708), ORGANIST OF WESTMINSTER ABBEY 1668–79 AND 1695–1708

Marble cartouche surmounted by a coat of arms and a lamp with gilded flames. A music book at the base displays the *Gloria Patri* from Blow's service in G minor. His pupils included Henry Purcell, who took over from his teacher as the Abbey's organist in 1679. Blow resumed the post after Purcell's death. Among Blow's compositions are works written for the coronations of James II and Queen Anne. **59**

ALMERICUS DE COURCY, 1ST BARON KINGSALE (1665–1720)

Marble monument, c.1727. Two cherubs kneeling on an inscribed base hold up a sarcophagus on which rests a reclining effigy. Columns support an architectural surround surmounted by heraldry and urns. Kingsale's widow, Ann (d. 1724), is buried with him in this aisle. **90**

WILLIAM CROFT (1677–1727), ORGANIST OF WESTMINSTER ABBEY 1708–27

Marble monument incorporating a bust, a coat of arms and an organ carved in relief. Croft's setting of the burial sentences has often been sung at Abbey funerals. **57 & 67**

HUGH CHAMBERLEN (1664–1728), PHYSICIAN

Marble monument by Peter Scheemakers and Laurent Delvaux, 1731. Chamberlen reclines on a sarcophagus between figures of Health (probably Delvaux's work) and Longevity, while a cherub descends to crown him with a wreath. Chamberlen and others of his family were 'men mid-wives' and are particularly associated with the use of forceps, which they kept as a closely guarded secret. Not buried in the Abbey. **96**

SIR EDMUND PRIDEAUX BT (1675–1729) AND HIS WIFE, **ANNE** (D. 1741)

Marble monument by Sir Henry Cheere, c.1745. Two mourning cherubs sit on a sarcophagus with a flaming lamp between them. A portrait medallion hangs above. Buried in the nave. **52**

CAPTAIN PHILIP DE SAUSMAREZ RN (1710–47)

Marble monument by Sir Henry Cheere, c.1756. The pedestal depicts the sea battle in which Sausmarez was killed. Above, a cherub unveils a portrait while another weeps. The inscription is on a large shell, and other shells and naval trophies provide decoration. Buried at Plymouth. **61**

VICE-ADMIRAL TEMPLE WEST (1713–57)

Marble monument by Joseph Wilton, 1761. A fine bust rests in front of a pyramid adorned with a coat of arms. Buried at West Wickham, Kent. **55**

SAMUEL ARNOLD
(1740–1802), ORGANIST OF
WESTMINSTER ABBEY 1793–1802
Marble tablet by Joseph Nollekens.
Arnold was sub-director of the Handel
commemoration concerts held in the
Abbey in 1784 and attempted the first
full edition of Handel's works, editing
forty volumes for publication between
1787 and 1797. 65 & 94

CAPTAIN GEORGE BRYAN
(D.1809)
Marble tablet by John Bacon the
Younger, c.1811. A kneeling woman
mourns in front of an urn on a high
pedestal, with military trophies
behind. Bryan died fighting under
Wellington in Spain and is buried at
the convent of St Jeronimo in Talavera.
92

JOHN PLENDERLEATH
(D. 1811), MILITARY PHYSICIAN
Marble monument by John Bacon the
Younger, c.1812. Plenderleath's portrait
is set amid medical emblems and a
drooping branch of cypress. He died
of typhus while serving as a physician
in Wellington's army. 88

CHARLES AGAR,
1ST EARL OF NORMANTON
(1736–1809), ARCHBISHOP OF
DUBLIN
Marble monument by John Bacon the
Younger, 1815. It shows the archbishop
addressing an audience while a cherub
places a mitre on his head. Beside him
is depicted his cathedral at Cashel.
The monument also commemorates
Agar's uncle Welbore Ellis, Baron
Mendip (d. 1802), with whom the earl
and his widow, Jane (d. 1826), are
buried in the north transept. 49

CHARLES BURNEY (1726–1814),
HISTORIAN OF MUSIC
Marble tablet by S. Gahagan, 1819,
with an inscription by Burney's
daughter Fanny. Buried at Chelsea
College. 58

SIR GEORGE LEONARD
STAUNTON BT
(1737–1801), DIPLOMAT
Marble monument by Sir Francis
Chantrey, c.1824. A carving on the
sarcophagus depicts Staunton holding
a scroll while an Indian sits under a
palm tree. 56

SIR STAMFORD RAFFLES
(1781–1826), FOUNDER OF
SINGAPORE
Seated marble figure by Sir Francis
Chantrey, 1832. Buried at Hendon,
Middlesex. 91

EVELYN SUTTON (1777–1835),
CANON OF WESTMINSTER 1832–5
Marble monument by Sir Francis
Chantrey, c.1839. On the base is a
kneeling and weeping woman; on the
western side a carved chalice and book;
and on the eastern a lamb and cross.
Not buried in the Abbey. 53

◆ **WILLIAM WILBERFORCE**
(1759–1833), ANTI-SLAVERY
CAMPAIGNER
Marble statue by Samuel Joseph, 1840,
based on Jean-Antoine Houdon's
statue of Voltaire in the Comédie

◆ *Memorial to*
William Wilberforce.

Française at Paris. Wilberforce's coffin was accompanied to its grave in the north transept by the Lords and the Commons, led by the lord chancellor and the speaker. 87

SIR THOMAS FOWELL BUXTON BT (1786–1845), PHILANTHROPIST AND ANTI-SLAVERY CAMPAIGNER

Marble statue by Frederick Thrupp, c.1845. Buried at Overstrand, Norfolk. 100

JAMES MONK (1784–1856), BISHOP OF GLOUCESTER AND BRISTOL, CANON OF WESTMINSTER 1830–56

Brass by Hardmans of Birmingham, 1858, depicting Monk in episcopal dress beneath a canopy. At the four corners are symbols of the Evangelists, and the shields include the arms of the sees of Gloucester and Bristol. 64

LORD JOHN THYNNE (1798–1881), PREBENDARY OF WESTMINSTER 1831–81

Alabaster tomb chest and marble effigy designed by John Loughborough Pearson and executed by Henry Hugh Armstead. The chest is decorated with heraldry and supports an effigy of Lord John in a cope. As sub-dean Thynne fought a vigorous but ultimately unsuccessful campaign against the enforced handing over of the Abbey's estates to the ecclesiastical commissioners. Buried at Haynes, Bedfordshire. 77

MICHAEL WILLIAM BALFE (1808–70), COMPOSER

Marble memorial by Louis-Auguste Malempré, 1882. A profile bust is flanked by musical instruments and scores displaying some of Balfe's compos-itions. Buried at Kensal Green cemetery, London. 97

◆ CHARLES DARWIN (1809–82), NATURALIST

Bronze roundel with bust by Sir J. Edgar Boehm, 1888, a short distance

◆ *Memorial to Charles Darwin.*

from Darwin's gravestone in the north nave aisle. Although some have viewed Darwin's theory of evolution by natural selection, or 'survival of the fittest', as challenging Christian understandings of the Creation, Dean Bradley readily agreed with the president of the Royal Society's view that Darwin's burial in the Abbey 'would be acceptable to a very large number of our fellow-countrymen'. Darwin himself never expressed any anti-Christian opinions, but by the end of his life he was an agnostic who believed that nothing could be known about God's existence. 78

WILLIAM FORSTER (1818–86), STATESMAN

Marble tablet with portrait by Henry Hope-Pinker, 1888. Buried at Burley in Wharfedale. 101

JAMES PRESCOTT JOULE (1818–89), PHYSICIST

Marble memorial tablet, c.1892. Joule established the law of conservation of energy and determined the mechanical equivalent of heat. Buried at Sale, Cheshire. 84

JOHN COUCH ADAMS (1819–92), MATHEMATICIAN AND ASTRONOMER

Marble portrait medallion by Albert Bruce-Joy, 1895. Adams correctly predicted the existence of the planet later named Neptune. Buried at Cambridge. 81

◆ ORLANDO GIBBONS (1583–1625), ORGANIST OF WESTMINSTER ABBEY 1623–5

Black marble bust by A.G. Walker, 1907. It is a copy of Nicholas Stone's bust on Gibbons's monument in Canterbury Cathedral (where he is buried). 95

41

◆ *Memorial to Orlando Gibbons.*

SIR GEORGE STOKES BT

(1819–1903), MATHEMATICIAN

Bronze roundel and bust by Sir Hamo Thornycroft, *c.*1903. Stokes, like Newton, was Lucasian professor of mathematics at Cambridge. Buried at Mill Road cemetery, Cambridge. **85**

SIR JOSEPH HOOKER

(1817–1911), BOTANIST

Marble tablet with portrait by Frank Bowcher, 1915. A close friend of Darwin, Hooker studied the botany of India and was director of Kew Gardens 1865–85. Buried at Kew, Surrey. **83**

◆ JOSEPH, BARON LISTER

(1827–1912), SURGEON

Marble roundel with profile bust by Thomas Brock, 1915. Lister pioneered antiseptic treatment and particularly its use in preventing death after an operation. Buried at Hampstead. **80**

ALFRED RUSSEL WALLACE

(1823–1913), NATURALIST

Marble roundel with profile bust by Albert Bruce-Joy, 1915. Wallace, like Darwin, formulated a theory of evolution by natural selection, and the two men jointly presented their ideas at meeting of the Linnean Society in 1885. Buried at Broadstone, Dorset. **79**

SIR WILLIAM RAMSAY

(1852–1916), CHEMIST

Marble tablet with bronze portrait by Charles L. Hartwell, 1922. In collaboration with Lord Rayleigh, Ramsay discovered the gas argon and later identified helium, neon and several other gases. Buried at Hazlemere, Buckinghamshire. **82**

SIR CHARLES VILLIERS STANFORD (1852–1924),

COMPOSER

Blue lozenge-shaped gravestone. Stanford's fine setting of the *Gloria* in B flat was sung at the coronations of both George VI and Elizabeth II. **71**

◆ *Memorial to Joseph, Baron Lister.*

JAMES WATT (1736–1819),

CIVIL ENGINEER

Bronzed plaster bust, 1960, given by the Institution of Mechanical Engineers after the removal of Watt's statue from St Paul's Chapel. Buried at Handsworth, Birmingham. **60**

RALPH VAUGHAN WILLIAMS

(1872–1958), COMPOSER

Slate gravestone lettered by Reynolds Stone, but since recut. A prolific composer in many genres, Vaughan Williams composed a motet for the dedication of the Battle of Britain Chapel in 1947 and an anthem for the coronation in 1953. His arrangement of 'The Old Hundredth', also made in 1953, was the first congregational hymn ever sung at a coronation. **73**

SIR EDWARD ELGAR

(1857–1934), COMPOSER

Memorial stone designed by Stephen Dykes Bower, 1972. In addition to well-known works such as the *Enigma Variations* and *The Dream of Gerontius*, Elgar wrote a short anthem for the coronation of George V in 1911. Buried at Little Malvern, Worcestershire. **74**

BENJAMIN, BARON BRITTEN

(1913–76), COMPOSER

Memorial stone designed by Peter Foster, 1978. The first London performance of Britten's *War Requiem* was given at Westminster Abbey in 1962. Buried at Aldeburgh, Suffolk. **68**

SIR WILLIAM WALTON

(1902–83), COMPOSER

Memorial stone designed by Peter Foster, 1983. Walton's march *Crown Imperial* was written for the 1937 coronation; his *Te Deum* and the march *Orb and Sceptre* were composed for The Queen's coronation in 1953. Buried on the island of Ischia, Italy. **63**

SIR ADRIAN BOULT

(1889–1983), CONDUCTOR

Memorial stone designed by Peter Foster, 1984. Educated at Westminster School, Boult became one of the most distinguished conductors of his day. Not buried in the Abbey. **62**

HERBERT HOWELLS

(1892–1983), COMPOSER

Gravestone designed by Peter Foster, 1985. Howells's many choral works include two sets of evening canticles for Westminster Abbey. **72**

THOMAS CLARKSON (1760–1846),

ANTI-SLAVERY CAMPAIGNER

Green slate memorial stone by the Kindersley workshop, 1996. Clarkson become the architect of a national campaign to abolish the slave trade. He enlisted William Wilberforce to wage the battle in Parliament, and the two men worked closely together for twenty years. Buried at Playford, Suffolk. **89**

Also in this aisle are monuments to: Mary James (1623–77); Robert Constable, 3rd Viscount Dunbar (*c.*1651–1714), and his second wife, Dorothy, dowager countess of Westmorland (*c.*1646–1740); Charles Williams (d. 1720). Also the gravestones of: Walter Mortimore (d. 1684); Howel Edwards (1762–1846),

42

canon of Westminster 1803–46, and his wife, Caroline (1762–1834); three children of Henry Hart Milman, canon of Westminster 1835–49 (later dean of St Paul's), who died in infancy; Sir William Sterndale Bennett (1816–75), composer.

OTHER FEATURES IN THE NORTH QUIRE AISLE

PRISONERS OF WAR WINDOW

Designed by Ninian Comper, 1926. It completes Comper's series of nave windows and depicts Henry VI (his face modelled on the Russian dancer Nijinsky) and Abbot Richard Harweden. Smaller scenes show the king imprisoned in the Tower of London and instructing the Abbey's mason on the place for his tomb (though in the end he was buried at Windsor). Other figures depict patron saints of Henry VI and some members of his family. The window commemorates British prisoners who died in Germany during the First World War and was presented by James W. Gerard, US ambassador in Berlin at that time.

MEMORIAL WINDOW TO JAMES TURLE (1802–82), ORGANIST OF WESTMINSTER ABBEY 1831–82

Designed by Messrs Clayton & Bell, exact date unknown. It mostly depicts biblical figures, but Turle and his wife, Mary, appear at the base (obscured slightly by the monuments on the window sill).

MEMORIAL WINDOW TO GEORGE STEPHENSON (1781–1848) AND HIS SON ROBERT STEPHENSON (1803–59), ENGINEERS

Designed by William Wailes, 1862, and originally installed in the nave. When it was moved in 1934, the original coloured glass background was replaced with clear glass to let in more light and emphasise the medallions, which depict bridges and building scenes. Between them are portrait heads of the Stephensons and of other engineers (Telford, Smeaton, Watt and Rennie). The window was conceived as a memorial to Robert Stephenson, but in 1948 the inscription was amended to include his father, and a depiction was added of George Stephenson's steam locomotive *Rocket*.

◆ ROLL OF HONOUR OF THE WOMEN'S VOLUNTARY SERVICE 1939–45

Inscribed and illuminated on vellum by Claire G. M. Evans and bound by Roger Powell; dedicated 1951. It names 244 members of the service who died during the Second World War.

◆ *Roll of honour of the Women's Voluntary Service.*

43

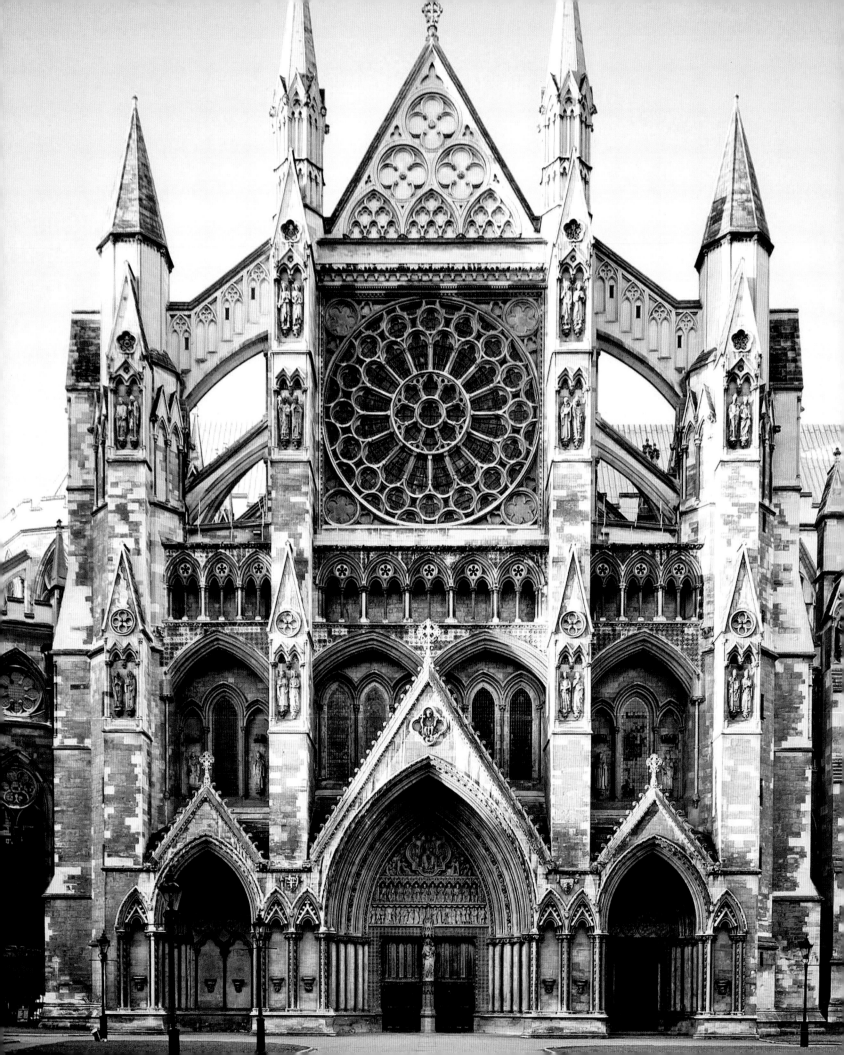

04 | NORTH TRANSEPT AND AMBULATORY

North Transept

OPPOSITE:
The exterior of the north transept was heavily restored in both the seventeenth and nineteenth centuries.

BELOW:
The north transept looking south.

IN MOST FRENCH GOTHIC CHURCHES the transepts are fairly shallow extensions of the main body of the nave. Westminster departs from this model: it has large transepts that extend three bays in width to the north and south and have aisles on their east and west sides. In medieval times wooden screens enclosed the crossing and quire, so visitors entering the church from the north door in medieval times would have seen nothing of either. However, the view of the south rose window that visitors see as they enter the Abbey today is largely unchanged from medieval times. The north door was the principal entrance to the church for many centuries, and its elaborate carved exterior was sometimes called 'Solomon's porch' in reference to the Temple in Jerusalem.

In the early seventeenth century the transept began to fill with monuments, beginning with Lord Chatham s monument on its western side, and the Norris and Vere tombs in the eastern aisle. Much later the main aisle became especially associated with the burial and commemoration of politicians, the series of nineteenth-century statues along its eastern arcade (including Disraeli and Gladstone), leading to the popular description of this part of the Abbey as 'Statesmen's Aisle'.

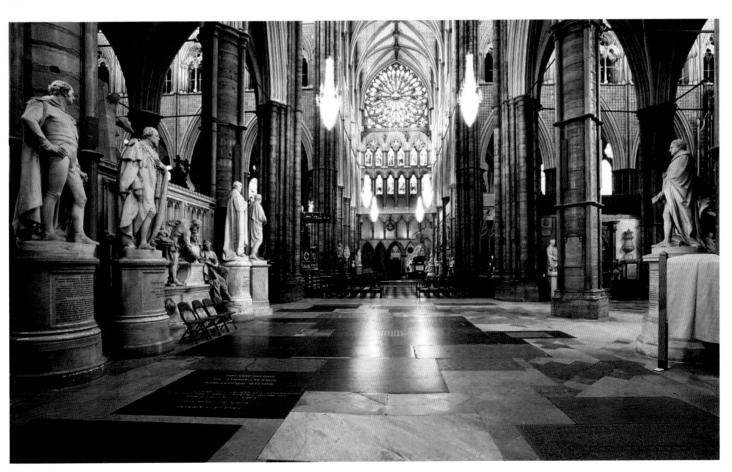

MONUMENTS AND FLOORSTONES

◆ **WILLIAM CAVENDISH, 1ST DUKE OF NEWCASTLE** (c.1593–1676), AND HIS SECOND WIFE, **MARGARET** (1623?–73)

This flamboyant monument of black and white marble by Grinling Gibbons was erected during the duke's lifetime. The base, with heraldic cartouches at each end and an inscription flanked by military trophies, supports a sarcophagus on which recline effigies of the duke and duchess in robes and coronets. The duke, a patron of learning and supporter of Charles I, holds a military baton; the duchess, who wrote poetry and plays, holds an open book, a pen-case and an ink-horn. **65**

JOHN HOLLES, 1ST DUKE OF NEWCASTLE (1662–1711)

Marble monument designed by James Gibbs and executed by Francis Bird and Michael Rysbrack, 1723. An armoured effigy of the duke, holding a coronet and a baton, looks upward at two angels on the pediment above. Statues of Wisdom (left) and Sincerity (right) flank the columns. **43 & 61**

SAMUEL BRADFORD (1652–1731), DEAN OF WESTMINSTER 1723–31

Marble tablet by Sir Henry Cheere, c.1731, displaying the star of the Order of the Bath, of which Bradford was the first dean. His wife, Jane, and son William are buried with him nearby. **02 & 37**

BRIGADIER-GENERAL RICHARD KANE (1662–1736), ARMY OFFICER

Marble monument by Michael Rysbrack, c.1739. A bust of Kane in armour rests on an inscribed base (showing an incorrect date of birth). His coat of arms is fixed separately to the arcading behind. Kane died on Minorca, of which he had been

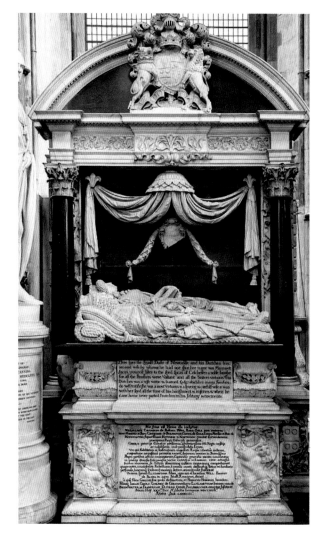

◆ *Tomb of William Cavendish, duke of Newcastle, and his wife Margaret.*

appointed governor in 1730, and is buried there. **03**

LIEUTENANT-GENERAL THE HON. PERCY KIRK (1684–1741), ARMY OFFICER

Marble monument by Peter Scheemakers, c.1742, consisting of a bust flanked by cherubs. **04**

CAPTAIN LORD AUBREY BEAUCLERK (1710–40), NAVAL OFFICER

Marble monument by Peter Scheemakers, 1745. A bust in a niche stands on a pedestal in front of a truncated pyramid. Beauclerk died in action during Admiral Vernon's campaign against the Spanish at Cartagena in Colombia. Not buried in the Abbey. **07**

ADMIRAL SIR JOHN BALCHEN (1670–1744) AND HIS SON **GEORGE** (D. 1745), NAVAL OFFICER

Marble monument by Peter Scheemakers, 1746. Balchen was commander-in-chief of the fleets of England and the Netherlands and was lost with his ship, *Victory*, in a violent storm in the English Channel. The shipwreck is depicted on the monument. George Balchen, captain of the *Pembroke*, fell ill and died in Barbados aged twenty-eight. **09**

HUGH BOULTER (1672–1742), ARCHBISHOP OF ARMAGH

Marble monument by Sir Henry Cheere, c.1746, consisting of a bust of Boulter (flanked by a mitre and crosier) resting on a sarcophagus. **01**

ADMIRAL SIR CHARLES WAGER (1666–1743)

Marble monument by Peter Scheemakers, 1747. A figure of Fame, assisted by a cherub, supports Wager's portrait amid naval trophies. A carving depicts his engagement with the Spanish fleet at Cartagena in 1708. **34**

LIEUTENANT-GENERAL JOSHUA GUEST (1660–1747)

Marble monument by Sir Robert Taylor, 1751. A bust of Guest in Roman armour, flanked by military trophies, sits above a sarcophagus. Buried in the east cloister. **11**

VICE-ADMIRAL SIR PETER WARREN (1703–52)

Marble monument by Louis-François Roubiliac, c.1753, installed 1757. A figure of Hercules places a bust of Warren onto a pedestal decorated with naval emblems. To the right, sitting on a lavish cornucopia, is a female figure sometimes identified as Britannia but, since a small ship's prow rests on her head, perhaps intended to represent Navigation. Buried at Warrenstown, Co. Meath. **68**

VICE-ADMIRAL CHARLES WATSON (1714–57)

Marble monument above the north-west door designed by James Stuart and sculpted by Peter Scheemakers, 1763. Watson, wearing a toga and holding a palm branch to symbolise Victory, stands between figures alluding to his role in the capture of Gheria, to the south of Bombay (1756) and the recapture of Calcutta (1757). On the right a kneeling woman represents Calcutta (where Watson is buried), and on the left is a native of Gheria in chains. Palm trees that originally flanked the figures were removed in 1957. **13**

ADMIRAL EDWARD VERNON (1684–1757)

Marble monument by Michael Rysbrack, 1763. Fame crowns Vernon's bust with laurels amid naval trophies and Roman armour. Buried at Nacton, Suffolk. **60**

GEORGE MONTAGU DUNK, 2ND EARL OF HALIFAX (1716–71), POLITICIAN

Marble monument by John Bacon, 1782. The earl's bust is revealed by a cherub who carries a mirror (representing Prudence) and tramples a mask (symbolising Hypocrisy). Another cherub holds the insignia of the Order of the Garter. An Irish harp and a seal purse allude to Halifax's service as lord lieutenant of Ireland and lord privy seal respectively. He also helped in the foundation of Nova Scotia, the capital of which is called Halifax after him. Buried at Horton, Northamptonshire. **14**

JONAS HANWAY (1712–86), PHILANTHROPIST

Marble monument by J. F. and James Moore, c. 1788. A carving of Britannia distributing clothing to boys destined for service at sea alludes to the work of the Marine Society, which Hanway founded. A portrait of Hanway, who is said to have been the first person in England to carry an umbrella, appears on the base. Buried at Hanwell, Middlesex. **19**

◆ WILLIAM PITT, 1ST EARL OF CHATHAM (1708–78), STATESMAN AND PRIME MINISTER

Very tall marble monument by John Bacon, 1779–83, erected at public expense (it cost more than £6,000). Pitt served as secretary of state during the Seven Years' War, was prime minister from 1766 to 1768 and was known as Pitt the Elder to distinguish him from his son and, until his elevation to the peerage, as 'the Great Commoner'. He is depicted at the top of the monument in the act of delivering a speech, while figures of Prudence and Fortitude sit beneath. Lower down is Britannia, who uses her trident to subdue Neptune (symbolising the Ocean), who rides on a dolphin. On the base of the monument a figure representing Earth reclines with an abundance of fruit, corn and flowers, echoing the sentiments of the inscription that under Chatham's leadership 'Divine Providence exalted Great Britain to an Height of Prosperity and glory unknown to any former Age'. The city of Pittsburgh in the USA takes its name from Pitt, and the Royal Institute of International Affairs, better known as Chatham House, occupies his former London home. Pitt collapsed in the House of Lords immediately after making his last speech and was buried here by order of Parliament. **33**

WILLIAM BAYNE (c.1732–82), WILLIAM BLAIR (c.1741–1782) AND LORD ROBERT MANNERS (1758–82), NAVAL OFFICERS

Tall marble monument by Joseph Nollekens, opened to viewing in 1793. Britannia (her shield held by a lion) and Neptune (on a sea horse) flank a pillar decorated with ships and portraits, one of which is put in place by a cherub. A figure of Fame at the top

◆ *Statue of William Pitt, earl of Chatham.*

of the column holds a laurel wreath and a trumpet. The 'Three Captains' died commanding ships at the battle of Dominica during the American War of Independence. All were buried at sea, and this memorial (costing £4,000) was erected at public expense. **32**

LIEUTENANT-GENERAL SIR EYRE COOTE (1726–83)

Marble monument by Thomas Banks, finished in 1789. The design alludes to Coote's career in India. An elephant is carved on the sarcophagus, above which is a palm tree set amid flags and trophies. Victory hangs Coote's portrait from the tree while a captive holds a cornucopia, the contents cascading onto a British shield. Buried at Rockbourne, Hampshire. **26**

BRIGADIER-GENERAL HENRY HOPE (D. 1789), LIEUTENANT-GOVERNOR OF QUEBEC

Marble monument by John Bacon, 1793. A woman in native American dress, mourning over a sarcophagus, and a carved beaver allude to Hope's career in Canada. Not buried in the Abbey. 21

SIR CLIFTON WINTRINGHAM (1710–94), MILITARY PHYSICIAN

Marble monument by Thomas Banks, 1794, depicting a mourning woman and a doctor attending a sick family. 15

WILLIAM MURRAY, 1ST EARL OF MANSFIELD (1705–93), LORD CHIEF JUSTICE OF ENGLAND

Large monument of white marble by John Flaxman, 1801. A figure of Mansfield (based on a portrait by Joshua Reynolds) sits high on a plinth, flanked by Justice and Wisdom. At the rear of the monument a youth with an inverted torch represents Death, and on each side of the plinth are funeral altars derived from Classical antiquity. Mansfield's important judgement in the case of the slave James Somerset established that slaves became free once on English soil. 10

JOHN WARREN (1730–1800), BISHOP OF BANGOR

Marble monument by Sir Richard Westmacott, c. 1803. An angel points to a cross held by a figure representing Religion. A Bible, a mitre and a crosier are on the base. 08

MAJOR-GENERAL COOTE MANNINGHAM (D. 1809)

Inscribed marble tablet by John Bacon the Younger, 1813. Not buried in the Abbey. 17

WARREN HASTINGS (1732–1818), GOVERNOR-GENERAL OF BENGAL

Marble monument by John Bacon the Younger, c. 1822. After a distinguished career in India, Hastings was later impeached on charges of cruelty and corruption. His trial in Westminster Hall lasted seven years and ended in his triumphant acquittal. Buried at Daylesford, Worcestershire. 22

FRANCIS HORNER (1778–1817), POLITICIAN AND ECONOMIST

Marble statue by Sir Francis Chantrey, 1823, depicting Horner in a barrister's robes. Buried at Livorno, Italy. 24

ELIZABETH WARREN (D. 1816), PHILANTHROPIST

Marble monument by Sir Richard Westmacott, installed after August 1824. It reflects Elizabeth Warren's concern for migrant workers in its depiction of a young woman dressed in rags. She nurses a baby and has a walking-stick and a bundle of belongings at her feet. Mrs Warren's sister commissioned the original sculpture, which was exhibited at the Royal Academy in 1822 as *The Houseless Traveller*, and Westmacott made this nearly identical replica for the Abbey. Mrs Warren's husband, John, is commemorated near by. 28

GEORGE CANNING (1770–1827), STATESMAN AND PRIME MINISTER

Marble statue by Sir Francis Chantrey, 1834, a replica of one now in Athens that commemorates Canning's support for Greek independence. In 1809 Canning fought a duel with Lord Castlereagh (whose statue is near by), provoking much public outrage since both men were Cabinet ministers at the time. Canning later succeeded Castlereagh as foreign secretary after the latter's suicide in 1822. He became prime minister in 1827, but his health was then already in decline and he died after only 119 days in office. 44 & 62

CHARLES, EARL CANNING (1812–62), STATESMAN AND FIRST VICEROY OF INDIA

Marble statue by John Henry Foley, 1834, depicting Canning in coronation robes. Buried with his father, George Canning. 44 & 63

VICE-ADMIRAL SIR HENRY BLACKWOOD BT (1770–1832)

Marble tablet by William Behnes, c.1834. Buried at Killyleagh, Co. Down. 23

MAJOR-GENERAL SIR JOHN MALCOLM (1769–1833), SOLDIER AND STATESMAN

Marble statue by Sir Francis Chantrey, 1838. Malcolm began his career in India as an ensign, aged fourteen, and concluded it as governor of Bombay (1827–30). Buried at St James's church, Piccadilly. 66

CHARLES BULLER (1806–48), POLITICIAN

Marble bust by Henry Weekes. Buried at Kensal Green cemetery, London. 25

◆ *Statue of Benjamin Disraeli, twice prime minister in the reign of Queen Victoria.*

04

ROBERT STEWART, VISCOUNT CASTLEREAGH AND 2ND MARQUESS OF LONDONDERRY
(1769–1822), STATESMAN

Marble statute by John Evan Thomas, 1850, depicting Castlereagh in Garter robes. 31 & 46

SIR ROBERT PEEL BT
(1788–1850), STATESMAN AND PRIME MINISTER

Marble statue in Classical dress by John Gibson, 1852. It was commissioned by the government but carved in Rome, where the sculptor lived. Peel is especially remembered for his reorganisation of the London police force, whose constables are still popularly called 'bobbies' after him. Buried at Drayton Bassett, Staffordshire. 70

SOLDIERS WHO DIED IN THE INDIAN MUTINY, 1857–8

A memorial stone commemorates: Major-General Sir Henry Barnard, Lieutenant-Colonel Charles Woodford, Captain William Thynne and Ensign Lovick Cooper (all of the Rifle Brigade); Captain W. R. Moorsom (13th Light Infantry); and Cornet William Bankes (7th Hussars). Memorial glass formerly in the lancet windows above the north entrance and in one window in the west aisle was destroyed in the Second World War. 35

SIR GEORGE CORNEWALL LEWIS
(1806–63), POLITICIAN

Marble bust and inscription by Henry Weekes, 1864. Buried at Old Radnor. 27

RICHARD COBDEN
(1804–65), POLITICIAN

Marble bust by Thomas Woolner, 1866. Cobden campaigned for free trade and the repeal of the Corn Laws, and Charles Dickens was among those who petitioned for his commemoration. Buried at West Lavington, Sussex. 16

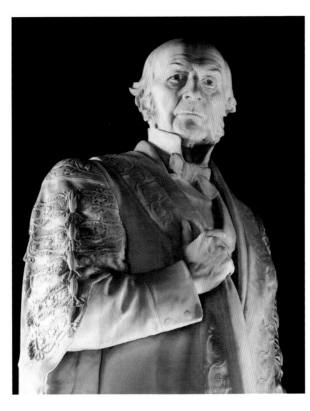

MAJOR-GENERAL SIR HERBERT EDWARDES (1819–68), ARMY OFFICER

Marble monument by William Theed the Younger, 1868, consisting of a bust flanked by angels. Buried at Highgate cemetery. 20

JOHN TEMPLE, 3RD VISCOUNT PALMERSTON (1784–1865)
STATESMAN AND PRIME MINISTER

Marble statue by Robert Jackson, 1870, depicting Palmerston in Garter robes. He was in government continuously from 1807, when he entered Parliament, until his death and twice served as prime minister. He had wished to be buried in Romsey Abbey, but Parliament insisted on a state funeral and burial in Westminster Abbey. Palmerston's gravestone, of red granite inscribed with a cross, was designed by George Gilbert Scott and is shared with his wife, Emily (1787–1869). 41 & 42

GEORGE GORDON, 4TH EARL OF ABERDEEN (1784–1860),
STATESMAN AND PRIME MINISTER

Marble bust on a bronze bracket by

William Ewart Gladstone was prime minister four times and received a state funeral in the Abbey.

Matthew Noble, 1874. Buried at Stanmore, Middlesex. 29

STRATFORD CANNING, VISCOUNT STRATFORD DE REDCLIFFE (1786–1880),
DIPLOMAT

Marble statue by Sir Edgar Boehm, c.1884, depicting Canning in Garter robes. Lines by Tennyson are on the pedestal. Buried at Frant, Sussex. 64

◆ BENJAMIN DISRAELI, EARL OF BEACONSFIELD (1804–81),
STATESMAN AND PRIME MINISTER

Marble statue by Sir J. Edgar Boehm, 1884, depicting Disraeli in Garter robes. He was twice prime minister and is regarded as the founder of the modern Conservative Party. Queen Victoria, who approved of Disraeli's imperialist views, held him in high regard and assumed the title of 'Empress of India' at his suggestion. Buried at Hughendon, Buckinghamshire. 67

SIR HENRY SUMNER MAINE
(1822–88), LAWYER

Carved portrait in black and white marble by Sir Edgar Boehm, 1889. Buried at Cannes, France. 18

◆ WILLIAM EWART GLADSTONE
(1809–98), STATESMAN AND PRIME MINISTER

Marble statue by Sir Thomas Brock, 1903, depicting Gladstone in academic dress. Unlike his great rival Disraeli, whose statue is close by, Gladstone had a difficult relationship with Queen Victoria, who once complained that he addressed her as if she were a public meeting. Gladstone was four times prime minister and has been acknowledged as an important influence by many subsequent politicians (including Winston Churchill). Parliament ordered a state funeral for him and also commissioned this statue. His nearby grave is shared with his wife, Catherine (d. 1900). 51 & 69

49

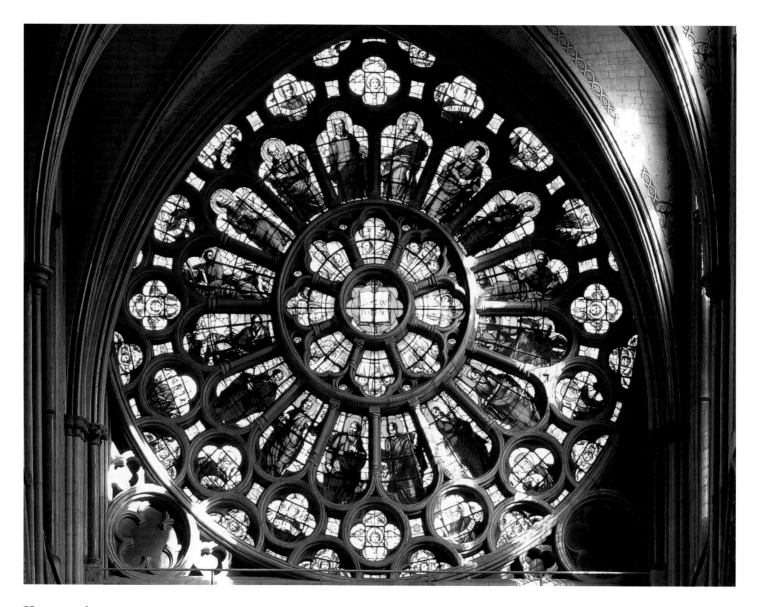

HERBERT ASQUITH, 1ST EARL OF OXFORD AND ASQUITH

(1852–1928), STATESMAN AND PRIME MINISTER

Marble tablet by Henry Pinker, 1934, with a quotation from Milton's *Paradise Lost*. Asquith served as prime minister from 1908 to 1916, leading a government that introduced important social welfare measures such as the national insurance system. In 1914 Asquith declared war on Germany, but following the military disasters at Gallopoli and the Somme, for which he was partly blamed by opponents, he resigned. Buried at Sutton Courtenay, Berkshire. 30

Here also are memorials to Sir William Sanderson (1586–1676) and Brigadier Adrian Hope (d. 1858). Also the graves of: Thomas Willis (d. 1675), his wife, Mary (d. 1670) and daughter Catherine (1663–7); Sarah Nevill (d. 1710) and Anne Elford (d. 1728); Sir Thomas Nevill (d. 1711); Elizabeth Campbell (d. 1714); William Forbes (d. 1728); George Hastings (d. 1730) and his brother Ferdinando (d. 1728); Archibald Hamilton (d.1744); Lieutenant-General Richard Philipps (1661–1750); Alexander Walker (d. 1757); Mary Illingworth (d. 1758) and her mother, Elizabeth (d. 1760); William Pearce (d. 1728); Bridget Hollinshead (1798); Gilbert Elliot, 1st earl of Minto

(1751–1814) and his brother Hugh (1752–1830); Henry Grattan (1746–1820); Charles James Fox and William Wilberforce, who have monuments elsewhere in the Abbey.

◆ *The north rose window today (above), and an engraving from Ackermann's 'Westminster Abbey' (1812) showing the tracery and glass before its late-nineteenth-century remodelling (left).*

OTHER FEATURES

◆ ROSE WINDOW

Designed by Sir James Thornhill and executed by Joshua Price, 1722; remodelled by John Loughborough Pearson, 1884–92. The glass was originally inserted under the direction of Dean Atterbury after Sir Christopher Wren had remodelled the window. In the centre is a book of the Scriptures surrounded by a band of cherubim, and there are more angels in the outer two bands. In between are Christ with the Apostles and Evangelists. During the nineteenth-century restoration of this transept Pearson remodelled Wren's tracery, and the glass was altered to fit, requiring all the main figures to lose their feet.

HMS CAPTAIN WINDOW

Glass by Clayton and Bell, 1871, commemorating Captain Hugh Burgoyne, Captain Cowper Coles and 451 officers and crew of HMS *Captain*, shipwrecked off Cape Finisterre in 1870. The glass depicts nautical scenes from the Bible. An inscribed brass plate is in the floor below. 05

◆ MEMORIAL WINDOW TO JOHN BUNYAN (1628–88)

Designed by Ninian Comper, 1912. It depicts scenes from *The Pilgrim's Progress* and shows Bunyan (bottom left) having the dream that the book describes. Buried at Bunhill Fields, City Road, London.

ACTS OF MERCY WINDOWS

Designed by Brian Thomas and made at the Whitefriars Studios, Wealdstone; installed 1958. The windows illustrate ministry to the hungry, the thirsty, the stranger, the naked, the sick and those in prison (acts of mercy described in St Matthew's Gospel).

◆ *Memorial window to John Bunyan.*

04

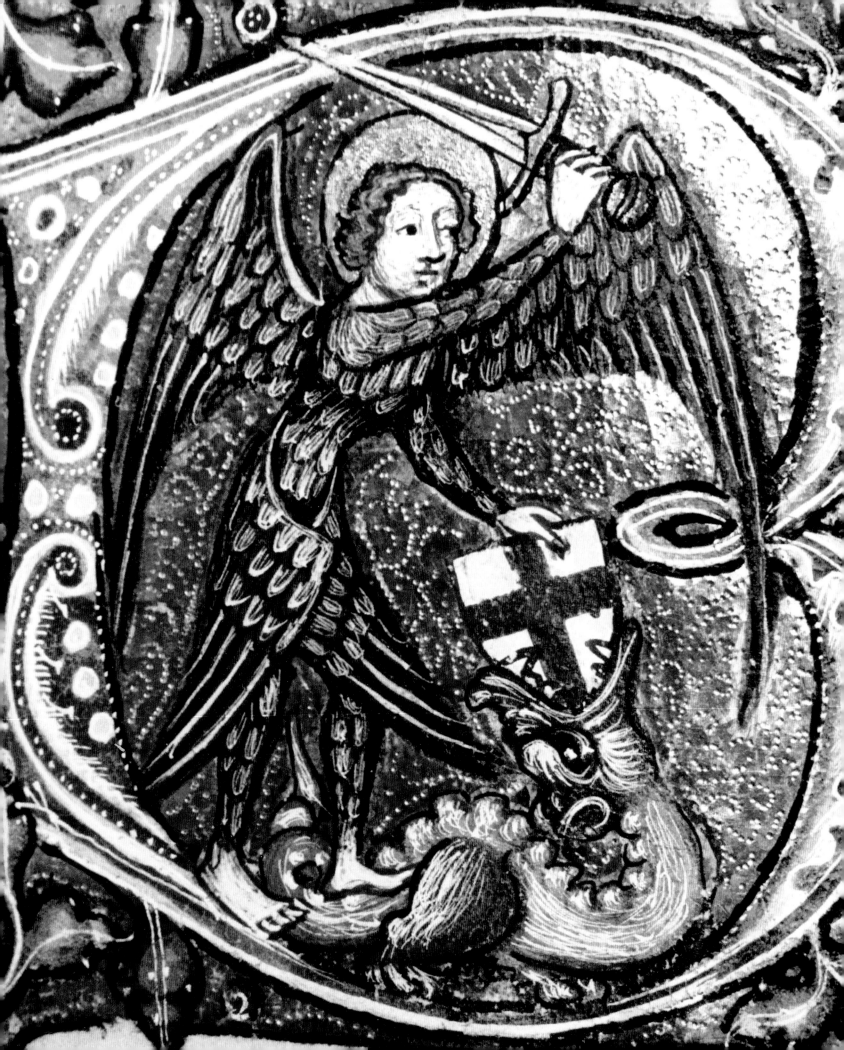

Chapels of St John the Evangelist, St Michael and St Andrew

The three bays of the eastern aisle of the north transept, now filled with many monuments, were once individual chapels separated by screens. The Chapel of St John the Evangelist, at the south end, was divided from the transept and ambulatory by a fifteenth-century stone screen, given by Abbot Esteney. Most of it was taken down in 1722, but a portion, including the doorway, survives on the transept side. In this chapel were probably kept the relics of St John presented to the Abbey by Queen Matilda, first wife of Henry I. The medieval altar stood to the east of the Vere tomb, and above it was erected *c.*1520 a roundel of the head of Christ (now in the Wallace Collection in London), by the Florentine sculptor Pietro Torrigiano.

The middle bay is St Michael's Chapel, the site of its original altar partly occupied by the monument to the duchess of Somerset and partly by the Nightingale monument. The altar slab was found in the floor of the transept in 1872 and replaced in the chapel in 1876. Part of the late medieval stone reredos also survives. In the late seventeenth century the Lower House of Convocation of Canterbury met here, and the chapel was filled with seating. A western screen was apparently still in place then, although the Newcastle (Cavendish) monument had been erected against it, but it was finally destroyed when the Mountrath monument was erected.

The northernmost bay is the chapel of St Andrew, relics of whom are said to have been given to the Abbey by King Athelstan and by St Edward the Confessor. Abbot Kyrton, when sacrist, built or at least enriched the screen of this chapel, decorating it with heraldry (including his own arms) and other embellishments. It was probably destroyed on the erection of the Newcastle (Holles) monument, the back of which now forms the chapel's west wall.

OPPOSITE AND RIGHT:
Illuminated initials from the Litlyngton Missal (1383–4) depicting St Michael the Archangel and St John the Evangelist.

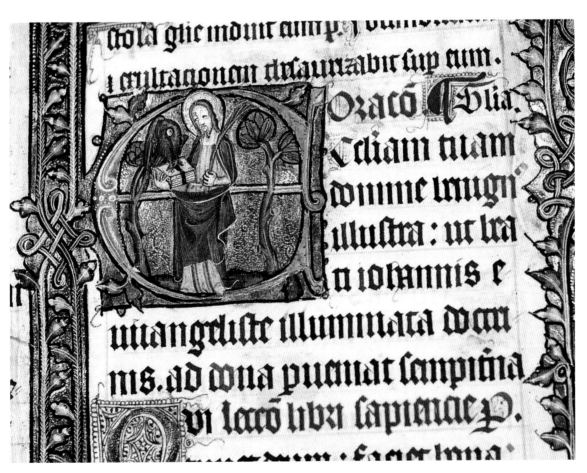

Kneeling figures of his sons surround the tomb of Henry, Lord Norris.

One of the armoured figures supporting the tomb of Sir Francis Vere.

The Norrises were favourites of Elizabeth I, partly because Lord Norris's father, Henry (d. 1536), had chosen execution rather than confess to a charge (probably unfounded) of adultery with Elizabeth's mother, Anne Boleyn. Lady Norris's father had also shown Elizabeth kindness during the reign of Mary I. Buried at Rycote Chapel, Oxfordshire. **91**

◆ **SIR FRANCIS VERE** (1560–1609), MILITARY COMMANDER

Freestanding monument of alabaster and marble, possibly by Isaac James. Four life-size men in armour kneel at the corners and support on their shoulders a marble slab. On this rests a complete set of armour in alabaster and a heraldic cartouche lying on a sword. An effigy of Sir Francis in civil dress lies beneath. The design is modelled on the tomb of Count Engelbert II of Nassau-Dillenburg (d. 1504) in Breda Cathedral. **108**

MONUMENTS AND FLOORSTONES

54

RICHARD DE CROKESLEY
(D. 1258), ABBOT OF WESTMINSTER 1246–58

A stone coffin thought to be Crokesley's was found here during excavations *c.*1921. Its lid, decorated with a floriated cross, was subsequently mounted on the wall. **107**

EDMUND KYRTON (D. 1466), ABBOT OF WESTMINSTER 1440–62

The stone slab and indent were originally on an altar tomb, perhaps on the south side of the chapel. The brass disappeared in the eighteenth century. **76**

ANNE KIRTON (D. 1603)

Alabaster and marble monument, largely obscured by the Norris tomb. An inscribed tablet flanked by pilasters supports an entablature and cartouche. Above is a weeping eye with tears dripping to the lettering below. Place of burial unknown. **92**

◆ HENRY, BARON NORRIS OF RYCOTE (1525?–1601), AND HIS WIFE, MARGARET (D. 1599)

Freestanding monument of alabaster, marble and stone by Isaac James, erected after 1606. The base supports a sarcophagus with recumbent effigies of Lord and Lady Norris. The former is in armour, and both wear ermine-lined mantles. Figures of their six sons in armour and breeches kneel on either side of the tomb. All have their hands joined in prayer except Edward, the only one who outlived his father. Above a high canopy supported on columns are an obelisk, a pedestal decorated with sculpture and a figure of Fame. There is no inscription, but blank panels around the base were perhaps intended for one. This is probably the finest monument of its period in the Abbey, though it suffers badly from its cramped position.

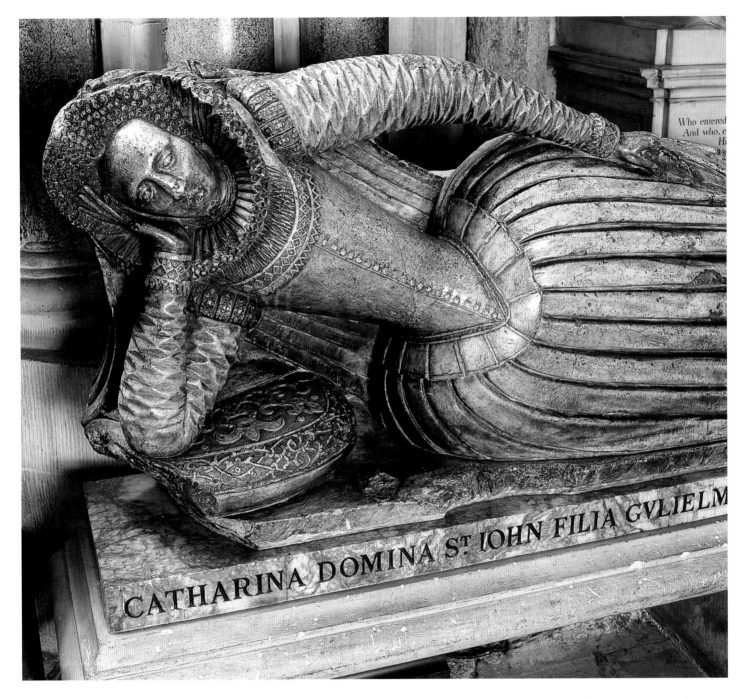

CATHARINA DOMINA St IOHN FILIA GVLIELM

◆ **CATHERINE, LADY ST JOHN OF BLETSO** (D. 1615)

Alabaster and marble monument consisting of a reclining effigy on a nineteenth-century base. There were originally also kneeling figures of Lady St John's two children, but these were removed in the early eighteenth century. 96

SIR GEORGE HOLLES (D. 1626)

Alabaster and stone monument by Nicholas Stone, *c.*1633. A statue of Holles in Roman armour, carrying a large shield, stands on a pedimented base and pedestal. Carvings on the base depict a battle at Nieuport in the Low Countries, where Holles fought along with his uncle Sir Francis Vere. Sleeping figures of the Roman goddesses of War (Bellona) and Wisdom (Pallas) are carved on the pediment. 101

◆ *Monument to Lady St John of Bletso.*

BRIAN DUPPA (1588–1672), BISHOP OF WINCHESTER

Marble tablet by Belthasar Burman, flanked by pilasters and with three shields of arms at the base. 116 & 119

SARAH SEYMOUR, DUCHESS OF SOMERSET (D. 1692)

Marble monument, possibly by Grinling Gibbons. An effigy of the duchess reclines between two charity schoolboys. 93

SIR GILBERT LORT BT

(*c*.1671–98) AND HIS SISTER
ELIZABETH CAMPBELL

(*c*.1666–1714)

Two marble tablets by Edward
Hurst. They were originally part of
a larger monument from which two
mourning cherubs survive (one is in
Little Cloister, the other in a private
part of the precincts). 55 & 100

◆ LADY ELIZABETH

NIGHTINGALE (1704–31)

AND HER HUSBAND,
JOSEPH [NÉ GASCOIGNE]

(1695–1752)

Large and dramatic marble monument
by Louis-François Roubiliac, 1761. The
basement supports a large niche in
front of which Joseph Nightingale
attempts to defend his wife (who died
in childbirth) from a figure of Death.
The latter, depicted as a grisly skeleton
with his bones draped in shroud-like
rags, hurls a lance as he emerges from
doors in the basement. 94

SUSANNAH DAVIDSON (D. 1767)

White marble tablet by Richard
Hayward, *c*.1768, incorporating a
female head covered by drapery.
Not buried in the Abbey. 88

ALGERNON COOTE,

6TH EARL OF MOUNTRATH

(1689–1744), AND HIS WIFE,
DIANA (D. 1766)

Marble monument designed by
Sir William Chambers and executed
by Joseph Wilton, 1771. Above a
sarcophagus an angel seated on clouds
prepares to carry Lady Mountrath to
the heavens. Originally the top of the
monument displayed a seated figure
of the earl with an empty chair at his
side and an attendant angel waiting
to crown Lady Mountrath with a
wreath. 74 & 98

REAR-ADMIRAL JOHN STORR

(1709–83)

Marble bust and tablet by William
Tyler. 103

◆ *The skeletal figure*
of Death emerges
from the monument
to Lady Elizabeth
Nightingale.

ADMIRAL SIR GEORGE POCOCK

(1706–92)

Marble monument by John Bacon, 1796.
Britannia, sitting amid sea-horses and
naval emblems, holds a thunderbolt
and Pocock's portrait. Buried at
Twickenham, Middlesex. 99

LIEUTENANT BENJAMIN FORBES

(D. 1791) AND HIS BROTHER
LIEUTENANT RICHARD FORBES

(D. 1799)

Marble monument by John Bacon the
Younger, 1803. An inscribed tablet
with carvings of a lion and military

trophies supports a larger tablet depicting a mourning woman. Above her are urns (displaying the brothers' initials) and a weeping willow. 78

ANASTASIA FITZMAURICE, COUNTESS OF KERRY (D. 1799), AND HER HUSBAND, **FRANCIS, EARL OF KERRY** (1740–1818)

Marble chest tomb and tablet by G. Buckham. 77

GENERAL SIR CHARLES STUART (1753–1801)

Marble monument by Joseph Nollekens. A boy holding Stuart's portrait sits on a sarcophagus in front of military trophies. Buried at Petersham, Surrey. 79

REAR-ADMIRAL THOMAS TOTTY (c.1746–1802)

Marble tablet by John Bacon the Younger. A carving depicts a three-masted ship firing its guns in tribute to Totty, who died of a fever contracted in Martinique. Buried at the Garrison Chapel, Portsmouth. 80

CAPTAIN EDWARD COOKE (1722–99), NAVAL OFFICER

Marble monument by John Bacon the Younger, 1806. A carving depicts the naval engagement in the Bay of Bengal in which Cooke was fatally wounded. Above it the wounded captain is shown supported by a sailor, while Victory descends with a wreath and a palm branch. Buried at Calcutta. 106

REAR-ADMIRAL RICHARD KEMPENFELT (1718–82)

Marble monument by John Bacon the Younger, 1808. It consists of a truncated pillar in the middle of which is a figure of the admiral ascending towards the clouds, where an angel waits with a crown and a palm branch. The base depicts the sinking of Kempenfelt's ship *Royal George* at Spithead. Buried at Alverstoke, Hampshire. 75

LIEUTENANT-GENERAL WILLIAM VILLETTES (1754–1808), GOVERNOR OF JAMAICA

Marble tablet by Sir Richard Westmacott, decorated with festoons. Buried at Kingston, Jamaica. 81

LIEUTENANT JOHN BERESFORD (1792–1812)

Inscribed marble tablet by Henry Westmacott, decorated with a military

standard and a sword. Beresford died after a powder magazine exploded during Wellington's siege of Ciudad Rodrigo. Buried at Almeida, Spain. 115

JOHN PHILIP KEMBLE (1757–1823), ACTOR

Marble statue by John Flaxman, completed by J. E. Hinchliff, c.1826, depicting Kemble as the Roman censor Cato. Buried at Lausanne. 83

◆ *Portrait of Sarah Siddons (1785) by Thomas Gainsborough (National Gallery, London).*

MATTHEW BAILLIE (1761–1823), PHYSICIAN AND ANATOMIST

Marble bust by Sir Francis Chantrey, 1827. Baillie served as physician to George III and Queen Charlotte. Buried at Duntisbourne Abbots, Gloucestershire.

SIR HUMPHRY DAVY BT (1778–1829), SCIENTIST

Marble tablet by Sir Francis Chantrey, c.1830. Davy is best remembered for his invention of a safety lamp that greatly improved working conditions for coal-miners. Buried at Geneva. 85

THOMAS YOUNG (1773–1829), SCIENTIST

Marble monument with portrait by Sir Francis Chantrey, c.1834. Young's interests ranged from physics and medicine (he identified the condition known as astigmatism) to the interpretation of Egyptian hieroglyphs. Buried at Farnborough, Kent. 90

THOMAS TELFORD (1757–1834), ENGINEER

Marble statue by Edward Hodges Bailey, 1839. Telford's achievements include the Menai Bridge, the Caledonian Canal and the inland navigation of Sweden. His grave in the nave is marked by a metal lozenge designed by Stephen Dykes Bower and made by Messrs Morris Singer. It replaces the original worn gravestone and was given by the Institution of Civil Engineers in 1974. 82

SARAH SIDDONS (1755–1831), ACTRESS

Marble statue by Thomas Campbell, 1845. Siddons was particularly noted for her tragic roles and especially for her performance as Lady Macbeth. Her farewell performance in that role at Covent Garden in 1812 was so enthusiastically received that the audience would not permit the play

to continue beyond her final scene. Buried in Paddington cemetery. 87

SIR WILLIAM WEBB FOLLETT (1798–1845), POLITICIAN AND LAWYER

Marble statue by William Behnes, 1849. Follett was perhaps the greatest advocate of his day and is depicted in a barrister's gown. Buried at the Temple Church. 73

◆ Monument to Sir John Franklin.

SIR JOHN FRANKLIN (1786–1847), ARCTIC EXPLORER

Marble and alabaster memorial by Matthew Noble, 1875. Franklin was lost, with all his crew, when completing the discovery of the North-West Passage. His bust rests over a carved relief of a ship trapped by ice. Beneath are a quotation from the *Benedicite* and a verse by Tennyson. 72

SIR JAMES YOUNG SIMPSON BT (1811–70), PHYSICIAN

Marble bust by William Brodie, 1879. Simpson's discovery of the use of chloroform as an anaesthetic became widely accepted after Queen Victoria consented to its use at the birth in 1853 of her seventh child. Buried at Edinburgh. 89

ADMIRAL SIR FRANCIS McCLINTOCK (1819–1907), ARCTIC EXPLORER

Alabaster tablet by Farmer and Brindley, 1908. McClintock discovered evidence of the fate of Sir John Franklin's Arctic expedition. Buried at Hanwell, Middlesex. 71

JOHN STRUTT, 3RD BARON RAYLEIGH (1842–1919), MATHEMATICAL PHYSICIST

Wall tablet by Francis Derwent Wood, 1921, incorporating a small portrait. Buried at Terling, Essex. 86

JOHN RAE (1813–93), ARCTIC EXPLORER

Memorial of red Orkney sandstone cut by Charles Smith, 2014. Placed near the memorials to Franklin and McClintock, it recognises Rae's role in the exploration of the North-West Passage. Buried in St Magnus Cathedral, Kirkwall, Orkney. 71a

Here also are monuments to Grace Scott (1622–46); and to Clement Saunders (d. 1695); and the gravestones of Theodore Paleologus (d. 1644) and William Moore (d. 1783).

North Ambulatory

From the north transept a semi-circular aisle called the ambulatory (from the Latin *ambulare,* meaning 'to walk') leads around the east end of Henry III's church to the vestibule of the Lady Chapel. On the south side it passes first the rear of the medieval tombs in the sacrarium and then the bases of the royal tombs in the Confessor's Chapel. On the outer (north) side is, first, the entrance to the chapels filling the eastern aisle of the north transept, then the Islip Chantry Chapel and finally the two radiating chapels that are a distinctive French Gothic feature of the Abbey's design. At its eastern end the ambulatory curves southwards, passing directly underneath the richly sculpted walls of Henry V's chantry chapel as it reaches the vestibule of the Lady Chapel.

MONUMENTS AND FLOORSTONES

JOHN WYNDSORE (D. 1414), LORD LIEUTENANT OF IRELAND
What remains of the medieval brass has been removed from the gravestone (adjoining the Longueville graves) and placed near the wall to preserve it. 155

SIR JOHN HARPEDON (D. 1428)
Purbeck marble slab with a brass depicting a knight, originally on a raised tomb in St John the Evangelist's Chapel. 114

THOMAS MILLYNG (D. 1492), ABBOT OF WESTMINSTER 1469–74
Stone coffin. In 1468, while still prior, Millyng oversaw the resumption of building work in the nave, partly funded by Edward IV and his queen, Elizabeth Woodville. The latter took sanctuary at Westminster during Millyng's abbacy, and in 1474 he was rewarded for his protection of her with the bishopric of Hereford. 136

JOHN ESTENEY (D. 1498), ABBOT OF WESTMINSTER 1474–98
Purbeck marble slab with the brass of an abbot in vestments and mitre. The words *Exultabo in Deo Jhesus Meo* ('I shall rejoice in Jesus my God') emerge from the mouth. In 1706 the tomb was opened to reveal the abbot's body lying in a chest quilted with yellow satin and wearing a crimson silk gown and white silk stockings. The tomb originally had iron railings and a canopy but was moved and mutilated in 1772. It was restored in 1866. 112

SIR THOMAS PARRY (D. 1560), TREASURER OF THE HOUSEHOLD TO ELIZABETH I
Stone slab, originally part of a marble tomb. The brass has been lost, and four remaining shields have been fixed to a column for better preservation. 109

JANE CREWE (D. 1639) AND HER DAUGHTER **FRANCES** (D. 1638)
Marble monument attributed to Epiphanius Evesham. It depicts Jane Crewe mourned by her husband and children. The body of Frances, who died in infancy, lies between them. The architectural surround is decorated with a skull and crossed bones and with heraldry and cherubs. 138

ESTHER DE LA TOUR DE GOUVERNET, LADY ELAND (1666–94), HER MOTHER, **ESTHER DE LA TOUR DU PIN, MARQUISE DE GOUVERNET** (*c.*1636–1722, NOT 1733 AS INCISED), AND HER GRANDMOTHER **ESTHER HERVART** (D. 1697)
Gravestone of three Huguenot women who took refuge in England after the revocation of the Edict of Nantes. A monument to Lady Eland by Henri Nadauld is now in the triforium. 175

REAR-ADMIRAL CHARLES HOLMES (*c.* 1711–61)
Marble monument by Joseph Wilton, *c.*1764, showing Holmes in Roman armour, leaning against a cannon and surrounded by naval trophies. Not buried in the Abbey. 156

◈ **FRANÇOIS DE LA ROCHEFOUCAULD, MARQUIS DE MONTENDRE** (1672–1739)
A stone bearing La Rochefoucauld's arms and recording that he was Field Marshal of Great Britain replaced the original vault stone in 2013. 173a

WILLIAM PULTENEY, 1ST EARL OF BATH (1684–1764), STATESMAN
Marble monument by Joseph Wilton. An architectural surround frames a figure of Wisdom leaning on an urn. A seated figure of Poetry clasps the urn and has an open book, quills, a lyre and other emblems at her feet. A portrait of the earl hangs above.
Pulteney's funeral took place at night and ended in riot when a large

◈ *Monument to Earl Ligonier.*

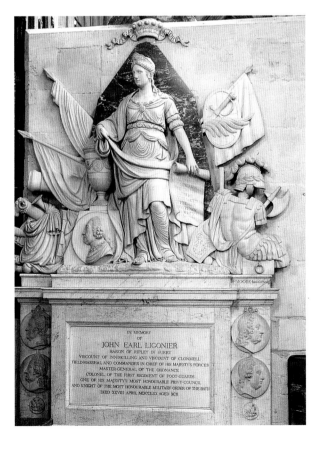

crowd broke in and mingled with the mourners. During the disorder some of the men present took a stand on the steps leading to the Confessor's Chapel, defending themselves against the pressure of the crowd with swords and with timbers wrenched from the canopy over Edward I's tomb. The earl is buried in the Islip Chantry Chapel with his wife and three of their children. **120 & 172**

◆ JOHN, EARL LIGONIER (1680–1770)

Marble monument by John Francis Moore. A figure of History, leaning on an urn and surrounded by military emblems, holds a scroll listing Ligonier's chief battles. The pedestal displays the earl's portrait, and four medallion portraits of the sovereigns Ligonier served are on the base. Buried at Edinburgh. **110**

◆ MAJOR-GENERAL JAMES WOLFE (1727–59), ARMY OFFICER

Large freestanding marble monument by Joseph Wilton, 1772. On a sarcophagus guarded by two lions is depicted the dying Wolfe, attended by a grenadier and a highland soldier. A figure of Victory descends with a laurel wreath and a palm branch. On the left tomahawks and scalping knives hang from a tree. A bronzed lead relief (attributed to Giovanni Capezzuoli) shows the assault on the Heights of Abraham, above Quebec, in which Wolfe was mortally wounded. This was Wilton's first public work, commissioned by Parliament in 1760 after he won a competition to design it. Wolfe is buried at St Alfege's church, Greenwich.

During the First World War the colours of several Canadian battalions were grouped on the monument. After the Armistice they were reclaimed, but at the request of the Canadian government two flags were placed here again in 1922 as a reminder of Canada's assistance to the United Kingdom during that war. **111**

LIEUTENANT-GENERAL SIR JAMES OUGHTON (1720–80)

Marble monument, probably by Richard Hayward. An inscribed tablet rests against a small pyramid bearing an urn with a relief portrait. Buried at Bath Abbey. **104**

JOHN PYM (1584–1643) AND WILLIAM STRODE (c.1594–1645), STATESMEN, AND COLONEL EDWARD POPHAM (c.1610–1651)

A nineteenth-century stone commemorates three Commonwealth figures whose bodies were disinterred at the Restoration of the monarchy. Popham has a monument in St John the Baptist's Chapel. **153**

MARY DE ST POL, COUNTESS OF PEMBROKE (1304–77)

Memorial tablet of slate and stone designed by Donald Buttress and executed by Dick Reid, 1992. The countess's benefactions to the Abbey included an alabaster statue of the Virgin Mary. The tomb of her husband, Aymer de Valence, is in the sacrarium. Buried at Denny Abbey. **117**

Here also are a monument to Juliana Crewe (d, 1621) and the gravestones of: George Wylde (d. 1649); John Doughty (1597–1672), prebendary of Westminster 1660–72; Edward Hyde, 1st earl of Clarendon (1609–74) and members of his family; Sir Thomas Peyton Bt (c.1613–84), his daughter Katherine Longueville (1641–1715) and other family members; Christian Ker (d. 1694); Rebecca Folliott (d. 1697); John Berkeley, 4th Viscount FitzHarding (1650–1712) and his wife, Barbara (c.1657–1708); Edward Willes (1694–1773), bishop of Bath and Wells, prebendary of Westminster 1724–42, and members of his family.

◆ *The monument to General Wolfe covered with Canadian military flags (above) and a detail of one of the lions on the plinth (left).*

Islip Chantry Chapel

This chantry, dedicated to the Holy Name of Jesus (a popular medieval devotion), has an upper and lower chapel and was built by Abbot John Islip. It was completed some time before his death in 1532. Islip's name and 'rebus' adorn the chapel and the elaborate carving on the frieze of the stone screen. The rebus is a visual pun on the abbot's name and depicts an eye within a 'slip' or branch of a tree grasped by a hand, and a man slipping from the branch Both chapels contained altars, each with a representation of the Crucifixion behind it and a frontal bearing Islip's arms.

Islip was buried in the lower chapel. His tomb consisted of a skeleton in a shroud beneath a black marble slab supported on four short, fluted brass columns. What remains of it is now in the upper chapel, and a simple stone in the lower chapel marks his burial 121. Details of the abbot's death were recorded in a document called the Islip Roll, which survives among the Abbey's muniments. It contains important drawings (attributed to Gerard Horenbout) of the abbot's deathbed, of the hearse standing before the high altar and of Islip praying within the chapel.

The present altar in the lower chapel is a modern reconstruction (1939), installed after a monument to Sir Christopher Hatton (d. 1619) and his wife, Alice (d.1630), had been moved to the triforium.

From the early seventeenth century the upper chapel housed the collection of funeral effigies, some in wooden cases, which remained here almost continuously until 1941. They are now in the museum. In 1950 the chapel was refurbished in memory of nurses and midwives who died during the Second

RIGHT: *The Islip Chantry Chapel as depicted in the Islip Roll of 1532.*

World War. On Abbot Islip's tomb slab rests the Nurses' Roll of Honour, in a bronze casket, flanked by a pair of gilded bronze candlesticks presented by Queen Elizabeth The Queen Mother.

The crucifix of wood and bronze is a copy of one by Giovanni da Bologna (d. 1608) in the church of SS Annunziata at Florence. Beneath it are an inscribed tablet supported by two gilded angels and blue damask hangings bearing the sacred monograms *IHS* and *XPC*. These furnishings (apart from the candlesticks) were designed by Sebastian Comper.

MONUMENTS AND FLOORSTONES

In this chapel are the gravestones of the following clergy or officers of the Abbey: William Barnard (1697–1768), prebendary 1732–43; William Elliott (1880–1940), canon 1938–40; Sir Charles Peers (1868–52), surveyor of the fabric 1935–51; Frederic Donaldson (1860–1953), canon 1924–53; Stephen Marriott (1886–1965), canon 1937–63; Harold Costley White (1878–1966), head master of Westminster School 1919–37 and canon 1936–8; John Carleton (1908–70), head master of Westminster School 1957–70; Lawrence Tanner (1890–1979), keeper of the muniments 1926–66 and librarian 1956–72; Stephen Dykes Bower (1903–94), surveyor of the fabric 1951–73.

Here also are the gravestones of Christopher, 1st Baron Hatton (d. 1670); Anna Hassall (d. 1750); Admiral Sir Charles Saunders (1713–75); and a memorial to members of the Wilberforce family, including Samuel Wilberforce (1805–73), dean of Westminster briefly during 1845.

◆ *Glass depicting the 'rebus' or visual pun on Islip's name.*

OTHER FEATURES

ISLIP WINDOW

Designed and executed by Hugh Easton, 1948. Dean Alan Don gave the glass in thanksgiving for the deliverance of the Abbey and St Margaret's Church from the Second World War, and in remembrance of both Abbot Islip and Dean Paul de Labilliere (Don's predecessor).

The main figures are Islip, shown in prayer holding a model of the rooms that he added to the abbot's lodgings (and that survived the wartime bombing), and St Margaret of Antioch, who stands on a dragon. A cherub holds a model of the Abbey with flames emerging (a reference to the air raid of 1941 that destroyed the lantern roof), and another holds a model of St Margaret's Church. Above

these are the respective arms of Deans Labilliere and Don. A small piece of medieval glass bears the Islip rebus and a Latin motto meaning 'Seek peace and pursue it'. Shields in the upper lights display heraldry associated with the Abbey.

NURSES' MEMORIAL WINDOW

Glass by Hugh Easton, 1950. It shows the Virgin Mary standing on a crescent moon with the Christ child in her arms. He raises his hand to bless a kneeling nurse, above whom is depicted St Luke (standing on a rainbow) and the star of Bethlehem. Also in the window are the badges of the nursing services, the arms of the British dominions and the names of the countries from which nurses came to serve in the war. The British Commonwealth and Empire Nurses War Memorial Fund gave the glass on behalf of the nurses and midwives of the Commonwealth.

LAMP

A lamp carried in procession at an annual service in commemoration of Florence Nightingale is kept here. It was given in 1973 in memory of Kathleen Dampien Bennett.

◆ *Stone head of Abbot John Islip.*

Chapels of Our Lady of the Pew and St John The Baptist

The chapel of St John the Baptist is now entered through a double vestibule, but in its original form the outer one of these spaces was a self-contained recess about five feet square and is believed to have been the Chapel of Our Lady of the Pew (meaning 'a small enclosure'). The painted vaulting with its carved boss of the Assumption dates from the second half of the fourteenth century, and in the back wall of the recess, facing the ambulatory, stood an image of the Virgin. The walls of the recess were elaborately painted, and some of the hooks from which votive offerings were hung remain. The outer doorway with its wooden half-gates and iron bracket for an alms-box is also original. In this form the chapel remained until about 1502, when it was enlarged northwards. An altar dedicated to St Erasmus was introduced, and the image of Our Lady was moved to the new north wall of the enlarged chapel. Hooks used to secure the image remain, and the painted background still shows a faint outline of the figure.

BELOW: *St John the Baptist depicted in the Litlyngton Missal (1383–4).*

RIGHT: *The Chapel of Our Lady of the Pew.*

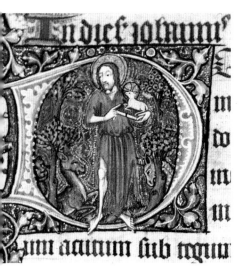

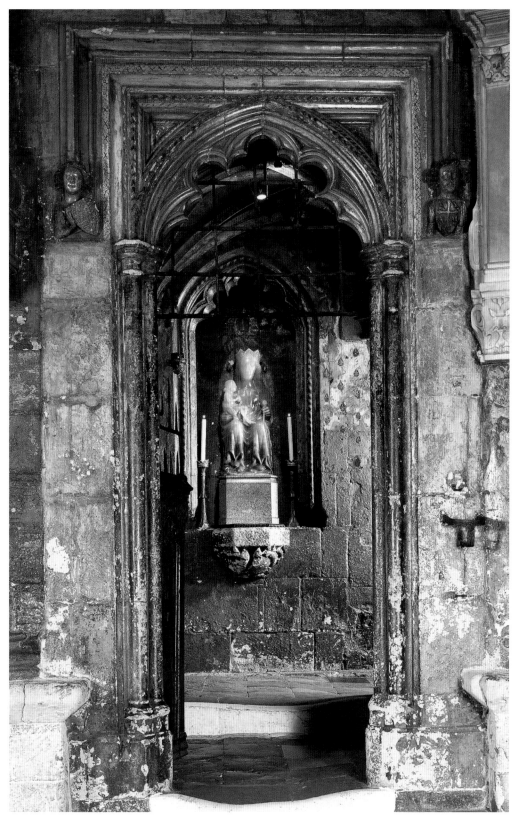

04

63

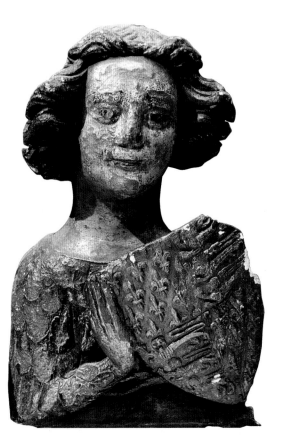

Nicholas's Chapel, the tomb was brought here in the sixteenth century and placed on the stone bench, the wall being cut away to accommodate it. The tomb was later brought forward and given a new base. 142

WILLIAM DE COLCHESTER
(D. 1420), ABBOT OF WESTMINSTER 1386–1420

Stone altar tomb with effigy. The canopy has disappeared, and the effigy (in mitre and vestments) is much decayed, but some original paintwork remains and renovation has restored the colours. Colchester continued Abbot Litlyngton's rebuilding of the nave, with support from Richard II and Henry V. He was involved in a plot to restore Richard and was briefly committed to the Tower after the accession of Henry IV but was restored to royal favour in the reign of Henry V. 146

SIR THOMAS VAUGHAN
(D. 1483), TREASURER OF THE CHAMBER TO EDWARD IV

Marble tomb beneath a four-centred arch. The brass of Sir Thomas in armour survives, but shields and much of the inscription have disappeared. 140

GEORGE FASCET (D. 1500),
ABBOT OF WESTMINSTER 1498–1500

Chest tomb with a marble slab beneath a stone canopy. On the ambulatory side iron railings fill the arch. Heraldic shields are displayed on the sides of the tomb and in the spandrels of the canopy. A brass inscription has been lost. 149

THOMAS RUTHALL (D. 1523),
BISHOP OF DURHAM

Stone tomb with effigy, 1524. It originally had a canopy similar to that of Abbot Fascet's tomb, but only

64

The present statue dates from 1971 and is by Sister Concordia Scott OSB. It was inspired by a fifteenth-century English statue in Westminster Cathedral. 139

St John the Baptist's Chapel was originally separated from the ambulatory by a wooden screen with a central doorway. This was displaced first by the tomb of Abbot Fascet and then, in 1524, by Bishop Ruthall's tomb. At that point the present entrance from within the Chapel of Our Lady of the Pew was made. Aumbries where the sacramental plate was kept in monastic times remain in the north-east wall, but the place of the altar is now occupied by the Hunsdon monument.

ABOVE: A carved figure at the entrance to the Chapel of Our Lady of the Pew.

MONUMENTS AND FLOORSTONES

HUGH DE BOHUN (D. 1304)
AND HIS SISTER MARY (D. 1305)

Marble tomb with an arcade of trefoiled arches. It dates from *c.*1260–70 and was reused for the burial of these children of Humphrey, earl of Hereford. Originally in St

Tomb of Henry Carey, Baron Hunsdon.

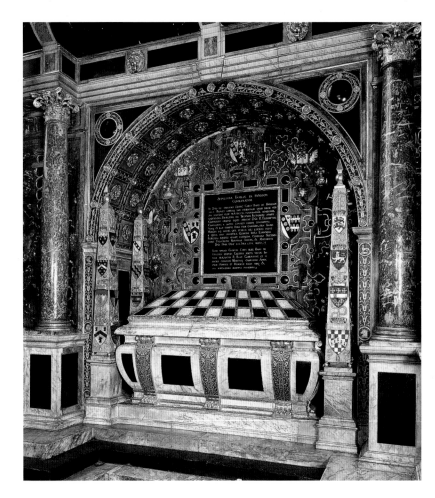

THOMAS CARY OR CAREY
(D. 1649), COURTIER

Marble gravestone of a gentleman of the bedchamber to Charles I who is said to have died of grief at his master's fate. 143

◆ COLONEL EDWARD POPHAM
(*c*.1610–51), PARLIAMENTARIAN, AND HIS WIFE, ANNE

Marble and alabaster monument attributed to William Wright. Figures of the Pophams flank a pedestal bearing a helmet. The inscription tablet is blank, for it is said that when Popham's body was disinterred at the Restoration this monument was permitted to remain on condition that the inscription be removed. 141

MARY KENDALL (1677–1709)

Marble monument of a kneeling woman within an architectural surround surmounted by a cartouche of arms. 150

LIEUTENANT-COLONEL CHARLES MACLEOD (D. 1812)

Marble monument by John Bacon the Younger, *c*.1813. An angel leans against a wall inscribed 'Badajos', the name of the city being besieged by MacLeod at the time of his death. 147

ELIZABETH SAVILE, COUNTESS OF MEXBOROUGH (1762–1821)

Marble monument by Robert Blore, *c*.1822, depicting a grieving woman beside an urn. Buried in the Lady Chapel. 145

ROBERT DEVEREUX, EARL OF ESSEX
(1591–1646)

Essex received a magnificent funeral in the Abbey, though his hearse was later damaged by a mob. The original intention to bury him in the Lady Chapel and erect a monument there was never carried out. Dean Stanley put down this gravestone (which also names others buried in the chapel) in 1879. 151

fragments now survive. Tomb and effigy are much decayed, and the painted inscription is now barely legible. The sides are decorated with heraldic shields. 148

◆ HENRY CAREY, 1ST BARON HUNSDON (*c*.1525–96), LORD CHAMBERLAIN TO ELIZABETH I

This grand and elaborately decorated monument of alabaster and marble is the largest in the Abbey, rising to 36 feet in height. At its core is a sarcophagus in an arched recess, above and around which extends a massive architectural framework, richly adorned with pedestals, obelisks, emblems and colourful heraldic shields. The second level has a large centrepiece displaying the Carey arms, and above this is a domed pavilion (surmounted by a swan) with a

balustrade and yet more heraldry and obelisks above. A floorstone names those buried in the Hunsdon vault. 144

THOMAS CECIL, 1ST EARL OF EXETER (1542–1623), AND HIS FIRST WIFE, DOROTHY (D. 1609)

Freestanding marble tomb with two effigies lying on a black marble slab. On the sides of the chest are shields of arms within wreaths of bay leaves or (in one case) the Garter. The earl is depicted in civil dress and a Garter mantle, his wife in an ermine-lined cloak. Though a vacant space was left for an effigy of the earl's second wife, Frances, she is actually buried at Winchester Cathedral and not here, as the inscription claims. A floorstone names those buried in the Cecil vault. 152

◆ *Monument to Colonel Edward Popham and his wife, Anne.*

St Paul's Chapel

The screen separating this chapel from the ambulatory is an integral part of the Robessart tomb, but the western part of it has been destroyed to accommodate monuments. The tomb of the countess of Sussex occupies the place of the medieval altar. Relics kept here during the Middle Ages included the cloth in which it was alleged St Paul's head was wrapped after execution.

The chapel was damaged around 1825, when Sir Francis Chantrey's large statue of the engineer James Watt (now at Heriot-Watt University, Edinburgh) was placed here. Its pedestal was dragged over the Robessart tomb, destroying the top of the tomb chest, and the statue itself was so heavy that part of the floor collapsed into the vault below. An inscription marks its former location. 171

MONUMENTS AND FLOORSTONES

SIR LEWIS (DE) ROBESSART, BARON BOURGCHIER (D. 1430)

Stone tomb chest and vaulted canopy, forming part of the chapel screen. The chest is decorated with shields and with heraldic standards held by a lion and a falcon. This decoration, vividly repainted in 1967–8, is a reminder of the extent to which the interior of the Abbey was coloured and gilded in medieval times. 166

GILES, 1ST BARON DAUBENEY (1452–1508), COURTIER, AND HIS WIFE, ELIZABETH (D. 1500)

Purbeck marble tomb with alabaster effigies. Daubeney, who was lord chamberlain to Henry VII, wears the Garter mantle over armour. His head rests on a helmet, and at his feet are a lion and two bedesmen with rosaries in their hands. Lady Daubeney rests her head on a cushion and her feet on a wolf

and a dog. The railings, and probably most of the colouring, date from the tomb's restoration in 1889. 169

SIR THOMAS BROMLEY (1530–87), LORD CHANCELLOR AND LORD KEEPER OF THE GREAT SEAL

Alabaster and marble monument with effigies. Sir Thomas, in an embroidered gown, rests on a sarcophagus in front of which kneel his four sons (in armour) and four daughters. The inscription is in a recessed arch (with figures of Fame and Immortality, bearing trumpets, in its spandrels) and has the official purse for the Great Seal, supported by cherubs, carved above it. A large achievement of arms surmounts the monument. 162

FRANCES, COUNTESS OF SUSSEX (D. 1589)

Marble tomb with alabaster effigy, possibly designed by Ralph Symons (architect of Sidney Sussex College, Cambridge, which the countess founded) and probably sculpted by Richard Stevens. The effigy depicts the countess in robes and a coronet with a wooden porcupine (the family crest) painted blue and gold at her feet.

The effigy lies beneath a decorated arch with an inscription on its back. Flanking columns support further storeys decorated with heraldry and obelisks. 164

SIR JOHN PUCKERING (1544–96), LORD KEEPER OF THE GREAT SEAL AND SPEAKER OF THE HOUSE OF COMMONS

Marble tomb with alabaster effigies. Puckering wears a black and gold robe, and his wife wears a widow's dress with a blue mantle. Both rest their heads on cushions and their feet on heraldic crests. In front are statues of their children, two of whom hold skulls as symbols of mortality. The tomb stands within a recess and is flanked by columns supporting a further storey decorated with obelisks and heraldry. Figures of a seal-purse bearer and a mace bearer (the mace now missing) allude to Puckering's two offices. 159

SIR JAMES FULLERTON (D. 1631), COURTIER

Marble tomb with alabaster effigies, attributed to the Southwark school of tomb-makers. The effigies lie on a black chest decorated with shields of

Tomb effigy of Frances, countess of Sussex, with a blue porcupine at her feet.

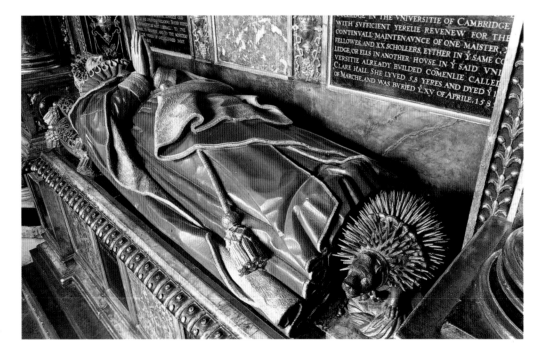

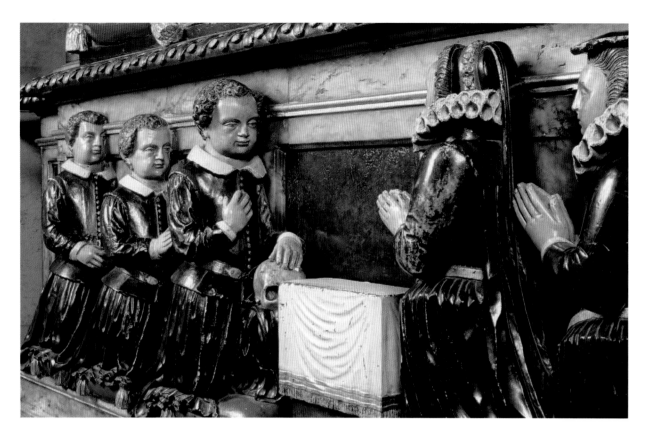

The children of Sir John Puckering depicted as 'weepers' on his tomb.

arms. Sir James is in armour, and his wife (who is not buried in the Abbey) wears a long mantle with a miniature portrait of her husband attached to the girdle. **160**

DUDLEY CARLETON, VISCOUNT DORCHESTER (1574–1632), SECRETARY OF STATE

Marble monument with effigy by Nicholas Stone, 1640. Carleton, wearing peer's robes and a coronet, reclines on his elbow and holds a sword. Flanking columns support an entablature and pediment with a heraldic achievement. **163**

FRANCIS, BARON COTTINGTON (1579?–1652), POLITICIAN AND DIPLOMAT, AND HIS WIFE, ANNE (D. 1634)

Black marble monument with a gilded bronze bust by Hubert Le Sueur and a white marble effigy, possibly by Francesco Fanelli, dating from after 1678. The high base supports a sarcophagus over which is an entablature embellished with two ornamental candlesticks. Between these is Lady Cottington's bust, enclosed by a metal wreath, and in this form the monument was erected by Lord Cottington. He himself died in exile in Spain and was at first buried at Valladolid until his remains could be returned to Westminster. A reclining effigy was then erected, originally at the base of the monument, but later in its present position above the sarcophagus. **165**

LIEUTENANT-GENERAL SIR HENRY BELASYSE (D. 1717)

Marble monument by Peter Scheemakers, 1735–7, consisting of a sarcophagus flanked by Roman helmets against a background adorned with shields and an urn. Other family members are also buried in the chapel. **168**

SIR ROWLAND HILL (1795–1879), INVENTOR OF PENNY POSTAGE

Marble bust by William Day Keyworth junior, 1881. **167**

JAMES USSHER (1581–1656), ARCHBISHOP OF ARMAGH

Ussher was buried here at Oliver Cromwell's direction and expense, and the funeral is probably the only occasion during the Commonwealth when the Prayer Book funeral service was used in the Abbey. The present gravestone dates from 1904. Ussher's scholarly works included an attempt to use ancient texts to establish a chronology of the events of the Old Testament, though few would now accept his conclusion that the world was created on 23 October 4004 BC. **161**

MATTHEW BOULTON (1728–1809), PIONEER OF THE INDUSTRIAL REVOLUTION

Memorial by Gary Breeze, 2014. The inscription is carved into a sheet of cast iron, a material crucial to the industrial revolution. **171a**

Here also is the gravestone of Susannah, Baroness Delaval (d. 1783), John Hussy, Baron Delaval (d. 1808), and his wife Sarah (d. 1800).

Henry V's Chantry Chapel

Henry V, who succeeded to the throne in 1413, is particularly remembered for his conquests in France, and especially his victory at Agincourt (1415), which the monks of Westminster celebrated by singing *Te Deum* before St Edward's shrine. After Henry's death, at Vincennes on 31 August 1422, the body was taken in procession to the French coast, but with such solemnity and with so many stops en route that his magnificent funeral at the Abbey did not take place until 7 November, more than two months after the king's death. Behind the effigy of the king his three chargers were led up to the altar and his banners were borne by great nobles.

Henry V had contributed money towards rebuilding the Abbey's nave and directed in his will that his tomb, and a high chantry chapel raised above it, should be placed at the east end of

RIGHT: *Henry V's Chantry Chapel seen from the north ambulatory.*

BELOW: *Portrait of Henry V by an unknown artist (National Portrait Gallery).*

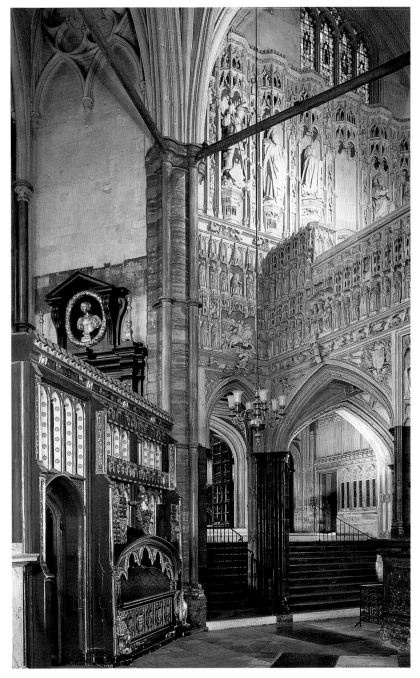

St Edward's Chapel. The mason John Thirske supervised the building of the chapel, which extends over the ambulatory below and is lavishly decorated with sculpted figures. Turrets flanking the tomb platform contain small spiral staircases leading to the chapel above.

Within the chapel stood an Altar of the Annunciation, where masses were said for the repose of the king's soul. The present altar was erected by Dean Stanley but incorporates the ancient altar slab, which had been embedded in the chapel floor. The central niche above the altar is vacant (it probably contained a representation of the Trinity), but the flanking statues of the patron saints of England and France, St George and St Denis, and of two saintly kings, the Confessor and St Edmund, survive along with smaller statues. Large figures of bishops and saints adorn the stair turrets, while the

68

decoration on the sides of the chapel includes depictions of the homage and crowning at Henry V's coronation. On the north side the king is shown on horseback leaping a stream with the tents of his soldiers behind.

MONUMENTS

◆ HENRY V (1387–1422)

Purbeck marble tomb supporting an effigy of black oak. The head, sceptre and other regalia, all of silver, and the plates of silver-gilt that covered the body were stolen in 1546. A new head modelled in polyester resin by Louisa Bolt, following a contemporary description of the king and the earliest portrait of him, was added in 1971, together with new hands and a new crown. Metal gates by a London smith,

◆ The wooden tomb effigy of Henry V lies directly beneath the chantry chapel where prayers were said for the repose of his soul.

Roger Johnson, put up in the reign of Henry VI, separate the tomb from St Edward's Chapel. 177

CATHERINE DE VALOIS

(1401–37), CONSORT OF HENRY V

After Henry's death Catherine married Owen Tudor, a Welsh squire. Edmund, earl of Richmond, Henry VII's father, was one of Catherine's sons by this marriage, making her an ancestress of the Tudor dynasty. A painted wooden funeral effigy (now in the Abbey's museum) was fully robed and carried on a magnificent hearse at Catherine's funeral in the old Lady Chapel. When Henry VII pulled down that chapel, his grandmother's body was removed and placed above ground in an open coffin of loose boards near Henry V's tomb, where it

remained for over 200 years. Samuel Pepys saw it in 1669 and noted: 'I did kiss her mouth, reflecting upon it that I did kiss a Queen, and that this was my birthday thirty-six years old that I did first kiss a Queen.' In 1798 the queen's body was finally buried beneath the Villiers monument in St Nicholas's Chapel, but it was removed again in 1878, by Dean Stanley, and placed beneath the ancient altar slab in Henry V's chantry chapel.

OTHER FEATURES

STAINED-GLASS WINDOW

Glass designed by Edward Woore, 1952, depicting Henry III, Edward III, Henry V and Henry VII. It uses glass salvaged from a war-damaged window in the south transept.

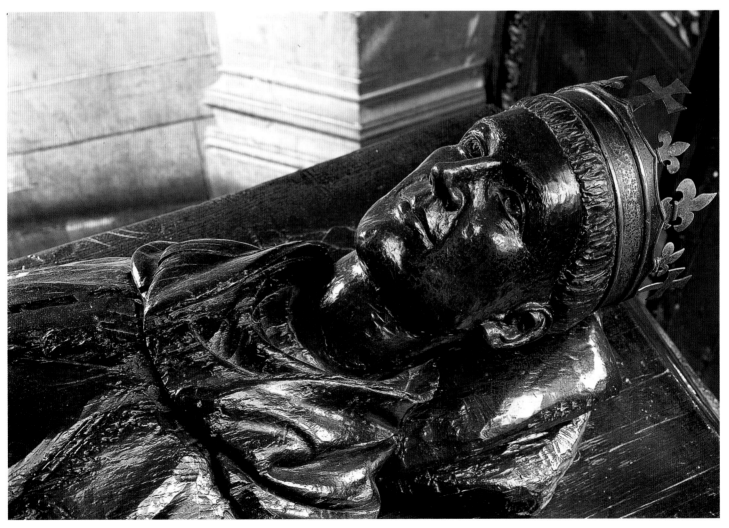

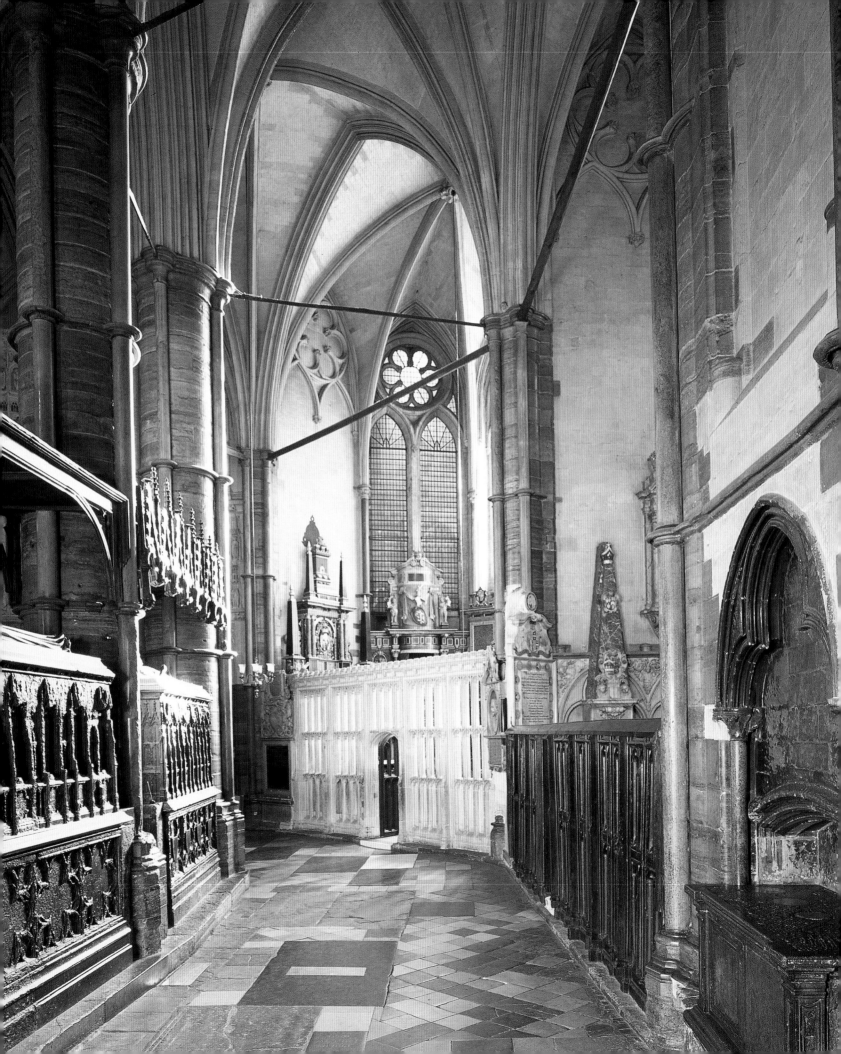

05 | SOUTH AMBULATORY AND TRANSEPT

South Ambulatory

OPPOSITE:
The south ambulatory looking east.

BELOW:
St Nicholas's Chapel.

THE SOUTH AMBULATORY mirrors its northern counterpart by providing a route between the Lady Chapel and the south transept. On the inner side the bases of the tombs of Queen Philippa, Edward III and Richard II (the latter two displaying surviving 'weepers') line the side of the Confessor's Chapel. On the other side screens separate two radiating chapels containing a mixture of medieval and post-dissolution tombs and monuments. At the west end of the ambulatory the small chapel of St Benedict occupies the equivalent position of the Islip Chantry Chapel on the other side of the church. The open design of this chapel, together with the fact that the eastern aisle of the south transept is not furnished with chapels, gives the impression that this ambulatory is shorter than its equivalent on the north side.

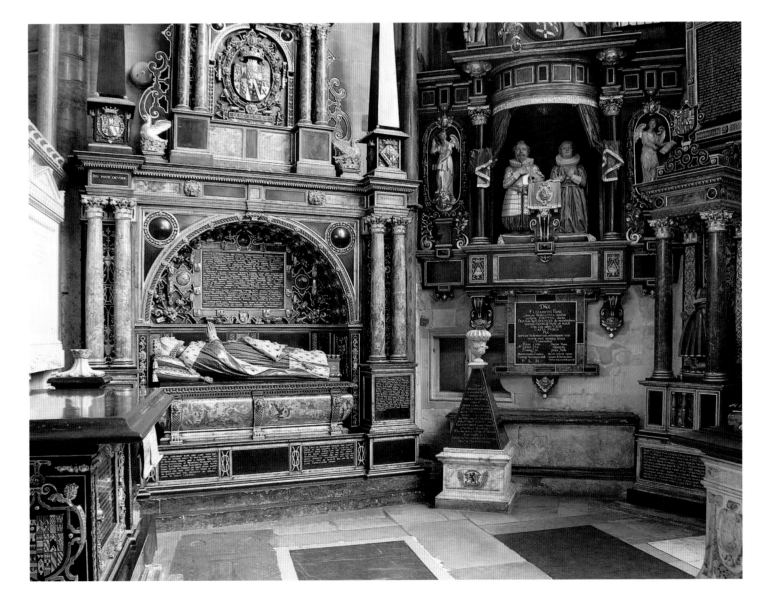

MONUMENTS AND FLOORSTONES

ALLEGED TOMB OF **SEBERT, KING OF THE EAST SAXONS** (D. 616)

The story claiming King Sebert as the Abbey's founder has no historical foundation, but this tomb was regarded as his for many centuries and was reputed also to contain the bones of his queen, Ethelgoda, and his sister Ricula. During Henry III's rebuilding of the church the stone coffin was removed and then installed in its present position. The moulded segmental arch is early fourteenth-century. 54

PRINCESS KATHERINE (D. 1257)
AND OTHER CHILDREN OF HENRY III AND EDWARD I

Marble altar tomb. Princess Katherine's death greatly grieved Henry III, who ordered a richly decorated monument for her, inlaid with mosaic. Three more of his children, and five children of Edward I, were also laid to rest in it. Most of the decoration has disappeared, but something of the design can still be traced on the slab. The back of the recess was painted with kneeling figures, and there were originally two images: one of brass, made by Simon of Wells, and another of silver (probably of St Catherine), by William de Gloucester, the king's goldsmith. The space between the arches over the tomb was elaborately painted and had an image of a saint in its centre. 49

SIR JOHN GOLOFRE (D. 1396)

Purbeck marble slab, now cracked. The indent is still visible, and fragments of the brass are preserved in the Muniment Room. Golofre's remains were brought here from their original burial place at Wallingford on the orders of Richard II. 51

RICHARD HARWEDEN (D. 1441),
ABBOT OF WESTMINSTER 1420–40

The gravestone has lost its original brass of a mitred abbot. Harweden was

one of the treasurers of the money given by Henry V for rebuilding the western part of the nave. 02

THOMAS BILSON (1546/7–1616),
BISHOP OF WINCHESTER

The gravestone is plain, its small brass inscription plate having been moved to the side of the ambulatory to preserve it. 48

RICHARD TUFTON (D. 1631)

Marble monument attributed to William Wright. A bust stands within an oval recess, above which two arms holding a wreath emerge from a cloud. A cartouche of arms above the pediment is flanked by reclining figures of Mercury and Mars. 24

SIR ROBERT AYTON (1570–1638),
POET AND PHILOSOPHER

Marble monument by Francesco Fanelli. Ayton's bust stands in a recess, flanked by figures of Apollo and

ABOVE: *St Nicholas depicted in the Litlyngton Missal (1383–4).*

Athena. Above are cherubs, a flaming urn and a heraldic cartouche. The Latin inscription is on a bronze plate in the form of a sheep's skin. 01

ANNE NEVILLE (1456–85),
CONSORT OF RICHARD III

Bronze plate with enamelled heraldry, by Sebastian Comper, 1960. Anne was the daughter of Richard Neville, earl of Warwick, and her memorial includes a quote from the Rous Roll, a fourteenth-century genealogy of the earls of Warwick. Buried on the south side of the sacrarium. 52

Here also are a monument to Sir Thomas Ingram (*c.* 1614–72), and the gravestones of: Sir Robert Anstruther (1578/9–1644/5?); Sir Henry Spelman (1563/4–1641); Philip Ludlow (d. 1650); Anne, Lady Apsley (d. 1681), and her son Allen (d. 1691); Sir Allen Apsley (d. 1683) and his wife, Frances (d. 1698).

St Nicholas's Chapel

This chapel has a fine stone screen (the frieze decorated with shields and roses), probably erected in Henry VII's reign. In the Middle Ages a finger of St Nicholas and other relics presented by Queen Eleanor of Castile were kept in the chapel, and those who attended Mass at its altar were granted indulgences of three years and sixty days. The burial vaults of the Percy family, including the dukes of Northumberland, lie beneath, and several of the chapel's monuments were moved when a new vault was made for the burial of Elizabeth Percy in 1776.

MONUMENTS AND FLOORSTONES

PHILIPPA, DUCHESS OF YORK
(D. 1431)

Stone altar tomb with a recumbent effigy of the duchess in a long cloak and widow's hood. The hands have been broken off, but traces of original pigment and of a painted inscription remain. A fine wooden canopy, shown in an eighteenth-century engraving, has been lost. The duchess died on the Isle of Wight and was brought in great state to be buried here. 21

WILLIAM DUDLEY
(ALSO CALLED SUTTON) (D. 1483), BISHOP OF DURHAM

Purbeck marble tomb. The inscription and a brass of the bishop in vestments have been lost, but an elaborate stone canopy survives, ornamented with sculpted heads and animals. 14

SIR HUMPHREY STANLEY
(D.1505), KNIGHT

Tomb-slab with a brass of Sir Humphrey in armour. 08

ELIZABETH CECIL, BARONESS ROS (c.1576–97), WIFE OF WILLIAM CECIL (SUBSEQUENTLY 2ND EARL OF EXETER)

Stone effigy of the countess in a hooded mantle, reclining beneath a semicircular arch above the Paulet monument. Three coloured shields are fixed to the wall behind. The monument has been reduced in size. 19

◆ WINIFRED PAULET, MARCHIONESS OF WINCHESTER
(D. 1586)

Alabaster and marble monument attributed to Garrett Johnson. The marchioness's effigy, in red ermine-lined robes and a coronet, lies on an altar tomb flanked by columns supporting an entablature and a heraldic cartouche. Figures of the two surviving children of the

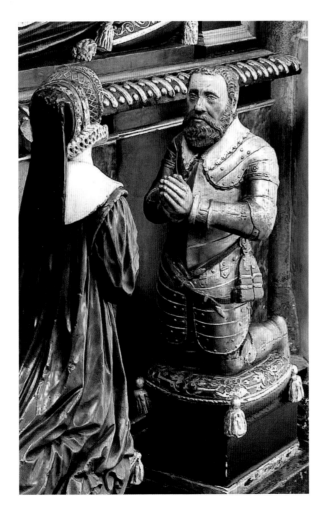

◆ *Figures of her children kneel beside the tomb of Winifred Paulet, marchioness of Winchester.*

marchioness's first marriage kneel in front. An effigy of a baby girl probably represents another child who died in infancy. 18

ANNE, DUCHESS OF SOMERSET
(D. 1587)

Standing monument, mainly of alabaster, 1588. An effigy of the duchess in red, ermine-lined robes and wearing a coronet, lies on a sarcophagus within a recessed arch. Columns support a superstructure decorated with heraldry and obelisks, and at the very top is the castle crest of the Stanhopes (the duchess's family) and a further pair of obelisks. The duchess's first husband was Edward, duke of Somerset, protector of Edward VI. 09

MILDRED CECIL, LADY BURGHLEY (D. 1589), AND HER DAUGHTER ANNE, COUNTESS OF OXFORD (D. 1588)

Tall marble monument attributed to Cornelius Cure. An effigy of Lady Burghley lies on a sarcophagus flanked by pavilions containing kneeling figures of her son Sir Robert and her three granddaughters. Behind, raised up within an arched recess, is an effigy of the countess of Oxford. The superstructure above contains a kneeling figure of Mildred's husband, Lord Burghley, long-serving secretary of state to Elizabeth I. At the summit is a heraldic achievement flanked by obelisks and shields. 13

ELIZABETH, LADY CECIL
(D. 1597), LADY OF THE BEDCHAMBER TO ELIZABETH I

Chest tomb of alabaster and marble. The ends are decorated with heraldry, the sides with gilded pilasters, winged cherub-heads and emblems of mortality, including a skull and a coffin. Corner pillars that once supported the tomb slab have been lost. Lady Cecil's husband, Sir Robert (later earl of Salisbury), composed the rhyming epitaphs. 06

ANNE SOPHIA DE HARLEY
(D. 1605)

Freestanding marble monument. The square base supports a pedestal decorated with heraldry and surmounted by an obelisk. A metal urn contains Anne Sophia's heart, placed here at the request of her father, the comte de Beaumont, who was French ambassador to the court of James I. 15

ELIZABETH, LADY FANE (D. 1618)

Wall monument of alabaster and marble. Figures of Lady Fane and her husband, Sir George (who erected the monument), kneel at a prayer desk within a canopied and curtained recess. Sir George, in armour, rests his hand on a skull. Carved angels fill recesses on either side, and above is a superstructure adorned with cherubs and heraldry. The inscription says Sir George intended to be buried with his wife, but this did not happen. 12

SIR GEORGE VILLIERS (D. 1605)
AND HIS SECOND WIFE,
MARY, COUNTESS OF
BUCKINGHAM (D. 1632)

Marble tomb and effigies by Nicholas Stone, assisted by Anthony Goor, 1631.
The chest is decorated with heraldry and supports recumbent effigies of Sir George (in armour and a plumed helmet) and his wife (in an ermine-lined robe and a coronet). Goor carved the four corner pedestals and Sir George's coat of arms (at the head of the tomb). 17

LADY JANE CLIFFORD (D. 1679)

Marble and alabaster monument, perhaps by John Bushnell. The urn-like sarcophagus is surmounted by a coronet and decorated with heraldry. The inscription is painted on two marble panels made to represent sheets of parchment. 07

NICHOLAS BAGENALL (D. 1688,
AGED TWO MONTHS)

Marble monument consisting of a base and a pyramid. The inscription records that the child was 'unfortunately overlayd' by his nurse. 10

ELIZABETH PERCY, DUCHESS
OF NORTHUMBERLAND (D. 1776)

Marble monument designed by Robert Adam and sculpted by Nicholas Read, 1778. From its base rise tall pedestals bearing figures of Hope (with an anchor) and Faith (with a
cross), between which is a sarcophagus with a carving of the duchess distributing alms. An urn above is flanked by weeping cherubs, and behind this rises a tall pyramid with heraldic decoration. The inscription within the arch commemorates the duchess, while an additional inscription below records those buried in the Percy vault. A floorstone with a brass coat of arms marks the entrance to the eighteenth-century vault (another stone marked with a crescent moon, a Percy family badge, covers the entrance to an earlier vault). 20

ISABELLA SUSANNAH PERCY,
COUNTESS OF BEVERLEY
(D. 1812)

Marble monument by Joseph Nollekens, c.1816, decorated with palm leaves. 05

Here is also the tomb of Nicholas Carew and his wife, Margaret (both d. 1470). Also the grave of Thomas Sprat (1635–1713), dean of Westminster 1683–1713, and his son Thomas (d. 1720), prebendary of Westminster 1713–20, a monument to both of whom is in the nave.

Tomb effigy of William de Valence, earl of Pembroke, in St Edmund's Chapel.

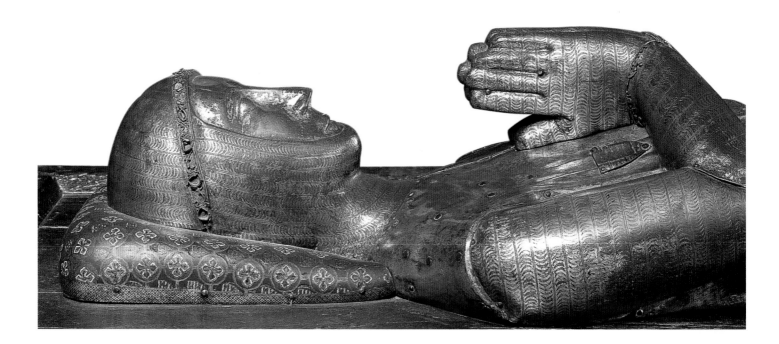

St Edmund's Chapel

This chapel is dedicated to Edmund, king of East Anglia (martyred 870), and is separated from the ambulatory by a fine wooden screen with a central doorway. The otherwise plain windows include three pieces of medieval heraldic glass, placed here in 1938. They depict the three lions of England for Henry III, the red pallets of Provence for his queen, Eleanor, and the red lion rampant crowned for Richard, earl of Cornwall, Henry's brother-in-law.

MONUMENTS AND FLOORSTONES

WILLIAM DE VALENCE, EARL OF PEMBROKE (D. 1296), HALF-BROTHER OF HENRY III

The tomb of Reigate stone has a wooden effigy adorned with the only surviving examples in England of Limoges *champlevé* enamel work. The effigy (in mail) and the chest on which it lies are of oak, and both were once covered with enamelled copper plates. Most of these have been lost, but those that remain include five small shields on round plates. The decoration on the figure is more complete, and the cushion under the head and the large shield show the *champlevé* work at its most impressive. The earl's arms also appear on the pillow, on small shields on his surcoat, and on one of the roundels of the stone base. 47

JOHN OF ELTHAM, EARL OF CORNWALL (D. 1336), SECOND SON OF EDWARD II

Alabaster tomb attributed to William Ramsay III. The twenty-four niches originally all contained 'weepers', probably representing the earl's royal relations. Three are now missing, and others have been mutilated; those on the north side are in the best condition. The armoured effigy holds

ABOVE: *Monuments in St Edmund's Chapel.*

a shield bearing the arms of England with a border of the arms of France. Two angels support the head, and the feet rest on a lion. The original tomb canopy was torn down at the duchess of Northumberland's funeral in 1776. 26

WILLIAM (D. 1348) AND BLANCHE (D. 1342), CHILDREN OF EDWARD III

Small marble tomb, with alabaster effigies only 20 inches long by John Orchard, 1376. The inscription and figures that adorned the base have disappeared. The children are often referred to as William of Windsor and Blanche of the Tower (i.e., the Tower of London) after their places of birth. 28

SIR BERNARD BROCAS (D. 1395)

Stone tomb, effigy and canopy. The effigy is in armour, the feet resting on a lion and the head on a helmet with the Brocas crest (a crowned Moor's head). The monument was repainted in the mid-eighteenth century, but the fine brass inscription (with depictions of animals and birds between the words) is original. 40

ROBERT DE WALDEBY (D. 1398), ARCHBISHOP OF YORK

Marble slab on a modern base with a brass of the bishop in vestments and mitre, his right hand raised in blessing, his left holding a cross. He stands beneath a canopy with the royal arms above. Two shields and part of the inscription have been lost. 44

ELEANOR (*née* DE BOHUN), DUCHESS OF GLOUCESTER (D. 1399)

Low marble tomb with the finest brass in the Abbey. It shows the duchess in her widow's dress beneath a triple canopy, the centre of which displays the Bohun badge of a swan. The supporting columns are decorated with shields of arms. Eleanor married Thomas of Woodstock, youngest son of Edward III. 45

SIR HUMPHREY BOURGCHIER (D. 1471), KNIGHT

Low marble tomb. A brass of Sir Humphrey in armour has mostly disappeared, but the helm, shields and badges survive. 39

FRANCES, DUCHESS OF SUFFOLK

(1517–59), MOTHER OF
LADY JANE GREY

Alabaster tomb and effigy, 1563. The chest has inscribed sides adorned with heraldry. The duchess's first husband, Henry Grey, duke of Suffolk, was executed shortly after their daughter, and the duchess lived in poverty throughout Mary Tudor's reign. 31

LADY JANE SEYMOUR

(D. 1560), DAUGHTER OF EDWARD, DUKE OF SOMERSET

Alabaster tablet decorated with a shield of arms and phoenix crests. This and the Knollys monument are the earliest mural tablets in the Abbey. 34

CATHERINE KNOLLYS

(D. 1569), LADY OF THE BEDCHAMBER TO ELIZABETH I

Alabaster tablet decorated with shields of arms. The decorative border features a swan crest and the heads of a bull and a young woman. 33

SIR RICHARD PECKSALL

(D. 1571)

Marble and alabaster monument with three arched recesses containing figures. Sir Richard, in armour, kneels in the middle flanked by his two wives (both called Eleanor). Beneath Sir Richard are small kneeling figures of his four daughters. 41

JOHN, LORD RUSSELL

(D. 1584), SON OF THE 2ND EARL OF BEDFORD

Large marble and alabaster tomb with an effigy of Lord John wearing a fur-lined robe and reclining on his elbow. At his feet is an effigy of his infant son Francis (d. 1581), who is also buried here. Against the wall is an arch with allegorical figures in the spandrels and an achievement of arms supported by two bedeswomen. The Latin, Greek and English inscriptions are by Russell's widow, Elizabeth, a noted linguist. 36

Carved detail from the tomb of John of Eltham, earl of Cornwall.

ELIZABETH RUSSELL (1575–1600), DAUGHTER OF JOHN, LORD RUSSELL

Alabaster and marble statue set on a decorated pedestal. It depicts Elizabeth Russell in a basket-weave chair, her right foot resting on a skull, and is thought to be the earliest English monument showing a seated figure. 35

EDWARD TALBOT, 8TH EARL OF SHREWSBURY (D. 1618), AND HIS WIFE, JANE (D. 1626)

Alabaster and marble monument by William Wright (formerly attributed to Maximilian Colt). A sarcophagus beneath a triumphal arch supports effigies of the earl and countess, the former wearing armour with a mantle, the latter a mantle and a coronet. At their feet are heraldic crests in the form of silver beasts. An effigy of their daughter kneels at the countess's feet. 42

FRANCIS HOLLES

(D. 1622), SOLDIER

Monument by Nicholas Stone depicting Holles in Roman armour sitting on a circular pedestal, his left hand resting on an armorial shield. The figure is derived from Michelangelo's Medici monument in the church of San Lorenzo, Florence. 32

NICHOLAS MONCK

(1610–61), BISHOP OF HEREFORD

Marble monument by William Woodman, 1723. An elaborate sarcophagus supports an inscribed pedestal and a background embellished with heraldry. The bishop's brother was George Monck, 1st duke of Albermarle. 29

JOHN PAUL STAFFORD-HOWARD, 4TH EARL OF STAFFORD (1700–62)

Marble monument by Robert Chambers, consisting of an inscribed tablet decorated with arms and badges associated with the Stafford family. The earl's grave, shared with his wife, Elizabeth (d. 1783), is near by. 27

Also in this chapel are the tomb of Henry Ferne (1602–62), bishop of Chester, and a monument to Mary, countess of Stafford (d. 1694). Here too are the gravestones of: Edward, 3rd Baron Herbert of Cherbury (c.1633–78); Henry Howard, earl of Stafford (d. 1719); Edward Bulwer Lytton, 1st Baron Lytton (1803–73).

St Benedict's Chapel

This small chapel, standing at the point where the south ambulatory opens into the south transept, is dedicated to the founder of the Benedictine Order, to which the monks of Westminster belonged. Here they kept a relic of the head of St Benedict, given by Edward III in 1335. Part of the medieval tiled floor survives, but the place of the altar is now occupied by the tomb of the countess of Hertford.

In the Middle Ages the Abbey sometimes had an anchorite – a person who had withdrawn from the world to live a solitary life of prayer and mortification. The doorway on the

◆ Tomb effigy of Abbot Simon Langham.

south side of this chapel, opened up in 1878 after long concealment, originally led to the cell where the anchorite was almost permanently confined.

MONUMENTS AND FLOORSTONES

◆ **CARDINAL SIMON LANGHAM** (D. 1376), ABBOT OF WESTMINSTER 1349–62

Alabaster and marble tomb by Henry Yevele and Stephen Lote, c.1395. The chest, decorated with heraldry, supports an effigy of Langham in Mass vestments with two dogs at his feet. The canopy was broken down at the coronation of George I in 1714 and not restored. Langham was successively abbot of Westminster, chancellor of England (1362–6) and archbishop of

Canterbury (1366–8). On being made a cardinal he was obliged to give up the archbishopric and go to the papal court at Avignon. He was originally buried there but in accordance with his wishes was later reburied in the Abbey, of which he was a great benefactor. Besides substantial gifts of money, plate and vestments during his lifetime he bequeathed it the residue of his fortune and seven crates of books. 60

WILLIAM BILL (D. 1561), DEAN OF WESTMINSTER FROM 1560

Low marble tomb with a brass figure of Bill in doctor's robes, inscriptions in brass and indents of lost shields at each corner. Bill was the first dean of the collegiate church after its establishment by Elizabeth I. 61

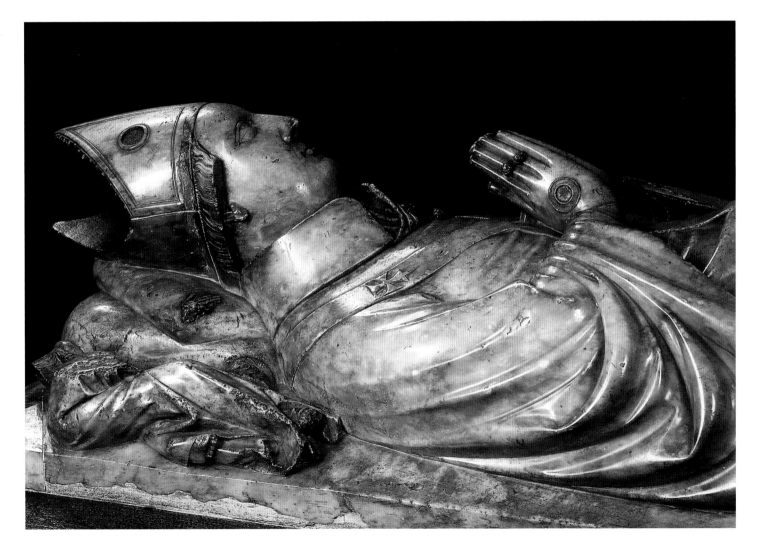

FRANCES, COUNTESS OF HERTFORD (1554–98)

Tomb and effigy, mainly of alabaster, by the Southwark school of tomb-makers. It extends to a considerable height and depicts the countess in a red fur-lined cloak, her head resting on cushions and with a golden lion at her feet. 63

◈ GABRIEL GOODMAN (1529–1601), DEAN OF WESTMINSTER FROM 1561

Painted stone monument depicting Goodman kneeling at a prayer desk beneath a round-headed arch. He succeeded William Bill as dean and was also chaplain to Lady Burghley, who named two scholarships for Old Westminsters at St John's College, Cambridge, after him. A Welshman by birth, Goodman founded the grammar school at Ruthin. 65

◈ Monument to Gabriel Goodman, dean of Westminster.

LIONEL CRANFIELD, 1ST EARL OF MIDDLESEX (1575–1645), STATESMAN, AND HIS SECOND WIFE, ANNE (D. 1670)

Marble tomb and effigies by Nicholas Stone. Heraldic achievements adorn the ends of the chest, on which lie effigies of the earl and countess in robes and coronets, the earl holding a sword and the countess a book. At their feet are respectively an antelope and a griffin. The Cranfields' graves are in the south ambulatory. 53 & 62

GEORGE SPRAT (1682–3), INFANT SON OF THOMAS SPRAT, DEAN OF WESTMINSTER

Wall tablet of Purbeck marble. 64

MONKS OF WESTMINSTER

Stone wall tablet by Alfred Siegenthaler, 1968. An inscription beneath the head of a monk commemorates the Benedictines who served at Westminster until its dissolution in 1540 and again during the reign of Mary Tudor. 66

Also in this chapel are the unmarked graves of: William de Curtlyngton (d. 1333), abbot of Westminster 1315–33; John Spottiswoode (1565–1639), archbishop of St Andrews; and James Spottiswoode (1567–1645), bishop of Clogher.

OTHER FEATURES

CITIZENS OF WESTMINSTER WINDOW

Designed by Hugh Easton, 1948, to commemorate Westminster citizens who died during the Second World War. It depicts St George and St Michael with the arms of the city of Westminster and badges and emblems representing the armed forces and other organisations. An earlier window (destroyed in 1940) commemorated the officers and men of the Queen's Westminster Rifles.

South Transept

In constructing the south transept Henry III's masons were constrained by the position of the existing Norman cloisters (though these were themselves soon to be rebuilt). It was impossible to build a western aisle to match that in the north transept since the east cloister walk filled the place where it should be. The solution was ingenious: the cloister was incorporated into the transept space at ground level (but separated from it by a solid wall), and the aisle was built at upper level only, above the cloister vault. In the process a chamber was created over the cloister walk, open to the church on its northern and eastern sides, which has been used for centuries as a muniment room. The eastern aisle of the transept also differed from the treatment of the same area on the north side. A door in the south-east corner led from the church to the Palace of Westminster, while another door beside it gave access to the crypt of the chapter house. Regular comings and goings through these doors probably explain why the eastern aisle of the transept was never furnished with chapels. Though divided by an arcade of arches, the aisle is at least visually part of the main body of the transept.

On the north side a wooden screen separated the transept from the crossing and quire, a central doorway providing access for services. Opposite, in the southern portion of the transept, stone screens originally enclosed a small vestry (giving access to St Faith's Chapel) and a chapel dedicated to St Blaize. In the vestry a spiral staircase (the 'night stairs') led via a gallery at the west end of St Faith's Chapel to the monks' dormitory. After the Reformation the stone screen was replaced with wainscot, but around 1723 the eastern side was removed and the present stone wall was erected and gradually filled with monuments on both sides.

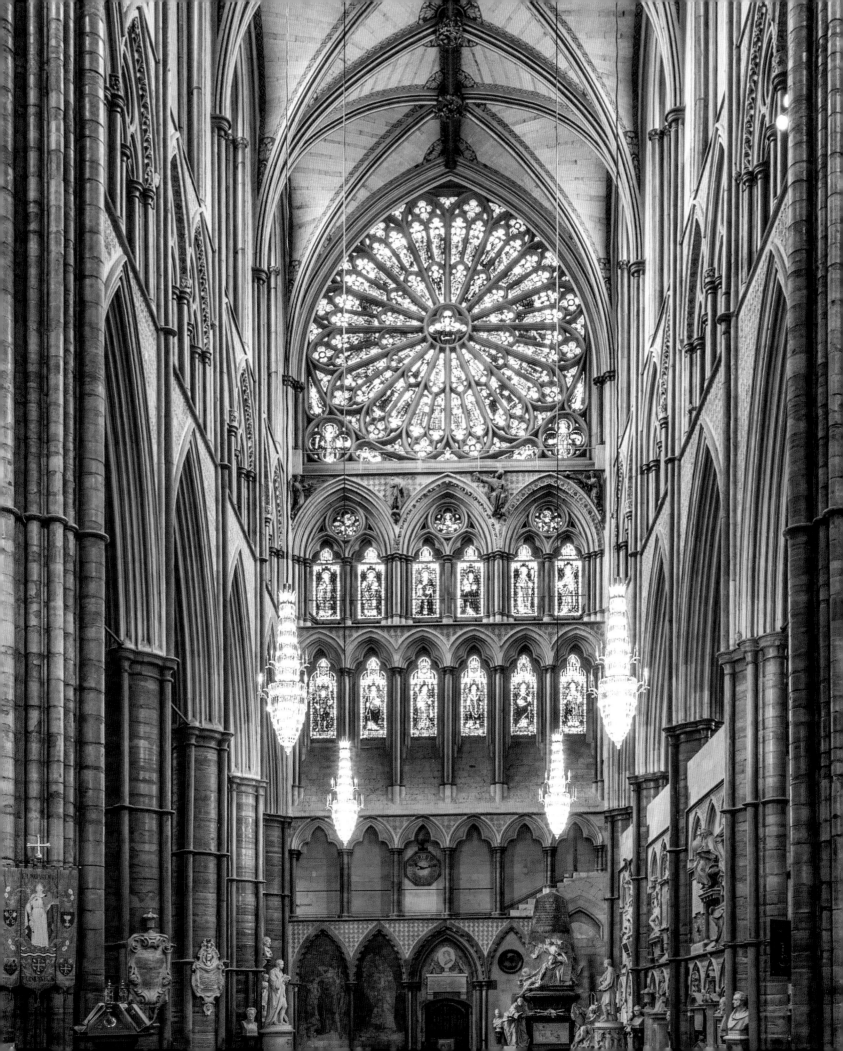

The night stairs were demolished in 1743 to accommodate the Argyll monument, but at least part of the enclosure remained as vestries until the latter part of the eighteenth century.

The south wall is dominated by the great rose window, beneath which are important survivals of the original sculptural decoration of the Gothic church. The censing angels at triforium level, carved during the 1250s, were originally coloured and gilded. Their style derives from sculpture produced at Reims in the previous decade, and they are among the most important examples of English medieval sculpture of their time. The same sculptor or his assistants probably produced much of the carving elsewhere in the eastern part of the church.

Although the whole of this transept is now often called 'Poets' Corner', it has long housed tombs and memorials of other writers such as historians and theologians. The burials of Chaucer and Spenser in the eastern aisle began the association of this part of the church with poets and dramatists, and over time the graves and memorials have spread across the transept. A poem of 1733 'Upon the Poets' Corner in Westminster Abbey' is the first known use of that title, but even before this Joseph Addison had written in *The Spectator* about 'the poetical quarter'. In the latter half of the nineteenth century Dean Stanley tried unsuccessfully to establish a 'Little Poets' Corner' under the south-west tower (the present St George's Chapel). A few literary memorials remain there, but others, such as Wordsworth's monument, have been moved to this transept.

ABOVE:
A modern cast of one of the censing angels carved beneath the south rose window.

LEFT:
Floorstones in Poets' Corner.

OPPOSITE:
◆ *The magnificent Crucifixion illumination from the Litlyngton Missal (1383–4).*

MONUMENTS AND FLOORSTONES

ROBERT HAULEY (HAULE *or* HAWLEY (D. 1378), KNIGHT

Hauley's burial here arose from a violent episode in the Abbey's history. At the battle of Najera in 1367 he had captured the count of Denia, an Aragonese nobleman. Subsequently Hauley and a fellow squire, John Shakel, took the count's elder son, Alfonso, hostage for the payment of his father's ransom. When Hauley and Shakel refused an order to release Alfonso, they were thrown into the Tower of London, but in 1378 they escaped by force and took sanctuary at Westminster. A royal letter to Abbot Litlyngton failed to secure their surrender, and on 11 August the constable of the Tower broke into the Abbey sanctuary with fifty soldiers and captured Shakel. Hauley and a sacrist named Richard were pursued into the quire during High Mass and killed there. Those responsible were excommunicated, and the church was later reconsecrated. Hauley's gravestone, the earliest surviving in this transept, bears the indent of a lost brass of a knight in armour. John Shakel (d. 1396) was subsequently buried beside Hauley. 112

◆ NICHOLAS LITLYNGTON (D. 1386), ABBOT OF WESTMINSTER 1362–86

Litlyngton continued the rebuilding of the nave (with the aid of his predecessor Simon Langham's money) and also rebuilt the west and south cloisters, the conventual buildings on the east side of Dean's Yard and the boundary wall of the monastic precinct. He enlarged the refectory and built the parts of the abbot's lodgings now known as the Jerusalem Chamber and College Hall. The magnificently illuminated missal he commissioned for the high altar in 1383 is one of only two liturgical books that remained at the Abbey after the dissolution. 141

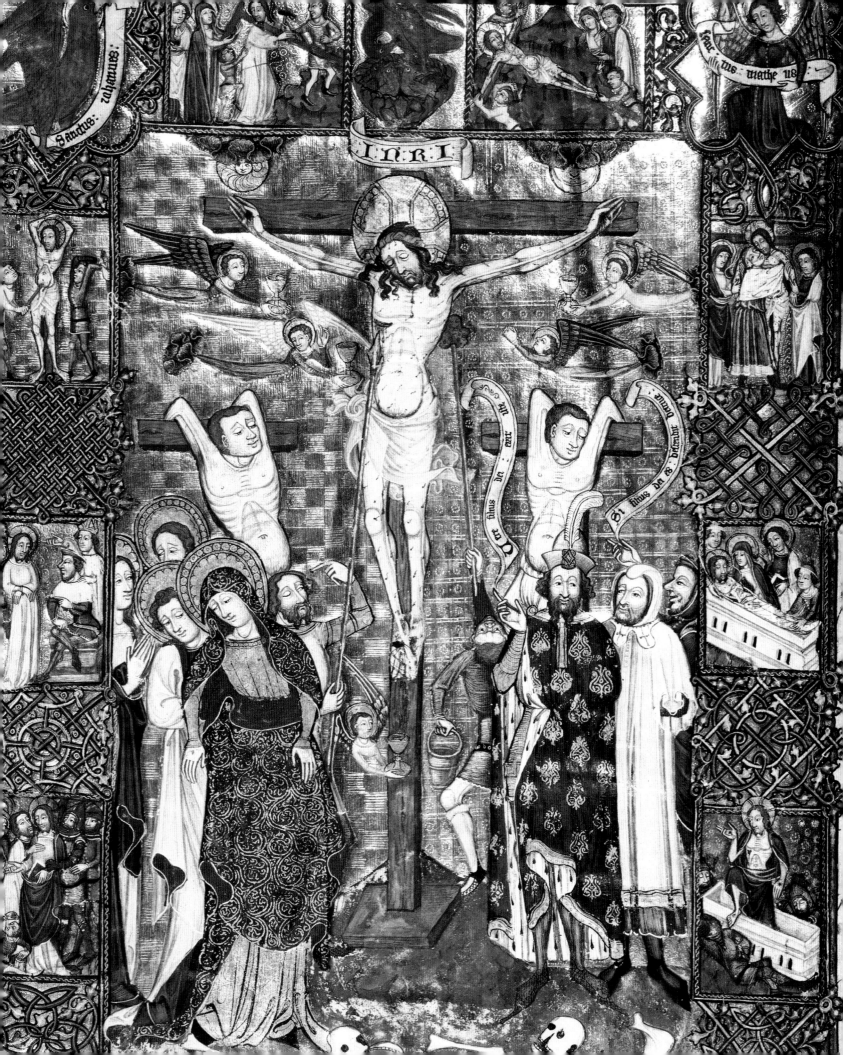

◆ Geoffrey Chaucer

(c.1343–1400), POET

Marble altar tomb with canopy, c.1556. Chaucer was first buried at the entrance to St Benedict's Chapel, not on account of his literary reputation but because he had held office in the royal household (including a period as clerk of the king's works at Westminster) and during the last years of his life had leased a house near the old Lady Chapel. For 150 years his only memorial was a metal epitaph hanging on an adjacent pillar, but in 1556 the poet Nicholas Brigham erected the present tomb and, according to the antiquary William Camden, moved Chaucer's remains to it. Alongside the Latin inscription at the back of the tomb was originally a portrait of Chaucer and probably a second figure too (perhaps of Brigham himself). 71

Owen Tudor

He was the son of Owen Tudor and Queen Catherine (widow of Henry V), and thus the uncle of Henry VII. Using the name Edward Bridgewater, he appears to have been a monk of Westminster c.1468–72. 141

William Boston (D. 1549), ABBOT
OF WESTMINSTER 1533–40 AND
DEAN OF WESTMINSTER 1540–49

Originally a monk of Peterborough Abbey, Boston later moved to Westminster, where as abbot he presided over the dissolution in 1540. Shortly afterwards the Abbey became a cathedral, and Boston, reverting to his family name of Benson, became its dean. At Edward VI's coronation (1547) Benson assisted the archbishop, as abbots of Westminster had traditionally done, and thereby established the right of deans of Westminster to participate in the ceremony. 141

Edmund Spenser

(1553–99), POET

Spenser, whose epic poem *The Faerie Queene* was dedicated to Elizabeth I, was the next poet after Chaucer to be

◆ *An eighteenth-century engraving of Geoffrey Chaucer.*

buried here. It is said that at his funeral his contemporaries, probably including Shakespeare, threw elegies they had written into his grave. The original marble monument by Nicholas Stone, erected in 1620, fell into decay and was replaced by an exact copy in 1778. 83

William Camden

(1551–1623), HERALD AND HISTORIAN

Marble monument featuring a portrait bust holding a book with painted shields on either side. Camden served Westminster School for over twenty years, first as under master and then as head master. He became the Abbey's first 'library keeper' in 1587 and Clarenceux king of arms in 1597 (the coronet on the monument refers to this office). In 1600 Camden published (in Latin) the first guide to the Abbey's monuments. 176

Sir Richard Coxe

(D. 1623), COURTIER

Marble monument by Nicholas Stone, c.1623. Coxe served as 'taster' to both Elizabeth I and James I, and was steward of the household to the latter. 182

William Heather

(1563–1627), MUSICIAN

Heather was a chorister and lay vicar in the Abbey's choir and a gentleman of the chapel royal. A stone marking

his grave was presented by the University of Oxford in 1926 on the 300th anniversary of its professorship of music, which Heather founded. 174

MICHAEL DRAYTON
(1563–1631), POET

Marble and alabaster monument by Edward Marshall, incorporating a bust crowned with laurels. The inscription may be by Ben Jonson, and the decoration includes Drayton's heraldic emblems (the winged horse Pegasus and the winged hat of Mercury on a radiant sun). 78

ISAAC CASAUBON
(1560–1614), SWISS CLASSICAL SCHOLAR AND HISTORIAN

Marble monument by Nicholas Stone, 1634. 178

THOMAS PARR (D. 1635)

The inscription alleges that Parr was 152 at the time of his death, which is perhaps unlikely, but he was obviously unusually old by the standards of his time. In 1635 he was taken from his Shropshire home to London, where he became an object of curiosity. City life did not apparently suit him, however, and he died within six weeks. 154

THOMAS TRIPLET(T)
(c.1602–70), PREBENDARY OF WESTMINSTER 1662–70

Marble monument with an inscription referring to Triplet's religious piety, his scholarship and his concern for the poor. Two charities established under his will to assist apprentices still exist. 184

ISAAC BARROW (1630–77),
MATHEMATICIAN AND THEOLOGIAN

Marble monument probably by John Bushnell. Barrow was master of Trinity College, Cambridge, and contracted a fever while attending the annual election of scholars from Westminster School. His attempts to cure himself by fasting and taking opium probably hastened his demise. 187

ABRAHAM COWLEY
(1618–67), POET

Marble monument by John Bushnell, c.1682, consisting of a large urn and pedestal, accommodated against the wall by ruthlessly cutting away the medieval arcading. In front, on Cowley's gravestone, are inscribed also the names of several writers whose graves in this transept are unmarked. They are: Chaucer, Dryden, St Evremond and Prior (who also have monuments), Sir John Denham (1615–69), Sir Robert Moray (1603–73) and Francis Beaumont (1584–1616). 70 & 109

THOMAS SHADWELL
(1642?–92), POET LAUREATE

Marble monument by Francis Bird, c.1700, consisting of a wreathed bust on an inscribed base. Shadwell died of an overdose of opium and is buried at Chelsea. 88

CHARLES DE ST DENIS, SIEUR DE SAINT-EVREMOND
(1613–1703), SOLDIER AND WRITER

Marble tablet supporting a bust within a niche. 91

RICHARD BUSBY (1606–95),
HEAD MASTER OF WESTMINSTER SCHOOL 1639–95 AND PREBENDARY OF WESTMINSTER 1660–95

Marble monument by Edward Chapman (formerly attributed to Francis Bird), 1703, incorporating a reclining figure of Busby holding a pen and a book. He was the most celebrated

◆ *Bust of John Milton.*

schoolmaster of his time, and the bulk of his library remains at Westminster School. His other benefactions included the paving of the quire (1677), beneath which he is buried. **57**

JOHN PHILIPS (1676–1709), POET
Marble monument, c.1710, consisting of a portrait medallion framed by a laurel tree (symbolic of an eloquent poet) and an apple tree. The latter alludes to Philips's poem 'Cyder', a celebration of his native Hereford-shire. The poem's epigraph (a quotation from Virgil) appears on the monument. Buried in Hereford Cathedral. **73**

ROBERT SOUTH (1634–1716), PREBENDARY OF WESTMINSTER 1663–1716
Marble monument by Francis Bird, incorporating a reclining figure of South, one hand resting on a skull, the other holding a closed book. He is buried close to the grave of Dr Busby, whose pupil he had been at Westminster School and whose monument seems to have been the inspiration for his own. **55**

SAMUEL BUTLER (1612–80), POET
Marble monument, the bust probably by Michael Rysbrack, 1721. The grotesque heads flanking the inscription may allude to Butler's satirical writings. **84**

JOHN DRYDEN (1631–1700), DRAMATIST AND POET LAUREATE
Marble plinth by James Gibbs, 1721; bust by Peter Scheemakers, 1731. The original monument, commissioned by John Sheffield, duke of Buckingham, incorporated a large architectural structure enclosing an idealized bust on a pedestal. The bust did not find favour, and the duchess of Buckingham later asked Scheemakers to replace it. The original surround was removed in the nineteenth century. **67**

MATTHEW PRIOR (1664–1721), DIPLOMAT AND POET
Marble monument designed by James Gibbs and mostly sculpted by Michael Rysbrack, c.1721. The sarcophagus, flanked by figures of Poetry and History, supports a bust of Prior made in Paris in 1714, by Antoine Coysevox, and given to the poet by Louis XIV. Above the pediment are cherubs bearing an hour-glass and an inverted torch (symbols of mortality). Prior's body lay in state in the Jerusalem Chamber for three days before his funeral and was escorted into church by the scholars of Westminster School carrying tapers, seventy mourning men bearing branch lights and a dozen almsmen carrying torches. **89**

BEN JONSON (1574–1637), DRAMATIST AND POET
Marble monument designed by James Gibbs and attributed to the sculptor Michael Rysbrack, c.1723. It consists of a portrait medallion with the inscription 'O rare Ben Jonson' and three masks linked by a ribbon. Earlier plans for a memorial to Jonson had been deferred at the outbreak of the Civil War. Buried in the nave. **82**

JOHN ERNEST GRABE (1666–1711), PRUSSIAN PRIEST AND THEOLOGIAN
Marble monument by Francis Bird, 1727, depicting Grabe holding a pen and a book and seated on a sarcophagus. Buried at St Pancras Old Church. **179**

◆ *Monument to William Shakespeare.*

EDWARD WETENHALL

(*c*.1660–1733), PHYSICIAN

Marble monument by William
Woodman, 1735. Wetenhall practised
in Cork but died visiting his native
England and is buried alongside his
father, Edward (1636–1713), bishop
of Kilmore and Ardagh. 156, 157 & 188

◆ JOHN MILTON

(1608–74), POET

Marble bust by Michael Rysbrack,
1737. The commemoration of the
author of *Paradise Lost* was long
delayed on account of his support
for the Parliamentary cause during
the Civil War. A stained-glass window
in his memory was erected in St
Margaret's Church (where he married
his second wife) in 1888. Buried in St
Giles Cripplegate, London. 86

◆ WILLIAM SHAKESPEARE

(1564–1616), DRAMATIST

Marble monument designed by
William Kent and sculpted by Peter
Scheemakers, 1740. A figure of
Shakespeare stands in front of an
architectural surround, his elbow
resting on a pile of books from which
hangs a scroll bearing a variant of
some lines from *The Tempest*. Beneath
are carved heads of Elizabeth I, Henry
V and Richard III. Renewed interest
in Shakespeare's writings in the
eighteenth century drew attention to
the lack of a monument in the Abbey,
and special performances of *Hamlet*
and *Julius Caesar* were given to raise
funds for one. Buried at Stratford-
upon-Avon. 124

ATKYNS FAMILY

Marble monument by Sir Henry
Cheere, *c*.1746, commemorating Sir
Edward Atkyns (1587–1669) and his
sons Sir Robert (*c*.1621–1710) and Sir
Edward (1631–98). All three were
judges (or 'barons') of the exchequer
court. Another family member, Sir
Robert Atkyns (*c*.1647–1711), is also
commemorated. Not buried in the
Abbey. 196

◆ JOHN CAMPBELL, DUKE OF ARGYLL AND GREENWICH

(1680–1743), SOLDIER AND
POLITICIAN

Marble monument by Louis-François
Roubiliac, 1749, his earliest work in
the Abbey. It depicts the duke in
Roman armour beneath a figure of
History, who inscribes the duke's
titles, stopping short at 'Gr' to show
that the dukedom of Greenwich
expired with him. On the left at
ground level is a figure of Eloquence,
with books representing the duke's
skill in oratory at her feet. On the right
sits Minerva, goddess of wisdom. A
carved relief shows Liberty enthroned,
with a cherub in front holding Magna

*◆ Monument to
John Campbell,
duke of Argyll.*

Carta. The duke's grave, shared with
his wife, Jane (d. 1767), and two of their
daughters, is in the Lady Chapel. 133

ELIZABETH, LADY LECHMERE,

AND HER SECOND HUSBAND,
SIR THOMAS ROBINSON

(1700–77), ARCHITECT AND
PATRON OF THE ARTS

Marble monument with busts
attributed respectively to Edmé
Bouchardon, 1753, and Filippo della
Valle, 1778. The busts stand on a
sarcophagus decorated with heraldry
and other ornaments. Sir Thomas is
buried at Merton, Surrey; Lady
Lechmere's place of burial is
unknown. 193

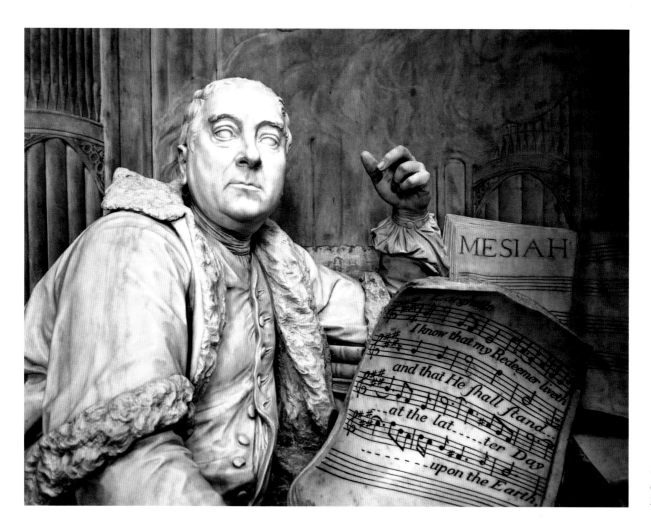

◆ Monument to
George Frederick
Handel.

STEPHEN HALES (1677–1761), PRIEST AND SCIENTIST

Marble monument by Joseph Wilton, 1761. Figures of Religion and Science, the latter holding a portrait and a cornucopia, allude to Hales's varied interests. At Science's feet is a globe with winged heads representing winds, probably a reference to Hales's invention of a ventilator. Buried at Teddington, Middlesex. 190

JAMES THOMSON (1700–48), POET, AUTHOR OF 'RULE BRITANNIA'

Marble statue designed by Robert Adam and sculpted by Michael Henry Spang, 1762. Thomson wears Classical dress and leans against a pedestal carved with scenes representing his poem *The Seasons*. Buried in Richmond parish church, Surrey. 127

◆ GEORGE FREDERICK HANDEL (1685–1759), COMPOSER

Marble monument by Louis-François Roubiliac, 1762. Though Handel had requested a private burial, his funeral was in fact a grand occasion conducted by the dean and attended by the prebendaries, the full choir and a large congregation. The monument occupies a deep niche and consists of a life-size figure of Handel standing before an organ. One hand gestures towards a figure of King David playing a harp, the other rests on a score of 'I know that my Redeemer liveth', from *Messiah*. Handel's gravestone is in the floor below.

A tablet above the arch commemorates the 'Handel Commemoration', a series of charitable concerts held in 1784. Some of the concerts were given elsewhere, but the Westminster performances particularly caught the

public imagination since the Abbey had never before been used as a concert venue. The musicians (a chorus of nearly 300 and an orchestra of about 240) occupied a gallery at the west end, and the audience (including George III and members of the royal family) numbered around 3,000 people. 145 & 195

MARY HOPE (D. 1767)

Marble tablet by Robert Adam, 1768. Not buried in the Abbey. 199

BARTON BOOTH (1681–1733), ACTOR

Marble monument by William Tyler, 1772. A portrait medallion resting on a sarcophagus is crowned with laurels by a cherub, while another holds a scroll and has a cup and dagger (symbols of tragedy) at his feet. Buried at Cowley, Middlesex. 74

◆ The eighteenth-century actor David Garrick has an appropriately theatrical monument.

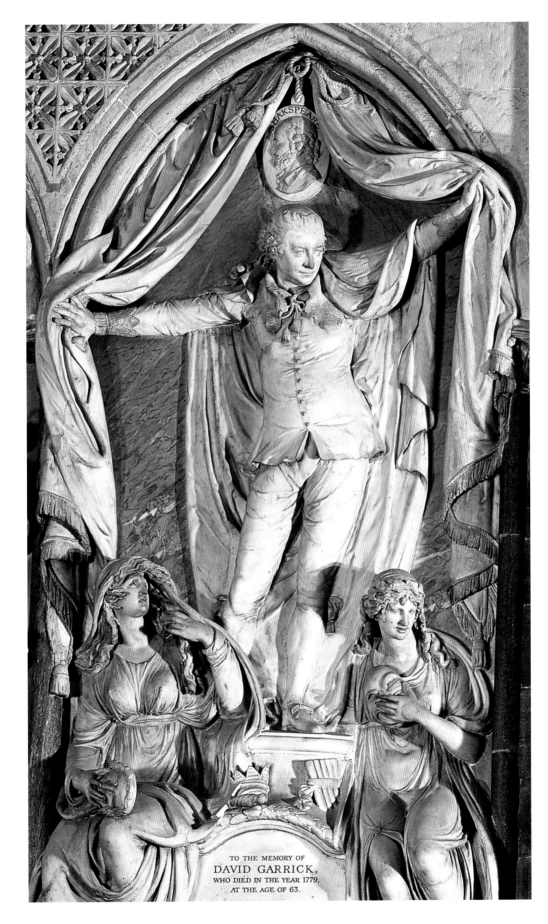

TO THE MEMORY OF
DAVID GARRICK,
WHO DIED IN THE YEAR 1779,
AT THE AGE OF 63.

JOHN ROBERTS (*c*.1712–72),
POLITICIAN
Marble tablet by Richard Hayward, 1776, resting on top of Chaucer's tomb. It includes a small portrait. Not buried in the Abbey. 72

OLIVER GOLDSMITH (1728–74),
POET, DRAMATIST AND NOVELIST
Marble monument by Joseph Nollekens, *c*.1777, with a Latin inscription by Dr Samuel Johnson. Buried at the Temple Church, London. 130

THOMAS GRAY (1716–71), POET
Marble monument by John Bacon, 1778. A seated figure of the Lyric Muse holds a portrait medallion and gestures to Milton's memorial above. The inscription is by the poet William Mason, who also paid for the monument. Buried at Stoke Poges, the scene of Gray's celebrated 'Elegy Written in a Country Churchyard'. 85

SIR JOHN PRINGLE BT
(1707–82), MILITARY PHYSICIAN
Marble monument by Joseph Nollekens, consisting of a bust on an inscribed base, ornamented with books and a staff entwined by a serpent (emblem of the Greek god of medicine). Buried at St James's church, Piccadilly, London. 185

SIR ROBERT TAYLOR (1714–88),
SCULPTOR AND ARCHITECT
Marble monument consisting of an urn decorated with flowers and a shield of arms ornamented with oak leaves. Taylor sculpted the Abbey monuments of Captain Cornewall (cloister entrance) and General Guest (north transept). Buried at St Martin-in-the-Fields, London. 181

ROBERT ADAM
(1728–92), ARCHITECT
Adam designed five monuments for the Abbey, including those to James Thomson and Mary Hope in this transept, and the Townshend and

André monuments in the nave. His own monument, designed by Joseph Nollekens, was never carried out. **163**

GENERAL SIR ARCHIBALD CAMPBELL (1739–91), COLONIAL GOVERNOR

Marble monument by Joseph Wilton, 1795. It depicts Fame bearing a trumpet and a portrait medallion, and a cherub carrying an extinguished torch and a wreath. It also commemorates Campbell's nephew Lieutenant-General Sir James Campbell Bt (1763–1819). **134 & 197**

SIR WILLIAM CHAMBERS (1722–96), ARCHITECT

Though best known as the architect of Somerset House, Chambers also designed the gold state coach used at coronations since 1760, and the Mountrath monument in St Michael's Chapel. **167**

◆ DAVID GARRICK (1717–79), ACTOR AND THEATRE MANAGER

Marble monument by Henry Webber, 1797. Garrick was paramount in re-establishing Shakespeare's reputation as the nation's greatest dramatist, and his monument is appropriately theatrical. Figures of Tragedy and Comedy hold an inscription while the actor himself pulls aside curtains in a dramatic gesture. A small portrait of Shakespeare is set above the actor's head. Garrick is buried with his wife, Eva Maria (d. 1822), beside his friend Samuel Johnson. **140 & 177**

WILLIAM MASON (1724–97), POET

Marble monument by John Bacon, 1799, consisting of a figure of Poetry mourning over a portrait. Buried at Aston, Yorkshire. **87**

JAMES STUART MACKENZIE (1719–1800), SCOTTISH POLITICIAN

Marble monument by Joseph Nollekens, 1801. Alongside a portrait medallion are a telescope, a square and

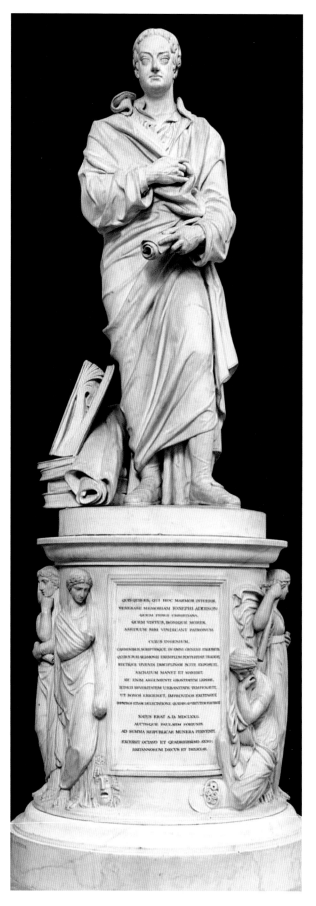

a pair of callipers, alluding to Mackenzie's interest in science. Not buried in the Abbey. **198**

CHRISTOPHER ANSTEY (1724–1805), POET

Marble monument by Charles Horwell. Buried at Bath. **111**

◆ JOSEPH ADDISON (1672–1719), POET AND ESSAYIST

Marble statue by Richard Westmacott, 1806. It depicts Addison in Classical costume, standing on a pedestal decorated with images of the Muses. In collaboration with Richard Steele, Addison founded and co-edited the journal *The Spectator,* in which he published two essays on the Abbey. He described it as 'a magazine of mortality' where 'men and women, friends and enemies, priests and soldiers, monks and prebendaries, were crumbled amongst one another, and blended together Beauty, Strength, and Youth, with Old-age, Weakness, and Deformity undistinguish'd in the same promiscuous heap of matter'. Guidebooks aside, these *Spectator* essays are the earliest published prose writings about the Abbey. Buried in the north aisle of the Lady Chapel. **146**

WILLIAM VINCENT (1739–1815), DEAN OF WESTMINSTER 1802–15

A marble tablet commemorates a dean of Westminster who entered Westminster School in 1748 and spent most of the rest of his life within the Abbey's precincts, as king's scholar, usher (assistant master), under master, head master (1788–1802), canon (1801–2) and finally dean. In the latter post his major preoccupation was the maintenance of the fabric, and he successfully petitioned Parliament for financial assistance to restore the Lady Chapel. Buried in St Benedict's Chapel. **56**

GRANVILLE SHARP

(1735–1813), CAMPAIGNER
FOR THE ABOLITION OF SLAVERY

Marble monument by Sir Francis
Chantrey, 1816. A small portrait is
flanked on one side by a praying slave,
and on the other by a lion and lamb
together. The inscription records
Sharp's tireless campaigning and his
part in the legal case involving the
slave James Somerset, over which Lord
Mansfield presided. The African
Institution of London erected the
monument. Buried at Fulham. 90

RICHARD BRINSLEY SHERIDAN

(1751–1816), DRAMATIST

Sheridan's friends provided him with
a magnificent funeral for, despite the
success of plays such as *The Rivals* and
The School for Scandal, he died in
poverty. 143

ROBERT SOUTHEY (1773–1843),
POET LAUREATE AND BIOGRAPHER

Marble monument by Henry Weekes,
c.1845, consisting of a bust within a
Classical niche. Buried at
Crossthwaite, Cumbria. 123

THOMAS CAMPBELL

(1777–1844), POET

Marble statue by William Calder
Marshall, 1848. Campbell died at
Boulogne, but his body was brought
back to England for burial. A group
of Polish exiles attended the funeral
(Campbell supported Polish
aspirations to independence) and
sprinkled on the coffin soil from the
grave of Tadeusz Kosciuszko, leader
of the Polish rising against Russia in
1794. 118 & 149

WILLIAM WORDSWORTH

(1770–1850), POET LAUREATE

Seated marble statue by Frederick
Thrupp, 1854. Wordsworth was one
of the leading figures of the Romantic
movement in English poetry, his love
of nature and especially of the
landscape of the Lake District,
expressed in such well-known

OPPOSITE:
◆ *Statue of Joseph
Addison.*

◆ *Bust of Alfred,
Lord Tennyson.*

poems as 'Daffodils' and in his verse
autobiography *The Prelude*. Thrupp's
statue, the winning design in a
national competition for a
Wordsworth memorial, was moved
here from its original position beneath
the south-west tower in 1932. Buried
at Grasmere, Cumbria. 119

◆ ALFRED, LORD TENNYSON

(1809–92), POET LAUREATE

Marble bust by Thomas Woolner, 1857,
a replica of one originally made for
Trinity College, Cambridge.

Tennyson's gravestone is near by.
His poem 'Crossing the Bar', set to
music by Sir Frederick Bridge, was
first sung at his own funeral in the
Abbey. 92 & 107

THOMAS BABINGTON, BARON
MACAULAY (1800–59), HISTORIAN

Marble bust by George Burnard, 1865.
Macaulay wrote a series of popular
poems on Roman history called *Lays
of Ancient Rome* but is best remembered
for his influential *History of England*.
151 & 191

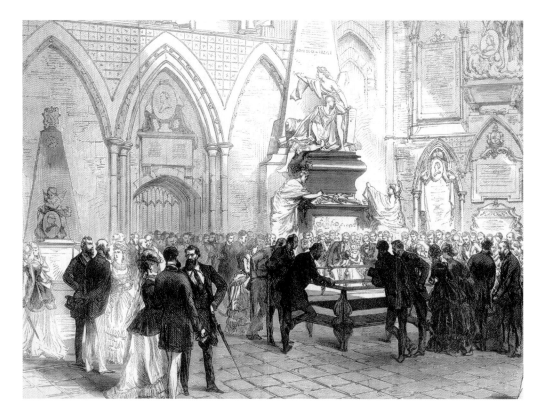

Crowds at the grave of Charles Dickens shortly after his funeral.

WILLIAM MAKEPEACE THACKERAY (1811–63), NOVELIST

Marble bust by Baron Marochetti, 1865. Though he was a prolific novelist and journalist, Thackeray is now best known for his novel *Vanity Fair*, which features the roguish anti-heroine Becky Sharp. Thackeray's Abbey memorial was prompted by a public petition whose signatories included Charles Dickens. Buried at Kensal Green cemetery, London. 192

◆ CHARLES DICKENS (1812–70), NOVELIST

The books of Charles Dickens (many originally written as serials) have had perhaps the largest circulation of any English works of fiction. He did not write only to entertain, however, but had a keen social conscience and, partly prompted by the experiences of his own childhood, highlighted the plight of the poorest and most disadvantaged in Victorian society. Dickens had wished to be buried in Rochester Cathedral, but by public demand his body was brought to Westminster Abbey for burial.

Though the funeral was strictly private, attended by only a few mourners, the grave was kept open for two days afterwards, and the public came in large numbers to pay their respects. 144

JOHN KEBLE (1792–1866), PRIEST AND POET

Marble bust by Thomas Woolner, 1872, originally part of a larger monument set up under the south-west tower. Keble was one of the founders of the Oxford Movement but is perhaps best remembered for his many hymns. Buried at Hursley, Hampshire. 183

GEORGE GROTE (1794–1871), POLITICIAN AND HISTORIAN OF GREECE, AND
CONNOP THIRLWALL (1797–1875), BISHOP, AND HISTORIAN OF GREECE

Marble busts by Charles Bacon, 1872, and E. Davis, 1876, respectively. Grote and Thirlwall were childhood friends and are buried in the same grave, though they have separate gravestones. 171 & 172

◆ FREDERICK DENISON MAURICE (1805–1872), THEOLOGIAN AND CHRISTIAN SOCIALIST

Marble bust, a replica of one by Thomas Woolner, sculpted in 1861. Set up in St George's Chapel by 1876 but moved to the south transept in 2014. Buried at Highgate cemetery. 79b

◆ CHARLES KINGSLEY (1819–75), AUTHOR, CANON OF WESTMINSTER 1873–5

Marble bust by Thomas Woolner, 1875, originally set up in St George's Chapel and moved to the south transept in 2014. Kingsley was a follower of F. D. Maurice and author of the children's book *The Water Babies*. Buried at Eversley, Hampshire. 79a

WILLIAM TWISSE (1577/8–1646), STEPHEN MARSHALL (1594/5–1655) AND WILLIAM STRONG (D. 1654), PURITAN CLERGY; THOMAS MAY (C.1595–1650), WRITER AND PARLIAMENTARY HISTORIAN

Memorial stone, 1880. Twisse presided over the Westminster Assembly of Divines, which Marshall also attended. Together with Strong they preached often in the Abbey during the Commonwealth. May's poetry and drama found favour at the court of Charles I, but he subsequently supported the Parliamentary side. All four men were originally buried in the Abbey but were reburied outside in 1661. 186

ARCHIBALD CAMPBELL TAIT (1811–82), ARCHBISHOP OF CANTERBURY

Marble bust by Henry Hugh Armstead, 1884. Buried at Addington, Kent. 59

HENRY WADSWORTH LONGFELLOW (1807–82), POET

Marble bust by Sir Thomas Brock, 1884, commemorating the author of *The Song of Hiawatha* and 'The Village

Blacksmith'. Though Longfellow's popularity as a poet has waned somewhat, phrases from his writing such as 'ships that pass in the night' and 'into each life some rain must fall' have entered the English language as popular expressions. This memorial was the first to an American poet to be placed in the Abbey and was erected by Longfellow's English admirers. Buried at Cambridge, Massachusetts. 68

ROBERT BURNS

(1759–96), POET

Marble bust by Sir John Steell, 1885, paid for by contributions of one shilling which were received from across the world. In Scotland and elsewhere 'Burns Night' continues to be celebrated on 25 January, the poet's birthday. Buried in Dumfries. 128

SAMUEL TAYLOR COLERIDGE

(1772–1834), POET

Marble bust by Sir Hamo Thornycroft, 1885, given by Dr Mercer, an American citizen. Coleridge was one of the Lake Poets and, with his friend Wordsworth, a founder of the Romantic movement in England. *The Rime of the Ancient Mariner* is probably his best-known work. Buried at Highgate. 122

ROBERT BROWNING

(1812–89), POET

Gravestone of Italian marble and porphyry. Browning died in Venice, but his body was returned to England for burial. The name of his wife, Elizabeth Barrett Browning (1806–61), who is buried in the English cemetery in Florence, was added in 1906. 108

MATTHEW ARNOLD

(1822–88), POET AND ESSAYIST

Marble bust by Albert Bruce Joy, 1891, and a tablet of limestone and slate, designed by Donald Buttress and lettered by Alec Peevor, 1989. The tablet quotes Arnold's memorial poem to Dean Stanley. Buried at Laleham, Middlesex. 75 & 76

JENNY LIND-GOLDSCHMIDT

(1820–87), SWEDISH SOPRANO

Marble memorial by Charles Bell Birch, 1894. A portrait medallion above a wreathed lyre is surrounded by lines from Handel's *Messiah*. Buried at Great Malvern, Worcestershire. 194

SIR WALTER SCOTT

(1771–1832), NOVELIST

Marble bust by John Hutchison, 1897, a replica of the bust by Sir Francis Chantrey at Scott's home, Abbotsford. Scott's *Waverley* is often regarded as the earliest historical novel. It was the first of a series of more than twenty, many set in the author's native Scotland, of which *Ivanhoe* is perhaps the best known. Buried at Dryburgh Abbey. 131

JOHN RUSKIN

(1819–1900), WRITER ON ART AND ARCHITECTURE

Bronze portrait roundel by Onslow Ford, 1902. Buried at Coniston in Cumbria. 132

SIR HENRY IRVING

(1838–1905), ACTOR

Irving revolutionised the nineteenth-century theatre with his revivals of Shakespeare's plays and was the first actor to be knighted. His ashes were the first cremated remains to be buried in the Abbey. 138

THOMAS HARDY

(1840–1928), NOVELIST AND POET

Hardy's ashes rest here, but his heart is buried at Stinsford in Dorset, in the midst of the fictional 'Wessex' in which such novels as *The Return of the Native* and *Tess of the D'Urbevilles* are set. 148

ADAM LINDSEY GORDON

(1833–70), POET

White marble bust by Kathleen Kennet, 1934. Buried at Melbourne, Australia. 117

SAMUEL JOHNSON

(1709–84), LEXICOGRAPHER AND CRITIC

Marble bust by Joseph Nollekens, *c.*1777; installed 1939. Johnson's highly influential *Dictionary of the English Language* defined 40,000 words (sometimes in highly idiosyncratic ways) and was published in 1755, after eight years of labour. 121 & 142

THE BRONTE SISTERS,

NOVELISTS

Tablet by Sir Charles Peers, 1939; unveiled, 1947. It commemorates Charlotte (1816–55), author of *Jane Eyre*, Emily (1818–48), author of *Wuthering Heights*, and Anne (1820–49), author of *The Tenant of Wildfell Hall*. All are buried in Yorkshire: Charlotte and Emily at Haworth, Anne at Scarborough. 126

WILLIAM CAXTON

(D. 1492), PRINTER

Stone memorial tablet, 1954, on the exterior wall near the Poets' Corner door. It commemorates Caxton's setting up of the first printing press in England within the Abbey's precincts in 1476. In St Margaret's Church (Caxton was buried in its churchyard) are another commemorative tablet and the remains of a stained-glass window (damaged by bombing in the Second World War). 79

JOHN KEATS (1795–1821) AND PERCY BYSSHE SHELLEY

(1792–1822), POETS

Two oval tablets of Hoptonwood stone by Frank Dobson, 1954, joined by a carved swag of flowers, commemorate key poets of the Romantic movement. Keats's work was not well received in his day but was enormously influential after his death, and he has long been regarded as one of the foremost of the English Romantic poets. Shelley, one of the great English lyric poets, was drowned off the coast of Italy, and his body, later washed ashore, was burned on a funeral pyre

at the sea's edge. The ashes were buried in the English cemetery in Rome, where Keats is also buried. 125

WILLIAM BLAKE (1757–1827), POET AND ARTIST

Bronze bust by Sir Jacob Epstein, 1957. As an apprentice engraver Blake was sent by his master to make sketches of various Gothic churches in London, including Westminster Abbey. The building and its medieval furnishings and tombs had a profound influence on his artistic development, and he claimed to have experienced a vision of monks while drawing in the Abbey. Buried at Bunhill Fields, London. 115

CAEDMON (*fl.* 670), POET AND MONK

Memorial stone, 1966, lettered by David Dewey. It commemorates the earliest writer of poetry in English whose name is known. Buried at Whitby. 81

RUDYARD KIPLING (1865–1936), NOVELIST AND POET

Gravestone of Belgian marble. Kipling's preoccupation with the British empire and colonialism have affected his reputation in recent years, but his children's books, such as *The Jungle Books* and the *Just So Stories,* remain popular. 147

JANE AUSTEN (1775–1817), NOVELIST

Memorial tablet, 1967, given by the Jane Austen Society. Austen was the daughter of a country clergyman and in novels such as *Pride and Prejudice* and *Emma* portrayed with acute perception and gentle humour the life and manners of the society in which she lived. Buried in Winchester Cathedral. 120

THOMAS STEARNS ELIOT (1888–1965), POET, DRAMATIST AND CRITIC

Memorial stone by Reynolds Stone, 1967. The rose engulfed in flames alludes to the final line ('the fire and

the rose are one') of Eliot's poem *Four Quartets*, other lines from which are quoted on the stone. Born in St Louis, Missouri, Eliot moved to London and took up British nationality. Buried at East Coker, Somerset. 106

JOHN MASEFIELD (1878–1967), POET LAUREATE

Gravestone designed by Stephen Dykes Bower. Masefield is best known for his poems about the sea, notably 'Sea Fever'. 98

GEORGE GORDON, 6TH BARON BYRON (1788–1824), POET

Memorial stone, 1969. Lord Byron was refused burial in the Abbey, and disapproval of his personal life delayed his commemoration for many years. The quotation is from his poem *Childe Harold's Pilgrimage*. Buried at Hucknall Torkard, Nottinghamshire. 93

JOHN, 1ST BARON REITH (1889–1971)

On the exterior wall of the chapter house a stone tablet designed by Stephen Dykes Bower, 1972, commemorates the first director-general of the BBC. Buried at Rothiemurchas, Scotland. 80

WYSTAN HUGH AUDEN (1907–1973), POET

Stone designed by Peter Foster and cut by Messrs Whitehead, 1974, to commemorate one of the great poets of the twentieth century. Buried at Kirchstetten, Austria. 96

GERARD MANLEY HOPKINS SJ (1844–89), PRIEST AND POET

Memorial stone designed by David Peace and cut by Messrs Whitehead, 1975. The Latin inscription means 'To the greater glory of God / To be, rather than to be seen', and the words 'Immortal diamond', at the foot of the stone, conclude Hopkins' poem 'That Nature is a Heraclitean Fire'. Buried at Glasnevin, Dublin. 99

HENRY JAMES (1843–1916), NOVELIST

Memorial stone cut by W. Carter, 1976. Born in New York, the author of *The Portrait of a Lady* and *The Turn of the Screw* was naturalised British in 1915 and died in London but is buried at Cambridge, Massachusetts. 100

GEORGE ELIOT [MARY ANN CROSS] (1819–80), NOVELIST

Memorial stone cut by John Skelton, 1980, commemorating the author of *The Mill on the Floss* and *Middlemarch*. The quotation is from *Scenes of Clerical Life*: 'The first condition of human goodness is something to love; the second something to reverence.' 95

LEWIS CARROLL [CHARLES LUTWIDGE DODGSON] (1832–98), AUTHOR

Memorial stone by E. Rees, 1982. Lines from the preface to Carroll's novel *Sylvie and Bruno* are arranged in a circular design, an allusion to the rabbit hole in his most popular work, *Alice in Wonderland*. Buried at Guildford, Surrey. 101

DYLAN THOMAS (1914–53), POET

Memorial stone cut by J. Jones, 1982, with a quotation from 'Fern Hill': 'Time held me green and dying / Though I sang in my chains like the sea'. Buried at Laugharne, Carmarthenshire, the village that inspired Thomas's celebrated verse play *Under Milk Wood*. 94

DAVID HERBERT LAWRENCE (1885–1930), NOVELIST AND POET

Granite stone designed and cut by David Parsley, 1985, to commemorate the author of *Sons and Lovers* and *Lady Chatterley's Lover*. It features a phoenix, the subject of one of Lawrence's poems and later his personal symbol. Buried at Taos, New Mexico. 102

◆ *Medieval wall paintings near the entrance to St Faith's Chapel.*

directed and in which he played the title role. He was the first director of the National Theatre in London. 139

ANTHONY TROLLOPE
(1815–82), NOVELIST

Memorial stone by Sarah More, 1993. Trollope spent much of his career working for the Post Office, but it is for his many novels, notably those set in the fictional cathedral city of Barchester, that he is particularly remembered. The memorial quotes the final sentence of Trollope's autobiography. Buried at Kensal Green cemetery, London. 104

SIR JOHN BETJEMAN
(1906–1984), POET LAUREATE

Eighteenth-century marble cartouche with a modern urn and bracket, designed by Donald Buttress and David Peace, 1996. The cartouche is supported by a Prayer Book and a Bible, carved at the workshop of Dick Reid, and a bell alludes to the verse autobiography *Summoned by Bells*. Betjeman's poems include 'In Westminster Abbey', which records the thoughts of a woman visiting the Abbey during the Second World War. Buried at Trebetherick, Cornwall. 113

FREDERICK WILLIAM MAITLAND
(1850–1906), HISTORIAN

Memorial stone designed by John Burton and cut by Richard Kindersley, 2001. The final sentence of Maitland's *Domesday Book and Beyond* is inscribed in a spiral: 'By slow degrees the thoughts of our forefathers, their common thoughts about common things, will have become thinkable once more.' Buried at Las Palmas in the Canary Islands. 170

DAME PEGGY ASHCROFT
(1907–1991), ACTRESS

Memorial stone designed and cut by Lida Kindersley, 2005. Ashes scattered at Stratford-upon-Avon, where Ashcroft gave many of her most memorable stage performances. 137

POETS OF THE
FIRST WORLD WAR

Memorial stone by H. Meadows, dedicated on 11 November 1985. Uniquely in the Abbey it names someone (Robert Graves) who was alive at the time of its dedication. Sixteen poets are commemorated: Richard Aldington (1892–1915); Laurence Binyon (1869–1943); Edmund Blunden (1896–1974); Rupert Brooke (1887–1915); Wilfrid Gibson (1878–1962); Robert Graves (1895–1985); Julian Grenfell (1888–1915); Ivor Gurney (1890–1937); David Jones (1895–1974); Robert Nichols (1893–1944); Wilfred Owen (1893–1918); Sir Herbert Read (1893–1968); Isaac Rosenberg (1890–1918); Siegfried Sassoon (1886–1967); Charles Sorley (1895–1915); and Edward Thomas (1878–1917). None is buried in the Abbey. Encircling the names are words by Wilfred Owen: 'My subject is War, and the pity of war. The Poetry is in the pity.' 105

EDWARD LEAR (1812–88), POET

Memorial stone cut by M. Bury, 1988, showing the poet's profile in silhouette. Lear was a skilled ornithological artist but is best known for his 'nonsense verse', including 'The Owl and the Pussy-Cat'. Buried at San Remo, Italy. 103

JOHN CLARE (1793–1864), POET

Limestone and slate tablet, designed by Donald Buttress and lettered by John Skelton, 1989, commemorating one of the finest of English nature poets. Buried at Helpston, Northamptonshire. 77

LAURENCE, BARON OLIVIER
(1907–89), ACTOR

Gravestone by Ieuan Rees, 1991. Laurence Olivier, the pre-eminent actor of his generation, is also considered by many to have been the greatest English-speaking actor of the twentieth century. He was celebrated for his Shakespearean roles on stage and for the film of *Henry V*, which he

◆ MEMORIAL TO FOUNDERS OF THE ROYAL BALLET

Slate lozenge stone with lettering by Stephen Raw, 2009. It commemorates Dame Ninette de Valois (1898–2001), founder director; Sir Frederick Ashton (1904–88), founder choreographer; Constant Lambert (1905–51), founder music director; Dame Margot Fonteyn (1919–91), *prima ballerina assoluta*. 150a

TED HUGHES (1930–98), POET

Memorial stone of green slate, designed and cut by Ronald Parsons, 2011. The design includes a quotation from Hughes's poem 'That Morning'. Ashes scattered on Dartmoor. 106a

◆ CLIVE STAPLES LEWIS (1898–1963), WRITER AND THEOLOGIAN

Memorial stone of Purbeck limestone designed and cut by Wayne Hart, 2013. An influential Christian apologist, Lewis is probably best known for his series of Narnia novels. The quotation on the memorial, 'I believe in Christianity as I believe that the Sun has risen not only because I see it but because by it I see everything else', is from the essay 'Is theology poetry?'. Buried at Headington, Oxford. 111a

◆ SIR DAVID FROST (1939–2013), BROADCASTER

Memorial stone of Dunhouse blue sandstone designed and carved by Tom Perkins, 2014. Buried at Nuffield, Oxfordshire. 117a

◆ *Memorial to the Founders of The Royal Ballet.*

The following clergy or officers of the Abbey have monuments in this transept: William Outram (*c.*1626–79), prebendary 1670–79, and his wife, Jane (d. 1721); Anthony Horneck (d. 1697), prebendary 1693–7; Samuel Barton (d. 1715); James Wyatt (1746–1813), surveyor of the fabric 1776–1813. Also here are the gravestones of: Samuel Bolton (d. 1668), prebendary 1662–8; Peter Birch (*c.*1652–1710), prebendary 1689–1710; Richard Lucas (1648/9–1715), prebendary 1701–15; John Heylyn (d. 1759), prebendary 1743–59, his wife, Elizabeth (d. 1747), and their daughter, Elizabeth (d. 1759); Adam Fox (1883–1977), canon 1942–63.

Here too are monuments to Martha Birch (*c.*1653–1703) and to Hannah Vincent (1735–1807), wife of Dean William Vincent, and her son George (1774–1859), who are buried in the north transept and the north cloister respectively. Also the gravestones of: William Loe (d. 1645); Thomas Chiffinch (1600–1666); Sir William Davenant (1606–68); William Burnaby (1673–1706); George Riddell (d. 1783) and his stepmother, Sarah (d. 1817); Barbara Simpson (d. 1795); James Macpherson (1736–96); Mary Eleanor Bowes, dowager countess of Strathmore (1749–1800); Richard Cumberland (1732–1811); William Gifford (1756–1826); Henry Francis Cary (1772–1844); William Spottiswoode (1825–83); Gilbert Murray (1866–1957).

Monuments originally set up in this transept to the writers John Gay (1685–1732) and Nicholas Rowe (1674–1718) are now in the triforium. Both are by the sculptor Michael Rysbrack.

OTHER FEATURES

◆ WALL PAINTINGS

The wall paintings beside the entrance to St Faith's Chapel date from between

◆ *Literary commemorations in the Poets' Corner window.*

1280 and 1300. They are remarkable survivals and provide important evidence of the medieval decoration of the Abbey. On the left St Thomas, the doubting Apostle, places his hand into the wounded side of Christ; on the right St Christopher (patron of travellers) carries the infant Jesus. These are among the most significant paintings of their kind in England and were rediscovered in 1934 behind the Gay and Rowe monuments. 129

BIBLICAL POETS' WINDOW

Glass by Clayton and Bell given by Dr Nathaniel Rogers, 1869. It depicts King David and St John the Evangelist, as representative poets of the Old and New Testaments respectively.

ROSE AND LANCET WINDOWS

Iconography devised by George Frederick Bodley and M. R. James; executed by Messrs Burlison and Grylls under Bodley's supervision, 1902. The medieval glass in the south rose was first replaced in 1462, but that glazing was destroyed either at the

Reformation or during the Commonwealth. New coloured glass installed in 1840 was removed in 1901. The present scheme is a memorial to Hugh Lupus Grosvenor, 1st duke of Westminster (1825–99).

Christ, in the centre, is surrounded by figures of the Virtues and the orders of angels. In the outer circle are thirty-two Old Testament prophets and leaders, together with Classical philosophers and writers, symbolising the preparation of the world for Christ. In the spandrels are Adam, John the Baptist, the archangel Gabriel and the Blessed Virgin Mary. In the upper lancets are teachers of the early church, and in the lower row early saints of the British Isles.

POETS' CORNER WINDOW

Designed by Graham Jones, 1994, and presented in memory of Edward Horton Hubbard (1937–89), architectural historian. The pattern of lozenges and roundels facilitates the gradual commemoration of further literary figures. Named in the window to date are: Christopher Marlowe (1564–?1593), dramatist, buried at Deptford; Robert Herrick (1591–1674), poet, buried at Dean Prior, Devon; Alexander Pope (1688–1744), poet, buried at Twickenham; Frances ('Fanny') Burney (1752–1840), novelist, buried at Walcot, Bath; Oscar Wilde (1854–1900), dramatist, buried in Paris; A. E. Housman (1859–1936), poet, buried at Ludlow, Shropshire; Elizabeth Gaskell (1810–65), novelist, buried at Knutsford, Cheshire.

CLOCK

The measurement of time was important in a medieval monastery, and the earliest reference to an Abbey clock, in the thirteenth century, specifies that one of the sub-sacrists should look after it. The present clock, above the entrance to St Faith's Chapel, dates from 1808 and is by Thomas Bray of Westminster.

St Faith's Chapel

This chapel, one of the most numinous spaces in the Abbey, lies between the south end of the transept and the chapter house. It was built around the same time, c.1250, and originally formed the monks' vestry. The east end tapers to accommodate a staircase in the corner of the transept, and at the west end is the gallery that in monastic times led from the dormitory to the night stairs. A fine pavement of medieval tiles survives at the eastern end of the chapel.

The altar is dedicated to St Faith, an early fourth-century martyr put to death by roasting on a gridiron. A fine wall painting of the saint dominates the east wall. She is crowned and holds a book in one hand; the instrument of her martyrdom in the other. On the left is a small half-figure of a praying Benedictine monk, from whose lips issues a scroll bearing Latin words which can be translated as: 'From the burden of my sore transgressions, sweet Virgin, deliver me; make my peace with Christ and blot out my iniquity.' Beneath is a painted reredos with a central Crucifixion scene flanked by four star-shaped medallions. The painting, executed in oil, probably dates from the period c.1290–1310. Another decorative feature of the chapel is the series of grotesque heads at the base of the corbels.

In this chapel are three small memorial tablets. A brass plate records that the body of Charles McIlvaine, bishop of Ohio, who died in Florence in 1873, rested here before its return to the USA. Other tablets commemorate two Abbey clergy: Jocelyn Perkins (1870–1962), minor canon 1899–1958, and Christopher Hildyard (1901–87), minor canon 1928–73.

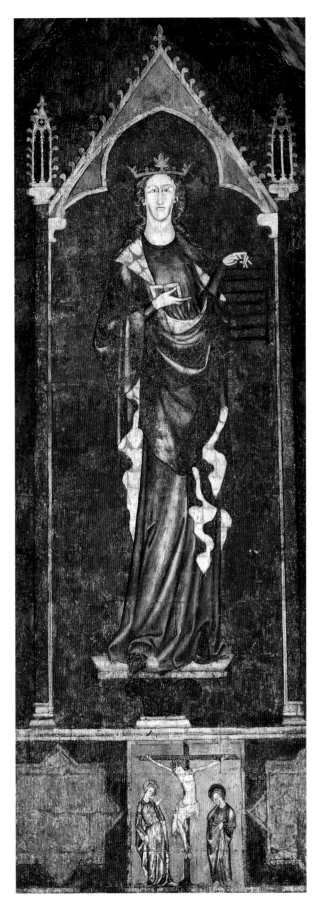

RIGHT: *The fine medieval painting of St Faith.*

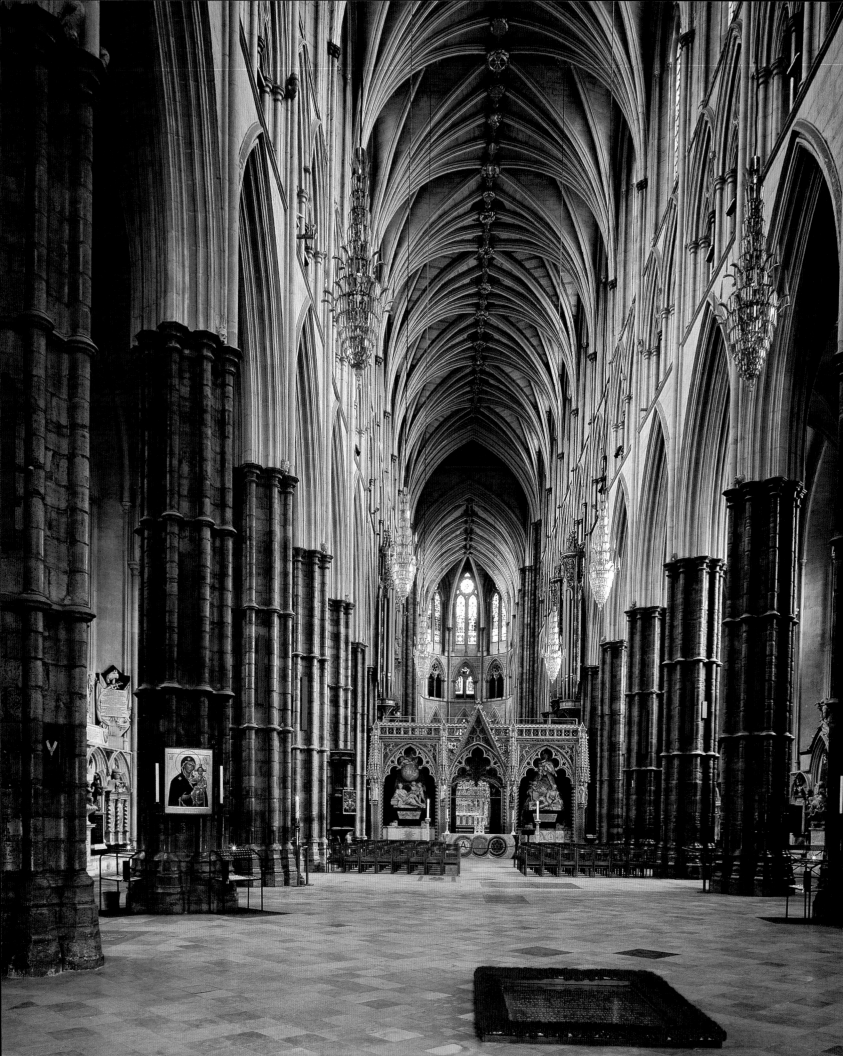

06 | NAVE

ARCHITECTURALLY THE NAVE extends from the crossing to the west end of the church, but because in most medieval churches, and always in monastic ones, a screen divided the quire from the rest of the nave, the term is usually used only for the bays west of the quire.

At Westminster the nave took several centuries to build. When the first phase of Gothic building ended in 1272, only one bay west of the quire screen was complete, and the new work abutted the much lower nave of the Confessor's church for the next hundred years. Work resumed in 1376 and proceeded, with many interruptions, until the early sixteenth century, but because the same materials and architectural style continued to be used (originally it seems at the insistence of Abbot Litlyngton) the nave has a remarkable unity of style. The only visible economy was to discontinue the diaper-work decoration above the arches. The nave vault, which rises to 102 feet, is one of the tallest in the country. As elsewhere in the Abbey,

most of the original medieval decoration has been lost, apart from the series of carved and painted shields, which continues from the quire aisles. The nave walls are crowded with monuments erected since the early seventeenth century, and in places the medieval arcading of the walls has been ruthlessly cut away to accommodate memorials.

The core of the quire screen is of thirteenth-century stonework but in its present form was designed by Edward Blore in 1834. He extended the screen a little to the west so that the Newton and Stanhope monuments, which were originally set up against it, now appear to be enclosed within it. The colouring and gilding were carried out by Stephen Dykes Bower in the 1960s.

At the west end of the south aisle is a small wooden gallery, reached from the deanery and looking down over the nave. It is known as the 'Abbot's Pew' and was built during John Islip's abbacy (1500–32).

OPPOSITE:
The nave looking east to the quire screen.

RIGHT:
An eighteenth-century engraving of the nave.

OVERLEAF LEFT:
The vaulting in the nave, showing carved and painted bosses.

OVERLEAF RIGHT:
The quire screen with the monuments to Sir Isaac Newton (left) and James, Earl Stanhope (right).

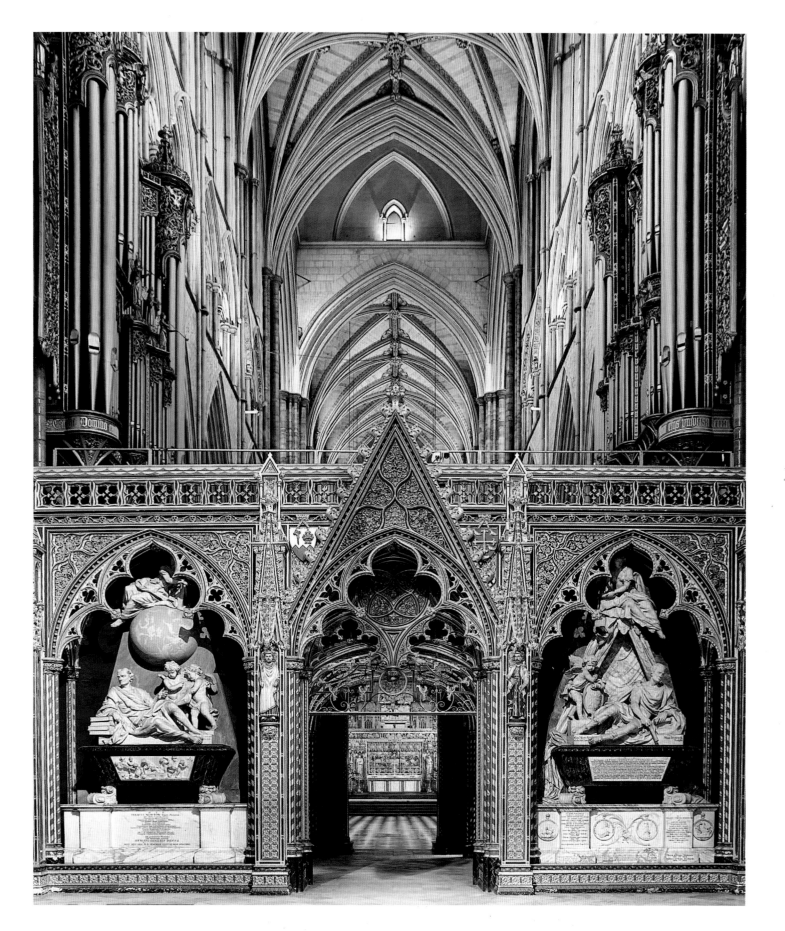

MONUMENTS AND FLOORSTONES

JANE HILL (D. 1631)

Alabaster and marble monument. A pedestal supports a small effigy kneeling on a cushion. Within the arch of the arcade on the left is a small skeleton with a winding sheet, and on the right is a grapevine. 53

BEN JONSON

(1574–1637), DRAMATIST

Ancient gravestone placed against the wall in 1821 to preserve the inscription. A modern stone now covers the nearby grave in which Jonson is said to have been buried standing up. One story says that, dying in great poverty, Jonson begged 'eighteen inches of square ground in Westminster Abbey' from Charles I, another that he was teased by the dean of Westminster about being buried in Poets' Corner and responded 'I am too poor for that, and no one will lay out funeral charges upon me. No, sir, six feet long by two feet wide is too much for me: two feet by two feet will do for what I want.' The dean responded: 'You shall have it.' Later, however, Jonson received a memorial in Poets' Corner. 45 & 51

SIR CHARLES HARBORD

(D. 1672), NAVAL OFFICER, AND **CLEMENT COTTRELL** (D. 1672), NAVAL VOLUNTEER

Marble monument consisting of inscribed panels beneath which, flanked by naval trophies, is depicted the sinking of the *Royal James*, the ship on which Harbord and Cottrell served. Harbord's father, Sir Charles, put up the monument and left 40 shillings annually to the poor of Westminster as long as it remained whole or undefaced. 192

SIR PALMES FAIRBORNE

(1644–80), GOVERNOR OF TANGIER

Marble monument by John Bushnell, with an inscription by John Dryden. A pair of obelisks that flanked the monu-ment and depicted scenes of Tangier has been lost. Buried at Tangier. 197

CAROLA MORLAND (D. 1674) AND ANN MORLAND (D. 1680)

Two marble monuments by William Stanton, with inscribed tablets surmounted by heraldic cartouches. They commemorate two of the wives of Sir Samuel Morland, who demonstrated his learning by providing inscriptions in Hebrew, Greek, Ethiopic and English. 187 & 190

EDWARD MANSELL

(D. 1681, AGED FIFTEEN)

Marble monument by William Woodman consisting of a pedestal supporting a shield of arms. 58

WILLIAM MORGAN

(*c*.1666–84) AND **THOMAS MANSELL** (*c*.1648–84)

Marble monument attributed to William Stanton. The inscription panels, decorated with cherubs' heads and palm branches, are flanked by twisting columns supporting an entablature and pediment. 55

SIR WILLIAM TEMPLE BT

(1628–99), DIPLOMAT, AND HIS WIFE, **DOROTHY** (1629–95)

Marble monument with an inscription in gold leaf on black marble beneath an entablature and heraldic cartouche. Also commemorated are Sir William's daughter Diana (1665–79) and his sister Martha Giffard (*c*.1638–1722). 191 & 200

MARY BEAUFOY (D. 1705)

Marble monument by Grinling Gibbons, consisting of a kneeling figure of Mary Beaufoy on a sarcoph-agus with weeping cherubs at each end. More cherubs hover above with a crown (now broken). 52

ROBERT KILLIGREW

(D. 1707), ARMY OFFICER

Marble monument by Francis Bird, consisting of an inscribed shield, surrounded by military trophies. Killigrew died at the battle of Almanza in Spain and is thought to be buried there. 47

SIDNEY, 1ST EARL GODOLPHIN

(1645–1712), STATESMAN

Marble bust by Francis Bird, 1712, depicting the earl in a full-bottomed wig and wearing the insignia of the Order of the Garter. 194

THE HON. PHILIP CARTERET

(1692–1711), KING'S SCHOLAR OF WESTMINSTER SCHOOL

Marble monument by Claude David, *c*.1715, consisting of a figure of Time holding a scroll inscribed with verses. The bust on the sarcophagus behind is one of the earliest representations of a Westminster scholar. 73 & 79

THOMAS TOMPION

(1638–1713) AND **GEORGE GRAHAM** (1673–1751), HOROLOGISTS

Their gravestone had been removed when the nave floor was relaid in 1834, but Dean Stanley found it in a cellar and replaced it in 1866. Tompion is known as 'the father of English watch-makers', while his pupil Graham (who was later also his son-in-law and partner) made the most accurate astronomical instruments then known in Europe. 129

ADMIRAL HENRY PRIESTMAN

(D. 1712)

Marble monument by Francis Bird, 1715. A sarcophagus supports a pyramid adorned with a portrait, nautical emblems and navigational instruments. Not buried in the Abbey. 68

VICE-ADMIRAL JOHN BAKER

(1661–1716)

Marble monument by Francis Bird, cut into the medieval wall arcade. The sarcophagus supports a column adorned with naval trophies and other emblems. 67

JOHN SMITH (*c*.1651–1718), COMMISSIONER OF EXCISE, AND HIS GRANDSON **THE HON. JOHN BURKE** (1716–19)

Marble monument designed by James Gibbs and sculpted by Michael Rysbrack, depicting a mourning woman sitting on a sarcophagus, holding a portrait. 115 & 188

THOMAS SPRAT (1635–1713), BISHOP OF ROCHESTER, DEAN OF WESTMINSTER 1683–1713, AND HIS SON **THOMAS** (1679–1720), PREBENDARY OF WESTMINSTER 1713–20

Marble monument by Francis Bird consisting of two inscribed panels decorated with heraldry. Originally set up in St Nicholas's Chapel (where the Sprats are buried), it was moved to make room for the Northumberland monument. Dean Sprat was one of the original fellows of the Royal Society. 173

KATHERINE BOVEY (1669–1727)

Marble monument designed by James Gibbs and sculpted by Michael Rysbrack, *c*.1728. Figures of Faith and Prudence sit on a sarcophagus, with a portrait medallion between them and an inscribed tablet, adorned with heraldry, rising above. The monument was erected by Katherine Bovey's companion, Mrs Mary Pope, 'who lived with her near 40 years in perfect friendship'. Not buried in the Abbey. 178

ANNE OLDFIELD (1683–1730), ACTRESS

Oldfield was the chief actress of her day, and her body lay in state in the Jerusalem Chamber before her magnificent funeral. Nevertheless Dean Bradford refused to permit any monument other than her gravestone. 171

WILLIAM CONGREVE (1670–1729), DRAMATIST

Marble monument by Francis Bird, *c*.1730. The base supports a sarcophagus displaying theatrical emblems and a portrait medallion. Congreve's body lay in state in the Jerusalem Chamber, and the prime minister was one of the pall-bearers at his funeral. 167

DR JOHN FREIND (1675–1728), PHYSICIAN

Marble monument designed by James Gibbs and sculpted by Michael Rysbrack, *c*.1730, consisting of a bust beneath a coat of arms. Freind's friendship with Dean Atterbury led to his imprisonment in the Tower after the latter's arrest for treason. Buried at Hitcham, Buckinghamshire. 168

◆ **SIR ISAAC NEWTON** (1642–1727), PHILOSOPHER AND MATHEMATICIAN

Marble monument designed by William Kent and executed by Michael Rysbrack, 1731. An inscribed base supports a sarcophagus on which lies a reclining figure of Newton. His right elbow rests on a pile of books, and with his left hand he points to a scroll, held by two cherubs, displaying an equation known as the 'converging series'. The background is a pyramid on which is a celestial globe with the signs of the Zodiac and the constellations, and the path of the comet that Newton determined in 1680. Seated on the globe is a figure of Astronomy leaning on a book. A carved panel on the front of the sarcophagus depicts children engaged in various experiments. The

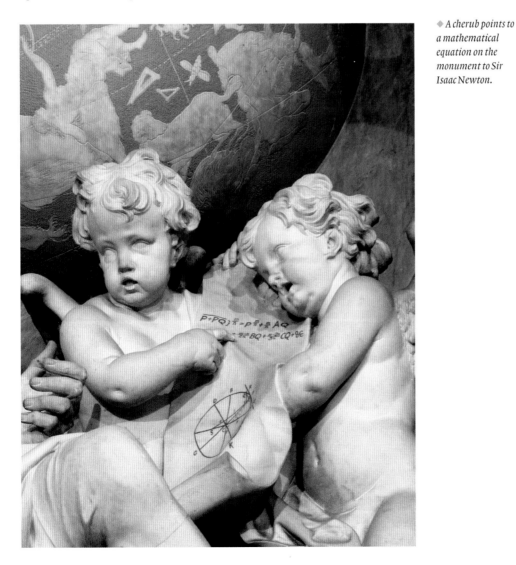

◆ *A cherub points to a mathematical equation on the monument to Sir Isaac Newton.*

inscription describes Newton as *Humani generis decus* ('An ornament of the human race').

Before the funeral Newton's body lay in state in the Jerusalem Chamber, and his coffin was followed to its grave (at the foot of the monument) by most of the fellows of the Royal Society and with the lord chancellor, two dukes and three earls acting as pall-bearers. **83 & 88**

JOHN WOODWARD (1665–1728), PHYSICIAN AND GEOLOGIST

Marble monument by Peter Scheemakers, 1732. A figure of Philosophy, supporting a portrait of Woodward, sits on a rock scattered with shells, fossils and plants. **38 & 95**

JAMES, 1ST EARL STANHOPE (1673–1721), SOLDIER AND STATESMAN

A monument designed by William Kent and executed by Michael Rysbrack, 1733, stands to the south of the quire screen arch and was intended to mirror Newton's monument on the other side. It depicts Stanhope in Roman armour reclining on a sarcophagus with a figure of Minerva above. On the base are medallions depicting battles in which Stanhope participated, and a later inscription commemorates other members of the family, including the second to the sixth earls, all of whom are buried at Chevening, Kent. **84**

REAR-ADMIRAL SIR THOMAS HARDY (1666–1732)

Marble monument by Sir Henry Cheere, *c*.1738, depicting the admiral in Roman armour, reclining on a sarcophagus. A cherub weeps at his feet beside an urn. **145**

JOHN CONDUITT (1688–1737), SCIENTIST

Marble monument by Sir Henry Cheere, *c*.1738. A sarcophagus supports a pyramidal background onto which two cherubs place a bronze portrait medallion. The monument was apparently designed as a pair to Admiral Hardy's on the other side of the west door but was later reduced in size. Conduitt's grave is near that of

◆ *The monument to Lieutenant-General William Hargrave depicts him rising from his tomb beside a figure of Time.*

his wife's uncle Sir Isacc Newton, whom he succeeded as master of the Mint and whose personal papers he preserved. 03

SIR JOHN CHARDIN (1643–1713), MERCHANT AND TRAVELLER

Marble tablet by Henry Cheere, 1744, depicting a globe marked with Chardin's travels, an hour-glass and books. Chardin was a jeweller by training but is best remembered for the published account of his travels, which is still regarded as an important work of scholarship on Persia and the Near East. Buried at Chiswick. 198

CAPTAIN WILLIAM HORNECK (c.1685–1746), MILITARY ENGINEER

Marble monument by Peter Scheemakers, c.1747. Minerva (symbolic of learning and warfare) draws aside a curtain to reveal Horneck's portrait. At her feet are a compass, books and a square, while a boy near by holds a plan of a fortification. Horneck was one of the earliest military engineers, 'without rival in the arts of fortification and bombardment'. He is buried in the south transept with his father, Anthony, a prebendary of the Abbey. 08

FIELD MARSHAL GEORGE WADE (1673–1748)

Marble monument by Louis-François Roubiliac, 1750. A column surrounded by military trophies has a portrait of Wade at its base and an urn at the top. A figure of Time (carrying a large scythe) attempts to destroy the column but is repulsed by Fame. Wade initiated the building of good roads in the highlands of Scotland, prompting the lines:

If you'd seen these roads
before they were made
You would hold up your hands
and bless Marshal Wade.

99 & 184

RICHARD MEAD (1673–1754), PHYSICIAN

Marble monument by Peter Scheemakers, 1754, consisting of a pedestal supporting a bust and shield of arms. On the left side is the staff of Aesculapius (symbolic of medicine), and on the right are books. Buried at the Temple Church, London. 62

JOSEPH WILCOCKS (1673–1756), BISHOP OF ROCHESTER, DEAN OF WESTMINSTER 1731–56

Marble monument by Sir Henry Cheere. During Wilcocks's long term

◆ Monument to Lieutenant-Colonel Roger Townshend.

of office the Abbey was extensively repaired and the western towers finally completed. A view of the Abbey appears on the base of the monument, flanked by small figures of Faith and Hope. Above the base two cherubs with a scroll are surrounded by episcopal emblems. On the wall is a cartouche of arms from which spread festoons of flowers. Wilcocks's wife, Joan (d. 1725), is buried with him. 159 & 175

◆ LIEUTENANT-GENERAL WILLIAM HARGRAVE (1672–1751)

Marble monument by Louis-François Roubiliac, 1757, dramatically depicting themes of Death, Resurrection and the end of time. At the blast of a cherub's trumpet Hargrave rises from his sarcophagus, casting off his shroud as a pyramid collapses to symbolise the end of time. A figure of Time breaks the dart of Death (depicted as a skeleton) who loses his crown and falls headlong down. Parts of the monument are painted to enhance the illusion of depth and perspective. 102 & 193

◆ LIEUTENANT-COLONEL THE HON. ROGER TOWNSHEND (D. 1759)

Marble monument by Robert Adam and Louis-François Breton, executed by John Eckstein and Benjamin and Thomas Carter. In front of a pyramidal background (breaking the medieval wall arcade) two life-size native Americans flank an inscription and support a sarcophagus surmounted by military trophies. A carving (by Eckstein) depicts Townshend's death at the battle of Ticonderoga. 195

GEORGE, 3RD VISCOUNT HOWE (1725–58), ARMY OFFICER

Marble monument designed by James 'Athenian' Stuart and sculpted by Peter Scheemakers, 1762. Above a large in-scribed tablet, supported by lions' heads, sits a mourning woman representing the Spirit of

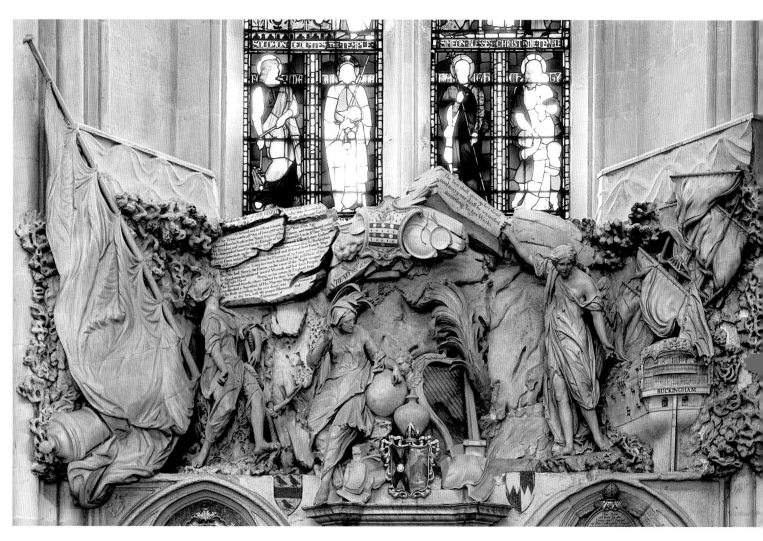

Massachusetts Bay. Howe died in a skirmish with the French during an expedition to recapture Fort Ticonderoga in North America and is buried at Albany, New York. A popular figure among the American forces, the court of the province of Massachusetts Bay took the unprecedented step of voting £250 to erect this memorial to him. **20**

◆ REAR-ADMIRAL RICHARD TYRRELL (D. 1766)

Marble monument by Nicholas Read, 1770. Only the lower portion of the original monument survives, depicting Tyrrell's ship, HMS *Buckingham*, grounded on a coral reef. In the centre a mourning figure of Hibernia and an Irish harp refer to Tyrrell's Irish ancestry. To the right an

◆ *Monument to Rear-Admiral Richard Tyrrell.*

angel points to a scriptural text beginning 'The sea shall give up her dead', while to the left stands a figure of Hope. Originally the Admiral's soul – represented as a slightly veiled naked body – was shown on its way from the sea to Heaven, represented by clouds and trumpeting cherubs, but these parts were removed in the nineteenth century. **174**

MAJOR-GENERAL STRINGER LAWRENCE (1697–1775)

Marble monument designed and sculpted by William Tyler, *c*.1775. A bust of Lawrence in armour is flanked by a figure of Fame holding an inscribed shield and by a female figure representing the East India Company. The latter has various French and Indian flags at her feet. A carving depicts Trichinopoly,

which Lawrence defended against the French, 1753–4. Buried at Dunchideock, near Exeter. **27**

ZACHARY PEARCE (1690–1774), BISHOP OF ROCHESTER, DEAN OF WESTMINSTER 1756–68

Marble monument by William Tyler, *c*.1777. Pearce's bust is flanked by the Scriptures and a mitre. He was a scholar at Westminster School and bequeathed his extensive library to the Dean and Chapter. Buried at Bromley, Kent. **176**

MAJOR JOHN ANDRÉ (1751–80), ARMY OFFICER

Marble monument designed by Robert Adam and executed by Peter Mathias Van Gelder, 1782. Britannia reclines mournfully on a sarcophagus

with a sorrowful lion at her feet. André, adjutant-general of British forces during the American War of Independence, was captured by the Americans while on a secret mission and hanged as a spy. A carving on the monument depicts George Washingon receiving a petition in which André asked in vain for death by firing squad; another scene shows André being led to his execution. He was originally buried at Tappan, New York, but forty years later his remains were returned to England and buried near this monument, erected at the expense of George III. 199

ANN WHYTELL (D. 1788)

Marble monument by John Bacon, 1791. An urn on a pedestal is flanked by figures of Innocence (holding a dove) and Peace (holding an olive branch). 183

JOHN GIDEON LOTEN (1710–89), GOVERNOR OF BATAVIA (JAKARTA)

Marble monument by Thomas Banks, 1793. A figure of Generosity, with a lion beside her, places a portrait of Loten on a pedestal. On either side, fixed to a truncated pyramid, are coloured shields of arms. Buried at Utrecht. 54

JOHN THOMAS (1712–93), BISHOP OF ROCHESTER, DEAN OF WESTMINSTER 1768–93

Marble monument by John Bacon. The bust, based on a portrait by Joshua Reynolds, rests on a plinth amid Eucharistic emblems including a chalice and paten. Thomas was dean at the time of the Handel commemoration in 1784 and an advocate of Catholic emancipation. His monument forms a pair with the earlier memorial to Zachary Pearce. Buried at Bletchingley, Surrey. 179

CAPTAIN JAMES MONTAGU RN (1752–94)

Marble monument by John Flaxman, c.1798. A high circular pedestal flanked by lions supports a statue of Montagu in uniform, standing in front of a naval trophy with a figure of Victory above. At the rear of the pedestal are two mourning sailors carved in relief, and on the front is a depiction of the battle known as 'the Glorious First of June', in which Montagu died. Fought off the coast of France, it was the first major naval engagement of the Napoleonic wars. Buried at sea. 22

CAPTAINS JOHN HARVEY RN (1740–94) AND JOHN HUTT (1746–94)

Marble monument designed by John Bacon and sculpted by his son John Bacon the Younger, 1804. Harvey and Hutt died commanding separate ships in the same naval battle off the coast of France. An urn adorned with portraits is flanked by figures of Britannia (with a lion) and Fame. A portion of the original monument had been removed by 1812 and now forms part of a memorial to Harvey in Eastrey church, Kent, where he is buried. Hutt is not buried in the Abbey. 44

THOMAS BANKS (1735–1805), SCULPTOR

Marble tablet commemorating the sculptor of five monuments in the Abbey (including that of J.G. Loten in this aisle). Buried in Paddington churchyard. 46

WILLIAM PITT 'THE YOUNGER' (1759–1806), STATESMAN AND PRIME MINISTER

Marble monument by Sir Richard Westmacott, 1813, above the west door. It depicts Pitt in a flight of oratory while a female figure representing History records his words and Anarchy (a chained naked male symbolising the French Revolution) crouches at his feet. Pitt became prime minister at the age of twenty-four in 1783 and remained in office, with a break of only three years, until his death. Buried in his father's grave in the north transept. 01

LIEUTENANT-COLONEL THE HON. GEORGE LAKE (1781–1808)

Marble monument by James Smith, c.1809, erected by men of Lake's regiment. He died in Portugal at the battle of Roliça (Wellington's first victory in the Peninsular War) and is buried there. 18

CHARLES HERRIES (1745–1819), ARMY OFFICER

Marble monument designed by Sir Robert Smirke and sculpted by Sir Francis Chantrey. It consists of a bust and a carved relief depicting a Roman soldier addressing a figure representing the City of London (Herries was colonel of the Light Horse Volunteers of London and Westminster). 100 & 185

REAR-ADMIRAL SIR GEORGE HOPE (1767–1818)

Marble monument by Peter Turnerelli, 1820, erected by naval captains who had served as midshipmen under Hope. 13

SPENCER PERCEVAL (1762–1812), STATESMAN AND PRIME MINISTER

Marble monument by Sir Richard Westmacott, 1822. Perceval's robed effigy lies on a bier attended by figures of Power (at his head), Truth and Temperance. Behind is a depiction of Perceval's assassination in the Palace of Westminster. The House of Commons passed a resolution asking the prince regent to direct that a monument be placed in the Abbey. Buried at Charlton, Kent. 61

◆ CHARLES JAMES FOX (1749–1806), STATESMAN

Marble monument by Sir Richard Westmacott, c.1823. Fox reclines on a bier, supported by a figure of Liberty. At his feet are Peace and a mourning slave (an allusion to Fox's support of the abolitionist cause). The monument was originally in the north transept, where Fox is buried. 24

LIEUTENANT-COLONEL SIR RICHARD FLETCHER BT

(1768–1813), CHIEF ENGINEER TO THE DUKE OF WELLINGTON

Marble monument by Edward Hodges Baily, 1830. It shows two soldiers (one with a broken sword, symbolic of death) in front of a tomb bearing Fletcher's portrait. Buried at San Sebastian, Spain. 12

MAJOR JAMES RENNELL

(1742–1830), CARTOGRAPHER

Marble bust by Jacob Hagbolt, c.1832. Rennell arrived in India in 1760 and joined the East India Company as a surveyor. His *Bengal Atlas* (1780) was the standard administrative map of the province for almost fifty years. 10

GEORGE TIERNEY

(1761–1830), STATESMAN

Marble bust by Richard Westmacott the Younger, 1832, beneath which a mourning woman leans on an inscribed tablet. Not buried in the Abbey. 17

ZACHARY MACAULAY

(1768–1838), CAMPAIGNER FOR THE ABOLITION OF SLAVERY

Marble bust by Henry Weekes, 1842. The plinth bears a small medallion with a kneeling figure of a chained slave inscribed 'Am I not a Man and a Brother'. Buried at Mecklenburgh Square, London. 07

◆ *Monument to Charles James Fox.*

JOHN IRELAND (1761–1842), DEAN OF WESTMINSTER 1816–42

Marble bust by John Ternouth. Ireland participated in the coronations of George IV and William IV but was too infirm to attend Queen Victoria's. In his will he founded scholarships and a theological professorship that bear his name at Oxford University. His grave is in the south transept. 180

HENRY FOX, 3RD BARON HOLLAND (1773–1840), STATESMAN AND WRITER

Marble monument with bust by Edward Hodges Bailey, c.1847. It is said to represent the 'Prison House of Death' and consists of a tall tomb with a closed doorway in front of which are mourning figures of two women and of a youth with an inverted torch. Buried at Millbrook, Bedfordshire. 15

GENERAL SIR ROBERT WILSON

(1777–1849) AND HIS WIFE, JEMIMA (1777–1823)

Brass by Hardmans of Birmingham set within grey granite. The antique design shows the Wilsons as a medieval knight and his lady beneath crocketed canopies. 49

MAJOR-GENERAL JAMES FLEMING (1682–1751)

Marble monument by Louis-François Roubiliac, 1754. At the base are figures of Prudence and Hercules, who bind together a serpent (Wisdom), a mirror (Prudence) and a club (Valour) to form a trophy. The background is a pyramid with branches of cypress and laurel on either side and a portrait of Fleming suspended from a ribbon. 108 & 189

SIR JAMES MACKINTOSH

(1765–1832), WRITER AND POLITICIAN

Marble monument and bust by William Theed the Younger, 1855. The base is flanked by two female figures, and a third figure sits mourning above the inscription. Buried at Hampstead, London. 19

WILLIAM BUCKLAND

(1784–1856), DEAN OF
WESTMINSTER 1845–56

Marble bust, by Henry Weekes. A
noted eccentric, Buckland was also one
of the best geologists of his day and
the first person to produce a scientific
description of a dinosaur. While Dean
he initiated a programme of stone
restoration and used his scientific
expertise to improve drains in the
Abbey's precincts. Buried at Islip,
Oxfordshire. 177

JOHN HUNTER (1728–93),
SURGEON AND ANATOMIST

Brass gravestone laid within pink
granite, 1859. Symbols of the four
Evangelists are at the corners of the
brass and above the inscription is a
shield of arms. Originally interred at
St Martin-in-the-Fields, London,
Hunter's remains were reburied here
by the Royal College of Surgeons and
at the instigation of Frank Buckland,
son of Dean Buckland. 50

ROBERT STEPHENSON

(1803–59), CIVIL ENGINEER

Brass designed by George Gilbert Scott
and made by Hardmans of Birmingham,
showing Stephenson in contemporary
dress. His steam locomotive *Rocket*,
depicted in the Stephenson window in
the north quire aisle, was built in 1830 to
run on the new Liverpool and Manches-
ter Railway and is regarded as the first
modern locomotive. 124

SIR CHARLES BARRY

(1795–1860), ARCHITECT

Brass by Hardmans of Birmingham
depicting a plan of Barry's chief work,
the Palace of Westminster, and an
elevation of its Victoria Tower. 120

THOMAS COCHRANE,
10TH EARL OF DUNDONALD

(1775–1860), NAVAL COMMANDER

Cochrane was made a knight
companion of the Order of the Bath in
1809 while a naval captain, but after
exposing abuses at the Admiralty

his career was sabotaged. He was
wrongfully convicted of fraud,
imprisoned, deprived of his seat in
Parliament and expelled from the
Royal Navy. Regardless of its statutes,
Cochrane was expelled from the Order
of the Bath, and his stall plate and
banner were removed from the Lady
Chapel. He subsequently accepted
command of the Chilean navy and
between 1819 and 1822 secured the
independence of Chile and Peru
from the Spanish; later, as first
admiral of the Brazilian fleet, he
secured the independence of Brazil.
Cochrane succeeded to the Dundonald
earldom in 1831 and was reinstated in
the Royal Navy. Prince Albert became

◆ *Portrait of*
William Buckland,
dean of Westminster,
by Thomas Phillips.

interested in his case, and he was
reinstated as a GCB in 1847. 113

LIEUTENANT-GENERAL
SIR JAMES OUTRAM BT

(1803–63), ARMY OFFICER

Marble monument by Matthew
Noble, 1863. Outram's bust rests on a
plinth flanked by seated figures of
a Scindian and a Bheel chief. A carving
depicts Outram's meeting with
Havelock and Clyde at the relief
of Lucknow. 114 & 186

GEORGE PEABODY (1795–1869),
AMERICAN PHILANTHROPIST

A memorial stone marks where the
body of this London-based banker

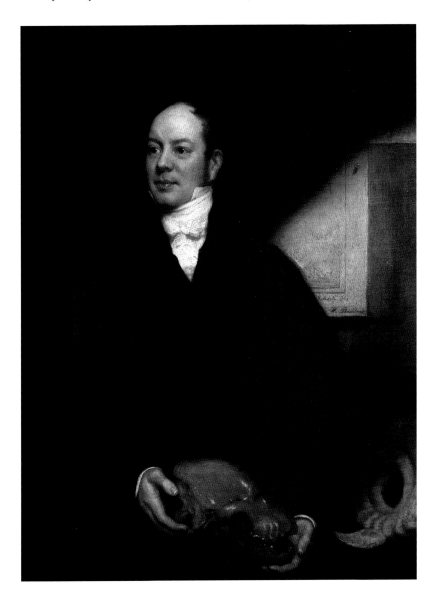

rested for one month before its return to the USA for burial at Peabody, Massachusetts. A fund established by Peabody in 1862 to provide affordable housing for Londoners continues that work to this day as the Peabody Trust. 137

HENRY PETTY-FITZMAURICE, 3RD MARQUESS OF LANSDOWNE
(1780–1863), STATESMAN

Marble bust by Sir J. Edgar Boehm, *c.*1873. Buried at Bowood, Dorset. 16

◆ DAVID LIVINGSTONE
(1813–73), MISSIONARY AND EXPLORER OF AFRICA

Black marble gravestone with brass letters, including a Latin quotation (from Lucan) alluding to the search for the source of the Nile. As a young missionary Livingstone had been the first European to see the great waterfalls between present-day Zambia and Zimbabwe, which he renamed the Victoria Falls, after his monarch. In 1866 he set out to discover the Nile's source, and it was after all

contact had been lost with him for several years that the explorer H.M. Stanley set out in pursuit, supposedly greeting him in November 1871 with the famous words 'Dr Livingstone, I presume?' Though weak and ill, Livingstone refused to abandon his quest and died two years later in the village of Chief Chitambo. His faithful African attendants carried his body over a thousand miles so that it could be returned to England for burial. 128

SIR JOHN HERSCHEL BT
(1792–1871), ASTRONOMER

Gravestone of black Belgian marble, 1979, replacing the original stone. Herschel established the first astronomical observatory in the southern hemisphere. 81

JEREMIAH HORROCKS
(1617–41), ASTRONOMER

Marble tablet erected by Dean Stanley in 1874 after the transit of Venus across the Sun in that year. Horrocks had predicted an earlier transit in 1639. 02

◆ *Gravestone of David Livingstone.*

SIR CHARLES LYELL
1797–1875), GEOLOGIST

Marble bust by William Theed, 1875, commemorating the only person in the Abbey after whom craters on both the Moon and the planet Mars are named. Lyell's writings were hugely influential, not least on the young Charles Darwin, who was given the first volume of Lyell's *Principles of Geology* by the captain of HMS *Beagle* shortly before the ship set off on its famous voyage to South America and the antipodes. Darwin received the second volume during the voyage. Lyell's gravestone (near his memorial) is of carboniferous limestone from Wirksworth in Derbyshire and incorporates fossils. 41 & 48

◆ SIR GEORGE GILBERT SCOTT
(1811–78), ARCHITECT, SURVEYOR OF THE FABRIC OF WESTMINSTER ABBEY 1849–78

Brass designed by George Edmund Street and executed by Messrs Barkentin and Krall. Scott was a prolific architect and worked on many of the English cathedrals and greater churches. As surveyor of the Abbey he restored the chapter house and drew up designs for the restoration of the north front. 112

JOHN, 1ST EARL RUSSELL
(1792–1878), STATESMAN AND PRIME MINISTER

Marble bust by Sir J. Edgar Boehm, 1880. Russell served twice as prime minister and in spite of his aristocratic background was a crusading radical. He was responsible for giving the Liberal Party its name. Buried at Chenies, Buckinghamshire. 14

JOHN, 1ST BARON LAWRENCE
(1811–79), GOVERNOR-GENERAL OF INDIA

Marble bust and pedestal by Thomas Woolner, *c.*1881, depicting Lawrence in the mantle of the Order of the Star of India. 109 & 182

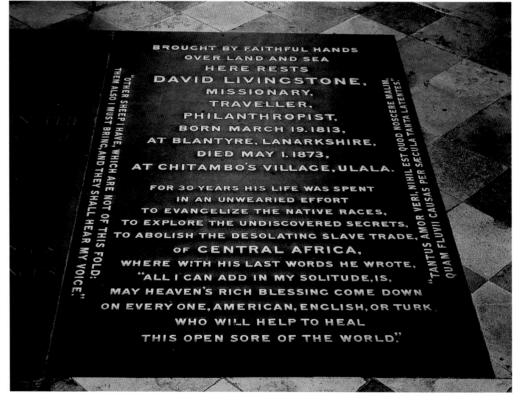

BROUGHT BY FAITHFUL HANDS
OVER LAND AND SEA
HERE RESTS
DAVID LIVINGSTONE,
MISSIONARY,
TRAVELLER,
PHILANTHROPIST,
BORN MARCH 19.1813,
AT BLANTYRE, LANARKSHIRE,
DIED MAY 1.1873,
AT CHITAMBO'S VILLAGE, ULALA.

FOR 30 YEARS HIS LIFE WAS SPENT
IN AN UNWEARIED EFFORT
TO EVANGELIZE THE NATIVE RACES,
TO EXPLORE THE UNDISCOVERED SECRETS,
TO ABOLISH THE DESOLATING SLAVE TRADE,
OF CENTRAL AFRICA,
WHERE WITH HIS LAST WORDS HE WROTE,
"ALL I CAN ADD IN MY SOLITUDE, IS,
MAY HEAVEN'S RICH BLESSING COME DOWN
ON EVERY ONE, AMERICAN, ENGLISH, OR TURK,
WHO WILL HELP TO HEAL
THIS OPEN SORE OF THE WORLD."

"OTHER SHEEP I HAVE, WHICH ARE NOT OF THIS FOLD; THEM ALSO I MUST BRING, AND THEY SHALL HEAR MY VOICE."

"TANTUS AMOR VERI, NIHIL EST QUOD NOSCERE MALIM, QUAM FLUVII CAUSAS PER SÆCULA TANTA LATENTES."

GEORGE EDMUND STREET

(1824–81), ARCHITECT

Brass designed by George Frederick Bodley and executed by Messrs Barkentin and Krall. 105

RICHARD CHENEVIX TRENCH

(1808–86), DEAN OF WESTMINSTER 1856–64 AND SUBSEQUENTLY ARCHBISHOP OF DUBLIN

Marble gravestone. In 1857 Trench inaugurated Sunday evening services at the Abbey, which were immediately popular and often filled the nave to capacity. His scholarly interests were in philology, and a suggestion he made at a meeting of the Philological Society in 1857 was the instigation for what ultimately became the *Oxford English Dictionary*. 133

FRANCIS ATTERBURY

(1663–1732), BISHOP OF ROCHESTER, DEAN OF WESTMINSTER 1713–23

Gravestone put down in 1877. Atterbury had been a scholar at Westminster School and as dean oversaw the building of its new dormitory. He chose the subjects for the remodelled north rose window and personally superintended Wren's repairs of the north front. Though he officiated at George I's coronation, Atterbury's Jacobite sympathies led to his arrest and imprisonment in the Tower. He was accused of conspiracy, deprived of office and exiled in 1723. Atterbury died in Paris, but his body was returned to the Abbey for burial, at his own request 'as far from Kings and Caesars as the space will admit of'. His wife, Catherine (d. 1722), and two daughters are buried with him. 170

ANTHONY ASHLEY-COOPER, 7TH EARL OF SHAFTESBURY

(1801–85), POLITICIAN AND PHILANTHROPIST

Marble statue by Sir J. Edgar Boehm, 1888, depicting the earl in Garter robes. He instigated legislation to improve working conditions in factories and

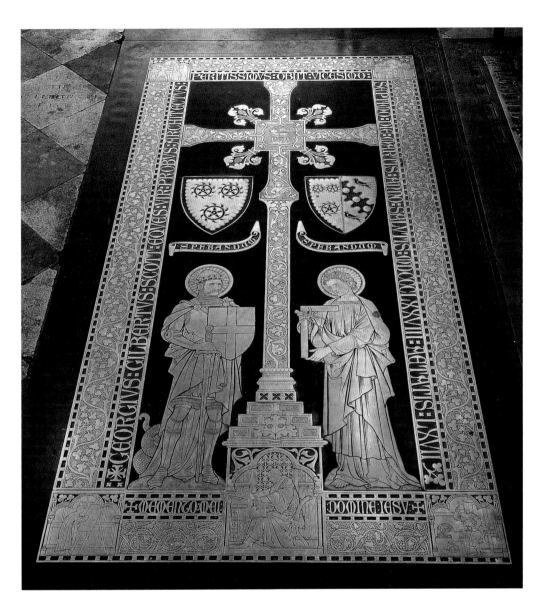

coal-mines and was particularly concerned for the welfare of children. The statue at Piccadilly Circus popularly known as 'Eros' (but officially entitled *The Angel of Christian Charity*) forms an additional memorial. 04

MAJOR-GENERAL CHARLES GORDON (1833–1885)

Bronze bust and cartouche, by Edward Onslow Ford, 1892. Early in his career Gordon was known as 'Chinese Gordon', but he was more often called 'Gordon of Khartoum' following his death during the siege of that place. 05

◆ *The fine brass over the grave of Sir George Gilbert Scott.*

109

06

THOMAS ARNOLD (1795–1842), HEADMASTER AND HISTORIAN

Bust by Sir Alfred Gilbert, 1896. Arnold transformed educational standards at Rugby School, of which he was headmaster 1828–41, and played a key role in reforming public school education. Subsequently he was Regius professor of modern history at Oxford. Buried in the chapel at Rugby. 06

JOHN LOUGHBOROUGH PEARSON (1817–97), ARCHITECT, SURVEYOR OF THE FABRIC OF WESTMINSTER ABBEY 1879–97

Brass designed by W. Caröe. Pearson succeeded G.G. Scott as surveyor. He

practically rebuilt the north front and refaced much of the exterior of the whole building. 111

GEORGE GRANVILLE BRADLEY
(1821–1903),
DEAN OF WESTMINSTER 1881–1902
Brass figure and inscription by Clayton and Bell, 1904. Bradley officiated at the Jubilee of Queen Victoria (1887) and at the coronation of Edward VII and Queen Alexandra (1902). 169

ANGELA, BARONESS BURDETT-COUTTS
(1814–1906), PHILANTHROPIST
Gravestone of a close friend of Charles Dickens who used her considerable fortune to initiate numerous philanthropic ventures, especially among the poor of London's East End. She founded the bishopric of British Columbia and paid for the building of St Stephen's church in Rochester Row, Westminster. 144

WILLIAM THOMSON, BARON KELVIN (1824–1907), PHYSICIST
Gravestone. Kelvin is remembered for his work, with James Prescott Joule, on the laws of thermodynamics and for the invention of navigational and electrical measuring instruments. 90

ROBERT GASCOYNE-CECIL, 3RD MARQUESS OF SALISBURY
(1830-1903), STATESMAN AND PRIME MINISTER
Black marble chest tomb designed by George Frederick Bodley and executed by William Goscombe John, 1909. The recumbent effigy depicts the marquess in Garter robes and holding a crucifix. His head rests on a cushion bearing the arms of Trinity House (of which he was master) and the Cinque Ports (of which he was lord warden). At his feet are St George and the Dragon, and the arms of Westminster Abbey and the University of Oxford (he was high steward of Westminster and chancellor of the university

respectively). On the south side are statuettes of Salisbury's Cecil ancestors: William, Lord Burghley, flanked by Robert, 1st earl of Salisbury (holding a model of Hatfield House), and James, 2nd marquess of Salisbury. Their wives are depicted on the north side. Statuettes of Old Testament figures are at each corner. Buried at Hatfield, Hertfordshire. 23

SIR HENRY CAMPBELL-BANNERMAN (1836–1908),
STATESMAN AND PRIME MINISTER
Marble and bronze monument designed by Maurice E. Webb and sculpted by Paul Montford, 1912. A bronze bust of Campbell-Bannerman in the robes and collar of the Order of the Bath sits within an architectural surround. Buried at Meigle, Perthshire. 25

JOSEPH CHAMBERLAIN
(1836–1914), POLITICIAN
Marble bust by John Tweed, 1916. Buried at Birmingham. A memorial to his son Prime Minister Neville Chamberlain, is near by. 09

◆ THE UNKNOWN WARRIOR
(BURIED 1920)
Gravestone of black Belgian marble with inscription in brass letters, 1920. The idea of burying the body of an

unidentified serviceman taken from the battlefields of the First World War came from an army chaplain, David Railton, who had noticed in a garden at Armentières a grave with a rough cross bearing the words 'An Unknown British Soldier'. Railton's idea won the support of Dean Ryle, through whose energies the memorial was carried into effect. In the aftermath of the war the grave became especially symbolic to the bereaved whose husbands, fathers or sons had no known burial place.

The Unknown Warrior was buried on 11 November 1920 in the presence of King George V and other members of the Royal Family, the prime minister, members of the Cabinet and the chiefs of the armed forces. A hundred holders of the Victoria Cross formed a guard of honour through the nave. The grave contains soil from France, and the inscription includes the text 'They buried him among the kings because he had done good toward God and toward his House'. 141

The Union Flag, known as 'the Padre's Flag', which covered the coffin on its journey from France hangs in St George's Chapel. It was presented in 1921 by David Railton, who had used it as a coffin pall and altar cloth during his war service. Other artefacts associated with the Unknown Warrior are near by: the ship's bell from HMS

◆ *The grave of the Unknown Warrior is filled with soil from France.*

OPPOSITE:
◆ *The grave of the Unknown Warrior surrounded by poppies.*

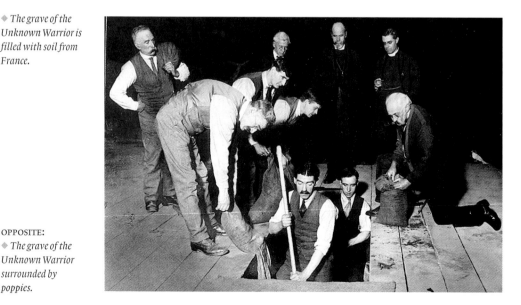

X THE LORD KNOWETH THEM THAT ARE HIS X

BENEATH THIS STONE RESTS THE BODY
OF A BRITISH WARRIOR
UNKNOWN BY NAME OR RANK
BROUGHT FROM FRANCE TO LIE AMONG
THE MOST ILLUSTRIOUS OF THE LAND
AND BURIED HERE ON ARMISTICE DAY
11 NOV: 1920, IN THE PRESENCE OF
HIS MAJESTY KING GEORGE V
HIS MINISTERS OF STATE
THE CHIEFS OF HIS FORCES
AND A VAST CONCOURSE OF THE NATION

THUS ARE COMMEMORATED THE MANY
MULTITUDES WHO DURING THE GREAT
WAR OF 1914-1918 GAVE THE MOST THAT
MAN CAN GIVE LIFE ITSELF
FOR GOD
FOR KING AND COUNTRY
FOR LOVED ONES HOME AND EMPIRE
FOR THE SACRED CAUSE OF JUSTICE AND
THE FREEDOM OF THE WORLD

THEY BURIED HIM AMONG THE KINGS BECAUSE HE
HAD DONE GOOD TOWARD GOD AND TOWARD
HIS HOUSE

GREATER LOVE HATH NO MAN THAN THIS

DYING AND BEHOLD WE LIVE

KNOWN AND YET WELL KNOWN

UNKNOWN AND YET WELL KNOWN

X

06

Verdun, the destroyer that brought the Warrior's body to England, was presented in 1990 and hangs on a pillar to the south; on a pillar to the north hangs the Congressional Medal of Honor, conferred by the USA in 1921. 140

ROYAL ARMY MEDICAL CORPS MEMORIAL

Marble tablet by Frederick John Wilcoxson, 1922, commemorating 6,873 members of the Corps who died in the First World War. An additional tablet (1987) commemorates a further 2,463 men who died in the Second World War, and a memorial window is above. 36

ANDREW BONAR LAW

(1858–1923), PRIME MINISTER

Bonar Law was Canadian by birth but Scottish by descent. He served as chancellor of the exchequer in Lloyd George's wartime Cabinet and as prime minister 1922–3. 104

HERBERT EDWARD RYLE

(1856–1925), BISHOP OF WINCHESTER, DEAN OF WESTMINSTER 1911–25

Oval stone tablet by Oscar Cheadle, 1928. Ryle officiated at the coronation of George V in 1911 and at the first modern revival of the installation ceremony for Knights of the Bath. He was dean throughout the First World War and greatly involved in the burial of the Unknown Warrior, near whose grave he himself is buried. 138 & 172

MICHAEL FARADAY (1791–1867),
PHYSICIST AND CHEMIST, AND
JAMES CLERK MAXWELL
(1831–79), MATHEMATICIAN AND PHYSICIST

Memorial stones to Faraday and Maxwell were first unveiled in 1931. The present metal plates, designed by Peter Foster and made by Messrs Morris Singer, date from 1976. Faraday is buried in Highgate cemetery, Maxwell at Parton, Kirkcudbrightshire. 85 & 89

ERNEST, BARON RUTHERFORD OF NELSON (1871–1937),
PHYSICIST

Rutherford undertook important work on radioactivity and atomic structure, and received the Nobel prize for chemistry in 1908. 92

NEVILLE CHAMBERLAIN

(1869–1940), STATESMAN AND PRIME MINISTER

Chamberlain became prime minister in 1937 and tried to prevent war with Germany by negotiating with Adolf Hitler. Though he proclaimed the Munich agreement of 1938 as 'peace for our time', he was nevertheless forced to declare war in September 1939. He resigned as prime minister the following year and died shortly afterwards. 103

SIR JOSEPH THOMSON

(1856–1940), PHYSICIST

Thomson's announcement in 1897 of the discovery of what are now called 'electrons' effectively marked the birth of modern atomic physics. He was awarded the Nobel prize in 1906. His wife, Rose (d. 1951), is buried with him. 93

SIDNEY WEBB, BARON PASSFIELD (1859–1947),
AND HIS WIFE, BEATRICE (1858–1943)

In 1924 Webb served as president of the Board of Trade in Britain's first Labour government. Both he and his wife (who shared his ardent socialism) wrote extensively on political matters. 30

PAUL DE LABILLIERE (1879–1946),
DEAN OF WESTMINSTER 1938–46

Labilliere took a deep interest in the Abbey's fabric and aimed to enhance its beauty and increase the dignity of the services. The placing of an altar once more in the nave was due to him. In May 1941 bombing destroyed much of the deanery, and Labilliere's personal possessions were lost, blows he bore with great courage. He lived to

see peace and the Abbey emerge from war relatively unscathed. His wife, Ester (d. 1954), is buried with him. 97

ROBERT, 1ST BARON BADEN-POWELL (1857–1941), FOUNDER OF THE SCOUT MOVEMENT, AND HIS WIFE, OLAVE (1889–1977),
WORLD CHIEF GUIDE

A memorial stone to Baden-Powell unveiled in 1947 was replaced in 1981 by a joint memorial of black granite with lettering and portraits in brass by Wilhelm Soukop. Both buried at Nyeri, Kenya. 165

FRANKLIN ROOSEVELT

(1882–1945), PRESIDENT OF THE USA

Tablet of Hoptonwood stone by Herbert Palliser, 1948, erected by the British government in recognition of 'a faithful friend of freedom and of Britain'. Above the inscription are eagle's wings in front of a wreath of oak leaves. Buried at Hyde Park, Dutchess County, New York. 147

SIR WILLIAM HERSCHEL

(1738–1822), ASTRONOMER

A memorial stone was first installed in 1954, but the present cast-iron lozenge dates from 1986. Herschel is the 'father' of modern stellar astronomy and was the discoverer (1781) of the planet Uranus. Buried at Upton, Berkshire. 82

ALAN DON (1885–1966),
CANON OF WESTMINSTER FROM 1941, DEAN 1946–59

Don was rector of St Margaret's until his appointment as dean. He officiated at the coronation in 1953 and in that year launched a great appeal for funds to preserve the Abbey's fabric. In his time also the deanery was restored after bomb damage, and both parts of the Islip Chantry Chapel were refurbished. 94

SIR JOHN NINIAN COMPER

(1864–1960), ARCHITECT

Black granite gravestone, 1967.

Comper was the leading church architect of his day and was greatly influenced by the architecture and artefacts of the medieval church, which informed his many designs for church interiors. His grave lies close to the series of stained-glass windows that he designed for this aisle. 65

◆ SIR WINSTON CHURCHILL
(1874–65), STATESMAN AND PRIME MINISTER

Memorial stone of green Italian marble, lettered by Reynolds Stone, 1965. Churchill held several of the principal government offices, including home secretary and first lord of the Admiralty, but it is for his leadership as prime minister during the Second World War that he is chiefly remembered. His memorial was unveiled by The Queen on the 25th anniversary of the Battle of Britain. Buried at Bladon, Oxfordshire. 143

CLEMENT, 1ST EARL ATTLEE
(1883–1967), STATESMAN AND PRIME MINISTER

Gravestone of Indian black marble. Attlee served as prime minister from 1945 until 1951, presiding over the establishment of the National Health Service and the granting of independence to India. 33

JOOST DE BLANK (1908–68),
CANON OF WESTMINSTER 1963–8

Black marble gravestone (with heraldry and inscription in white marble), designed by James Sutton. It describes De Blank as an 'indomitable fighter for human rights' in allusion to his opposi-tion, when archbishop of Cape Town (1957–63), to the policy of apartheid. The grave of his sister Bartha de Blank (1906–75) adjoins his own. 162

JAMES RAMSAY MACDONALD
(1866–1937), STATESMAN AND PRIME MINISTER

Memorial stone designed by Alister MacDonald, 1968. Ramsay MacDonald

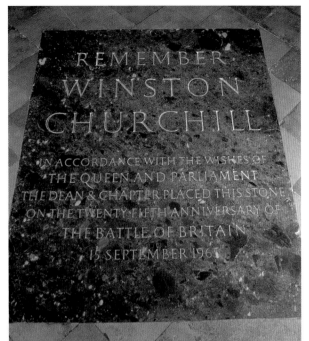

◆ *Memorial stone to Sir Winston Churchill.*

was Britain's first socialist prime minister, serving first in 1924 and again from 1929 to 1935 during the height of the Depression. Buried near Lossiemouth, Moray. 32

DAVID, 1ST EARL LLOYD GEORGE OF DWYFOR (1863–1945),
STATESMAN AND PRIME MINISTER

Memorial stone carved by Jonah Jones, 1970. In 1908, as chancellor of the exchequer, Lloyd George introduced the Old Age Pension Act, which guaranteed an income for the first time to those too old to work. He served as prime minister between 1916 and 1918, during the final years of the First World War, and again from 1918 to 1922. Buried at Llanystumdwy, Caernarvonshire. 39

HOWARD, BARON FLOREY
(1898–1968), BACTERIOLOGIST

Black syenite memorial stone from Black Hill, South Australia, designed by J. Peters and lettered by P. Trappe, 1981. The stone, a gift from the government and people of South Australia, records that Florey 'made penicillin available to mankind'. Buried at Marston, Oxford. 78

ERIC ABBOTT (1906–83),
DEAN OF WESTMINSTER 1959–74

Abbott presided over the 900th anniversary of the consecration of Edward the Confessor's abbey church and worked to make Westminster Abbey 'a place of pilgrimage and prayer for all peoples'. 96

LOUIS, 1ST EARL MOUNTBATTEN OF BURMA
(1900–79), AND HIS WIFE, EDWINA (1901–60)

Memorial stone of Belgian marble inlaid with brass and stainless steel, by Christopher Ironside, 1985. After a naval career spanning two world wars Mountbatten became last viceroy of India in 1947 and governor-general from August 1947 to June 1948. His time there covered the period of Partition, when British India was divided into the separate republics of India and Pakistan. Later he returned to naval duties, serving as chief of UK defence staff. Mountbatten was assassinated in an IRA terrorist attack, and his funeral was held in Westminster Abbey. Buried at Romsey, Hampshire. 164

GEORGE GREEN
(1793–1841), MATHEMATICIAN AND PHYSICIST

Memorial stone designed by Donald Buttress, executed by J. Hutchinson and Dick Reid, 1993. It depicts the windmill at Sneinton, Nottinghamshire, built by Green's father. Green pioneered the application of mathematics to physical problems, and his work has influenced modern nuclear and solid-state physics. Buried at Sneinton. 86

JOHN SMEATON
(1724–92), CIVIL ENGINEER

Memorial stone of Purbeck marble designed by Donald Buttress and executed by David Dewey, 1994. A bronze inlay depicts Smeaton's

most famous design, the Eddystone lighthouse. Buried at Whitkirk, near Leeds. 57

PAUL DIRAC
(1902–84), THEORETICAL PHYSICIST

Stone carved by Lida Cardozo, 1995. It depicts Dirac's equation, describing the behaviour of the electron. Buried at Tallahassee, Florida. 91

STANLEY, 1ST EARL BALDWIN OF BEWDLEY (1867–1947), STATESMAN AND PRIME MINISTER

Memorial designed by Donald Buttress and carved by Ion Rees, 1997. Baldwin served as prime minister three times, including from 1935 to 1937 during the crisis that preceded the abdication of Edward VIII. Buried at Worcester Cathedral. 34

EDWARD CARPENTER (1910–98), CANON OF WESTMINSTER FROM 1951, DEAN OF WESTMINSTER 1974–85

Gravestone designed by John Burton with lettering by the Cardozo Kindersley workshop, 2000. It quotes a prayer that Dr Carpenter often used. He was a fervent campaigner for social justice and for a closer understanding between world faiths. 98

VICTORIA CROSS AND GEORGE CROSS MEMORIAL

Stone tablet designed by John Burton with lettering by J. Larkum, 2003. It commemorates all recipients of the nation's highest awards for gallantry and displays enlarged representations of the two medals, cast in bronze and silver respectively by David Callaghan and inlaid with enamelled ribbons. 142

JOHN HARRISON
(1693–1776), HOROLOGIST

Purbeck marble memorial designed by John Burton and lettered by Gary Breeze, 2006. Harrison made the first chronometer to keep accurate time at sea, thus allowing the proper measurement of longitude and so making a major contribution to the accuracy

of navigation. The bimetallic strip running across Harrison's name marks the memorial's longitude. Buried at Hampstead. 130

MICHAEL MAYNE (1929–2006), DEAN OF WESTMINSTER 1986–96

Gravestone of Hopton Wood stone, designed by Ken Thompson, 2008. It incorporates a quotation from the writings of the medieval philosopher Boethius. 96a

◆ OCTAVIA HILL (1838–1912), SOCIAL REFORMER

Memorial stone of Purbeck marble designed and cut by Rory Young, 2012. Octavia Hill is best known as one of the founders of the National Trust. 107a

◆ HAROLD, BARON WILSON OF RIEVAULX (1916–1995), STATESMAN AND PRIME MINISTER

Memorial stone of Crossland Hill York sandstone, cut by Corin Johnson. Wilson was twice Labour Prime Minister, leading governments which abolished capital punishment and removed discrimination against women and ethnic minorities. Another initiative was the creation of the Open University in 1969, enabling thousands of mature students to take degrees by distance learning. 32a

ADMIRAL ARTHUR PHILLIP
(1738–1814)

Memorial of Sydney sandstone cut by Ken Thompson, 2014. The inscription describes Phillip as 'First Governor of New South Wales & founder of modern Australia' and the design includes a depiction of a kangaroo. 129a

JAMES, BARON CALLAGHAN OF CARDIFF (1912–2005), STATESMAN AND PRIME MINISTER

Slate memorial with lettering by Nicholas Sloan, 2015. Callaghan served as Prime Minister 1976–79. Having at various times also served as

Chancellor of the Exchequer, Home Secretary and Foreign Secretary, Callaghan is the only politician to date to have held all four of the great offices of state. 31a

The following clergy or officers of the Abbey have monuments in the nave: Robert Cannon (1663–1722), prebendary 1715–22, whose grave is in the south transept; William Foxley Norris (1859–1937), dean 1925–37. Here also are the gravestones of: Samuel Smith (c. 1732–1808), head master of Westminster School and prebendary 1787–1808 ; William Bell (1731–1816), prebendary 1765–1816; William Carnegie (1859–1936), canon, and rector of St Margaret's Church 1913–36, and his wife, Mary (d. 1957).

Also in the nave are monuments to: Penelope Egerton (d. 1670); Edward de Carteret (1670–77); Gilbert Thornburgh (d. 1677); Martha Price (1640–78); Bridget Radley (d. 1679); the Hon. Richard Cholmondeley (d. 1680, aged twelve), king's scholar; James Egerton (1677–87); Henry Wharton (1664–95); Colonel James Bringfeild (or Bingfield) (d. 1706), who is buried at Beauvechain, Belgium; Lieutenant John Twysden RN (d. 1707) and Captain Josiah Twysden (d. 1708), who are buried at sea and at Agremont, near Lille, France, respectively; Captain Heneage Twysden (d. 1709), buried at Malplaquet, France; Thomas Livingston, Viscount Teviot (c.1651–1711); Edward Herbert (c.1693–1715); Elizabeth, Lady Carteret (1663–1717), and her son Charles (1679–1715); Colonel John Davis (c.1662–1725); Anne, dowager countess of Clanricarde (c.1686–1733); William Levinz (c.1712–65); Sir James Denham Bt (d. 1780); Major the Hon. Charles Stanhope (1785–1809); Captain John Stewart RN (c. 1775–1811); Colin Campbell, Baron Clyde (1792–1863).

The great west window, dating from 1735, depicts figures from the Old Testament.

Here too are the gravestones of John Temple (1680–1752); Margaret Stradling (d. 1681); Catherine Hyde (d. 1706); Charles Williams (d. 1720); Anna Wardour (d. 1736); William Wardour (d. 1746); Colonel Tomkyns Wardour (d. 1752); General the Hon. James Cholmondeley (1708–75); William, Baron Blakeney (1672–1761); Hargrave Fleming (d. 1763); Margaret Fleming (d. 1769); James Oswald (1715–69) and members of his family; Field Marshal Sir George Pollock Bt (1786–1872); Anna Smith (1738–89); Susannah Smith (1749–92); John Smith (b. and d. 1792); Jane Morris (d. 1801); Mary, Baroness Ennismore (d. 1810); Jane, Baroness Harewood (d. 1813); Edward Delaval (d. 1814); John Milles (d. 1815); William Hare, earl of Listowel (1751–1837); Freeman Freeman-Thomas, 1st marquess of Willingdon (1866–1941), and his wife, Marie (1875–1960); Sir Herbert Baker (1862–1946), architect; Ernest Bevin (1881–1951), statesman.

OTHER FEATURES

WINDOW DEPICTING ST EDWARD THE CONFESSOR

A figure beneath the north-west tower probably represents Edward the Confessor, but the jumbled nature of the glass, which is probably late fourteenth-century, makes definite identification impossible.

WINDOW DEPICTING THE BLACK PRINCE

The fifteenth-century glass in the single light window of St George's Chapel is believed to depict Edward the 'Black Prince', son of Edward III.

◆ GREAT WEST WINDOW

Designed by Sir James Thornhill and executed by William Price, 1735. It depicts Abraham, Isaac, Jacob (Israel) and his twelve sons, together with Moses and Aaron. Beneath these are the arms of George II, flanked by those of King Sebert, Queen Elizabeth I,

Dean Joseph Wilcocks and the City of Westminster.

MEMORIAL WINDOW TO ISAMBARD KINGDOM BRUNEL

(1806–59), ENGINEER

Designed by Norman Shaw, 1868, and moved to its present position in 1952. It depicts scenes connected with the building of the Temple in Jerusalem and Christ's teaching there.

MEMORIAL WINDOW TO GEORGE HERBERT (1593–1633) AND WILLIAM COWPER

(1731–1800), POETS

Designed by Clayton and Bell, 1876, and given by George Childs of Philadelphia, USA. It depicts the poets (who both attended Westminster School) above quotations from their works.

MEMORIAL WINDOW TO RICHARD TREVITHICK

(1771–1833), ENGINEER

Glass by Burlison and Grylls, 1888; moved to its present position, 1924. It depicts nine Cornish saints, including St Piran, whose face it thought to be a portrait of Trevithick himself. At the base of the window are angels holdings scrolls with drawings of Trevithick's inventions.

YOUNG MEN'S CHRISTIAN ASSOCIATION WINDOW

Designed by Dudley Forsyth, 1921. It commemorates the founder of the YMCA, Sir George Williams (1821–1905), and the association's work during the First World War. The glass depicts St Michael and St George, together with scenes of the Transfiguration and the Sermon on the Mount. Small heads of Williams in youth and old age appear at the base.

ROYAL FLYING CORPS WINDOW

Designed by Harry Grylls, 1922. It commemorates members of the corps who died during the First World War, and the design reflects the themes of flying men and wings. A figure of St Michael appears alongside numerous angels, one of whom has the face of Louis Bennett, who served with the corps and was killed in France. His mother, Mrs Louis Bennett of West Virginia, presented the window.

◆ STAINED-GLASS WINDOWS ON THE NORTH SIDE

These were designed by Sir Ninian Comper and installed over some decades, beginning in 1909. They depict kings and abbots in whose time the Abbey was gradually built, but each also forms a memorial to an individual or organisation. From west to east the windows commemorate:

SIR FREDERICK HENRY ROYCE

(1863–1933), AERONAUTICAL ENGINEER

The main figures are King Edgar and St Dunstan. In the canopy above King Edgar is a scene from a drawing by St Dunstan himself of Christ enthroned and Dunstan kneeling before him. In the right-hand window St Dunstan reads the Scriptures, while an angel plays a harp. Dedicated 1962.

ROYAL ARMY MEDICAL CORPS

The glass was originally a memorial to members of the RAMC who died in the First World War, but it now also commemorates those who died 1939–45. The figures are St Edward the Confessor and Abbot Edwin (d. 1071). The Confessor holds the ring that he gave to St John when the apostle appeared to him in the guise of a pilgrim, and from his right hand hangs a tablet inscribed with the opening words of his charter to the Abbey. Dedicated 1927.

SIR CHARLES PARSONS

(1854–1931), MARINE ENGINEER

The figures are King Henry III and Abbot Richard de Ware (d. 1283), in whose time the eastern half of the present church was built. Dedicated 1950.

SIR JOHN WOLFE BARRY

(1836–1918), CIVIL ENGINEER

The figures are Edward I (who continued his father's building work) and Abbot Walter de Wenlock (d. 1307). Within the canopy the abbot is shown giving the heart of Henry III to the abbess of Fontevrault, a scene that took place in the presence of Edmund Crouchback, the king's brother, and of William de Valence, his uncle, who are depicted in niches below. Dedicated 1922.

SIR BENJAMIN BAKER

(1840–1907), ENGINEER

The figures are Edward III and Cardinal Simon Langham (d. 1376). Langham's generosity enabled building work in the nave and the cloisters to continue. A small picture of the Forth Bridge, designed by Benjamin Baker, is included in the window. Dedicated 1909.

DONALD SMITH, 1ST BARON STRATHCONA AND MOUNT ROYAL (1820–1914)

The figures are Richard II and Abbot Nicholas Litlyngton (d. 1386). The latter devoted most of his time at Westminster, first as prior and then as abbot, to the continued rebuilding of the church and its associated buildings. Dedicated 1919.

WILLIAM THOMSON, BARON KELVIN (1824–1907), PHYSICIST

The figures are Henry V, a generous contributor to work on the western bays of the nave, and Abbot William of Colchester (d. 1420), in whose time the work was carried out. Kelvin's gravestone is in the floor below. Dedicated 1913.

◆ PORTRAIT OF RICHARD II

This magnificent wooden panel painting hangs on the pillar just outside St George's Chapel and is the earliest known contemporary painted portrait of an English sovereign. It shows the king enthroned and crowned, wearing state or coronation robes and holding

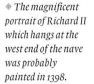

◆ *Richard Whittington, Lord Mayor of London, and his cat feature in the memorial window to Lord Kelvin. Whittington supervised building work at the Abbey on behalf of Henry V.*

◆ *The magnificent portrait of Richard II which hangs at the west end of the nave was probably painted in 1398.*

an orb and sceptre. The artist may be André Beauneveu, portrait painter to Charles V of France, who visited the English court about 1398. The portrait used to hang over the lord chancellor's stall on the south side of the quire but suffered damage there (allegedly from the wigs of the stall's occupants) and was moved to the Jerusalem Chamber in 1775. In the following century Dean Stanley returned it to the church, placing it in the sacrarium, above the tomb of Anne of Cleves. It was moved to the nave in 1946. In the nineteenth century the portrait was restored by George Richmond and Henry Merritt, by which time the pattern of raised and gilt gesso work had already disappeared. The vivid colours of the king's costume, however, are unimpaired. The frame, designed by George Gilbert Scott, dates from 1872. 163

PULPIT

The early sixteenth-century pulpit with linenfold panelling was formerly in the Lady Chapel. There is a tradition that Archbishop Thomas Cranmer preached from it at the coronation of Edward VI.

NAVE ALTAR AND FURNISHINGS

In monastic times an altar dedicated to the Holy Cross stood before the quire screen. The present nave altar, which has the same dedication, dates from 1968 and replaces one installed after the bombing of the Abbey's east end in 1940. The stalls, kneeling desks and communion rails associated with it were designed by Stephen Dykes Bower and date from 1965. The kneeling desks were given by Dean Don, in memory of his wife, and by the state of Queensland, Australia.

HMS *BARHAM* MEMORIALS

A pair of standard candlesticks and a pair of altar candlesticks used at the nave altar form a memorial to those who died when HMS *Barham* was sunk by a German U-boat off the Libyan coast in November 1941. The

candlesticks, of gilded oak, were designed by Sir Charles Peers and made by Robert Thompson, 1943. The smaller candlesticks particularly commemorate Captain Geoffrey Cook, and were the gift of his widow, Constance, who also presented a roll of honour in 1946.

◆ ICONS

Two icons by the Russian painter Sergei Federov, in steel frames designed by Donald Buttress, were introduced in 1994. They depict the Mother of God *Hodegitria* ('she who points the way') and Christ *Pantocrator* ('the all-ruling Lord'). 135

CHANDELIERS

The sixteen crystal-glass chandeliers in the nave and transepts were designed by A. B. Read and Stephen Dykes Bower. They were given by members of the Guinness family in 1965 to mark the 900th anniversary of the Confessor's abbey and were hand-blown at Waterford. Each weighs 280 lb. (*c.*127 kilos).

GLASS DOORS

The inner west doors, of engraved glass, were designed by David Peace and Sally Scott in June 1990. They were the gift of Barclays Bank, whose eagle symbols, cast in bronze by Sir David Hughes, feature in the central door-pulls.

ROLLS OF HONOUR

A number of memorial books and rolls of honour are normally kept in the nave:

The 'Golden Book' of the Royal Army Medical Corps (1922), inscribed and illuminated on vellum by Graily Hewitt and others, commemorates those who died in the First World War. A second book, designed and inscribed by M. C. Oliver and bound by George Frewin, names the fallen of the Second World War.

The Civilian War Dead Roll of Honour, in seven printed volumes, records the 66,375 civilians killed during the Second World War. 146

◆ *Icon of Christ, one of a pair by the Russian artist Sergei Federov.*

The HMS *Barham* Roll of Honour (1946) names the individuals commemorated by the candlesticks at the nave altar.

The Metropolitan Police Force Roll of Honour (1950), inscribed and illuminated on vellum by Dorothy Hutton and Vera Law, and bound in blue Morocco leather by Sydney M. Cockerell, names 1,076 police officers who died during the two world wars.

The Book of Remembrance of The Queen's Westminsters (1983) names those who died in South Africa, 1900–02, and in the two world wars.

The Coastal Command and Maritime Air Personnel Roll of Honour (2004) commemorates those who died on active service during the Second World War.

St George's Chapel

In this place the consistory courts of the Dean and Chapter's peculiar jurisdiction were formerly held. The chapel also served as the baptistery until the font was moved to the Lady Chapel. In 1925 it became a memorial chapel for members of the Abbey's staff killed during the First World War, but shortly afterwards it was redesigned as a general memorial chapel for the nation's war dead and was dedicated for this purpose in 1932. A stone tablet records that the refurbishment was completed as a memorial to Viscount Plumer, whose gravestone is here.

The furnishings were designed by Sir Ninian Comper and include the wrought-iron screen, decorated with bronze arabesques, which incorporates a trophy presented by the city of Verdun. Comper added alabaster tabernacle work to the medieval screen on the east side and provided a new altar below, originally dedicated to the Holy Cross, but rededicated to St George in 1944. A frontal of gilt bronze was paid for by the Mothers' Union from donations presented by the women of the empire. Other costs were borne by John Denham of Johannesburg and private donors.

◆ *Memorial to Henry Fawcett.*

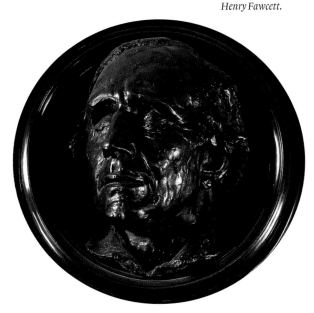

MONUMENTS AND FLOORSTONES

JAMES CRAGGS (1686–1721), STATESMAN

Marble statue designed by James Gibbs and executed by Giovanni Guelfi and Francis Bird, 1727. It depicts Craggs in Classical drapery, leaning on an urn. **157**

◆ HENRY FAWCETT (1833–84), STATESMAN, AND HIS WIFE, DAME MILLICENT GARRETT FAWCETT (1847–1929), CAMPAIGNER FOR WOMEN'S RIGHTS

Bronze monuments by Sir Alfred Gilbert and Sir Herbert Baker, 1887 and 1932 respectively. Henry Fawcett's memorial consists of a portrait above a Gothic arcade in which are seven figures representing Justice and other virtues characteristic of the man. Dame Millicent's memorial is a pair of bronze wreathed roundels, one displaying the insignia of the National Union of Women's Social Services, the other the Order of the British Empire. **156**

BRITISH EMPIRE WAR MEMORIAL

Stone tablet designed by P. H. Cart de Lafontaine, 1926, displaying the arms of the United Kingdom, India, Canada, Australia, South Africa, New Zealand and Newfoundland. Originally a memorial to the First World War, it now commemorates all the dead of the British empire who fell in the two world wars. **151**

WESTMINSTER ABBEY WAR MEMORIAL

Wooden panels, 1925, commemorating twenty-one 'servants of the Abbey' who died during the two world wars. Sixteen are former choristers. **155**

WILLIAM BOOTH (1829–1912), FOUNDER OF THE SALVATION ARMY

A marble bust on a marble bracket, by Albert Siegenthaler, unveiled 1965. The Salvation Army began in 1865 as a Christian mission, established by Booth and his wife to work among the poor of the East End of London, and especially with alcoholics, prostitutes and criminals. In 1878 the name of the organisation was changed to the Salvation Army, and it now has a world-wide membership. Buried at Abney Park cemetery, London. **158**

Also in this chapel are a memorial to Major-General Sir Fabian Ware (1869–1949) and the gravestones of Hubert, 1st Viscount Plumer (1857–1932), and of Edmund, 1st Viscount Allenby (1861–1936), and his wife, Adelaide (d. 1942).

OTHER FEATURES

REGIMENTAL AND MILITARY MEMORIALS

As well as the Padre's Flag this chapel contains: the framed guidon of the Westminster Dragoons **154**; standards of the Royal British Legion (together with a torch presented by the Legion in 1966) **148**; the Commando Association's Battle Honours Flag 1940–5 **152**; and the Commandos Roll of Honour, naming officers and men of Combined Operations Command who fell in the Second World War.

Coronation Chair

The Coronation Chair was made on the orders of Edward I in 1300–01 to enclose the Stone of Scone (also known as the Stone of Destiny). This stone, used in the inauguration ceremonies of Scottish kings, had been brought from Scotland by Edward in 1296 and placed in the care of the abbot of Westminster. The king commissioned a court painter, Master Walter, to decorate the chair with patterns of birds, foliage and animals on a gilt background. The figure of a king (either the Confessor or Edward I) was painted on the back. Only traces of this paintwork survive, and the chair has been much damaged by carved graffiti, much of it the result of visitors and Westminster schoolboys carving their names in the eighteenth and nineteenth centuries. The gilt lions date from 1727.

At coronations the chair is placed in the sacrarium, facing the high altar. After many centuries in St Edward's Chapel the chair was moved to the ambulatory, at the east end of Henry V's tomb, in 1998 and displayed there until 2010. A programme of conservation work followed and the chair was placed in its present setting in St George's Chapel in June 2013 to commemorate the sixtieth anniversary of The Queen's Coronation.

On 25 December 1950 the Stone of Scone was stolen by Scottish nationalists, who broke part of it while doing so. It was recovered in April 1951 and replaced in the chair, but in November 1996 it was taken to Scotland by order of the United Kingdom government. It is now displayed at Edinburgh Castle. 153

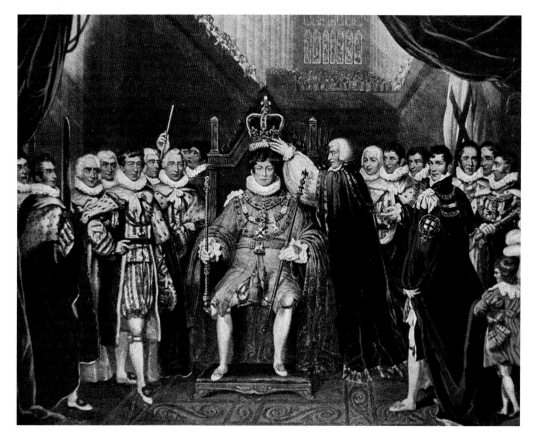

ABOVE: *The coronation of George IV in 1821.* OPPOSITE: *The Coronation Chair.*

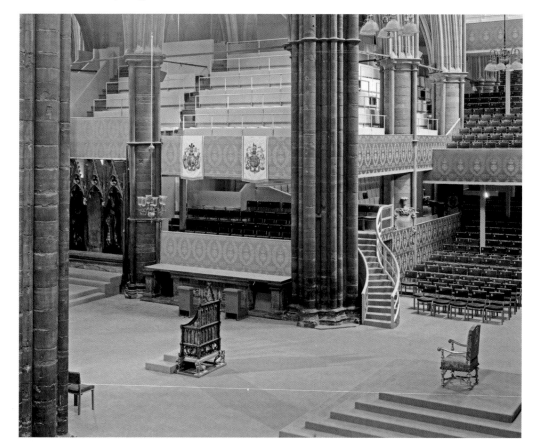

RIGHT: *The Abbey prepared for the Coronation of Queen Elizabeth II, June 1953.*

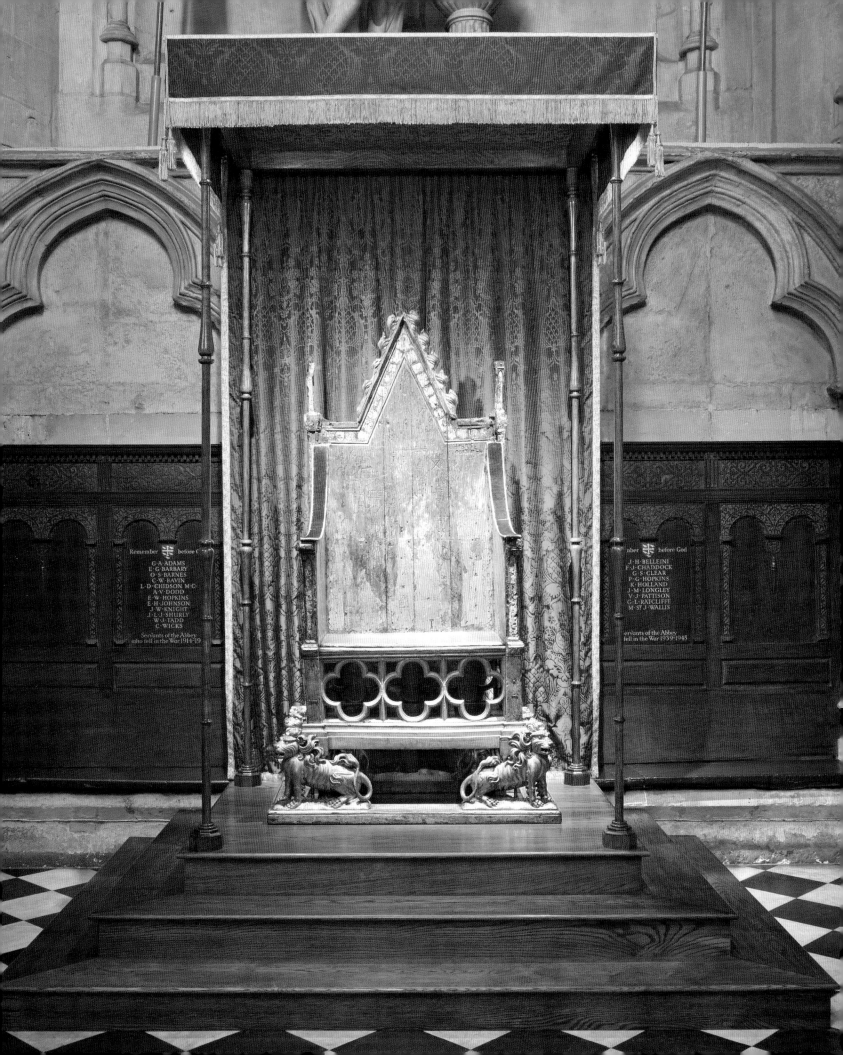

West Front

Between 1989 and 1993 the west front was completely restored. The heraldry above the west porch was newly painted and gilded, and a cross was added to the west gable as a memorial to Tommy Thompson (d. 1991), who worked for the Westminster Abbey Trust. In the niches flanking the west window new statues were added: on the north side the Blessed Virgin Mary, St Peter and St Edward; on the south side St John, St Paul and St Faith.

In 1998 the hitherto empty niches between the window and west door were filled with statues of ten martyrs of the twentieth century who died for their Christian faith. From left to right they are: Grand Duchess Elizabeth (d. 1918), murdered by the Bolsheviks in Russia; Manche Masemola (d. 1928), killed by her own parents in South Africa; Maximilian Kolbe (d. 1941), killed by lethal injection in the Auschwitz concentration camp in Poland; Lucian Tapiedi (d. 1942), killed during the Japanese invasion of Papua New Guinea; Dietrich Bonhoeffer (d. 1945) executed by the Nazis in a German prison; Esther John (d. 1960), brutally murdered in Pakistan; Martin Luther King (d. 1968), assassinated for his leadership of the Civil Rights Movement in the USA; Wang Zhiming (d. 1973), publicly executed by the Chinese authorities; Archbishop Janani Luwum (d. 1977), murdered during the regime of Idi Amin in Uganda; and Archbishop Oscar Romero (d. 1980), shot dead while celebrating Mass in El Salvador. The statues were designed by Tim Crawley, who also carved some of them along with Neil Simmons, John Roberts and Andrew Tanser. Crawley also carved the four statues of allegorical figures placed in 1996 in the niches flanking the arch of the west

BELOW:
*Statues of twentieth-century martyrs.
From left to right,
Lucian Tapiedi,
Dietrich Bonhoeffer,
Martin Luther King,
Oscar Romero,
Grand Duchess
Elizabeth,
Maximilian Kolbe.*

122

06

TREASURES OF WESTMINSTER ABBEY

door. They represent (from north to south) Truth, Justice, Mercy and Peace, virtues for which Christian martyrs have laid down their lives.

The Innocent Victims memorial, set in the paving in front of the north-west tower, commemorates all innocent victims of oppression, violence and war. Consisting of a circular stone of green Cumberland slate within a York stone surround, it was designed by Kenneth Thompson and unveiled by The Queen in 1996. It is inscribed with a quotation from the book of Lamentations: 'Is it nothing to you, all you who walk by.'

High up in the north-west tower itself is a ring of ten bells hung for change-ringing: the traditional English style in which the bells swing full circle on their wheels, allowing the ringers to vary the order in which each bell is rung. There have been bells at Westminster since at least the reign of Henry III, but the present ring dates from 1971 and forms a memorial to Jocelyn Perkins, who was super-intendent of the Tower from 1921 to 1958. There are also two bells cast in the reign of Elizabeth I (in 1583 and 1598 respectively), which are not used for change ringing but are chimed before the Abbey's normal services.

West of the towers, in Broad Sanctuary, stands a column erected in 1854 to commemorate former pupils of Westminster School who died in the Crimean War and the Indian Mutiny. A figure of St George slaying the dragon is at the top, and there are also statues of Edward the Confessor, Henry III, Elizabeth I and Queen Victoria. The memorial stands on the site of the medieval monastic gatehouse, which was used as a prison both before and after the dissolution (Sir Walter Raleigh spent the night there before his execution) and was not pulled down until 1776.

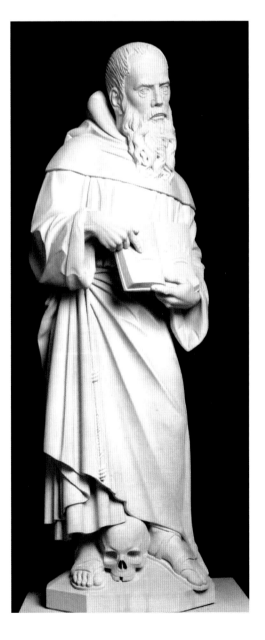

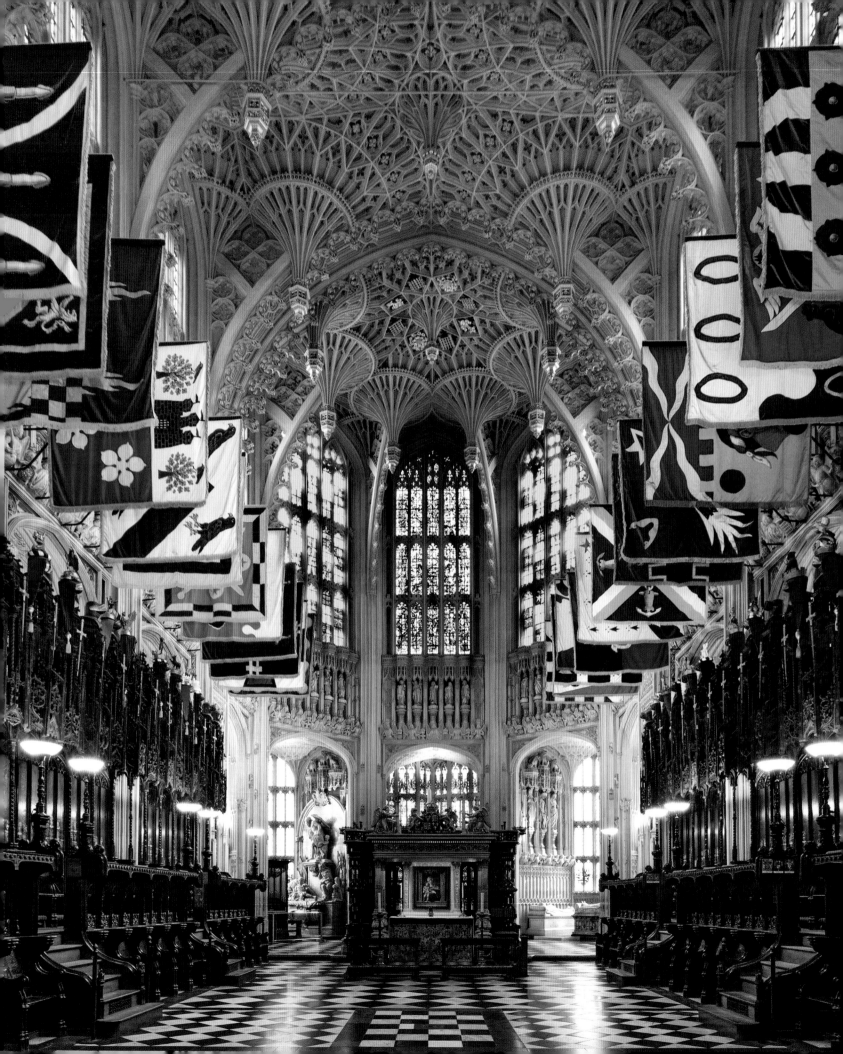

07 | LADY CHAPEL

OPPOSITE:
The magnificent interior of Henry VII's Lady Chapel, built between 1503 and 1516.

BELOW:
The exterior of the Lady Chapel viewed from the southeast.

URING THE thirteenth century an increased devotion to the Blessed Virgin Mary led to the building of 'Lady' chapels in many cathedrals and churches. At Westminster, Henry III built the first such chapel in 1220, at the east end of the Confessor's church, and later incorporated it into his rebuilding of the main church. Here the monks celebrated a daily Mass in honour of the Virgin at which especially elaborate music was performed. The increasingly complex polyphonic music used at this 'Lady Mass' led the monks to employ professional singers for the first time.

The present Lady Chapel has long been called 'Henry VII's Chapel' after its founder, who planned it as a burial place for himself and his Tudor successors, having abandoned an earlier scheme for burial in St George's Chapel at Windsor Castle. At the east end of the chapel was to be a new shrine for the body of Henry VI, whose canonisation was expected soon. West of this would be the principal altar, and Henry VII's own tomb would stand more or less in the middle of the new chapel. However, this original scheme was never carried out: Henry VI remained uncanonised, his intended connection with the new chapel faded away and the founder's own tomb was placed instead to the east of the altar.

125

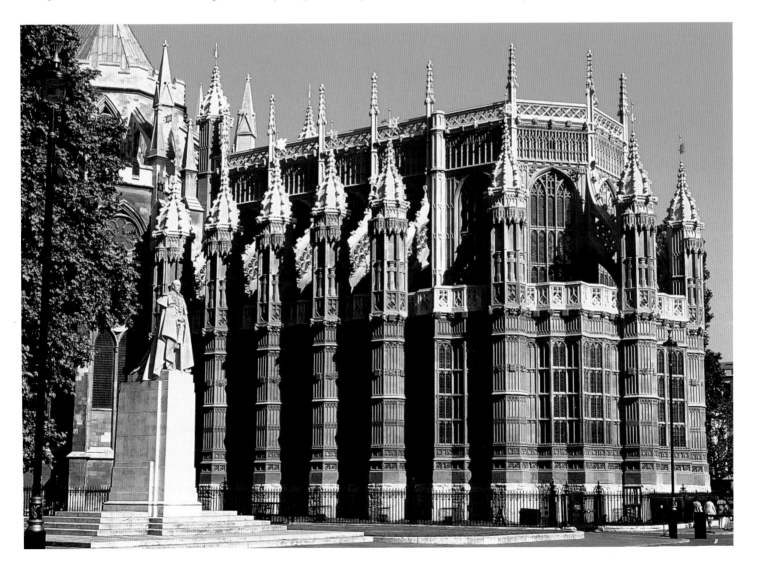

The demolition of the first Lady Chapel and of the small adjoining chapel of St Erasmus began in October 1502, and on 24 January 1503 Abbot Islip laid the foundation stone of the new building. We do not know for certain who designed it, but it has been suggested that Robert Janyns was originally responsible for the lower half of the chapel, his design being modified around 1506 by the mason William Vertue to allow for the fan vaulting. William and his brother Robert had already constructed the vaulting at Bath Abbey.

Henry VII's will and a series of illuminated indentures show how carefully he planned both the new chapel and the liturgical observances he envisaged for it. Despite a reputation for parsimony the king lavished money on the enterprise, and it is estimated that the total cost of building and establishing the chapel was at least £20,000. Henry dissolved several religious houses to fund priests for the new foundation and to support the charities he established in connection with it. He also bequeathed crucifixes, communion plate, embroidered hangings and other ornaments.

The decoration of the chapel emphasises its role as a royal burial place. Royal badges abound: the roses of Lancaster and York; the portcullis and the daisy (associated with Lady Margaret Beaufort, the king's mother); the lions of England; the fleurs-de-lis; the Welsh dragon; the initials R. H. (probably for Rex Henricus) beneath a crown; the greyhound of Richmond; and a falcon within an open fetter-lock (a badge of Edward IV, father of Henry VII's queen).

The windows contained painted glass by the glazier Bernard Flower, the upper windows displaying figures, the lower ones Tudor badges. Only fragments now remain, in the west window and in the aisles, but the original scheme can be imagined since Flower's designs were copied post-humously in the glass of King's College Chapel at Cambridge. Although the intended painting of the stonework and sculpture in the new Lady Chapel was never carried out, the interior must have appeared magnificent.

The superb fan vaulting, constructed between 1503 and 1509, is the climax of late medieval vault design and innovative in several ways. The ribs and panels are cut from single stones, and the fans spring from pendants rather than from the walls. No previous fan vaulting over rectangular bays had filled the centre of each compartment with pendants in the way carried out here. An unusual feature is the 'disappearance' of the tops of the transverse arches into the vault above, either

entirely, as in the eastern-most portion, or so as to leave only the cusped fringe visible, as in the main body of the nave. To the spectator below the result is breathtaking in its beauty and artistry.

The chapel was consecrated in February 1516, and the daily Lady Mass and other devotions in honour of the Virgin, which had continued elsewhere in the church, now returned to their proper home. To them were added other liturgical observances for the repose of Henry VII's soul, including four daily masses at the tomb altar. In choosing to be buried in the Abbey, the coronation church and the resting place of many medieval monarchs, Henry emphasised his royal legitimacy. That he planned the chapel as a dynastic mausoleum for his successors is confirmed by Latin verses inscribed around his tomb enclosure, which state that he had 'established a sepulchre for himself and for his wife, his children and his house'.

Henry VII had probably always intended the south aisle as a chantry chapel for his mother, Lady Margaret Beaufort. She was much involved in its planning and made bequests of plate and vestments to it. Even the choice of statues for the niches above the altar probably reflects her preferences: on the left of the empty central niche (which perhaps contained the Virgin and Child) is the patron of scholars, St Katherine of Alexandria, to whom Lady Margaret had a particular devotion, and on the right is her name saint, Margaret of Antioch. Lady Margaret's tomb was in place here by 1515 and was the sole monument until the Lennox tomb was set up.

It is not known how the north aisle was used when the Lady Chapel was first built, although there was undoubtedly an altar (its dedication now unknown) at the east end. Henry VII probably expected the aisle to be used for the burial of his successors, though this did not happen until his granddaughter Mary Tudor was interred here in 1558. In the early seventeenth century James I's decision to place here the tomb of his predecessor, Elizabeth I, and to erect a monument to his mother, Mary Queen of Scots, in the south aisle, perpetuated the Lady Chapel's function as a royal mausoleum.

During the Commonwealth period significant parliamentary figures were interred in the chapel, including Oliver Cromwell, but with the restoration of the monarchy in 1660 royal burials resumed. The first Hanoverian, George I, lies in his native Hanover, but his son George II constructed a vault beneath the floor of the nave for his own and his family's burial. In it were also buried several

BELOW: *The stall plate of HM The Queen as sovereign of the Order of the Bath.*

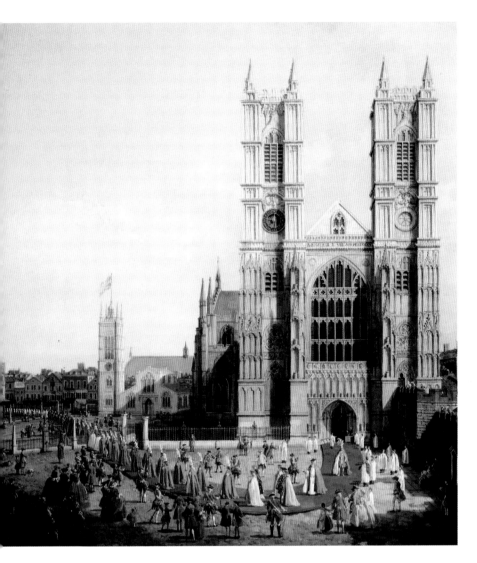

ABOVE: *Canaletto's painting of Knights of the Order of the Bath leaving the Abbey (1749).*

sculpture and the painted glass survived, but the latter was destroyed early in the Civil War. The black and white marble floor was given in 1699 by Henry Killigrew (d. 1700), who was appointed a prebendary of Westminster in 1643 and resumed his post at the Restoration. Inscriptions in the floor either side of Henry VII's tomb record his gift. 11 & 12

After 1660 'early morning prayers' were held in the chapel, consecrations of bishops took place here until 1708, and it was the occasional meeting place of the Upper House of Convocation. The reintroduction of an altar in 1870 brought the chapel back into regular use for worship, and it is now used for some early morning celebrations of the Eucharist and for baptisms and weddings.

In 1725 George I established the Most Honourable Order of the Bath, a revived order of knighthood whose title derived from the ritual washing and vigil of prayer that medieval knights-elect had undertaken before their investiture. The dean of Westminster was appointed ex officio dean of the Order, and the Lady Chapel was designated for the installation of its knights. Membership is generally awarded to recognise military or political service.

At his installation each knight is assigned a stall in the chapel. His heraldic banner is hung over it, a carved representation of his crest is placed over the canopy, and a metal plate displaying his coat of arms is fixed to the back of the stall. The stall is reassigned after a knight's death, and the banner and crest are removed, but the heraldic plate remains in perpetuity. Originally each knight also had three 'esquires', who occupied the front seats and had their own stall plates.

George I himself installed the first knights in 1725, and installation ceremonies were held at intervals until 1812, by which date there were no longer enough stalls for the number of knights. No further installations were held until the early twentieth century, when the structure of the Order was reformed. Esquires were abolished and several classes of membership were devised, of which only the most senior, knights grand cross (GCB), were to be installed. King George V revived the installation ceremony in 1913, and it is now normally held every four years.

The return stall on the south side of the chapel is for the sovereign of the Order, that on the north side (with a small wooden figure of Henry VI on its ledge) for the great master. Below this stall is kept the ceremonial sword used at installation ceremonies.

children of George III who died in infancy, though his own burial at Windsor ended the tradition of royal burial at Westminster. Remarkably – especially given the very large number of other monuments erected in the Abbey in the seventeenth and eighteenth centuries – none of the monarchs buried here after Elizabeth I is commemorated by anything more substantial than a small gravestone.

The five small apsidal chapels each contained an altar in medieval times, though their dedications are unknown. The westernmost chapels on each side have stone screens, reduced to their present size by the removal of openwork upper parts in the eighteenth century. These chapels were perhaps planned as royal 'closets', where members of the royal family might pray privately before the intended shrine of Henry VI. The central chapel is now the RAF Memorial Chapel.

At the dissolution the Lady Chapel was stripped of many fittings, and its altars were destroyed. The

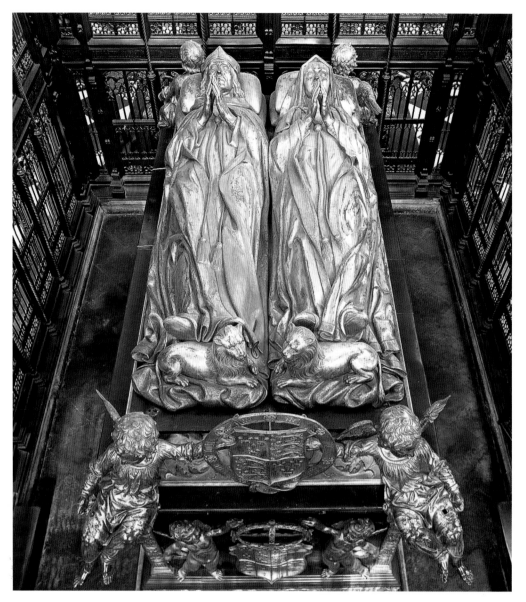

king's patron saints, among whom are Michael, George, Christopher (carrying the infant Christ), Edward the Confessor and Barbara (with the tower which is her emblem). At either end are the king's arms supported by gilt-bronze cherubs. Bronze effigies of the king and queen lie on top. A small altar originally stood at the foot of the tomb.

The surrounding screen or grille was partly erected before the king's death and is decorated with royal badges and emblems. Some of the upper part of the screen has been lost, and only six of the original thirty-two statues that filled the niches have survived. **13**

⬧ EDWARD VI (1537–53)

Gravestone placed here in 1966 by Christ's Hospital, which Edward VI founded. An unexecuted design for a monument (perhaps by William Cure) survives in the Bodleian Library at Oxford. **09**

JAMES I (1566–1625)

His exact burial place in the Abbey was unknown until 1869, when Dean Stanley identified the coffin, resting in the same vault as Henry VII and his queen. **13**

LUDOVIC STUART, 2ND DUKE OF LENNOX AND DUKE OF RICHMOND (1574–1624), AND HIS WIFE, FRANCES (1578–1639)

Freestanding monument of black marble and bronze by Hubert Le Sueur. A double sarcophagus supports recumbent effigies of the duke and duchess, the former wearing armour with the mantle and collar of the Order of the Garter. At the corners of the monument figures of Faith, Hope, Charity and Truth support a domed canopy of bronze decorated with vases at the corners and with a figure of Fame on the top. **27**

⬧ GEORGE VILLIERS, 1ST DUKE OF BUCKINGHAM (1592–1628)

Large monument, the marblework by Isaac Besnier, the bronzework by

128

07

MONUMENTS AND FLOORSTONES

⬧ HENRY VII

(1457–1509) AND HIS CONSORT, **ELIZABETH OF YORK** (1465–1503)

A bronze grille by Thomas Ducheman encloses a chest tomb of marble and bronze by Pietro Torrigiano, 1518. Henry VII gave detailed directions in his will for this monument, and the surviving contracts reveal that it cost £1,500. The black marble chest has a beautifully carved frieze and is adorned with medallions in copper gilt, representing the Virgin Mary and the

⬧ Tomb of Henry VII and Elizabeth of York.

⬧ A bronze cherub at the foot of Henry VII's tomb.

Hubert Le Sueur, 1634. The tomb chest supports bronze effigies of the duke and duchess with a figure of Fame (who originally held a trumpet) at their feet. At each corner is a black marble obelisk supported by skulls, and seated beside these are life-size mourning figures in bronze: at the head, Pallas and Benevolence; at the feet, Neptune and Mars. A tall wall-piece rising behind displays figures of the duke's four children. The recumbent child is Charles (1625–7), and the kneeling figures, from right to left, are Mary (1622–85), George (1628–87) and Francis (1629–48). All are buried with their father (who was assassinated) in a vault beneath the monument, but the widowed duchess, who commissioned it, remarried (becoming marchioness of Antrim) and is buried in Ireland. 14

◈ OLIVER CROMWELL
(1599–1658), LORD PROTECTOR FROM 1653

Cromwell's body lay in state at Somerset House before a great procession of mourners accompanied it to Westminster for a state funeral. The hearse bore a lifelike effigy in royal robes, wearing a crown and holding an orb and sceptre. After the Restoration Cromwell's remains were removed from the Abbey and hung from a gibbet at Tyburn. 19

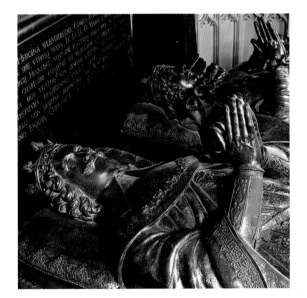

◈ Portrait of Edward VI by the school of Hans Holbein (Collection of the Earl of Pembroke, Wilton House).

◈ Tomb effigy of George Villiers, duke of Buckingham.

ESMÉ STUART, 5TH DUKE OF LENNOX AND DUKE OF RICHMOND (1649–1660)

Marble monument taking the form of an obelisk supported by four small skulls. A small urn contains the heart of the young duke, who is buried in the vault below. 26

COMMONWEALTH BURIALS AND THE ORMOND VAULT

Beneath carpet a vault stone names those buried here during the Commonwealth who were disinterred in 1661 and reburied in a pit on the north green. They are: General Henry Ireton (1611–51), Oliver Cromwell's son-in-law; John Bradshaw (1602–59), president of the tribunal that condemned Charles I to death, and his wife, Mary; Elizabeth Cromwell (d. 1645) and Jane Desborough (d. 1656), Cromwell's mother and wife respectively; Anne Fleetwood, probably Cromwell's granddaughter; Admiral Richard Deane (1610–53); Colonel Humphrey Mackworth (d.

1654); Sir William Constable (d. 1655) and Dennis Bond (d. 1658), both regicides; and Admiral Robert Blake (d. 1658). The remains of Cromwell's daughter Elizabeth Claypole (d. 1658), who is not listed on the stone, were left undisturbed to the north-west of Henry VII's tomb. 10

The vault was subsequently used for the burial of James Butler, 1st duke of Ormond (1610–88), and his family, as well as for several other members of the nobility. The fifty-one names inscribed on the vault stone include some illegitimate descendants of Charles II, together with William Bentinck, 1st earl of Portland (1649–1709), who accompanied William III to England from the Netherlands, and John Churchill, 1st duke of Marlborough, who was interred in the vault in August 1722 before his later reburial at Blenheim Palace. 20

JOHN SHEFFIELD, 1ST DUKE OF BUCKINGHAM AND NORMANBY
(1647–1721), STATESMAN

Marble monument, designed by Denis Plumière and sculpted by Laurent Delvaux and Peter Scheemakers, 1722. It draws inspiration from a tomb by Plumière at the church of Notre Dame de la Chapelle in Brussels. Surrounded by military trophies and wearing Roman armour, the duke reclines on a sarcophagus, while his widow mourns both her husband and her dead children. Portraits of the latter are carried away at the top of the monument by Time and his attendants. The names of four children are now inscribed on the step of the monument: John (d. 1710), Henrietta (d. 1715), Robert (d. 1715) and Edmund (d. 1735). The monument was erected by the duke's widow, Catherine, duchess of Buckingham (1682–1743), who is buried with him at the foot of the monument. Funeral effigies of the duchess and of Edmund, who succeeded his father in the dukedom, are in the Abbey's museum. 18

07

GEORGE II (1683–1760) AND HIS CONSORT, CAROLINE OF ANSBACH (1683–1737)

George II was the last British monarch to be born outside of Great Britain and the last to be buried in the Abbey. His coffin was placed alongside that of Queen Caroline in a marble sarcophagus within the royal vault, and it is said that one side of each coffin was removed so that their remains should not be separated in death. 07 & 08

ANTOINE-PHILIPPE, DUC DE MONTPENSIER (1775–1807)

Marble chest tomb with recumbent effigy, by Sir Richard Westmacott, 1829. It was commissioned by Montpensier's brother Louis-Philippe, afterwards king of France, and depicts the duke (who died in exile in England) wearing a coronet and a mantle decorated with fleurs-de-lis and roses. The arms of Orléans are at one end of the tomb. 24

ARTHUR PENRHYN STANLEY (1815–81), DEAN OF WESTMINSTER 1863–81

Alabaster tomb with recumbent white marble effigy, by Sir J. Edgar Boehm, 1884, paid for by public subscription. The dean wears the badge of the Order of the Bath over a surplice. Stanley was a leading theologian of his day and a major figure in the nineteenth-century history of the Abbey. He devoted much energy to preserving and recording its historic fabric, and through his writing and preaching he promoted the Abbey's unique place in the life of the nation and the empire.

Stanley's gravestone, in front of the monument, also records the burial of his wife, Lady Augusta, *née* Bruce (1822–76), who was one of Queen Victoria's ladies-in-waiting. In 1877 Stanley erected in this chapel a window in her memory (glass by Clayton and Bell), which depicted scenes from the history of the Bruce family together with heraldic emblems. It was destroyed by bombing in 1940, and only the inscription survives. 25

ANNE (MOWBRAY), DUCHESS OF YORK (1472–81)

Anne was the child bride of Richard, duke of York, one of the 'princes in the Tower', and was originally buried in the chapel of St Erasmus, demolished in 1502 to make way for the present Lady Chapel. It had been assumed that her remains were then reburied elsewhere in the Abbey, but in 1964 her coffin was found on the site of a medieval nunnery in east London, and in 1965 she was reburied here. 16

Here also is the gravestone of Anne of Denmark (1574–1619), consort of James I of England. Also stones recording the burial of four children of George II: Frederick Louis, prince of Wales (1707–51), and his wife, Augusta (d. 1722); William, duke of Cumberland (1721–65), Caroline (1713–57), and Amelia (1711–86); and of five children of Prince Frederick Louis: Elizabeth (d. 1759); Frederick (d. 1765); Edward, duke of York (d. 1767); Louisa (d. 1768); and Henry, duke of Cumberland (d. 1790).

OTHER FEATURES

VESTIBULE AND GATES

A flight of steps leads from the ambulatory to the Lady Chapel entrance and three magnificent gates of bronze mounted on wooden frames. They display emblems and badges associated with Henry VII and, since they resemble the king's tomb grille, may perhaps also be by Thomas Ducheman. The walls of this vestibule are lined with painted metal panels naming benefactors who supported the restoration of the chapel between 1992 and 1995.

07

◆ *Tomb effigy of Arthur Penrhyn Stanley, dean of Westminster.*

STALLS

The oak stalls date from different periods. Originally the back rows occupied the first three bays, while the lower row extended for only two bays, thus leaving space for Henry VII's tomb in the position first intended for it. East of the stalls as originally arranged were stone screens separating the nave from the aisles on either side. After the establishment of the Order of the Bath these screens were replaced with additional stalls to provide additional seats for knights and esquires. Extra canopies were obtained by cutting some of the original ones on the south side in half.

The stalls retain their original hinged seats or misericords (from the Latin word for 'mercy'), which tip up to form a small ledge that gave the monks a little support while standing for services. Each has a decorative carving, and since they were normally out of sight, the carvers often selected vivid and non-religious subjects, including scenes from daily life, animals and mythical creatures. Most of the misericords are contemporary with the building of the chapel, but one stall on the south side (the eighth from the west) has a thirteenth-century example assumed to have come from Henry III's church, though how it came to its present position is a mystery. The eighteenth-century misericords are of noticeably inferior workmanship.

SCULPTURE

Running around the chapel at a high level is a series of statues of saints, installed as part of the chapel's original decorative scheme. Of the original 107 figures a remarkable 95 are extant. Below them an equally fine frieze of angels, interspersed with royal emblems, also survives largely undamaged and continues across the west wall.

FONT

The font was first set up in the north transept in 1663 but was later displaced and by 1819 stood within the south-west tower (now St George's Chapel). In 1871 George Gilbert Scott renovated the font, designed the cover and moved it to its present position. As the Abbey is not a parish church, only residents of the precinct and children of members of the Order of the Bath are normally baptised here.

ALTAR AND ALTARPIECE

Marble altar in Renaissance style, designed by Sir Walter Tapper and executed by Lawrence Turner, 1935. The original altar was begun by Pietro Torrigiano in 1519 and set up in the chapel by Benedetto da Rovezzano in 1526. It was dismantled after the dissolution of the monastery, and there was then no permanent altar until 1870, when George Gilbert Scott introduced a black marble slab supported by eight cedarwood columns. Part of the frieze of the original altar (discovered by Dean Stanley) was added to this, and two of its pillars, discovered at the Ashmolean Museum in Oxford, were later also incorporated.

The present altar, given by members of the Order of the Bath, is based on the sixteenth-century original as shown in engravings. The surviving original pillars and two replicas (usually hidden by a frontal) support Scott's marble slab. Four columns support a baldacchino over the altar, decorated with a frieze of emblems of the Order of the Bath. The altarpiece is a framed oil painting of the Virgin and Child, *c.* 1480, by Bartolommeo Vivarini. It was presented by Viscount Lee of Fareham in 1935.

WEST WINDOW

Devised by Donald Buttress and Hubert Chesshyre, designed by John Lawson, and executed by Goddard and Gibbs; unveiled 1995. It commemorates the completion of a long programme of restoration of the Abbey's fabric and contains initials, ciphers and coats of arms of donors to the restoration appeal, 1973–95. It especially honours Sir John Templeton (b. 1912), a major benefactor. In the centre are the royal arms, flanked on the left by those of the Duke of Edinburgh (president of the Westminster Abbey Trust) and on the right by the arms of the Prince of Wales as great master of the Order of the Bath.

DONOR WINDOWS

In the apsidal chapels are a number of small windows designed by Alfred Fisher and Peter Archer (of Chapel Studios). They were installed in 1995 and 1997 to commemorate individual and corporate donors to the Abbey's restoration appeal (1973–95).

EAST WINDOWS

The central window, designed by Alan Younger (2000), celebrates the life of the Blessed Virgin Mary. In the lower panels is a Nativity scene with shepherds, wise men and the star of Bethlehem (depicted as the Hale-Bopp comet, which was passing over Younger's home while he worked on the design). On either side of the Nativity is the Annunciation, the angel Gabriel to the left and the Virgin at prayer to the right. In the middle panels is the Assumption. The two flanking windows of predominantly blue glass were created by Hughie O'Donoghue RA and made by Helen Whittaker (2013). They were inspired by the verse from the Sermon on the Mount beginning 'Consider the lilies of the field'. All three windows were the gift of Lord Harris of Peckham.

CHAMBER ORGAN

By Noel Mander, 2013. Presented by the Lord Mayor (Alderman Roger Gifford) and the Corporation of the City of London to mark the sixtieth anniversary of the Coronation of HM The Queen.

07

RAF Chapel

The small eastern chapel immediately behind Henry VII's tomb was dedicated in 1947 as the Royal Air Force Chapel and particularly commemorates those who died in the Battle of Britain (July–October 1940). The carpet, woven in RAF blue with the RAF's motto (*Per Ardua Ad Astra*) and crest, dates from *c*.1979.

The principal memorial is the Battle of Britain window of stained and painted glass by Hugh Easton, 1947. In the upper tier are figures of Seraphim, while the remaining glass mainly depicts the badges of the seventy participating fighter squadrons. Four panels show scenes symbolising the Redemption: two depict a squadron leader kneeling before the Virgin Mary, who is shown holding in one panel the infant Jesus, and in the other the dead Christ; the other two panels show a flying officer kneeling before visions of the crucified and resurrected Christ. Also depicted are the royal arms, the badge of the Royal Air Force and the flags of the countries from which the pilots came. At the base of the window are words from Shakespeare's *Henry V*, 'We few, we happy few, we band of brothers', and below is a glazed hole made by a fragment of a bomb dropped during the battle. The names of six wartime leaders of the RAF are painted below the window. They are: William, Baron Douglas of Kirtleside (1893–1969); Lord Dowding (whose gravestone is here); Sir Arthur Harris Bt (1892–1984); Cyril, 1st Baron Newall (1886–1963); Charles, Viscount Portal of Hungerford (1893–1971) and Arthur, 1st Baron Tedder (1890–1967).

RAF CHAPEL ALTAR AND ORNAMENTS

Altar of walnut designed by Sir Albert Richardson with silver-gilt ornaments by J. Seymour Lindsey, 1947. The altar incorporates figures of King Arthur and St George by A. F. Hardiman, but these are normally concealed by the frontal. The ornaments consist of a cross and candlesticks, a pair of standard candlesticks and altar rails.

BATTLE OF BRITAIN ROLL OF HONOUR

Inscribed on vellum by Daisy Alcock and bound in inlaid blue leather by William F. Matthews, 1947. It lists

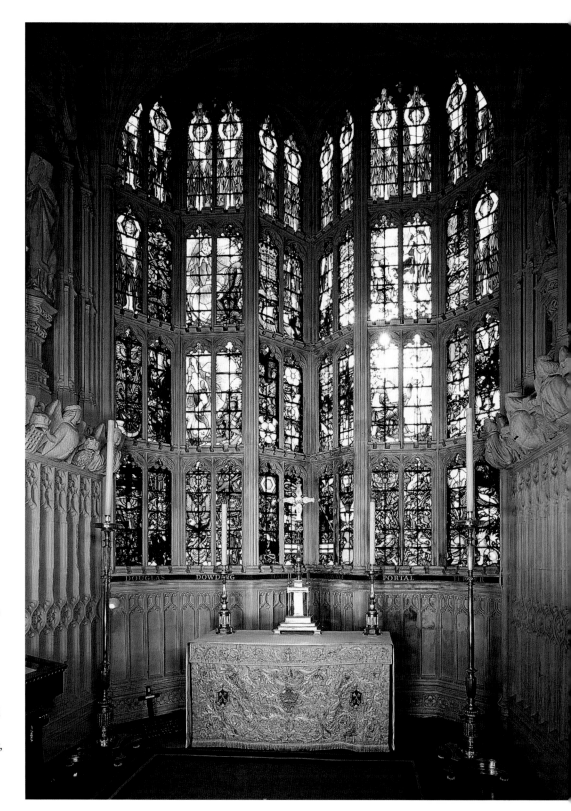

ABOVE: *The RAF Chapel, showing the Battle of Britain window, the altar and its ornaments.*

07

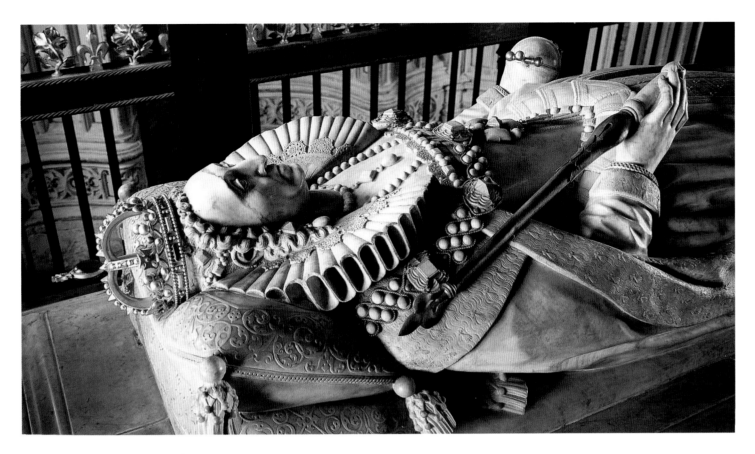

1,497 pilots and crew killed or mortally wounded in the battle, including men from the United Kingdom and its colonies and from Australia, New Zealand, Canada, South Africa, Belgium, Czechoslovakia, Poland and the USA. The roll was the gift of Captain Bruce S. Ingram.

FLOORSTONES

SIR FRANK WHITTLE
(1907–96),
AERONAUTICAL ENGINEER

Memorial stone designed by Donald Buttress, 2000, commemorating the pioneer of the jet engine. Buried at Cranwell, Lincolnshire. 23

Here also are the gravestones of Hugh, 1st Viscount Trenchard (1873–1956), air marshal and 'Father of the RAF', and of Hugh, 1st Baron Dowding (1882–1970), air chief marshal, and his wife, Muriel (1908–93).

MONUMENTS IN THE NORTH AISLE

◈ TOMB OF ELIZABETH I
(1533–1603) WITH GRAVE OF MARY I (1516–58)

Large marble monument by Maximilian Colt, assisted by John de Critz, 1606. Ten black columns rise from its base to support a barrel-vaulted triumphal arch, decorated with shields and heraldic emblems. At each corner royal supporters (the lion and the dragon) hold shields with royal badges. The fine effigy resembles the queen in her later portraits but was much vandalised in former times so that the jewellery and regalia are replacements dating from the 1970s. Railings that originally enclosed the tomb were removed in 1822; the present ones are modern (1983) but incorporate Tudor emblems.

When Elizabeth I was crowned in January 1559, the monastic foundation revived by Mary I in 1556 was still in place, so Abbot John Feckenham

◈ *Tomb effigy of Elizabeth I.*

◈ *Tombs of princesses Mary (left) and Sophia (right).*

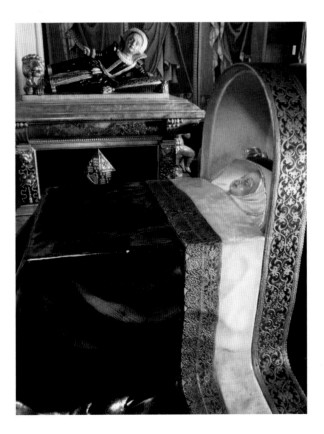

assisted with the liturgy, which was partly in English and partly in Latin. In May 1560 the queen dissolved the monastery and by royal charter established the Abbey in its present form as a collegiate church.

Elizabeth I was buried here in April 1603 amid scenes of great mourning. James VI of Scotland, who succeeded to the English throne as James I, commissioned a monument for her and for his mother, Mary Queen of Scots, whose death warrant Elizabeth had signed. When Elizabeth's tomb was finished, at a total cost of £1,485, her coffin (which had originally been placed in the vault of her grandfather Henry VII) was moved to a vault in this aisle. It rests on the coffin of her half-sister Mary I. **33**

At Mary's funeral in December 1558 an effigy of the queen in royal robes lay on a hearse decorated with wax angels and escutcheons. The coffin was escorted to the grave by Abbot Feckenham and the monks of Westminster, with Margaret, countess of Lennox, as chief mourner. No monument to Mary was ever erected, but she is recalled in the Latin inscription at the base of Elizabeth I's tomb, which may be translated as: 'Partners both in throne and grave, here rest we two sisters, Elizabeth and Mary, in the hope of the Resurrection.' Because of the contrasting religious policies of the two sisters, the floor in front of Elizabeth's tomb was chosen in 1977 as an appropriate place for a memorial stone commemorating all who died in the religious conflicts of the Reformation. **32**

◈ **PRINCESS SOPHIA** (D. 1606, AGED THREE DAYS) AND **PRINCESS MARY** (D. 1607, AGED TWO YEARS), INFANT DAUGHTERS OF JAMES I

Alabaster and marble tombs by Maximilian Colt. Princess Sophia's takes the form of a cradle with the child's head revealed above the bedclothes. The Latin inscription calls the princess 'a royal rosebud untimely

◈ *Bronze tomb effigy of Lady Margaret Beaufort, countess of Richmond and Derby.*

plucked by Fate ... to flower again in the rose-garden of Christ'. The other tomb consists of a sarcophagus with a small figure of Princess Mary reclining on top. **34 & 35**

EDWARD V (B. 1470) AND **RICHARD, DUKE OF YORK** (B. 1472), 'THE PRINCES IN THE TOWER'

Marble sarcophagus in the east wall, designed by Sir Christopher Wren and executed by Joshua Marshall, 1678. It contains bones found at the Tower of London in 1674 and placed here on the orders of Charles II, who believed them to be the remains of the murdered princes. The Latin inscription implicates Richard III in the murder, but modern opinion is sharply divided on this matter. **36**

Also in this aisle are monuments to Charles Montagu, 1st earl of Halifax (1661–1715), and George Saville, 1st marquess of Halifax (1633–95).

MONUMENTS AND FLOORSTONES IN THE SOUTH AISLE

◈ **MARGARET BEAUFORT, COUNTESS OF RICHMOND AND DERBY** (1443–1509)

Chest tomb of marble and bronze by Pietro Torrigiano, who contracted for the work in November 1511, undertaking to complete it by February 1513. The effigy is his masterpiece, depicting Lady Margaret in old age, in widow's dress with a hood and long mantle. Her feet rest on the Beaufort beast (the yale), and the delicate wrinkled hands are raised in prayer. The effigy, the canopy and the wreathed coats of arms on the sides of the tomb (recalling those on Henry VII's tomb) are all of bronze. In 1529 the tomb was enclosed by iron railings paid for by St John's College, Cambridge, and constructed by Cornelius Symondson. These were sold around 1822 but (together with

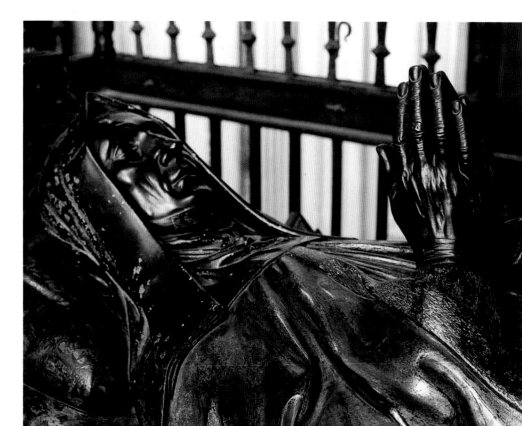

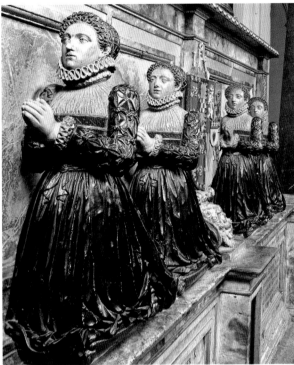

railings from the tomb of Mary Queen of Scots) were subsequently rediscovered and returned to their original position.

Lady Margaret was the mother of Henry VII by her second husband, Edmund, earl of Richmond (d. 1456), who was the eldest son of Owen Tudor and Catherine de Valois (Henry V's widow). Her fourth husband, Thomas, Lord Stanley (later earl of Derby), deserted Richard III and crowned his stepson Henry with Richard's coronet on the battlefield of Bosworth.

A shrewd, pious and immensely rich woman, she founded Christ's and St John's colleges at Cambridge University, established professorships of divinity there and at Oxford, and supported the first English printer, William Caxton. Lady Margaret died in the abbot of Westminster's lodgings shortly after the coronation of her grandson Henry VIII. **43**

MARGARET, COUNTESS OF LENNOX (1515–78)

Marble tomb with recumbent alabaster effigy, 1578, depicting the countess (a niece of Henry VIII) in

Figures of her daughters (above) beside the tomb of Margaret, countess of Lennox (below).

robes of state. Along the sides of the tomb are kneeling figures of her four daughters and four sons. Her eldest son, Henry, Lord Darnley, who later married Mary Queen of Scots, wears a cloak over his armour and has a crown above his head. **41**

MARY QUEEN OF SCOTS (1542–87)

Marble and alabaster tomb by William and Cornelius Cure, 1612. The sarcophagus supporting the queen's effigy lies beneath an elaborate canopy carved with roses and thistles. The queen wears a coif and an ermine-lined mantle, her head resting on embroidered cushions with the crowned lion of Scotland at her feet. The tomb is richly decorated with heraldry and carvings, and there is a lengthy Latin inscription. The railings (like those around Margaret Beaufort's tomb) were removed around 1822 but later reinstated.

James I commissioned this monument to his mother, together with that of his predecessor Elizabeth I (who had signed Mary's death warrant) after his accession to the English throne in 1603. It took many years to complete, and it was not until September 1612 that Mary's body was transferred to Westminster from Peterborough Cathedral, where she had been buried after her execution. **42**

Among those buried in the same vault as Mary Queen of Scots are: Henry, prince of Wales (1594–1612), eldest son of James I; Lady Arabella Stuart (1575–1615), daughter of Margaret, countess of Lennox; Prince Henry (1639–1660), youngest son of Charles I, and his sister Princess Mary (1631–1660), mother of William III; Elizabeth, Queen of Bohemia (1596–1662), eldest daughter of James I and grandmother of George I; Prince Rupert, count palatine of the Rhine (1619–82); Anne (Hyde), duchess of York (1637–71), first wife of the future James II and mother of queens Mary II and Anne.

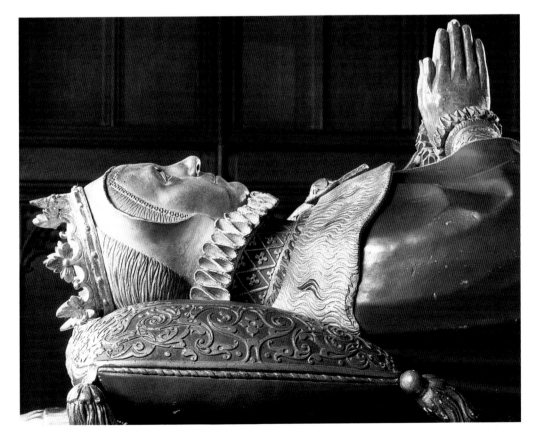

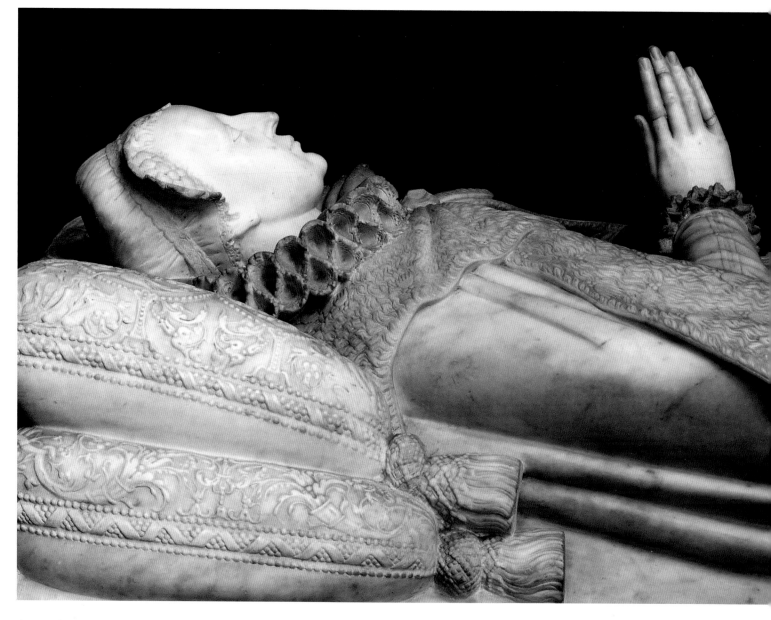

07

◆ STUART MONARCHS

Remarkably, none of the Stuart or Hanoverian monarchs buried in Westminster Abbey has any kind of funerary monument. The Stuart vault is beneath the east end of this aisle, and the only record of the royal burials within it are simple inscribed lozenge stones naming the following: Charles II (1630–85); Mary II (1662–94) and William III (1650–1702); Queen Anne (1665–1714) and her consort, Prince George of Denmark (1653–1708). **47 – 51**

◆ *Tomb effigy of Mary, Queen of Scots.*

GEORGE MONCK, 1ST DUKE OF ALBEMARLE (1608–70), AND CHRISTOPHER, 2ND DUKE OF ALBEMARLE (1652–88)

Marble monument designed by William Kent and sculpted by Peter Scheemakers, installed *c.*1744–6. The base supports a column decorated with ships, anchors and heraldry. On one side stands an armoured figure of George Monck and on the other a mourning woman holding a portrait of his son Christopher. Unusually, there is no inscription. The funeral of the first duke (who was principally responsible

for the Restoration of Charles II) took place amid great pomp in the north aisle of the chapel, with the king himself as chief mourner. Christopher Monck (who died in Jamaica) is buried in the same grave. **30 & 46**

CATHERINE, LADY WALPOLE (D. 1737)

Marble statue by Filippo della Valle, *c.*1743, on a plinth by Michael Rysbrack, 1754. This slender statue of a graceful woman in simple drapery was commissioned by Lady Walpole's son, Horace, and is a copy of a Classical statue (now in the Vatican) known as

Pudicity (Modesty). Buried at
Houghton, Norfolk. 44

EVELYN BARING,
1ST EARL OF CROMER
(1841–1917),
COLONIAL ADMINISTRATOR

Marble memorial by William
Goscombe John, 1920, showing an
Egyptian peasant woman and her
children. At the base is a small portrait
of the earl, who is described as
'Regenerator of Egypt'. An entwined
ribbon is inscribed 'And the desert
shall rejoice and blossom as the rose'.
Buried at Bournemouth. 37

GEORGE, 1ST MARQUESS
CURZON OF KEDLESTON
(1859–1925), VICEROY OF INDIA

Marble tablet by Sir Bertram
Mackennal, 1930, incorporating
Curzon's portrait, his crest and the
arms of the University of Oxford
(of which he was chancellor). Buried
at Kedleston, Derbyshire. 40

ALFRED, 1ST VISCOUNT
MILNER (1854–1925),
STATESMAN

Limestone memorial tablet by Gilbert
Ledward, 1930, consisting of a portrait
within a laurel wreath. Buried at
Salehurst, Sussex. 39

CECIL RHODES
(1853–1902), IMPERIALIST

Inscribed tablet designed by Stephen
Dykes Bower, unveiled at the end of
1953. Buried in Zimbabwe (formerly
Rhodesia). 38

MEMORIAL PRESENTED
BY TRINITY CHURCH,
NEW YORK

A small plaque (erected 1966)
commemorates a grant of land by
King William III in 1697, which
established Trinity Church as the
first Anglican church in New York.
A further grant of land by Queen
Anne in 1705 is also recorded. 45

◆ *Portrait of Queen
Anne and William,
duke of Gloucester
(c.1694) by Sir
Godfrey Kneller
(National Portrait
Gallery).*

OTHER FEATURES
IN THE SOUTH AISLE

ALTAR, TAPESTRY AND CROSS

The black marble altar by Detmar
Blow dates from 1924 and is a
memorial to Percy Wyndham (d. 1914)
and Horatio, 1st Earl Kitchener of
Khartoum (1850–1916). It was given
by Wyndham's mother, Sibill,
Countess Grosvenor (d. 1929), who is
herself commemorated by an early
sixteenth-century tapestry above
the altar. The altar cross, by Gerald
Benney, was given by the Royal Stuart
Society in 1992.

07

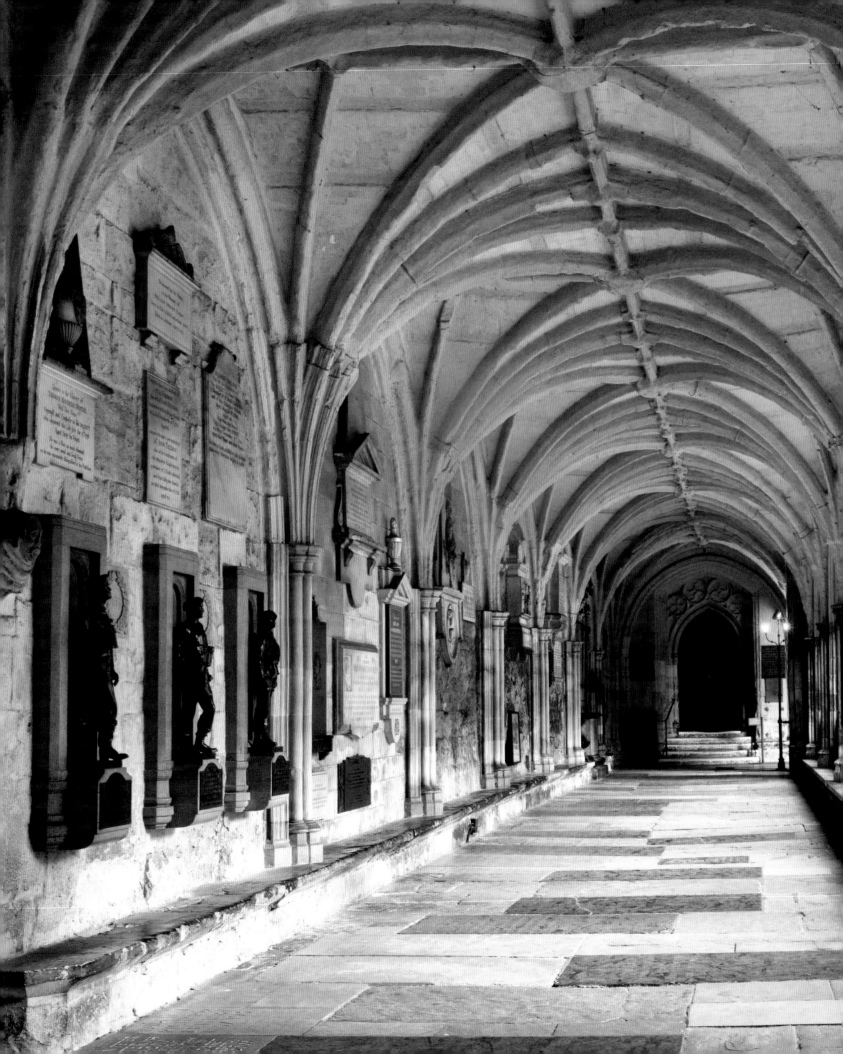

o8 | CLOISTERS

THE FIRST CLOISTERS at Westminster were built soon after the completion of Edward the Confessor's abbey church. They were lower than the present ones and had lean-to wooden roofs rather than stone vaults. New cloisters were built as part of Henry III's rebuilding programme, but their construction, as with the church itself, extended over a long period.

The four bays of the east cloister nearest to the church, including the chapter house entrance (finished 1253), were begun by Abbot Crokesley (1246–58). The east cloister door (with heads of Henry III and Queen Eleanor of Provence carved on either side) and the four easternmost bays of the north walk were built next, at the same time as the quire aisle, under Abbot Ware (1258–83). The east cloister was finished under Abbot Bircheston (1344–9). The north walk was completed between 1350 and 1366, during the abbacies of Simon Langham (who funded much of the work) and Nicholas Litlyngton (whose initials and arms are carved on some of the bosses). The south walk was rebuilt about the same time (1351–65), followed a few years later by the west walk.

OPPOSITE:
The west cloister, looking north.

BELOW:
The south cloister, looking east.

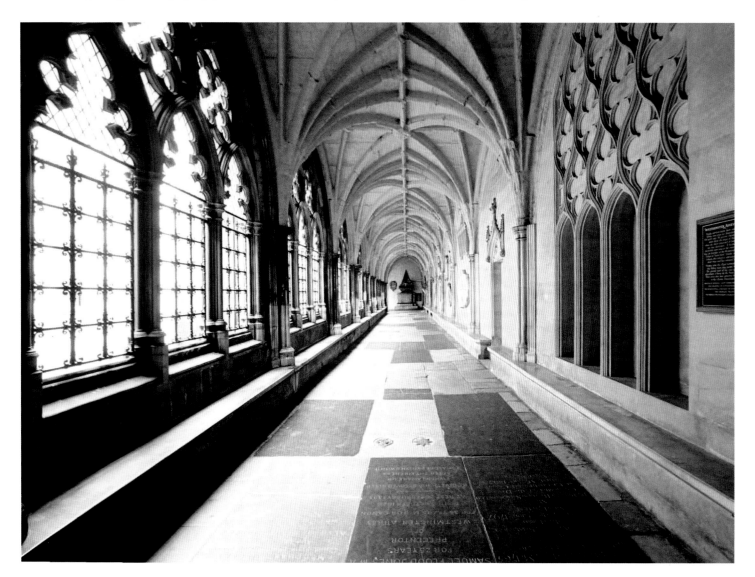

Later restoration work was not always kind to the medieval cloisters. Edward Blore rebuilt much of the south walk in 1835, and in the later nineteenth century George Gilbert Scott refaced the stonework and renewed much of the window tracery in the north walk. In the south cloister most of the original stonework of the walls was entirely replaced during the 1960s.

The monks of Westminster spent much of their time in the cloisters. The upper parts of the windows were glazed, but the lower portions remained open, although shutters gave some protection from bad weather. Hay and straw in winter and rushes in summer covered the stone floor and benches, and the walls were decorated with paintings. Additional light was provided by lamps suspended from the roof.

From the east walk the monks entered the chapter house and the dormitory. Here too, in Holy Week, the abbot held his Maundy, washing the feet of thirteen elderly men, who were then given a gift of money, food and ale. The monks meanwhile washed the feet of children in the south cloister.

At the west end of the south cloister is an early fourteenth-century doorway that once led into the refectory. On one side are four recesses, originally cupboards with wooden doors, which contained the monks' towels (a trough where the monks washed before eating was near by, in the west cloister). The refectory itself lay behind the wall of the south cloister though only the fragile north wall survives, rising above the roof of the south cloister walk.

Linking the south cloister with Dean's Yard are two vaulted bays, which originally formed a parlour where the monks received guests. The outer gateway itself belongs to the late fourteenth century (heads of Litlyngton and of Richard II are on either side of the outer arch). The niches in the exterior wall over the gate once held figures of the Confessor and the Pilgrim.

The novices were taught in the west walk, where paintings with verses alluding to the Abbey's foundation decorated the walls. In the north walk, which received good light from the south and was protected from the colder north winds, the monks read and studied. Bookcases stood against the wall, and wooden partitions provided small cubicles in which the more senior monks would sit to study. A 'scriptorium' for the copying of manuscripts was located elsewhere.

The green or 'garth' in the centre of the cloister was used as a garden and never as a burial ground. After the dissolution of the monastery it was a popular place for the Westminster boys to fight, and they even played racquets and football in the cloisters. The walks were also frequented by beggars, gamblers and all sorts of disorderly people, so that in the eighteenth century the Dean and Chapter appointed a constable to keep order.

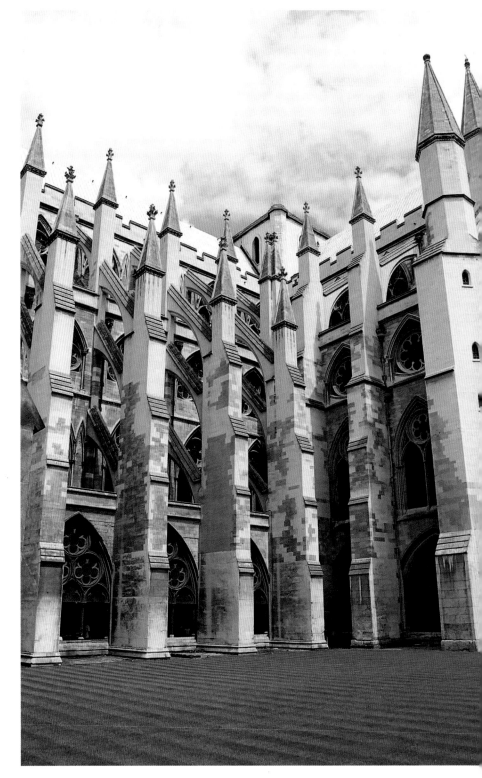

BELOW: *The south transept and the flying buttresses of the nave seen across the cloister garth.*

MONUMENTS AND FLOORSTONES IN THE EAST CLOISTER

SIMON DE BIRCHESTON (D. 1349), ABBOT OF WESTMINSTER 1344–9

Bircheston died from the plague, having overseen the continued building of this walk of the cloister. Only a fragment of the inscription on his gravestone survives. **117**

ARTHUR AGARD (1535/6–1615), ANTIQUARY, AND HIS WIFE, **MARGARET** (D. 1610 OR 1611)

Agard was deputy chamberlain of the exchequer and for over forty years cared for the state records kept in the chapter house. The small marble panel is the oldest mural monument in the cloisters, its Latin inscription now much decayed. **14**

EDWARD GODFREY (1627–40), KING'S SCHOLAR

This marble monument names all the children of the two marriages of Edward's father, Thomas Godfrey. Those already dead when the monument was erected (including Edward) are marked with a cross. In 1696 the sole surviving son, Benjamin, added another tablet commemorating Sir Edmund Godfrey. Edward's place of burial is unknown. **12**

GEORGE WHICHER (D. 1681), YEOMAN OF THE VESTRY OF THE CHAPEL ROYAL

A simple marble memorial belies the generous provisions of Whicher's will, which established almshouses for six poor Westminster men. The almshouses continue to this day but are now in south London. **10**

JANE LISTER (*c.*1683–8) AND HER BROTHER **MICHAEL** (D. 1676)

A marble tablet commemorates the children of the physician and naturalist Dr Martin Lister. The short inscription begins 'Jane Lister, dear

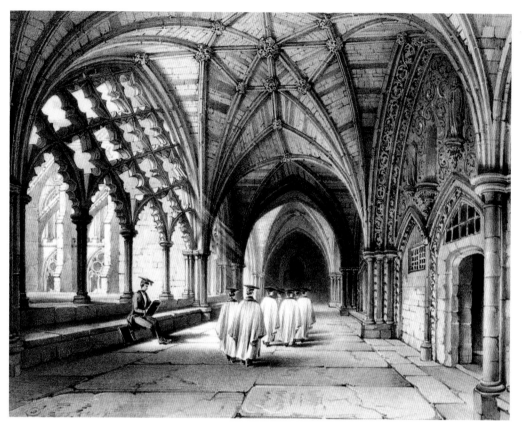

childe'. Jane is buried in the cloister, her brother in York. **04**

SIR EDMUND BERRY GODFREY (1621–78), MAGISTRATE

Marble monument, 1696. Sir Edmund disappeared in mysterious

ABOVE: *An early nineteenth-century engraving showing choristers and a Westminster scholar in the east cloister.*

◆ *An early engraving of Aphra Behn.*

circumstances at the time of the Popish Plot. His body was later found run through with his own sword, but closer examination revealed marks of strangulation, and his death has never been satisfactorily explained. Buried at St Martin-in-the Fields, London. **12**

◆ **APHRA BEHN** (1640–89), DRAMATIST AND NOVELIST

Gravestone of the first English professional female writer, though she began her career working as a spy for Charles II. Behn's literary works were long neglected, but her champions included Virginia Woolf, who wrote that 'all women together ought to let flowers fall upon the grave of Aphra Behn'. **104**

LIEUTENANT-GENERAL HENRY WITHERS (1650/51?–1729) AND **COLONEL HENRY DESNEY** (D. 1731)

Marble monument, *c.*1731. Desney erected this memorial to his lifelong friend Withers and was then

08

commemorated on it after his own death. The epitaph is by Alexander Pope. **16**

SCIPIO DUROURE
(D. 1745) AND HIS BROTHER **ALEXANDER** (D. 1765), SOLDIERS

Marble monument. Scipio died in battle during the War of the Austrian Succession and is buried at Ath (Belgium). Alexander died at Toulouse but was brought back for burial here. His gravestone is near by. **9 & 119**

WILLIAM BARRELL
(D. 1749), ARMY OFFICER

Marble monument attributed to Louis-François Roubiliac, consisting of a marble tablet surmounted by a drum, shield and military standard. **112**

BONNELL THORNTON
(1724–68), WRITER

Marble monument, 1771, with a portrait reflecting Thornton's preference for wearing his own hair rather than the then customary wig. Buried at St Margaret's Church. **02**

SIR JOHN KEMP BT (1754–71)

Marble monument commemorating a pupil of Westminster School who died shortly after completing his studies. Buried at Gissing, Norfolk. **06**

CHRISTOPH STEIGER
(D.1772)

Marble monument, 1773, commem-orating a Swiss student who died while studying at Oxford University. **03**

ALBANY WALLIS
(D. 1776, AGED THIRTEEN)

Marble tablet, 1777, surmounted by a coat of arms among palm leaves. Carved books and quill pens at the base allude to the fact that Albany was a pupil at Westminster School. The actor David Garrick, a friend of the Wallis family, erected the monument. **05**

The following clergy and other officers of the Abbey also have monuments or

gravestones in this cloister: Ernest Hawkins (1802–69), canon 1864-8; Evan Nepean (1800–1873), canon 1860–73, and his wife, Anne (1808–71); John Troutbeck (1832–99), minor canon 1869–95; Charles Furse (1821–1900), canon 1883–1900; Herbert Westlake (1879–1925), minor canon 1909–25, and his wife, Edith (1893–82); Howard Nixon (1909–83), librarian 1973–83; Burke, Baron Trend of Greenwich (1914–1987), high bailiff 1983–7, and his wife Patricia (1919–2008).

Here also are monuments to: Elizabeth West (d. 1710); Elizabeth Abrahall (d. 1711); Jane Addison (d. 1715); George Walsh (d. 1761); Thomas Winstanley (1748–69); Michael van Millingen (1765–78); Lieutenant-Colonel Richmond Webb (d. 1785) and his wife, Sarah (d. 1789); Thomas Vialls (1768–1831); and the gravestones of Ambrose Fisher (d. 1617); ◆ Anne Bracegirdle (c.1671–1748), actress; Margaret Grant (d. 1775); Clayton Cracherode (1730–99); Charles Marsh (d. 1812). A lozenge stone marks where the National Association of Flower Arrangement Societies buried freeze-dried flowers in 1977 to commemorate the twenty-fifth anniversary of Queen Elizabeth II's accession.

◆ *The actress Anne Bracegirdle depicted in one of her roles.*

08

OTHER FEATURES IN THE EAST CLOISTER

STAINED GLASS

In the 1950s glass surviving from the Abbey's war-damaged windows was set in an abstract pattern in the half-windows at the north end of this walk. The glass is mostly of nineteenth- and twentieth-century date, but some Tudor quarries (with the initials H and R crowned) from the eastern window of the Lady Chapel are included.

MONUMENTS AND FLOORSTONES IN THE SOUTH CLOISTER

TOMBS OF THREE EARLY ABBOTS OF WESTMINSTER

In 1753 the tomb slabs of three medieval abbots of Westminster were moved to the side of the cloister from their original, slightly raised, positions in the centre of the walk. The effigies are now very worn. From east to west they are: Laurence of Durham (d. 1173), abbot from *c*. 1158, who succeeded in obtaining the canonisation of King Edward in 1161; Gilbert Crispin (d. 1117), abbot from 1085, whose effigy is possibly the oldest in the country; William de Humez (d. 1222), abbot from 1214, during whose abbacy the foundation stone of the first Lady Chapel was laid. Abbot William wears a mitre, a privilege granted to abbots of Westminster in the time of Abbot Laurence. **122, 125 & 127**

'LONG MEG OF WESTMINSTER'

Large stone slab that was once believed to cover the graves of monks who died of the Black Death in the mid-fourteenth century, though in fact only a single coffin lies beneath. The stone is sometimes called 'Long Meg' after a legendary giantess who in earlier times was also supposed to be buried beneath it. **123**

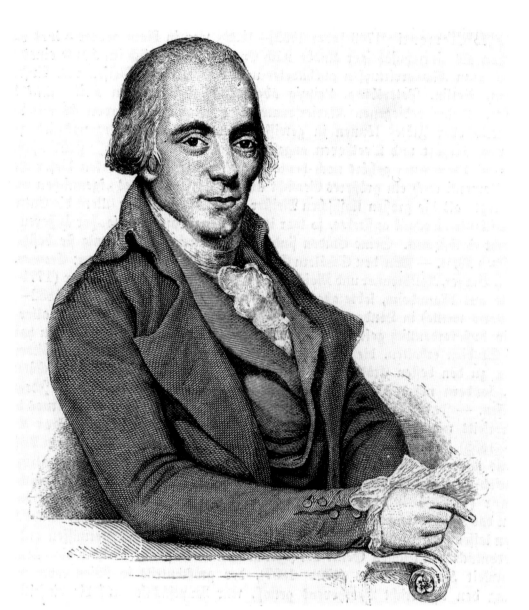

Portrait of Muzio Clementi, 'father of the pianoforte'.

143

ELIZABETH JENINGS
(D. 1720) AND HER HUSBAND, THOMAS (*c*.1660–1734), LAY VICAR OF WESTMINSTER ABBEY 1679–1734

Marble tablet surmounted by two lamps and an urn. **33**

DANIEL PULTENEY
(*c*.1682–1731), POLITICIAN

Marble monument designed by Giacomo Leoni and sculpted by Michael Rysbrack, 1732. The base has an armorial cartouche on its north side and supports a sarcophagus mounted on lions' paws. On this reclines a figure of Pulteney in Classical robes, holding a book. The monument was erected when Pulteney's remains (originally interred in St James's church, Piccadilly) were reburied here. **20**

EDWARD TUFNELL
(D. 1719), MASTER MASON TO WESTMINSTER ABBEY

Marble monument, possibly by Edward Stanton. A sarcophagus supports an architectural background and a bust of Tufnell with a cherub beside it. The Latin inscription records Tufnell's restoration of the southern and eastern sides of the abbey church. His nearby grave is shared with his son Edward (d. 1737) and granddaughter Elizabeth (d. 1815). **23 &124**

08

COLONEL FRANCIS LIGONIER

(1693–1746), SOLDIER

Marble tablet by Louis-François Roubiliac, 1748, consisting of an oval inscription panel and a heraldic cartouche. Buried at Edinburgh. 31

THE HON. JOHN HAY

(1719–51), CLERGYMAN

Marble monument by Michael Rysbrack, 1754, surmounted by an urn. 27

PIERRE LE COURAYER

(1681–1776),
ROMAN CATHOLIC THEOLOGIAN

Marble monument. A further memorial inscription is on the nearby gravestone of Charles Congreve. 25 & 126

JOHANN PETER SALOMON

(1745–1815), IMPRESARIO,
AND WILLIAM SHIELD
(1748–1829), COMPOSER

Saloman moved to London from Germany in 1781 and established a career as a violinist and impresario, arranging the celebrated visits to London of the composer Joseph Haydn in 1791 and 1794–5. Shield began his career as an apprentice boat-builder but rose to be master of the King's Musick. He composed almost exclusively for the theatre, and among his works is the tune now sung as 'Auld Lang Syne'. 131

◆ MUZIO CLEMENTI

(1752–1832), COMPOSER AND
KEYBOARD PLAYER

Described on his gravestone as 'father of the piano-forte', Clementi's keyboard works are still widely performed. He was born in Rome but established a career in London as a pianist, composer and teacher and later went into the business of manufacturing pianos, bringing his experience as a virtuoso performer to bear on the technical aspects of the trade. 132

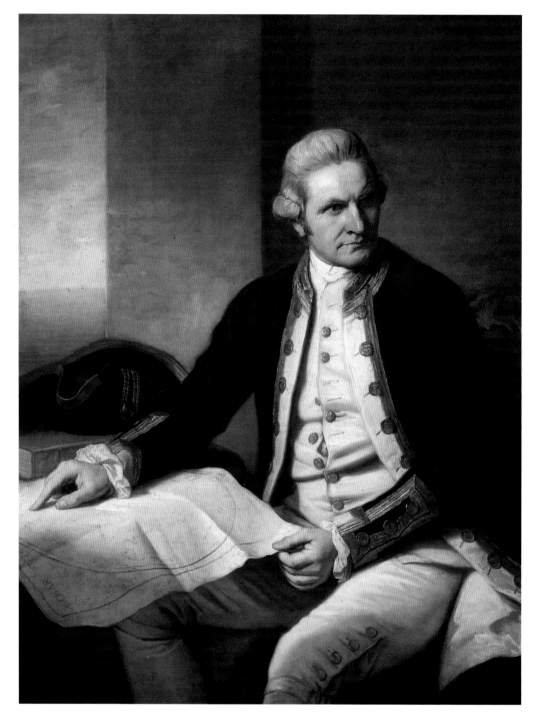

◆ *Portrait of Captain James Cook (1775–6) by Nathaniel Dance (National Maritime Museum).*

COLONIAL SERVICE MEMORIAL

Grey marble tablet surmounted by the royal arms, 1966. It commemorates all who served in the United Kingdom's overseas territories. 36

◆ SIR FRANCIS DRAKE

(1540?–96),
◆ CAPTAIN JAMES COOK
(1728–79) AND
SIR FRANCIS CHICHESTER
(1901–72), CIRCUMNAVIGATORS
OF THE WORLD

Memorial of Portland stone designed by Eric Fraser, 1979. The border was designed and cut by Arthur Ayres, and

08

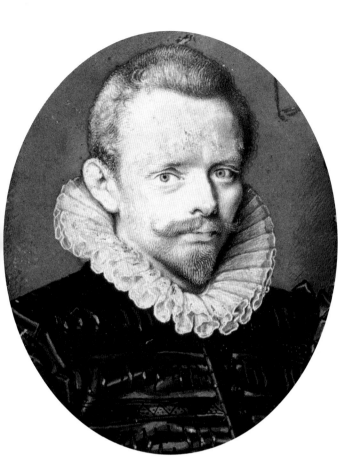

Portrait of Sir Francis Drake by Isaac Oliver (Victoria and Albert Museum).

ROYAL AIR FORCE COASTAL COMMAND MEMORIAL

Grey marble monument, designed and executed by Neil and Richard Talbot, 2004. An incised line represents the horizon, and the sky is overlaid with a map of the world and a carved eagle (symbolising mastery of the air). Below the horizon are the breaking waves of the sea, conveyed by the naturally varying tones of the marble. An undulating inscription and the badge of Coastal Command are carved on the wall. 35

ARMED AND AUXILIARY FORCES MEMORIAL

Memorial designed by Tom Phillips RA, 2008, consisting of a central panel of welded steel lettering surrounded by an inscription incised into the wall behind. It commemorates members of the armed and auxiliary services killed in conflicts since the end of the Second World War. The metalwork is treated with an acrylic resin incorporating soil from several battlefield sites, including Agincourt and the Somme. 30

INTELLIGENCE SERVICES MEMORIAL

Marble memorial stone by John Maine RA, 2009. It commemorates the work of MI5, the Secret Intelligence Service and GCHQ (Government Communications Headquarters) in protecting the United Kingdom at home and abroad. 24a

CAPTAIN JAMES CORNEWALL RN (1699–1744)

Large marble monument by Sir Robert Taylor. The plinth is carved with a beach scene adorned with rocks, fossils, plants and nautical emblems. Above these, as though carved in two caves, are a depiction of the naval engagement off Toulon in which Cornewall died and an inscription. At the top of the monument figures of Britannia and Fame flank Cornewall's portrait. Originally set up in the nave, the monument was

the coloured marble mosaics are by Messrs Whitehead. A border of doves, dolphins and oak and laurel branches surrounds a map of the world on which are three ships representing the *Golden Hind*, the *Endeavour* and *Gypsy Moth IV*. Coloured lines trace the route taken by each vessel. Drake and Cook were buried at sea; Chichester is buried at Shirwell, Devon. 32

THE 'DEFENDERS' MEMORIAL'

Slate tablet by Simon Verity, 1982, commemorating all who died 'in the service of the Crown to defend freedom, justice and peace'. 29

EDMOND HALLEY

(1656–1742), ASTRONOMER

Slate memorial by Richard Kindersley, 1986, designed to represent the comet that bears Halley's name. His achievements are listed on its tail, and in its head is a small depiction of the *Giotto* spacecraft that intercepted the comet during its transit in 1986. Buried at Lee, Kent. 26

reduced in size and moved to its present position in 1932. 39

The following clergy or other officers of the Abbey also have monuments or gravestones in this cloister: Edward Glanvill (1770–1808), clerk of the works 1803–7; William Dakins (1767–1850), minor canon 1796–1846, and his wife and infant son; Samuel Flood Jones (1826–95), minor canon 1859–95; Thomas Wright (1822–1906), clerk of the works 1871–1906 (buried at Nunhead, Surrey); Max Warren (1904–77), canon 1963–73, and his wife; Harry Barnes (1909–85), lay vicar 1936–77. An inscribed wooden panel (1992) names benefactors of Westminster Abbey's choir.

Here also are monuments to John Collins (1657–81), Mary Peters (d. 1688), Jane Rider (d. 1735), Thomas Master (1723–42) and the Hon. Henry Pomeroy (d. 1804). Also the gravestones of: Philip Clark (d. 1707), plumber; Catherine Smalbroke (d. 1765) and two of her sons; Charles Congreve (d. 1777); Mary Medley (d. 1783) and her son and daughter-in-law.

OTHER FEATURES IN THE SOUTH CLOISTER

FIGURES OF CHRIST, ST PETER AND ST EDWARD THE CONFESSOR

Figures of lightly gilded teak by Michael Clark, 1967, given in memory of Martha D. Cavendish. They were originally set up over the inner west door of the nave. 40

MONUMENTS AND FLOORSTONES IN THE WEST CLOISTER

JOHN BANNISTER (1624/5–79), VIOLINIST AND COMPOSER

A marble tablet. Bannister played in Charles II's 'private music' but resented the employment of foreign musicians at court and was demoted

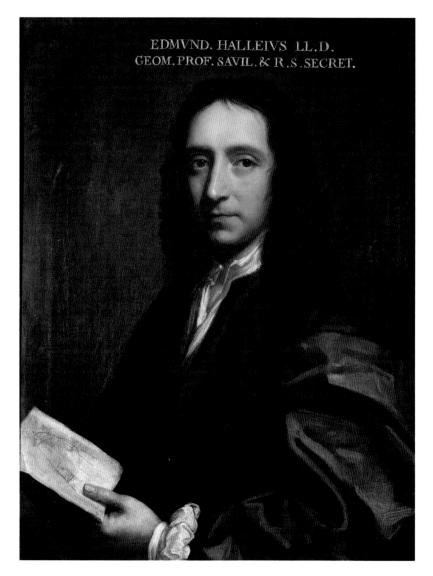

EDMVND. HALLEIVS LL.D.
GEOM. PROF. SAVIL. & R.S. SECRET.

◆ *Portrait of Edmond Halley (c.1687) by Thomas Murray (Royal Society, London).*

for 'some saucy words spoken to His Majesty'. In 1676, attempting to ease his financial difficulties, Bannister established some of the earliest public concerts held in England. 65

JOHN LAURENCE
(D. 1685), ROYAL SERVANT
Marble monument consisting of a winged cherub's head (now damaged) above a heraldic cartouche. 56

CHARLES GODOLPHIN
(1651–1720) AND HIS WIFE, ELIZABETH (D. 1726)
Tall marble monument. Pillars rise from the sarcophagus to support a pediment and a cartouche of arms. Among the Godolphins' benefactions

was the foundation (by Elizabeth) of the Godolphin School at Salisbury. 68 & 162

ARTHUR O'KEEFFE (D. 1756) AND HIS WIFE, ISABELLA (D. 1762)
Marble monument and bust by Benjamin Palmer, *c.* 1758, describing O'Keeffe as 'lineally descended from the kings of Ireland'. 62 & 160

EDWARD WORTLEY MONTAGU
(1750–77)
Monument of Coade stone, 1787. It consists of a sarcophagus supported on paws with a garlanded urn above and an inscription below. Montagu was shipwrecked returning from the East Indies, and his friend Sir John

Dolben erected the monument to commemorate a friendship begun at Westminster School. 71

SIR RICHARD JEBB
(1719–87), PHYSICIAN
Marble monument, probably by John Bacon, featuring a portrait of Jebb within a circular border of snakes and foliage. Beneath, within another roundel, is a woman representing the Genius of Medicine. The inscription is lost. 54

JOHN BROUGHTON
(1703–89), PUGILIST, AND HIS WIFE, ELIZABETH (D. 1784)
Gravestone of the most celebrated fighter of his day. He later opened a boxing amphitheatre in Oxford Street and an academy where gentlemen could learn to box wearing mufflers, thus avoiding the 'inconveniency of black eyes, broken jaws, and bloody noses'. Alongside his boxing career Broughton also served as a member of the Yeomen of the Guard. His relative Roger Monk (d. 1831) and Monk's wife, Catherine (d. 1832), are also buried here. 19 & 151

WILLIAM WOOLLETT
(1735–85), ENGRAVER
Marble monument by Thomas Banks, 1792. Beneath Woollett's bust a carved relief panel depicts him at work in his studio, attended by symbolic figures. Buried at Old St Pancras churchyard, London. 57

BENJAMIN COOKE
(1734–93), ORGANIST OF WESTMINSTER ABBEY 1762–93
Marble tablet displaying an open music book with a setting of 'Amen' in canon, which won Cooke a Catch Club prize. 63

THOMAS SANDERS DUPUIS
(1733–96), ORGANIST AND COMPOSER
Marble monument by R. Wilford, 1796. The inscription tablet supports a black marble pyramid in front of which is an urn decorated with heraldry. 42

WILLIAM BUCHAN
(1729–1805), PHYSICIAN
White marble tablet with portrait,
attributed to John Flaxman. **55**

JAMES BARTLEMAN (1769–1821),
FORMER CHORISTER, LAY VICAR OF
WESTMINSTER ABBEY 1790–96
Marble tablet, 1823, surmounted by a
lyre and a musical setting of the words
'O Lord have mercy upon me!' **60**

JAMES TURLE (1802–82), ORGANIST
OF WESTMINSTER ABBEY 1831–82,
AND HIS WIFE, **MARY** (1801–69)
Stone tablet with a line of music
setting the words 'Vouchsafe, O Lord,
to keep us this day without sin' from
the *Te Deum*. A memorial window is in
the north quire aisle. **59**

SIR FREDERICK BRIDGE
(1844–1924), ORGANIST OF
WESTMINSTER ABBEY 1882–1918
Stone tablet by Eric Gill, 1925. Bridge
arranged and supervised the music at
the coronations of Edward VII (1902)
and George V (1911). Buried at Glass,
Aberdeenshire. **58**

**THE SUBMARINE SERVICE
OF THE ROYAL NAVY,
THE COMMANDOS AND
THE AIRBORNE FORCES
AND SPECIAL AIR SERVICE**
Three niches of Ancaster stone with
bronze statues by Gilbert Ledward,
1948. This 'Combined Services'
memorial commemorates officers and
men who died in the Second World
War. The figures of a submariner, a
commando and a parachute soldier
were modelled on serving soldiers and
cast at the Morris Singer foundry,
Basingstoke. In between are tablets
bearing the dates 1939 and 1945 within
laurel wreaths. **43**

WILLIAM RICHARD LETHABY
(1857–1931), ARCHITECT, SURVEYOR
OF THE FABRIC OF WESTMINSTER
ABBEY 1906–28
Memorial stone. Lethaby was a

disciple of the Arts and Crafts
movement and an influential figure
in the education of artists and
designers. He published important
studies of the Abbey's architectural
history and adopted a sensitive
approach to its conservation and
repair. Buried at Hartley Wintney,
Hampshire. **144**

**CIVIL SERVICES
OF THE CROWN IN INDIA**
Monument of stone and black marble,
designed by Stephen Dykes Bower,
1958. It is surmounted by the royal
arms and the stars of two British
Indian orders of chivalry. **41**

**WILLIAM MALCOLM,
BARON HAILEY** (1872–1969),
COLONIAL ADMINISTRATOR
Stone tablet with portrait, designed
by Stephen Dykes Bower, 1971. Buried
at Simla, India. **50**

**IAN, BARON FRASER OF
LONSDALE** (1897–1974)
Slate and bronze memorial by
David McFall, 1976, consisting of an
inscription on slate and in braille,
a heraldic achievement, and a portrait.
Fraser was blinded at the battle of the
Somme (1916) and was subsequently
elected to Parliament, where he cam-
paigned on behalf of blind people.
Not buried in the Abbey. **48**

FRANCES PARNELL (1806–12)
Slate and marble tablet designed by
Peter Foster and executed by Arthur
Ayres, 1981. It replaces the original,
which had become damaged. **53**

SIR WILLIAM MCKIE (1901–84),
ORGANIST OF WESTMINSTER ABBEY
1941–63, AND HIS WIFE,
PHYLLIS (D. 1983)
McKie re-established the choir of
Westminster Abbey after the Second
World War and prepared them for
their first post-war state occasion, the
wedding of Princess Elizabeth in 1947.
When the Princess succeeded to the

throne as Queen Elizabeth II, McKie
served as director of music at her
coronation in 1953. **159**

**CZECHOSLOVAK ARMY
AND AIR FORCE**
Bronze plaque designed by Franta
Bělský and cast by Burleighfield
Arts, High Wycombe, 1993. It
commemorates members of the
Czechoslovak armed forces who died
fighting with the Allies during the
Second World War. **49**

**SPECIAL OPERATIONS
EXECUTIVE**
Marble tablet by David Dewey with
bronze work by Gervase Cowell, 1996.
It commemorates members of S.O.E.
who died during the Second World
War and features the emblem of the
Special Forces Club. **47**

THE OLD CONTEMPTIBLES
Limestone and slate tablet designed by
Donald Buttress and lettered by David
Dewey, 1993. It commemorates the
small British Expeditionary Force that
prevented the German advance to the
channel ports during the first battle of
Ypres in 1914. **52**

LONG RANGE DESERT GROUP
On the stone bench beneath the
Special Air Service element of the
Combined Services Memorial, a
wedge-shaped stone carved by John
Maine RA, 2013. From 1940 onwards
the LRDG operated behind enemy
lines in the north African desert,
prior to the formation of the SAS.
The memorial's design incorporates
the group's emblem and lines
representing tracks across a sandy
landscape. **43a**

The following clergy and other officers
of the Abbey also have monuments or
gravestones in this cloister: John
Freeman (1666–1737), lay vicar 1715–36,
and his wife, Avis (d. 1732); James
Chelsum (d. 1743), lay vicar 1736–42;
Benjamin Fidoe (d. 1780), clerk of the

08

works 1748–80; Thomas Gayfere (d. 1812), mason, and his wife Frances (d. 1770); Edward Smedley (1750–1825), usher of Westminster School, his wife, Hannah (1754–1824), and their son Francis (1791–1859), high bailiff 1836–59; Lord Henry Fitzroy (1770–1828), canon 1806–28; Thomas Greatorex (1758–1831), organist 1819–31; Thomas Vaughan (d. 1843), lay vicar 1804–43; Enoch Hawkins (d. 1847), lay vicar 1842–6; James Lupton (d. 1873), minor canon 1829–73; John Thomas Micklethwaite (1843–1906), surveyor of the fabric 1898–1906; Robert Hudson (1864–1927); Thomas James Wright (1851–1928), clerk of the works 1906–28; Sir Walter Tapper (1861–1935), surveyor of the fabric 1928–35; Sir Sydney Hugo Nicholson (1875–1947), organist 1919–28 and founder of the Royal School of Church Music; William Bishop (1882–1962), clerk of the works 1928–55, and his wife, Ann (d. 1971); Osborne Peasgood (1902–62), sub-organist 1924–41 and 1946–62, acting organist 1941–6, and his wife, Dora (d. 1968); Harry Carter (1906–1966), clerk of the works 1955–66, and his wife, Nan (d. 1970); Sidney Andrews (1918–81), clerk of the works 1967–81, his wife, Kathleen (1918–99), and son Anthony (1955–79); Henry ('Harry') Tooze (1930–98), clerk of the works 1981–89; Douglas Guest (1916–96), organist 1963–81, and his wife Peggie (1918–2009); Peter Foster (1919–2010), surveyor of the fabric 1973–88, and his wife Margaret (1921–2009).

Here also are monuments to: Peter Mason (d. 1738); George Vertue (1684–1756), engraver; William Dobson (d. 1813). Also the gravestones of: John Willis (d. 1736), and his son Edward (d. 1780); Jeremiah Lewis (d. 1761); Mary Hare (d. 1797) and her husband, Michael (d. 1807); Charlotte Fisher (d. 1813) and her brother James (d. 1821); Emily Tennyson Bradley (1862–1946), author, and her husband, Alexander Murray Smith (1866–1939).

MONUMENTS AND FLOORSTONES IN THE NORTH CLOISTER

WILLIAM LAURENCE (D. 1621)

A verse inscription records Laurence's exemplary service to one of the Abbey's prebendaries. **95**

RICHARD GOULAND
(D. 1659), LIBRARIAN OF WESTMINSTER ABBEY 1626–59

Marble monument surmounted by a skull and drapery. Gouland is misleadingly described as 'first keeper of the library' (the antiquary William Camden was appointed to that post in 1587), but he was the first librarian to be appointed after Dean John Williams's major benefaction of books and furniture to the library in 1623. **89**

CHRISTOPHER CHAPMAN
(D. 1675) AND HIS BROTHERS RICHARD (D. 1672) AND PETER (D. 1672)

Black marble tablet. An adjacent tablet commemorates their parents. **74**

CHRISTOPHER CHAPMAN
(D. 1681), SINGING MAN OF WESTMINSTER ABBEY 1642–8 AND 1660–81, AND HIS WIFE, MELIOR (D. 1707)

Alabaster tablet flanked by skulls, with a shield of arms and palm leaves at the base. It also commemorates their daughter Elizabeth (d. 1680). **72**

FRANCES MEYRICK (D. 1734)

Marble monument by Peter Scheemakers, 1735. **75**

EPHRAIM CHAMBERS
(1680?–1740), ENCYCLOPAEDIST

White marble monument by N. Hedges, 1758. Chambers's *Cyclopaedia*, first published in 1728, was the first general encyclopaedia and a great influence on subsequent attempts to record and classify knowledge. **87**

GENERAL JOHN BURGOYNE
(1723–92), ARMY OFFICER

Burgoyne commanded the northern British army during the American War of Independence, but his forced surrender at Saratoga in 1777 paved the way for US independence. Though temporarily disgraced he remained an MP, opposing the American war and becoming a privy councillor and commander-in-chief in Ireland. Also a songwriter and playwright, some of Burgoyne's comedies were produced by Garrick. **176**

WILLIAM MARKHAM
(c.1719–1807), ARCHBISHOP OF YORK; HEAD MASTER OF WESTMINSTER SCHOOL 1753–65

Brass plate in a frame of black marble, c.1844, with heraldic decoration. The inscription records the burial of Markham's wife, Sarah (d. 1814), and of his father, William (d. 1771), in this grave. Among family members buried elsewhere in this cloister is the archbishop's brother Enoch (d. 1801), who fought in Canada under General Wolfe and is said to lie wrapped in his regimental colours. **90**

OWEN WYNNE (D. 1700)

Marble tablet by John Bacon Junior, 1817. Wynne is not buried in the Abbey, but his widow, Dorothy (d. 1724), is interred near by. **102**

WILLIAM LYNDWOODE
(D. 1446), BISHOP OF ST DAVID'S

Black marble ledger-stone beneath which are remains believed to be Lyndwoode's. They were reburied here in 1852 after their discovery in the crypt of St Stephen's chapel at the Palace of Westminster during rebuilding work there. **196**

HENRY MAYNE (1819–61), OLD WESTMINSTER AND SOLDIER

Marble tablet, c.1863, surmounted by a heraldic achievement and with a military cipher at the base. Not buried in the Abbey. **101**

Queen's Westminster Volunteers and City of London Imperial Volunteers

Metal plaque, designed by F. Wheeler and cast at Coalbrookdale (Shropshire), 1901. Decorated with royal emblems and the arms of the City of London, it commemorates Queen's Westminster Volunteers who joined the City of London Imperial Volunteers and died fighting in South Africa in 1900. They are: Lance-Corporal Charles Nixon; Privates Frederick Aylen, James Appleford, John Bryce, Reginald Cameron, Sidney Carr and Francis Welsby. 92

Percy Dearmer (1867–1936), canon of Westminster 1931–6, and his wife, Nan (1889–1979)

Dearmer encouraged the use of ceremonial derived from English medieval usage as a means of enriching church services. His ideas, set out in *The Parson's Handbook* (1899), had great influence in the Church of England and on liturgical custom at Westminster Abbey. 173

Sudan Memorial

Inscribed tablet, 1960, commemorating those who served in the Sudan 1898–1955. 81

Malaya Memorial

Large stone tablet, designed by Stephen Dykes Bower, 1962, commemorating those who served in Malaya 1786–1957. 76

The following clergy or officers of the Abbey also have monuments or gravestones in this cloister: George Jewell (d. 1725), usher of Westminster School; Owen Davies (d. 1759), receiver general 1729–58, and his wife, Mary (d. 1778); Bernard Gates (d. 1713), lay vicar 1711-73, and his wife Elizabeth Atkinson (d. 1726); David Morgan (1764?–95), minor canon 1758–95; Thomas Prickard (d. 1795), Westminster coroner 1762–92, auditor 1786–95; Anthony Gell (d. 1817), receiver general 1787–1817, and his sons Thomas (d. 1792) and Anthony (d. 1801);

George Vincent (1744–1859), chapter clerk 1803–53, and his wife, Emilia (d. 1848); Robert Marsh (d. 1865), receiver general 1854–65; John Haden (1805–69), minor canon and precentor 1846–69; Charles Bedford (1810–1900), Westminster coroner 1845–88, chapter clerk and registrar 1854–1900; Basil Wilberforce (1841–1916), canon 1894–1916, and his wife, Charlotte (1841–1909); William Boyd Carpenter (1841–1918), bishop of Ripon, canon 1911–18, and his wife, Annie (1854–1915); Kenneth, Baron Muir Mackenzie (1845–1930), high bailiff and searcher of the sanctuary 1912–30; Robert Charles (1855–1931), canon 1913–31, and his wife, Mary (1815–1935); Sir Edward Knapp-Fisher (1864–1940), chapter clerk and receiver general 1917–38; Vernon Storr (1869–1940), canon 1921–40, rector of St Margaret's Church 1936–40 (buried at Matfield, Kent); Tom Hebron (1894–1980), registrar *c.*1948–64 and receiver general, 1958–9, and his wife, Eva (1895–1979); Sir Reginald Pullen (1922–96), receiver general 1959–87, and his wife Angela (d. 2007); Rear Admiral Kenneth Snow (1934–2011), receiver general 1987–98.

Here also are monuments to: Francis Newman (d. 1649); Ann Gawen (d. 1659) and several members of her family; James Fox (d. 1677) and his brother Captain William Fox (d. 1680); Elizabeth Palmer (d. 1706) and her grandchildren Matthew Johnson (d. 1725) and Frances Merest, *née* Johnson (d. 1727); John Coleman (1625?–1709); Rachel Field (d. 1718); John Collier (d. 1732); Rachel Taylor (d. 1740) and her daughter Anne Ludford (d. 1748); Elizabeth Playford (d. 1743); John Stagg (d. 1746), bookseller, and his wife, Elizabeth (d. 1750); Thomas Ludford (d. 1776); Guyon Griffith (d. 1789, aged eleven), pupil at Westminster School; Susannah Bernard (d. 1791); Lady Mary Markham (1778–1814); Harriet Benthall (d. 1838) and her son John (d. 1846); Charles Bonnor (1832–48), queen's scholar. Also the gravestones of: John Fox (d. 1691); Thomas Fox (d. 1691); John

Frost (d. 1696); William Cliffe (d. 1742), Mary Davies (d. 1786) and her sister Ann (d. 1791); John Bancroft (d. 1762) and his wife, Elizabeth (d. 1758); William Wynne (d. 1765) and his wife, Grace (d. 1779); Charles Hall (d. 1774); Mary Jennings (d. 1779) and her husband, Robert (d. 1779); Abraham Acworth (d. 1781), his wife, Margaretta (d. 1794), and their sons Abraham (d. 1773) and Buckeridge (d. 1818); John Rutherford (d. 1782); Hannah Wyatt (d. 1782), Sarah Newcombe (d. 1825) and Elizabeth Newcombe (d. 1840); Sir John Hawkins (1719–89) and his wife, Sidney (d. 1793); Elizabeth Joye (d. 1790) and her sisters Jane Joye (d. 1810) and Mary Champnes (d. 1813); John Croft (d. 1797) and his wife, Sarah (d. 1798); William Sayer (d. 1811) and his wife, Sarah (1744–1830); Luttrell Wynne (d. 1814); Samuel Goodenough (1743–1827); Joyce Gray (1930–2010).

In the Dark Cloister, adjoining the south end of the east cloister, are monuments to: Elizabeth Moore (d. 1720); John Savage (d. 1747), king's scholar of Westminster School; Elizabeth Hollingworth (d. 1785); Walter Hawkes (d. 1808); Edward Webber (1816–33), scholar of Westminster School and buried in the north cloister with Caroline Fynes-Clinton (d. 1845); James Dodd (d. 1818), usher of Westminster School; Emma Hawkins (d. 1823), her husband George (d. 1846) and her father John Gell (d. 1856), receiver general of Westminster Abbey; George Preston (d. 1841), king's scholar and under master of Westminster School. Also in the Dark Cloister are the gravestones of Elizabeth Finny (d. 1770), her husband, Thomas (d. 1776) and their descendant William (d. 1952), Sarah Thorpe (d. 1776), and John Rae (1931–2006), head master of Westminster School 1970–86. In the west wall a small stained-glass window, designed by F. Skeat and dating from 1988, commemorates Robinson Duckworth, whose grave is in the quire. The glass depicts St Francis and the birds.

08

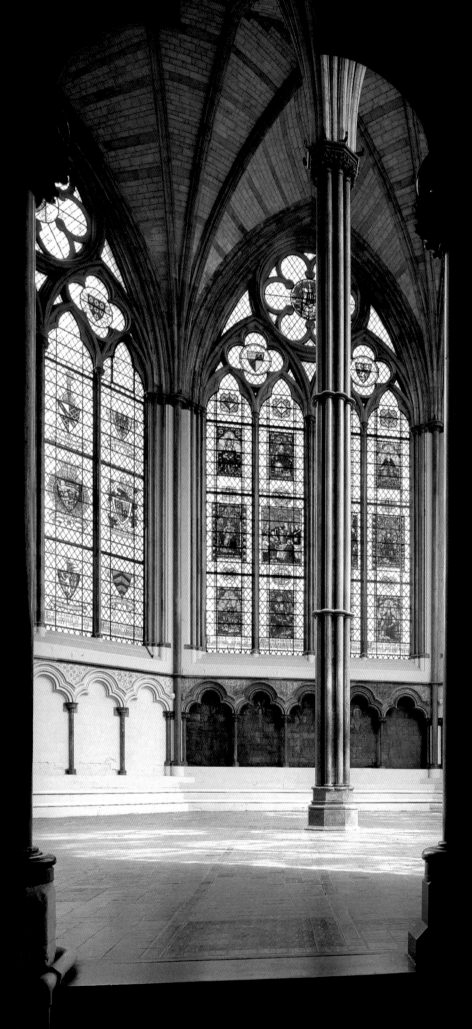
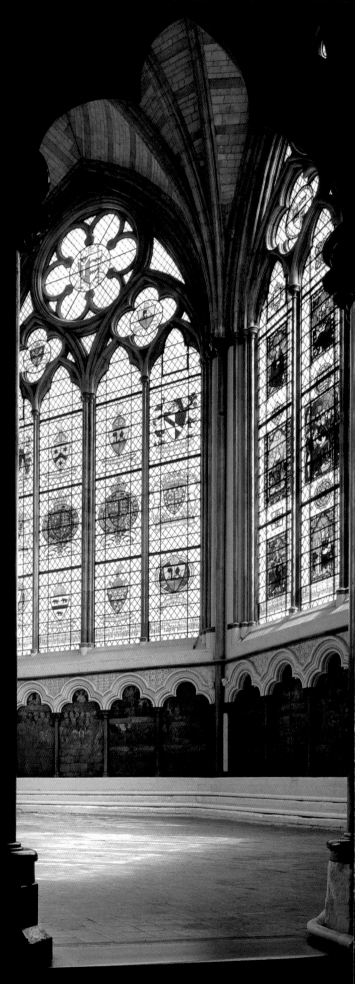

09 | ABBEY PRECINCTS

THE ABBEY CHURCH at Westminster stood at the heart of a monastic precinct within which the monks of Westminster lived, worked and worshipped. The precincts covered several acres and were entirely surrounded by a stone wall, stretches of which survive to this day in Great College Street and along the eastern boundary of College Garden. There were a number of gateways in addition to the principal entrance, which was a gatehouse to the west of the abbey church.

The community within these precincts varied in numbers through the centuries, but there were generally between thirty and sixty monks, together with lay servants. The ancillary buildings required for the most basic activities of monastic life – the refectory, the dormitory and the chapter house – were arranged around the great cloister. Elsewhere other buildings housed the infirmary (for the care of the sick), the almonry (where charitable provision was made for the poor) and the cellarium (where food and drink were stored). Senior monks called 'obedientiaries' oversaw these and other 'departments' of the community's life. The detailed records or 'rolls' kept by the infirmarer, the cellarer and many other obedientiaries survive among the Abbey's muniments and tell us much about life at medieval Westminster. Gardens within the precinct walls, and an orchard just outside provided fresh fruit and vegetables for the monks, but the monastery also managed extensive farms and other properties across southern England and the midlands, and these greatly added to its wealth.

At the west end of the Abbey an area still known as 'The Sanctuary' became a refuge from the law for thieves, murderers and vagabonds, in accordance with an ancient privilege enjoyed by the monastery. Within the Sanctuary was a tower containing two chapels, where those who had taken sanctuary were expected to attend services, and a belfry. The right of sanctuary was widely abused and was finally abolished by James I.

The monks who settled on Thorney Island in the tenth century must have found life at Westminster physically and spiritually challenging, but by the mid-thirteenth century monastic life had become less austere. The monastery was a safe and relatively comfortable place to live, and the monks even received pocket money. Life never ceased to revolve around the *opus dei*, the daily round of liturgical prayer laid down in the Rule of St Benedict, and there were sometimes attempts to curb the creeping relaxation of earlier, more rigorous disciplines, but as Barbara Harvey (a distinguished historian of medieval Westminster) has noted, the monks 'were able to live like the nobility or gentry... as well housed and well fed as their social equals in secular society'. This was especially true of the abbot, who had his own lodgings in which he was often required to entertain the king or other great personages.

During the Middle Ages Westminster Palace became the principal royal residence, and much of the machinery of government settled around it. A small town grew up outside the monastery's walls, and even within the precincts certain shops and dwellings were permitted. Caxton set up the first printing press in England within the precincts, and Chaucer leased from the monastery a house that stood against the walls of the old Lady Chapel. The resident population worshipped in a church dedicated to St Margaret of Antioch which the monks built to the north of their own abbey church, perhaps as early as the eleventh century. St Margaret's has been closely linked with the Abbey ever since and in 1972 was placed entirely within the jurisdiction of the Dean and Chapter.

151

OPPOSITE:
The chapter house showing some of the medieval wall paintings and the windows re-glazed after the Second World War.

Chapter House and Library

In the east cloister is the thirteenth-century entrance to the chapter house. The statues of the Virgin and Child originally over the arch have crumbled away, and part only of one of the two angels is left. The vaulted passage within is very low because the night path from the monks' dormitory to the south transept was above it.

The door on the south side of the vestibule is the oldest in Britain. It dates from the 1050s and was perhaps a major door of the Confessor's abbey. When moved to its present position it was reduced in size, but much of the Anglo-Saxon structure remains. It was made of five vertical oak planks, held together with horizontal battens and covered with animal hide to provide a smooth surface for painting. Iron straps, one of which survives, were then fixed in place.

To the right of the steps leading to the chapter house itself are memorials to two American diplomats who served in London. James Russel Lowell (d. 1891), minister of the USA in London 1880–85, is commemorated by a tablet and by a stained-glass window (made by Clayton and Bell) depicting St Botolph (patron saint of Boston, Massachusetts), Sir Launfal (about whom Lowell wrote a poem) and St Ambrose. A memorial tablet by Eric Gill, commemorates Walter Hines Page (1855–1918), US ambassador to the United Kingdom during the First World War.

The magnificent chapter house, built between 1250 and 1259, is octagonal in shape, with a central pillar, and is one of the largest in England (60 feet in diameter). There was room for eighty monks on the stone benches

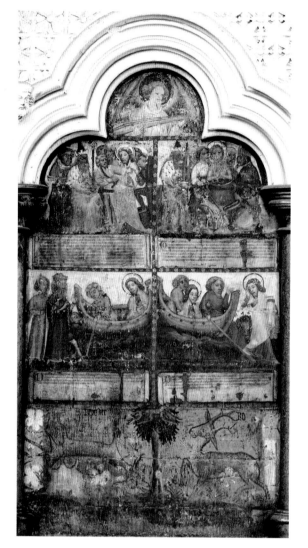

OPPOSITE: *A single slender pillar supports the vaulting of the chapter house roof.*

LEFT AND BELOW RIGHT: *Late-fourteenth-century wall paintings in the chapter house.*

BELOW LEFT: *Thirteenth-century floor tiles form a magnificent pavement in the chapter house.*

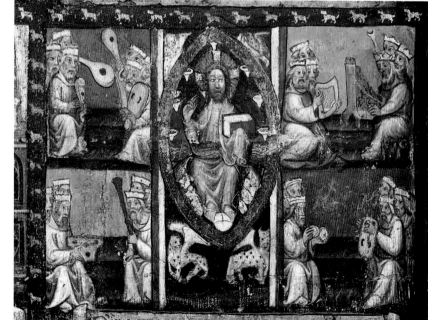

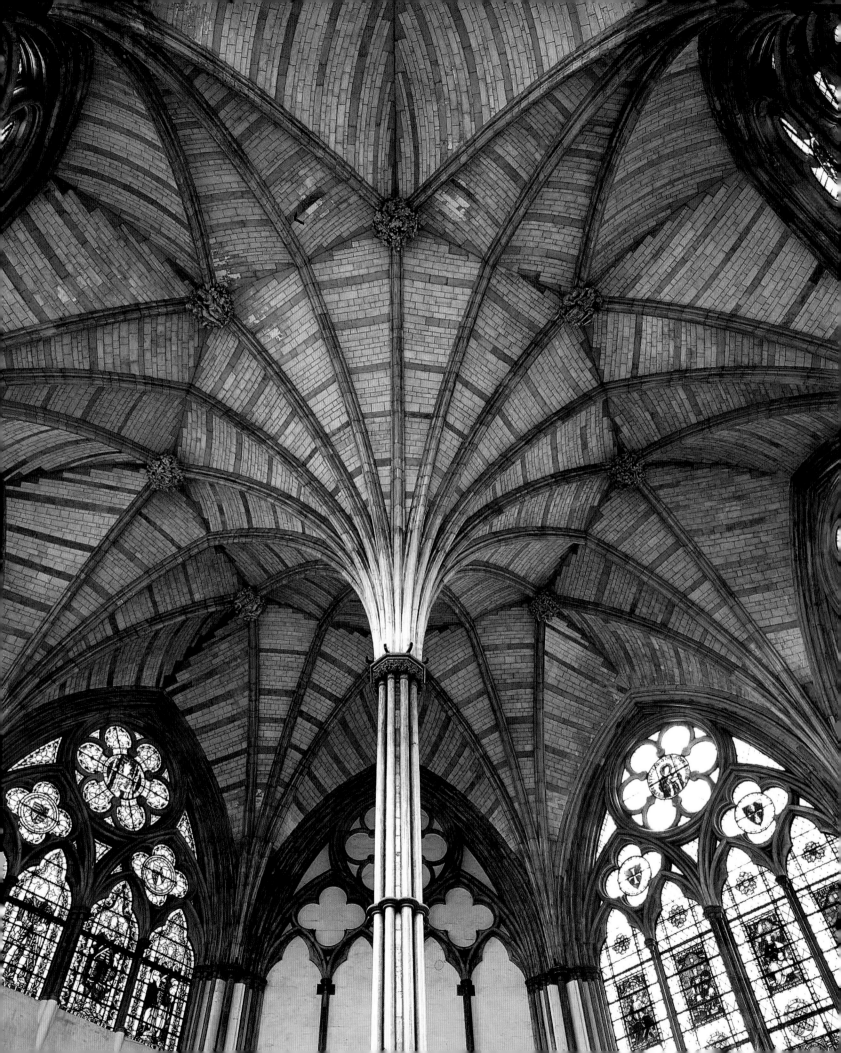

round the walls, and on the east side were seats for the abbot (beneath a great crucifix on the wall) and four of the chief brethren. Every morning, after early Mass, the whole convent passed in solemn procession from the church to the chapter house. Prayers and a chapter from the Rule of St Benedict were read from a valuable lectern presented by Henry III, which stood near the central pillar. All were then given their appointed tasks for the day, and the novices and some of the lesser monks retired. After this the affairs of the monastery were discussed in solemn conclave, and those monks who had committed misdemeanours were issued with penances or punishments.

Some of the mural paintings that decorated the chapter house survive. The earliest on the eastern wall represented the Doom – i.e., the Last Judgement – and dates from about 1390. The western wall was decorated with scenes from the Apocalypse, which were executed by the order of John of Northampton, who was a monk

OPPOSITE: *The former dormitory of the monks has been the Abbey's library since 1591.*

BELOW: *The chapter house vestibule contains the oldest door in Britain, dating from c.1050.*

here from 1372 to 1404. Another medieval survival is the original tiled pavement, laid in the 1250s. Among the varied subjects on the tiles are the Confessor giving his ring to the pilgrim, a king on a throne (Henry III) and the royal arms.

The chapter house was used for other ecclesiastical assemblies besides those of the monastery, and in the second half of the fourteenth century the House of Commons met here (and later in the monastic refectory). For three hundred years after the dissolution of the monastery it was used as a repository for state records. The medieval tiles were boarded over, and the space was filled with storage areas on several levels. After the building of the Public Record Office in 1863 the chapter house was restored by George Gilbert Scott.

The windows were largely reglazed by Joan Howson after they had been extensively damaged during the Second World War. The previous glass, by Clayton and Bell, was given as a memorial to Dean Stanley in 1882. Some undamaged panels, which are easily recognisable, were incorporated into the new scheme, but the opportunity was taken to fill some of the windows with coats of arms set in clear glass, thus reverting to what is known to have been the way these windows were originally glazed. The arms are those of sovereigns, abbots and benefactors of the Abbey.

Beneath the chapter house is a small crypt, which either Henry III or Edward I appropriated as a private treasury. In 1303, during Edward I's absence in Scotland, this treasury was broken into, the royal regalia, other jewels and a quantity of money were stolen, and strong suspicion fell on the monks. The abbot, Walter de Wenlock (d. 1307), and forty-eight brethren were sent to the Tower but released after a long trial, two only of the lesser monastic officials having been found guilty. Most of the valuables were found hidden round about the precincts, but the king afterwards removed his money-chests from the abbot's care. The regalia seem, however, to have been left in the precincts but were probably removed to the monastic treasury in the Pyx Chamber, where they remained until the Commonwealth.

South of the chapter house entrance is a doorway leading to the Abbey's library. It has a fine oak roof dating from the end of the fifteenth century and originally formed part of the dormitory where all the brethren slept. It has been used as a library since the end of the sixteenth century, but the present bookcases were given by Dean John Williams in 1623, together with a valuable collection of printed books and manuscripts, which has been added to over the centuries and now consists of around 16,000 volumes. From the library is reached the Muniment Room, where the Abbey's vast and important collection of muniments (archives) is kept.

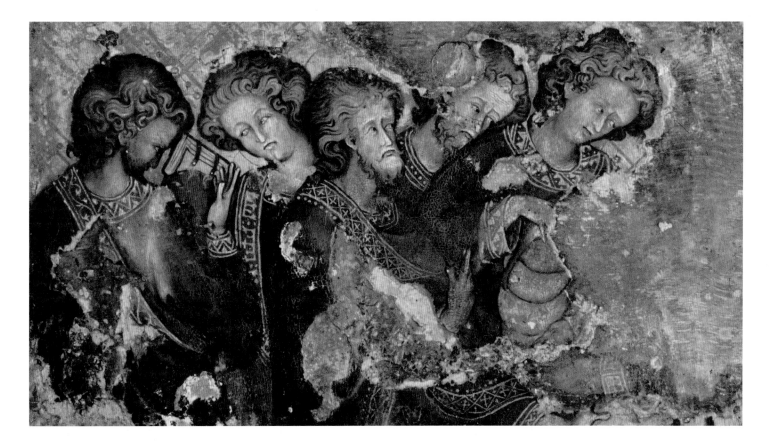

Pyx Chamber and Undercroft

ABOVE: *A detail from the Westminster retable*
BELOW: *The Pyx Chamber.*

RIGHT: *St Peter, patron of the Abbey, depicted in the Westminster retable.*

The Pyx Chamber and the undercroft are the oldest surviving buildings at Westminster. They date from between 1065 and 1090 and have fine Romanesque vaults. The Pyx Chamber has a medieval tiled floor and the only stone altar left at the Abbey, indicating that the room must have been used as a chapel at some time before the fourteenth century, when it certainly functioned as a monastic treasury. The chamber takes its name from a 'pyx', or box, that was kept here and which contained the standard pieces of gold and silver against which the coinage was tested each year.

A wall now divides the Pyx Chamber from the much larger undercroft, though originally the two chambers formed a single space. The undercroft probably served as the monks' common room until the dissolution of the monastery. In 1908 a museum was opened in the undercroft and the Abbey's important collection of royal funeral effigies and other exhibits was displayed there. The museum closed in 2015 and the undercroft currently houses a temporary conservation studio to prepare exhibits for the new Queen's Diamond Jubilee Galleries, which are due to open in 2018 in the Abbey's eastern triforium.

09

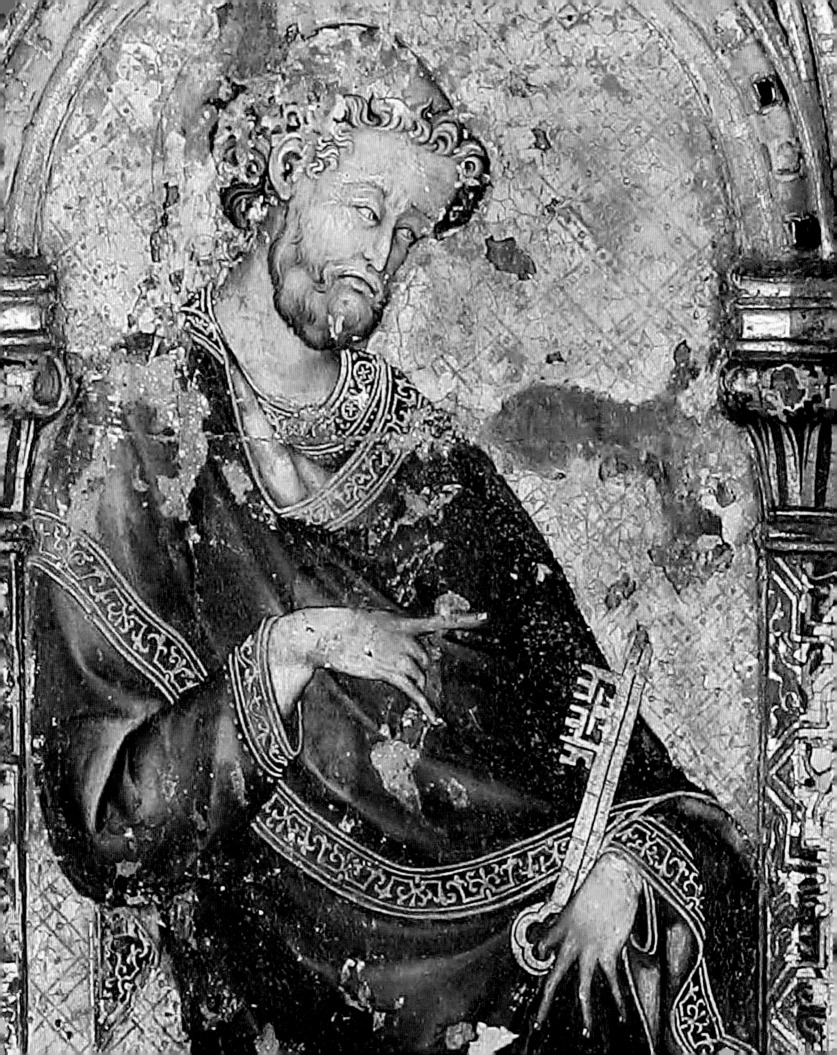

Dean's Yard

Dean's Yard is a large enclosed square lying to the south-west of the Abbey. In the Middle Ages its northern portion, then called 'The Elms', was part of the abbot's garden. Further south stood the monks' granary, later used as a dormitory for the Westminster scholars and finally demolished in 1756. When other buildings were cleared away in 1815, the central space of the yard was sown with grass.

In the north-east corner is the entrance to the Abbey's cloisters, and on the east side in medieval times were the monastic guest house and a range of buildings used by the cellarer. Today these buildings are variously owned by the Abbey and by Westminster School, but much of their original fourteenth-century fabric remains. At the south end of Dean's Yard stands Church House, the central administrative building of the Church of England and the meeting place of its General Synod.

The large red-brick building on the west side of Dean's Yard is the Westminster Abbey Choir School. The first school for the choristers was opened in 1848 in a room off the cloisters, but in 1891 a 'Choir House' was opened in Little Smith Street near by; this remained in use until the construction of the present building, which was opened in 1915. The boys (normally around thirty-five in number) board during term-time and follow a standard educational curriculum in addition to their singing duties. The Abbey's is now the only choir school in the country solely dedicated to the education of choristers.

BELOW: *Watercolour of Dean's Yard by Thomas Malton (1793).*

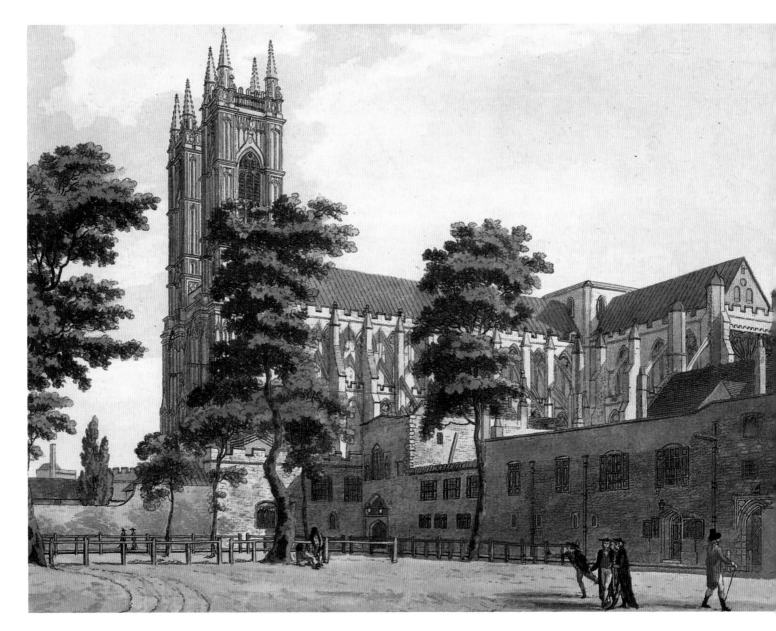

158

09

The Deanery

The deanery of Westminster Abbey, originally built in medieval times as the abbot's lodgings, is probably the oldest continuously occupied residence in London. Abbots of Westminster were not only prominent figures in the life of the church but also royal advisers who were sometimes sent on diplomatic missions for the king and were often required to entertain guests. At the end of the fourteenth century Abbot Nicholas Litlyngton rebuilt his residence to reflect these responsibilities, making the abbot's lodgings a substantial town house, with a large dining hall and a comfortable chamber.

The dining hall, built between 1369 and 1376, has a fine timber roof, the corbels that support it adorned with angels displaying Litlyngton's coat of arms. After the dissolution the room became the College Hall, and it continues to be used as a dining hall by Westminster School. The minstrel's gallery at the west end dates from late Tudor or Jacobean times and the wainscoting from the middle of the eighteenth century. Until the mid-nineteenth century an open fire in the middle of the room warmed the hall. The smoke escaped through a lantern in the roof, and the boys of the School would jump through the flames as a dare. The School's Latin play, which Elizabeth I is known to have attended on two occasions, was acted here until 1730, when it was moved to the new dormitory.

Litlyngton's other addition to the abbot's lodging was the Jerusalem Chamber, built at the same time as the hall. It may have taken its name from the original tapestry hangings, which perhaps depicted the Holy Land. The room was restored in the time of Dean Stanley (1864–81), who uncovered the original roof and repanelled the walls with cedar wood from Lebanon.

He placed in the room busts of Henry IV and Henry V, to recall that the former died in the Chamber in 1413. The king had been taken ill while visiting the Confessor's shrine in preparation for an expedition to the Holy Land. The story as dramatised by Shakespeare in *Henry IV* is that the king asked the name of the room where he lay and on being told 'Jerusalem' said 'I know that I shall die in this chamber, according to the prophecy that I should die in Hierusalem'.

John Williams, dean of Westminster, redecorated the chamber in the seventeenth century. He erected the carved cedarwood overmantel in 1624, when he entertained the French ambassador to a banquet here on the occasion of the betrothal of Charles I – then prince of Wales – to the French princess Henrietta Maria.

The Chamber has been the scene of many other gatherings. The Westminster Assembly of Divines, which formulated key doctrinal statements for the Presbyterian and reformed churches, met here between 1643 and 1652. The room was used by those engaged on the King James version of the Bible (published 1611), and later by the translators of the Revised Version and the New English Bible. The Upper House of Convocation met there, and the bodies of famous persons (for example, Sir Isaac Newton) have rested in the Chamber before their funerals. On the eve of a coronation the regalia are kept in the Chamber overnight in preparation for the ceremony.

The tapestries that now line the walls are sixteenth- and seventeenth-century in date. They come from series depicting the Acts of the Apostles and the 'History of Abraham' and have been cut to fit the spaces available.

The approach to the Jerusalem Chamber is through a smaller room added, with apartments above it, by Abbot Islip in the early sixteenth century. It is known as the Jericho Parlour and has fine linenfold panelling.

After the dissolution the abbot's lodgings became instead the home of the dean. It stands around a small courtyard and has been enlarged and altered at various times. By the nineteenth century it had become a large rambling residence, parts of which extended over the roof of the west cloister, but in May 1941 almost the entire eastern range of the house was completely destroyed by bombing, and the deanery was subsequently rebuilt. Fortunately both College Hall and the Jerusalem Chamber survived the war unscathed. Rooms known as Cheyneygates, situated above the cloister entrance, are also part of the deanery. Though rebuilt after war damage, they are on the site of a medieval lodging of that name where Elizabeth Woodville, queen of Edward IV, took refuge during the later fifteenth century.

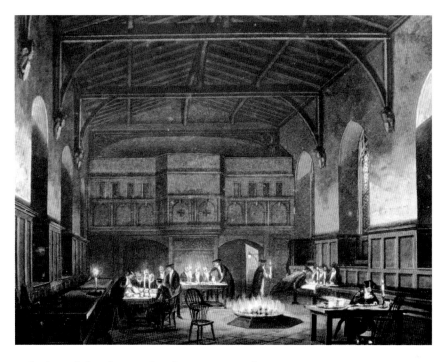

ABOVE: *The interior of College Hall c.1812.*

159

09

Little Cloister and St Catherine's Chapel

Little Cloister consists of a square enclosed garden with a central fountain, surrounded by arcaded walks. It occupies the site of the monastic infirmary, which in early times consisted of one large room with a smaller building around it for the sick, infirm and aged monks. The inner arcade of the cloisters dates from the end of the seventeenth century, but most of the surrounding houses were destroyed or seriously damaged in an air raid during the Second World War and have been rebuilt.

Here are memorials to: Thomas Smith (d. 1664); John Charles Thynne (1838–1918), receiver general of Westminster Abbey 1865–1902; Henry Roper (1871–87), an Abbey chorister from 1879–84; and Lilian Carpenter (1917–2008). Here also is the grave of John Wilson (1591–1674), chamber musician to Charles I.

In the south-east corner is the Infirmarer's Hall, and to the north of it, in the centre of the east walk, the doorway that led into the ancient Chapel of St Catherine, of which only the ruins survive. It was built in the twelfth century and consisted of a nave and two aisles. The north arcade partly survives in the form of the lower parts of columns, alternately round and octagonal. On the south side all the columns stand to the height of the capitals, though the three eastern arches have been filled in. The roof of the chapel was removed in 1578, and a house was built over part of it. The successor of this house was destroyed by bombs in 1941, and in the subsequent rebuilding much of the original chapel was left exposed. In a niche on the wall of the houses on the north side of the garden is a statue of St Catherine forming a memorial to Henry Seely, 2nd Baron Mottistone (1899–1963), architect of the rebuilding of the deanery and the precinct houses following the war damage. The statue was given in 1966 by Dean Alan Don and by Paul Paget, Lord Mottistone's former partner.

The chapel was used for many important assemblies, both secular and clerical, including the consecration of bishops. In 1176 a quarrel for precedence took place here between the archbishops of Canterbury and York, which resulted in the one receiving the title of primate of '*all* England', the other primate 'of England'. According to one chronicler, when the archbishop of York arrived at a synod in the chapel to find his fellow archbishop sitting in the position of honour, to the right of the papal legate, he sat down in the archbishop of Canterbury's lap. Here too Henry III, surrounded by prelates, swore on the Gospels to observe Magna Carta.

LEFT: *Little Cloister occupies the site of the monastic infirmary. The enclosed garden is now one of the hidden treasures of the Abbey.*

College Garden

A passageway from the south-east corner of Little Cloister leads to College Garden, thought to have been in continuous cultivation for 900 years. In monastic times this was the garden of the Infirmarer, who grew here the herbs and other medicinal plants used to care for the sick and elderly. The five magnificent plane trees were planted in 1850.

The garden occupies a little over an acre and is bordered to the north by canons' houses, on the south and east by the fourteenth-century walls of the monastic precinct. On the west side is the school dormitory, begun to a design by Sir Christopher Wren in 1722. The scheme was controversial as it involved building on some of the prebendaries' gardens, and the proposals were contested all the way to the House of Lords. Wren's original designs were amended by Lord Burlington, and the building was completed in 1733.

BELOW: *College Garden looking towards the dormitory of Westminster School. The garden has been in continuous cultivation for 900 years.*

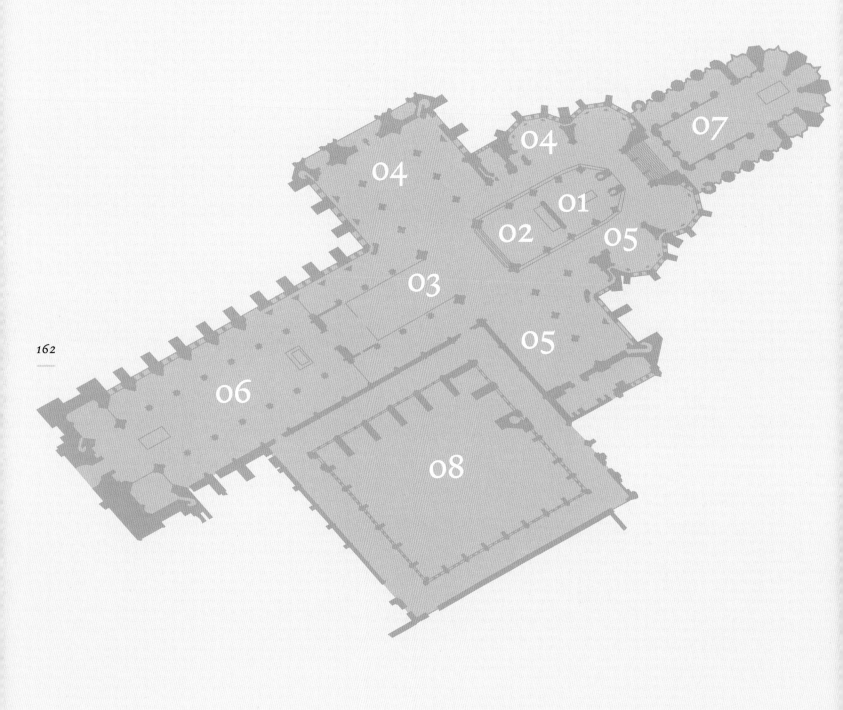

01 | Edward the Confessor's Chapel

ALTAR

3

2

1

4

9

5

6

8

7

03 | Quire and Crossing

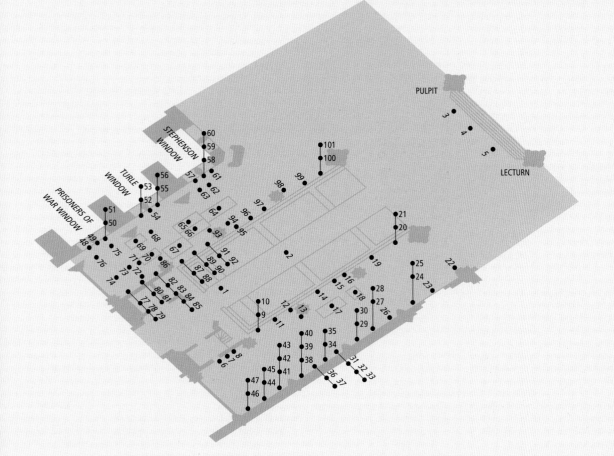

STEPHENSON WINDOW

TURLE WINDOW

PRISONERS OF WAR WINDOW

PULPIT

LECTURN

NURSES WINDOW ABOVE
ISLIP WINDOW BELOW

ACTS OF MERCY WINDOWS BELOW
ROSE WINDOW ABOVE
NORTH DOOR

BUNYAN WINDOW

HMS CAPTAIN WINDOW

05 | South Ambulatory and Transept

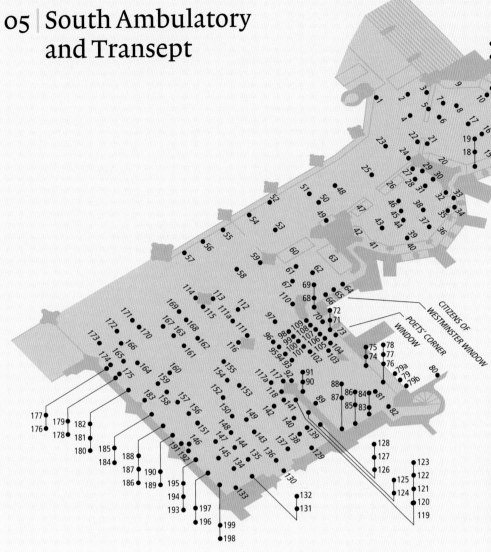

05

167

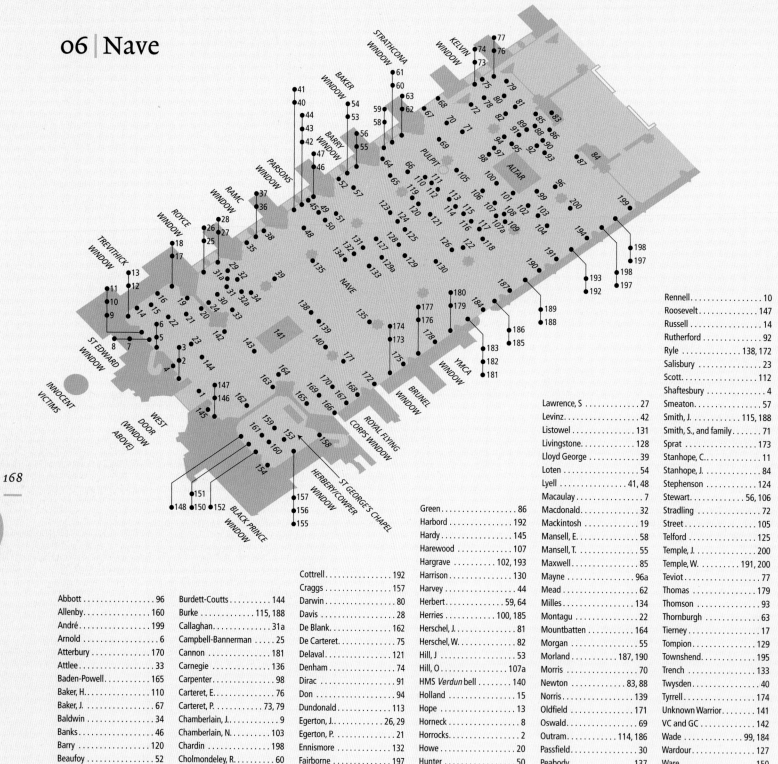

06

07 | Lady Chapel

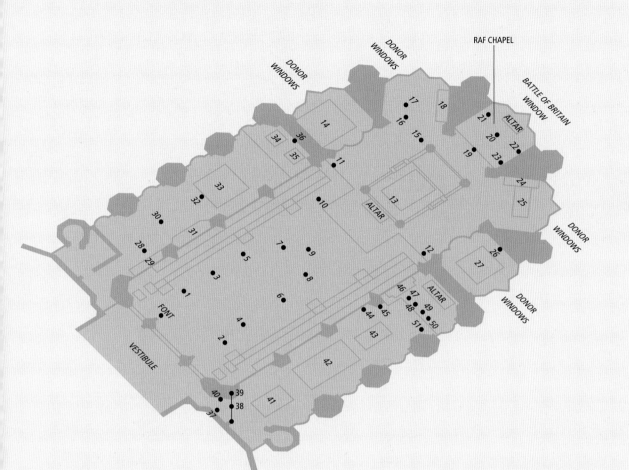

07

08 | Cloisters

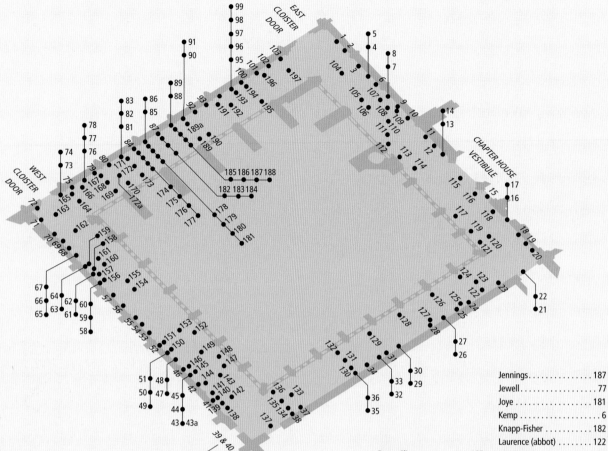

CHAPTER HOUSE

ST CATHERINE'S CHAPEL

PYX CHAMBER

UNDERCROFT (MUSEUM)

LITTLE CLOISTER

DEANERY

DARK CLOISTER

JERUSALEM CHAMBER

JERICHO PARLOUR

COLLEGE HALL

171

COLLEGE GARDEN

DORMITORY

WESTMINSTER SCHOOL

DEAN'S YARD

09

Index

Page references in italic are to illustrations; page references in **bold** are to main entries

172

173

174

176